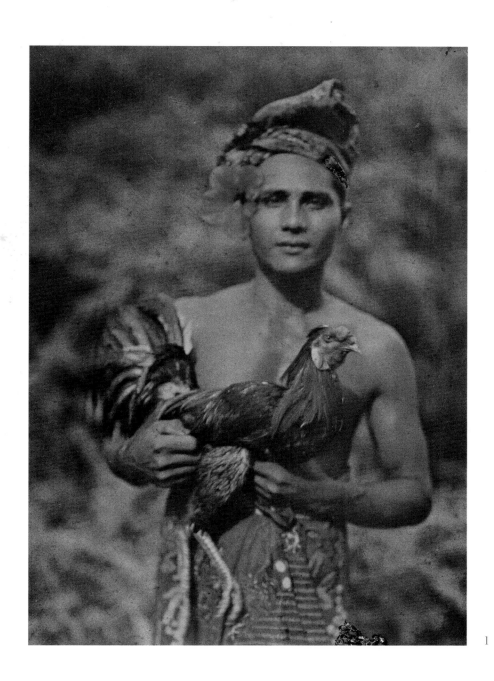

1

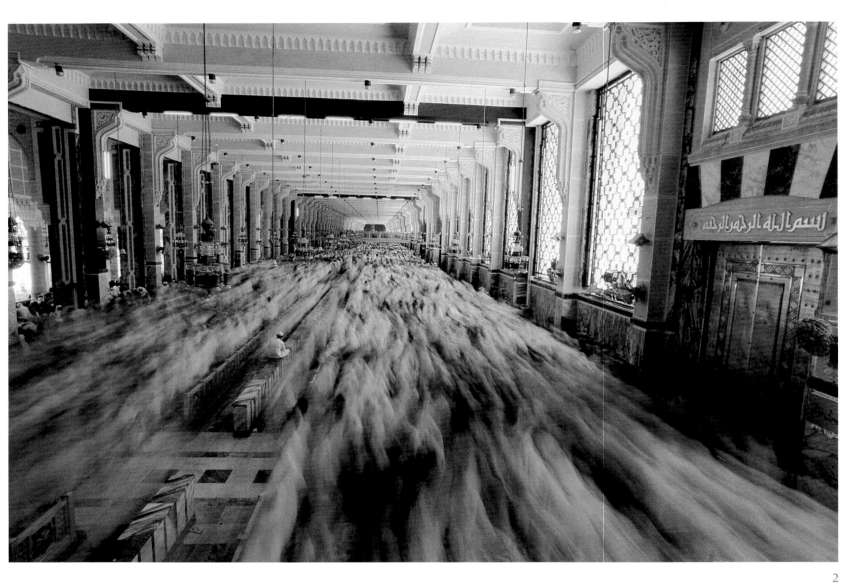

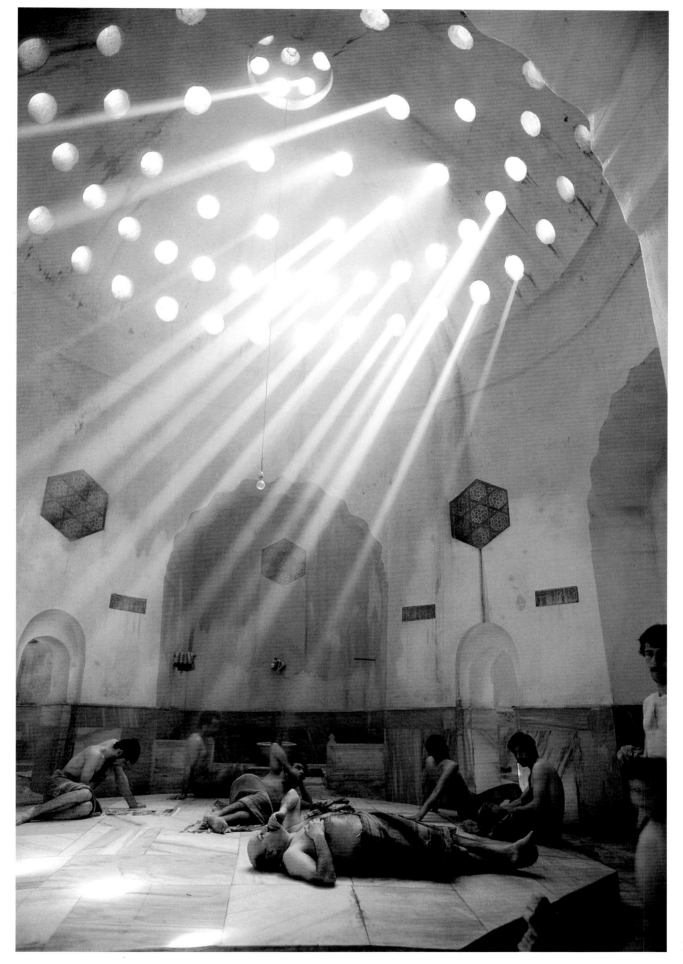

3

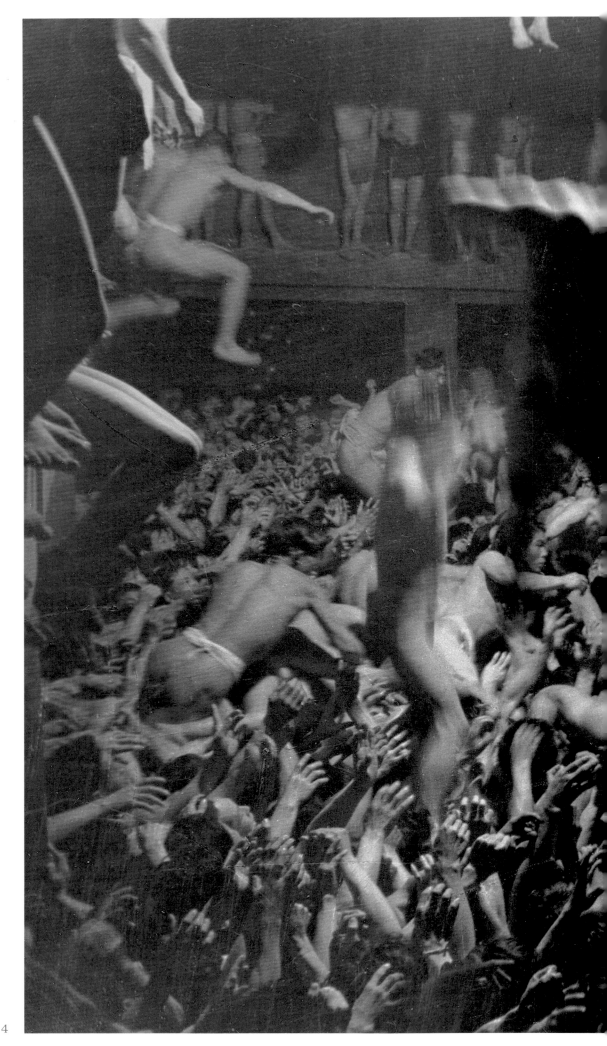

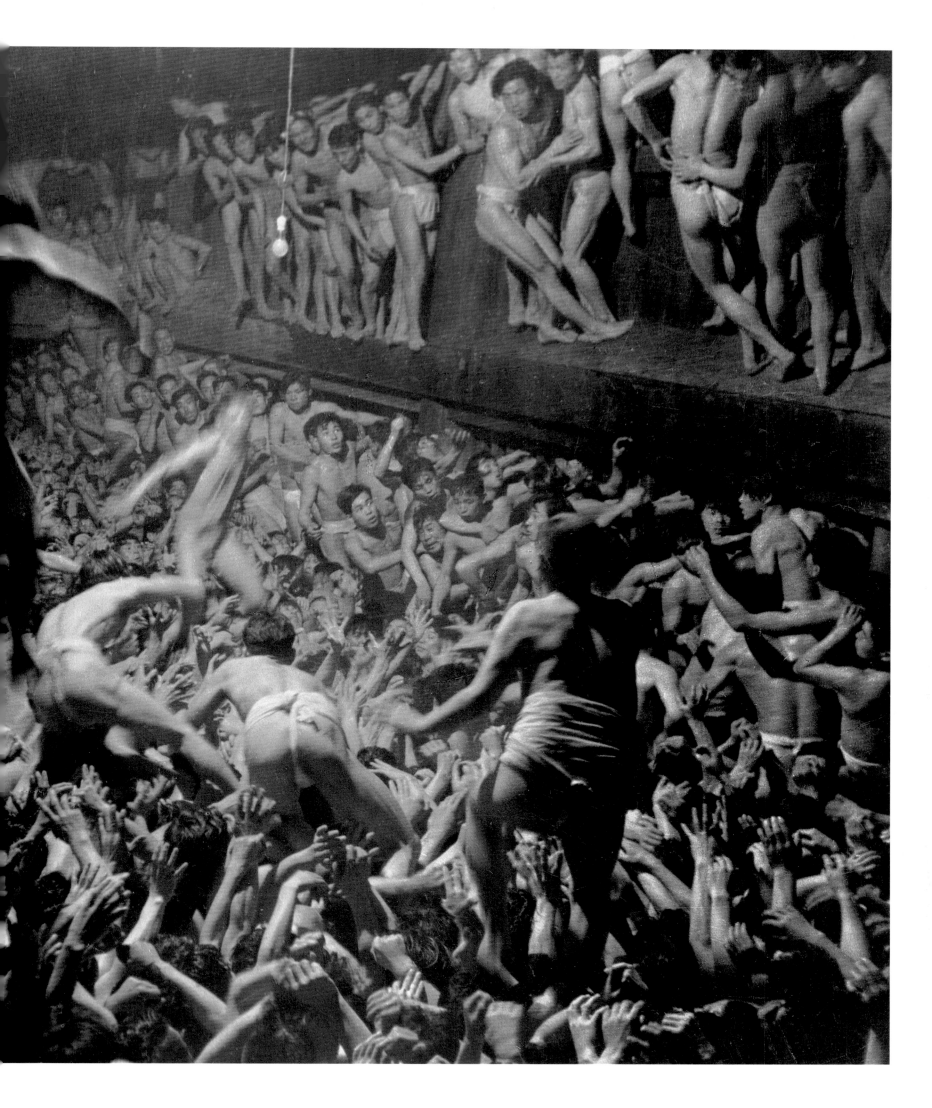

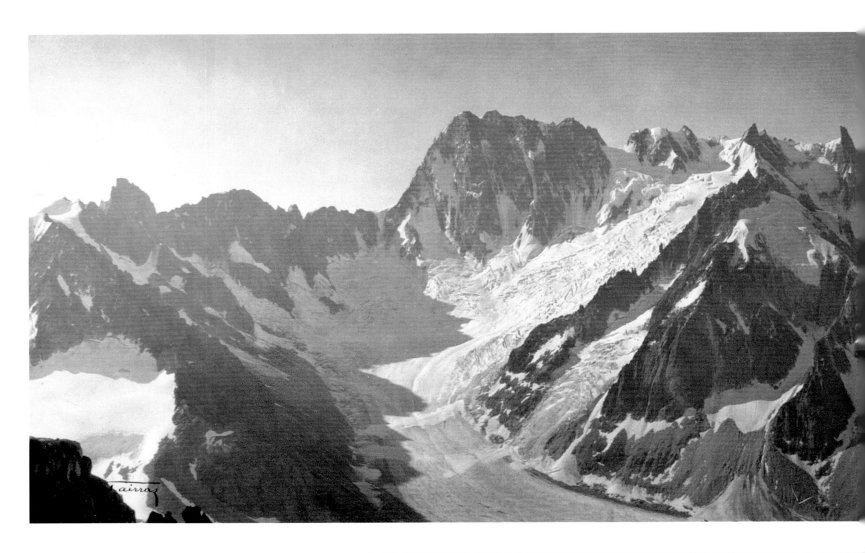

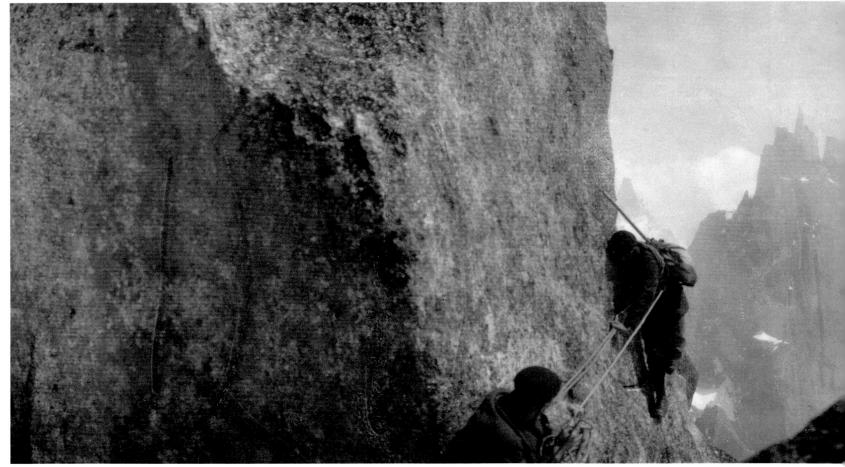

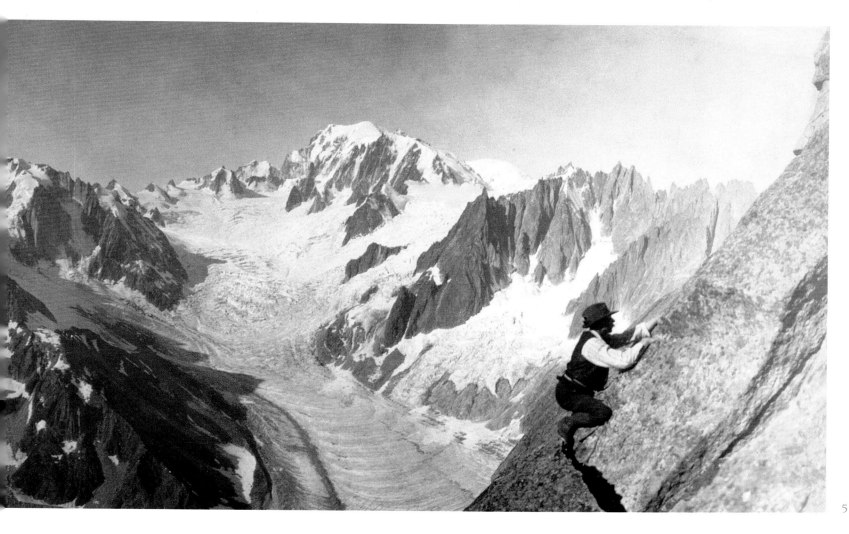

5

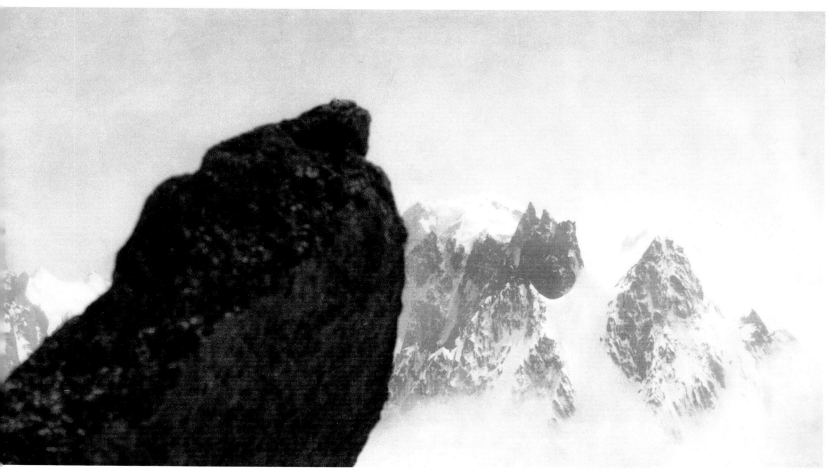

6

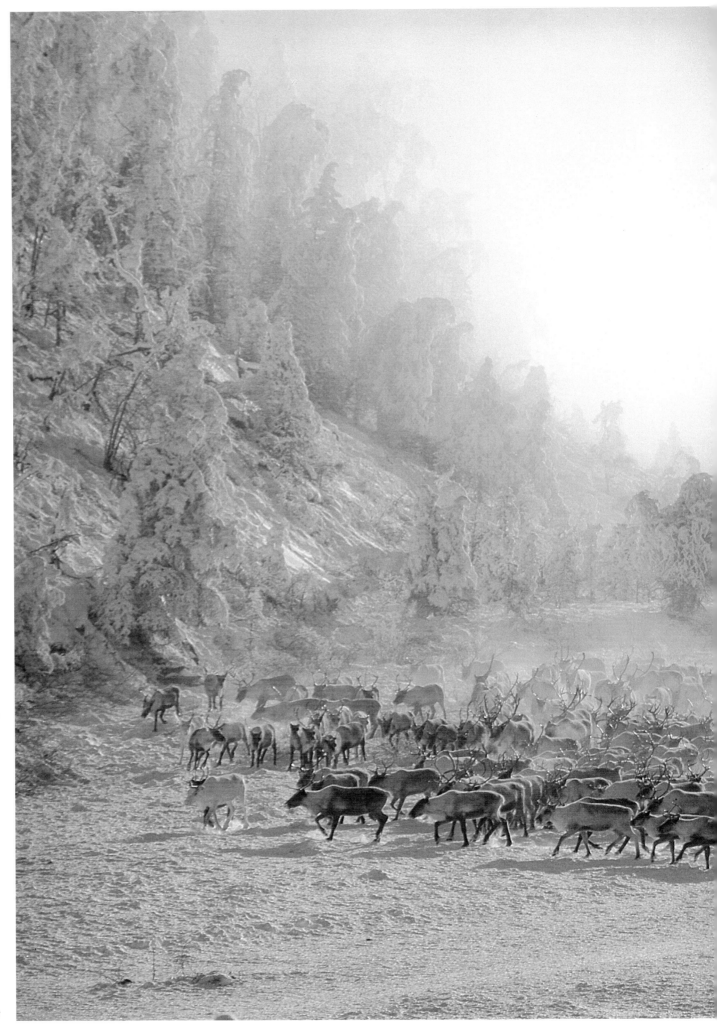

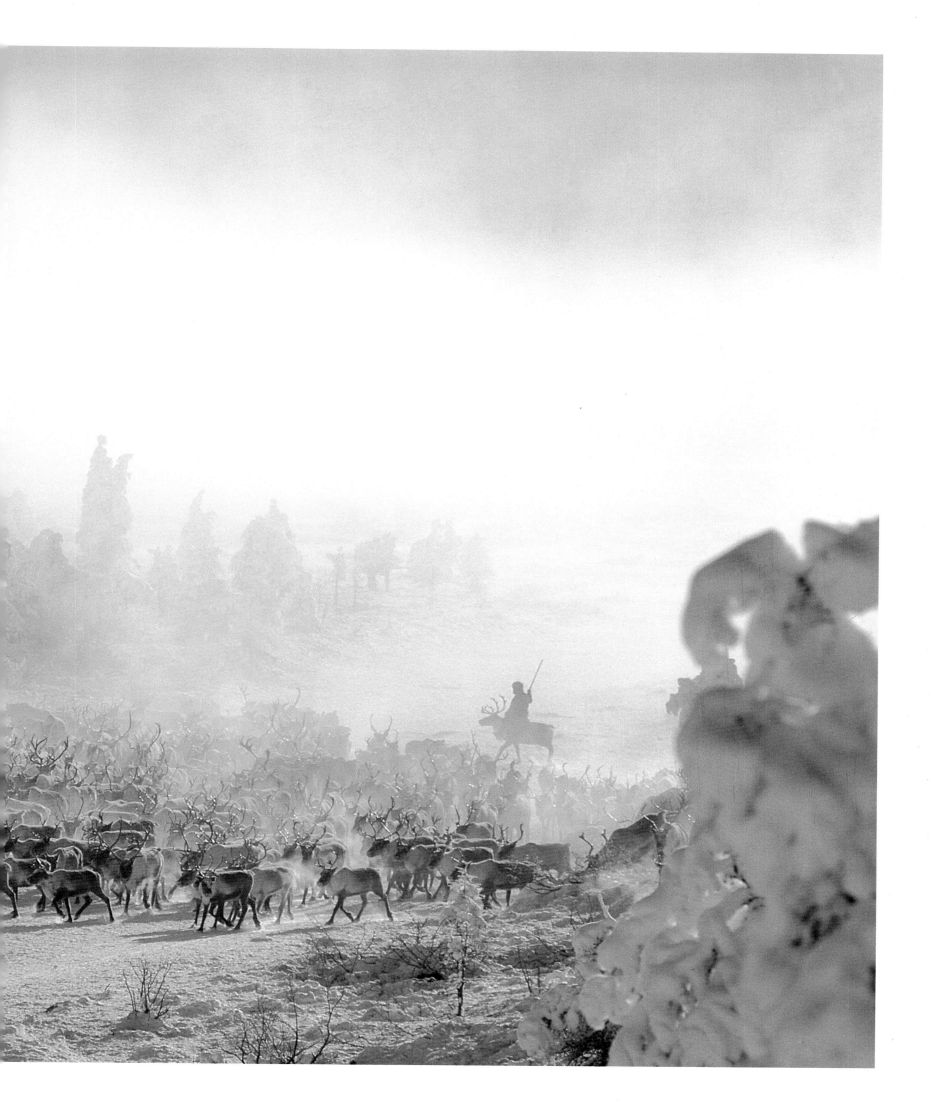

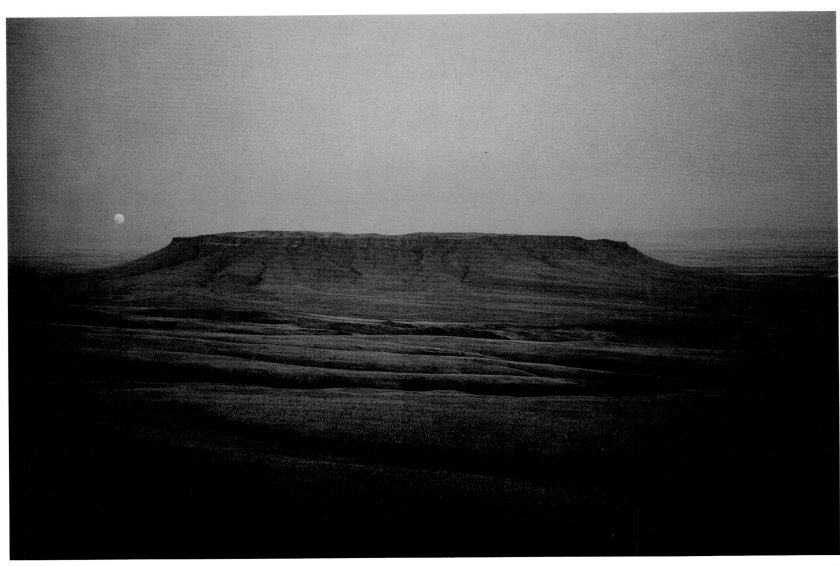

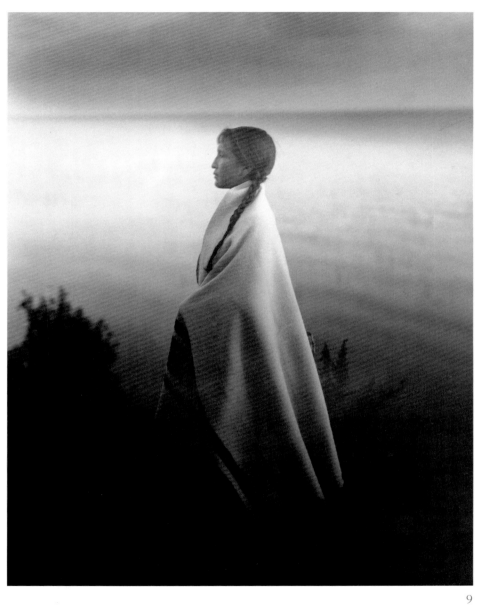

9

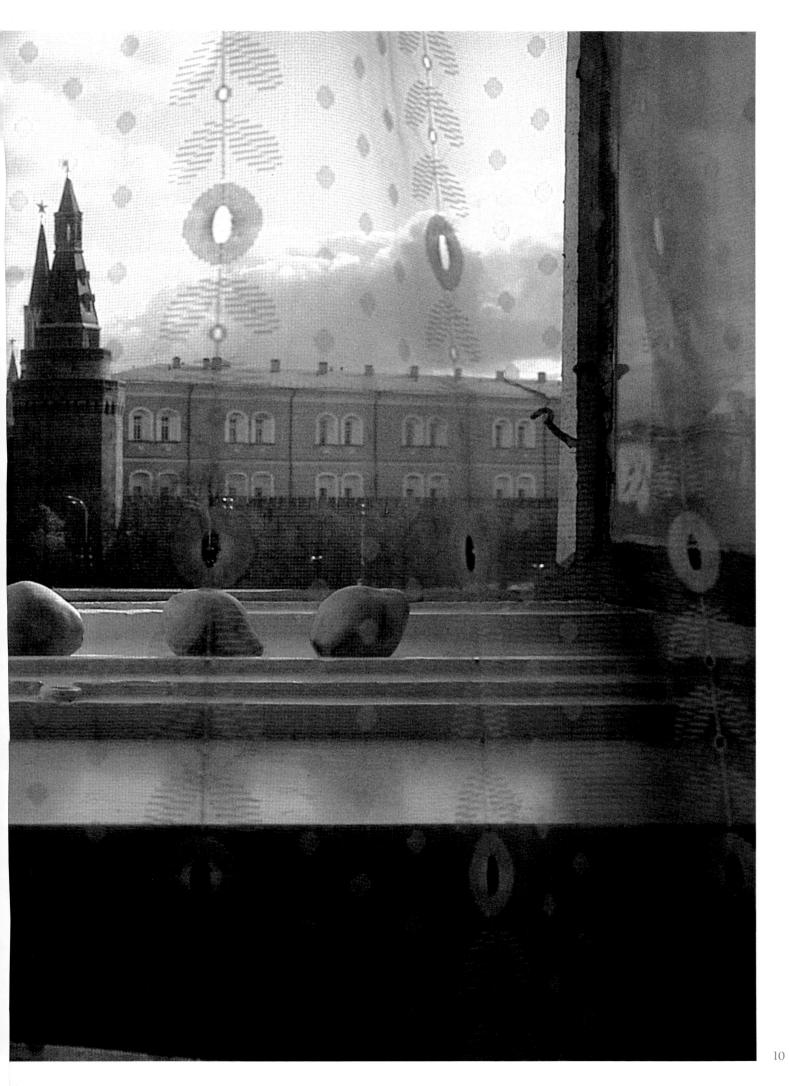

Preceding pages:

1. Franklin Price Knott, Bali, Dutch East Indies (Indonesia), c. 1927, *autochrome*

2. Mehmet Biber, Inside the Holy Mosque, Mecca, Saudi Arabia, 1980

3. Winfield Parks, Istanbul, Turkey, 1973

4. Horace Bristol, Honshū, Japan, 1946

5. George Tairraz, French Alps, 1890s

6. George Tairraz, French Alps, 1890s

7. Dean Conger, Siberia, Soviet Union, 1974

8. Sam Abell, Square Butte, Montana, 1984

9. Roland W. Reed, Minnesota, 1907

Following page:

10. Sam Abell, Moscow, Soviet Union, 1983

Odyssey

This book and exhibition have been supported by
the Eastman Kodak Company and the National Geographic Society.

Introduction by Jane Livingston
Design by Alex and Caroline Castro
Organized by Jane Livingston, Frances Fralin, and Declan Haun
with the assistance of Dena Andre

Library of Congress Catalog Card Number: 88-50159
ISBN 0-934738-45-9
Printed in the United States of America by Gardner Lithograph

96 95 94 93 92 91 90 89 88 5 4 3 2

Any inquiries should be directed to the publisher, Thomasson-Grant, Inc.,
One Morton Drive, Suite 500, Charlottesville, Virginia 22901, telephone
(804) 977-1780.

Library of Congress Cataloging-in-Publication Data

Livingston, Jane.
 Odyssey: the art of photography at National
Geographic.

 Catalogue of an exhibition held at the Corcoran
Gallery of Art.
 1. Travel photography — Exhibitions. 2. Photography,
Documentary — Exhibitions. 3. National Geographic
Society (U.S.) — Photograph collections — Exhibitions.
I. Fralin, Frances. II. Haun, Declan. III. National
Geographic Society (U.S.) IV. National geographic.
V. Corcoran Gallery of Art. VI. Title.
TR790.L58 1988 779'.074'0153 88-50159
ISBN 0-934738-45-9
ISBN 0-934738-46-7 (pbk.)

Odyssey

THE ART OF PHOTOGRAPHY AT
NATIONAL GEOGRAPHIC

JANE LIVINGSTON

with
FRANCES FRALIN
and
DECLAN HAUN

THOMASSON-GRANT
CHARLOTTESVILLE, VIRGINIA

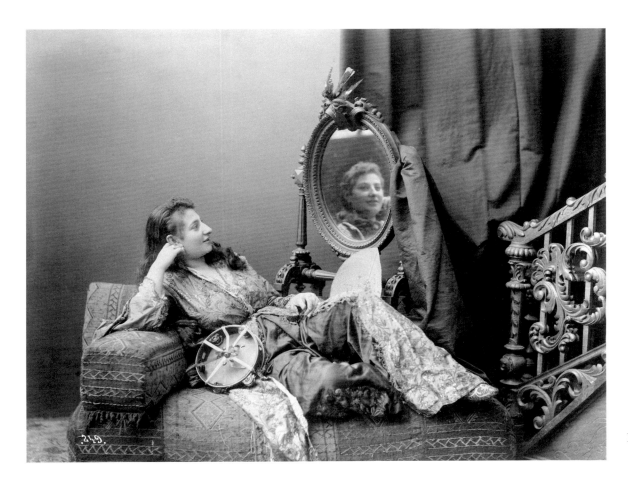

11. Photographer unknown,
Turkey, 1870s

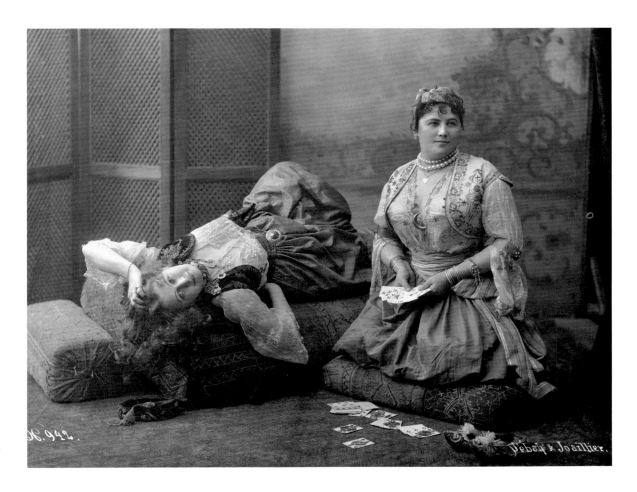

12. Sebah & Joaillier,
Turkey, 1880s

THE ART OF PHOTOGRAPHY AT
NATIONAL GEOGRAPHIC

For most of us, the words "National Geographic" automatically summon associations to colorful, diverse photographs contained in a compact, yellow-bordered magazine. In recent generations photography has been more emblematic of this unique institution than geographic maps or scientific discoveries. Yet, to appreciate fully National Geographic's enduring contribution as a source of important photographs requires that we see beneath the surface. It may, for instance, be difficult to imagine that photography was by no means always integral to the National Geographic Society or its magazine. The Society was incorporated to "diffuse knowledge" about our planet — and it was not immediately apparent that the camera was the most potent means to do that. But once this form of image making became indispensable, its history at the magazine paralleled many of the triumphs and vicissitudes of *photography*'s history. *National Geographic* may have influenced modern photography's history in ways previously unsuspected.

At first glance, it may startle everyone who loves both photography and *National Geographic* to realize that never before has the Society been systematically mined as a photographic resource. ODYSSEY marks the first exploration in the name of art of the vast photographic archives of the National Geographic Society. However, there are reasons why a full century passed during which the artistic establishment and the National Geographic Society ignored one another.

The history of the relationships between the world of professional journalistic or documentary photographers and that of the artistic establishment has long been characterized by mutual distrust and attraction. Yet it seems we are finally ready to face and sort out this ambivalent legacy. Many individuals and photo agencies whose roles have traditionally resided outside the received history of fine-art photography are now aggressively being adopted by museums and galleries.

So to view *National Geographic* photography, as we are doing here — holding it up by itself, full-frame, out of context, and away from words — is to put it to a test that curators and art historians are giving virtually every form of photography in the 1980s.

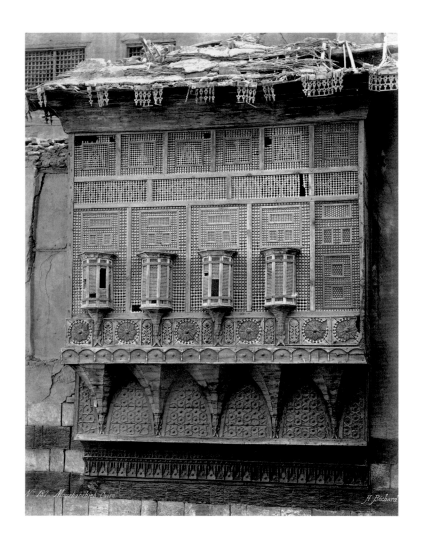

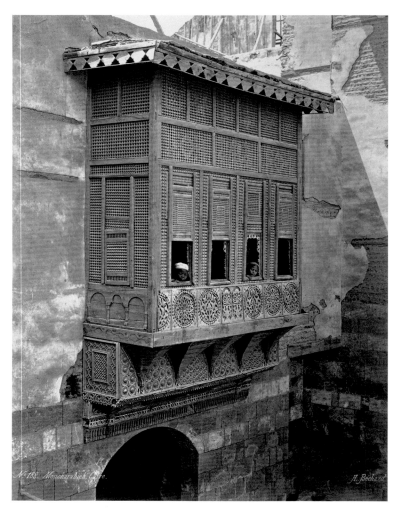

13-14. Henri Béchard, Cairo, Egypt, 1880s

To be sure, many guideposts to unity between the worlds of journalistic and artistic photography have shown themselves along the way. From the turn of the century on, legendary figures such as Eugene Atget or August Sander appeared whose "straight" photographs transcended the utilitarian spirit in which they were made. In America, a few social documentarians of the 1920s, '30s, and '40s — Jacob Riis, Lewis Hine, Dorothea Lange, Eugene Smith among them — were easily acknowledged by the world of art photography; the watershed 1955 exhibition, *Family of Man*, began to broaden the public's appreciation of photographs as artistic objects in themselves. Then, at a suddenly accelerating rate during the 1970s and '80s, photographs made under virtually every aegis, from the scientific to the reportorial, from anonymous snapshots to bureaucratic records, began to be scrutinized critically by curators, critics, art dealers, and collectors.

Thus, the discovery of *National Geographic's* rich contributions should not be surprising. What is remarkable is that an entire episode within the history of photography remained for so long sealed off from the fine-art photographic establishment, while it was also, until the 1980s, more or less tangential even to the mainstream journalistic world.

A distinction survives to this day between the ethos of the National Geographic Society photographer and that of the art world, and also between other news photographers or feature magazine freelancers. This distancing is subtle and complex. It originates partly in a long-standing editorial policy of *National Geographic*: namely, thinking of its pictorial staff heads not as "photo editors," but as "illustrations editors."

In its first seventy-five years, *National Geographic's* essential concern, from assignment inception to image gathering to final layout, was the story. It was not merely that the text (which was sometimes overshadowed by images) carried more priority than the pictures in structuring the magazine; it was that the photographers until quite recently were encouraged to think of themselves as suppliers of illustrations rather than as the people in the field who *make* the story. Being skillful and lucky enough to get The Great Shot seldom garnered editorial applause.

Sometimes, particularly in the magazine's early period, the author of a *National Geographic* story also served as its illustrator. But not until the 1970s did photographers and editors allow pictures to carry the main weight both of description and atmosphere. Thus, there is a sense in which the many photographers whose work we see here, at least in the minds of their editors, and perhaps in their own minds, were artisans and not artists. Even today, photography for *National Geographic* is neither a form of aesthetic design, nor, until recently, politically or sociologically committed journalism. At least in its editors' intentions, it has illustrated and educated rather than proclaimed itself as art.

This is not to imply that what has been produced under the aegis of the National Geographic Society is something other than art or less than superlative photography. Nor is it to suggest that the editorial powers ascendant at *National Geographic* have lacked in wisdom or sophistication. Indeed, both the early and recent histories of photography at the National Geographic Society can be viewed as a prolonged, quiet unfolding of genius. Something precious, unrivaled, was set in motion when this institution decided to follow its course, holding steadfastly to illustrative photography. Even as it defined a segment of middle-class cultural values, the National Geographic Society itself became a kind of slightly eccentric subculture. The mass of popular photography that has developed at *National Geographic* over the past fifty years in a unique set of conditions can now be judged by any standard to have yielded some of the most satisfying photographs ever achieved.

The particular view of photography at *National Geographic* offered here was obtained first through study of the Society's formidable archive and second through its publications. As with many other periodicals,

most of the photographs taken or gathered by the National Geographic Society never found their way into print. The present selection of pictures has been culled from a vast bank of images both published and unpublished. More than half of what is presented here is being published for the first time.

National Geographic, in the name of educating its audience about the world, began in 1888 as a popular scientific journal, and developed along the way into a resoundingly successful photographic magazine. It sustained difficult transitions from one era to another; many internal upheavals were survived. The policies formulated at the outset of the National Geographic Society's history, evolving through ten decades, would create not one but a series of distinct contexts. From its beginning, the question of how to illustrate the magazine demanded attention; eventually, in wrestling with this issue of illustration, photography became the primary vehicle. Through successive generations, the photographs produced by and for *National Geographic* have taken various technical and stylistic forms, and played different roles in relation to the Society's mission. Some of the Society's reigns of leadership have directly fostered artistic performances; others single-mindedly furthered technical progress.

The magazine existed for more than a decade before photographs began to dominate its pages. In its infancy it resembled a scholarly journal, with its plain yet well-designed double-columned text sometimes judiciously illustrated by diagrams, drawings, or paintings that usually looked like reproduced lithographs. This state of affairs might have lasted well into the 1920s — but it did not. Since the Society's founding in 1888 coincided with photography's rudimentary emergence as a mass-produced print medium, it was perhaps inevitable that this "recording tool" would be incorporated in its articles. Although often skeptical or actively resistant, after the turn of the century the Geographic's Board of Managers increasingly allowed photographs to appear as illustrations in the magazine (along with halftone reproductions of gravure prints or paintings). Still, a true commitment on the part of the Society's early managing editor and president, Gilbert Hovey Grosvenor, himself a dedicated photographer, to accompany its articles with photographs was not made until 1906. In July of that year, the magazine's entire staff, responding to a large group of images by George Shiras, decided to publish seventy-four of his magnesium powder "flashlight photographs" of wild animals. From then on, the future of illustration for *National Geographic* stories was more and more bound up with photography. Photographs began to be purchased, commissioned, hunted down however possible, and amassed for use in illustrating *National Geographic's* stories.

Now, of course, photographers are assigned to "shoot" stories. But in the early days, men who were nominally scientists, explorers, or even inventors, such as Hiram Bingham, Joseph Rock, Donald B. MacMillan, or Alexander Graham Bell, contributed photographs. Acquiring relevant pictures often meant seeking out, sometimes by word of mouth, images from local shops, photo studios, or professional photographers in remote lands.

In the early decades of this century, a large number of photographs came to the National Geographic Society from the inventories of internationally based individuals or photographic studios. There were no full-time staff photographers or those regularly assigned to stories until the mid-1920s. It was the Society's principle to maintain a stockpile of photographs from various regions, ready for use in future stories with short deadlines. This policy resulted in the acquisition of hundreds of images destined to be more valued by later generations than by their contemporaries. For instance, early works by independent, international photographers like Roland W. Reed, Vittorio Sella, Hugo Brehme, Baron von Gloeden, and the professional team Lehnert & Landrock — though many were never published — found their way to the Geographic's possession through luck and circumstance.

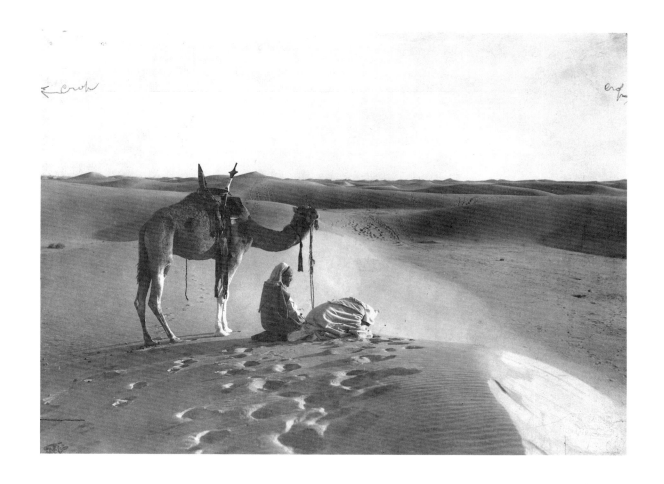

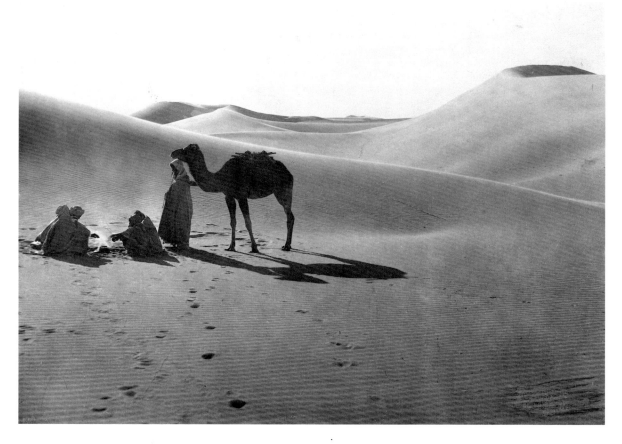

15-16. Lehnert & Landrock, Sahara Desert, c. 1905

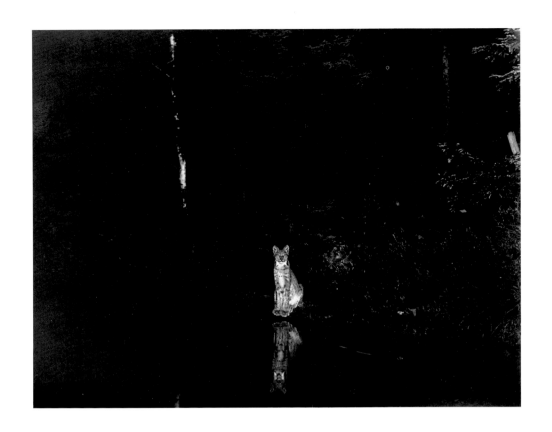

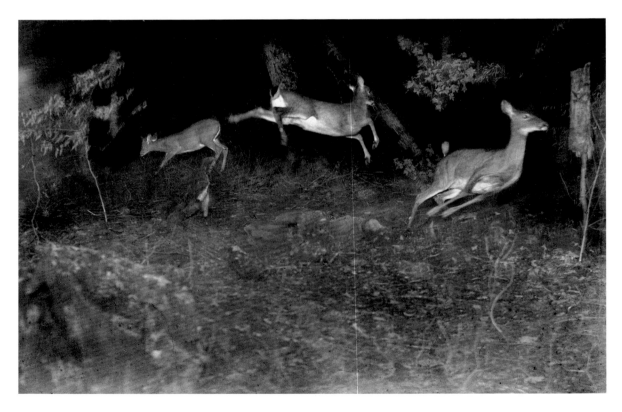

17. George Shiras III, Loon Lake, Ontario, Canada, n.d.

18. George Shiras III, Lake Superior, 1893

In addition to the individual photographs bought or commissioned for possible use by writers or story editors, a few portfolios and miscellaneous collections were acquired by the National Geographic Society, some published, some not. The entire set of Edward Curtis' published Indian photos (several published in the July 1907 *National Geographic*) and many beautifully preserved leaves from Jack Hillers' Western Survey albums, done under the auspices of the William Henry Jackson Studio, reside in the National Geographic Society's files. The selection made for this exhibition draws sparingly from these well-known sources, because its goal is largely to present little-known pictures truly indigenous to the National Geographic Society itself. In this first museum-initiated excavation of the Society's archive, it seemed better to lean in the direction of what is specific to *National Geographic*, rather than what is already familiar to students of photographic history.

The National Geographic Society's vast archive of early material literally bulges with photographs of every size and description: dry-mounted prints made casually or carefully, in every conceivable tonality, format, and process; photogravures, gum prints, platinum prints, carbon prints, albumen prints, and other manifestations of the silver print.

Most of the black-and-white photographs reproduced here look quite different from the way they were originally presented. The ones that appeared in *National Geographic*'s early issues are reproduced in this book with a technology far different from the halftone process used for so many decades. The duotone method of printing photographs employed here yields a closer approximation of the original print in subtlety, contrast, resolution, and, above all, tonality. Moreover, many, if not most, of the black-and-white works selected on this occasion were printed by their makers, a practice virtually unheard of with contemporary color-slide work. When we had the option of showing a vintage print made by the photographer rather than one made anonymously, we usually chose the author's print based on its superior quality.

The sensation of discovering some of these early black-and-white images surpasses the typical response to recent color work. Something about the arduous pioneering, the inventive brinkmanship of early black-and-white photography imparts to the best prints an ineffable mystique. Hiram Bingham's sweeping 1912 records of the ancient landscape of Machu Picchu, newly visited by twentieth-century man [no. 103]; Herbert G. Ponting's photographs of the Scott Polar expedition in 1911 [nos. 80, 81, and 157]; Joseph Rock's hundreds of Tibetan images from the 1920s and '30s [nos. 177, 178, 181, and 277]; George Tairraz's early Alpine panoramas [nos. 5 and 6]; or Henri Béchard's architectural photographs of ornate Arab wooden balconies dating from the 1880s [nos. 13 and 14] — all take on a preciousness and rarity they perhaps could not have had at the time they were made.

However, before an archive was amassed of globally ranging black-and-white photographs, several developments changed the magazine's early emphasis on acquiring or even commissioning photographs. A home developing and processing laboratory was established at the National Geographic Society's Washington, D.C. headquarters in 1910, and by the 1920s, full-time staff photographers were being hired.

Between 1900 and 1920, the National Geographic Society gave black-and-white photography significant exposure worldwide as a popular illustrational medium. The simple halftone plate, starting in the 1800s, enabled photographs to be printed on the same presses as type, and would soon replace earlier methods of mass photographic printing such as Woodburytype, photogravure, and photolithography. Offset halftone reproduction — probably the oldest technique for printing photographs still widely used in the mass media — made its first appearance in *National Geographic* in 1889.

In recent years, halftones have been superseded in most quality periodicals by four-color or duotone reproductions, although cost and the need for high-speed print runs sometimes limit their use. But for a

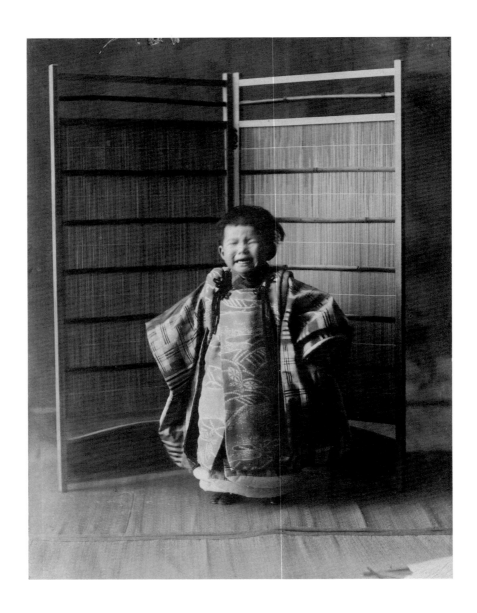

19. Eliza R. Scidmore, Japan, n.d.

substantial period of *National Geographic's* history, black-and-white halftones provided the best alternative to illustrating articles with engraved diagrams, drawings, or paintings. This era, from about 1905 well into the 1950s, provided the setting for a phenomenal funneling of black-and-white photographs into one place.

Long before the pioneering era of black-and-white photography and its reproduction began to die out in the 1940s, color pushed insistently at its heels. The saga of color photography at the National Geographic Society is fascinating and complex. The sheer length of time it took for the novelty of the colored image to wear off seems now incomprehensible. Even after 1914, with the Society's first publication in halftone of a color image, it was not until some indefinable moment in the 1960s that the public could readily *see* a color photograph for its subject or content, rather than for its "coloredness." Creating the economical, visually "accurate" color process we now take for granted literally obsessed two generations of publishers and photographers.

The very first attempts at photographic color involved applying dyes and pigments by hand to black-and-white prints. In the November 1910 issue of *National Geographic*, the first hand-colored photograph, "Scenes in Korea and China" by W. Chapin, appeared and "caused a sensation."[1] Several beautiful, and some rather amusing, unique hand-tinted prints are included here [nos. 19, 110, 111, 124, 125, 126, and 127]. Their peculiar fragility, like that of faded painted miniatures, today seems more like an art historical curiosity than a step leading to mass-produced color work. Although many hand-colored black-and-white photographs were reproduced in the magazine, few were done so successfully. Yet the exceptions are striking: Eliza Scidmore's astonishing painted snapshots of Japanese children, whether in the original or in reproduction, call for reassessment of this entire episode in the development of color photography.[2]

In tracing the unique odyssey of photography at *National Geographic*, the magazine's long-time policy of limiting personal stylistic latitude, of insisting on the photographer's role as illustrator and not "camera artist," is a key concept. But perhaps even more important is the drive to use color, more color, and finally all color, at a time when other publications shied away from it. This unswerving editorial commitment had profound aesthetic consequences in critical periods of the magazine's development.

What truly heralded the riveting age of color photographic reproduction in the mass market — a story played out with more authority and persistence by the National Geographic Society than by any other institution — was the advent of the autochrome method of color photography.

The autochrome process, using potato-starch grains dyed to primary colors, acting as a filter deployed on a glass plate, was invented by the Lumiére brothers. It was demonstrated in 1907 at the Little Galleries of the Photo-Secession in New York, with plates by Edward Steichen, Frank Eugene, and Alfred Stieglitz. There for the first time the American public saw the oddities that are autochrome plates: objects usually five by seven inches in size, at least one-eighth inch thick, usually taped at the edge, viewed most easily with the help of a "diascope," an ingenious device in which the backlit image is reflected in a mirror. Their character differs radically from today's familiar plastic-and-paper slide: the glass autochrome functions as a vessel for the image, yet in itself takes up space.

The manufacture of autochrome plates was discontinued in 1932; the National Geographic Society stopped using them by 1930. Between 1921 and 1930, about 1,700 autochromes were published in *National Geographic*. The first autochrome appeared in the July 1914 *National Geographic* and was by Paul Guillamette. In 1920 the National Geographic Society established the first color laboratory in American publishing, and the starch-filter, glass-plate method continued to be the standard one in their laboratory for a decade. For this entire period, *National Geographic* produced more images in the autochrome medium than any other mass-market organization.

Autochrome plates by nature are oddly puritanical, stubbornly untheatrical objects, even after transformation into printed images. Yet, when illuminated, these musty plates begin to seduce, if only by their tempered palette or quietude. The strange combination of a physically transparent surface with an often subdued, limited color range makes the autochrome, now outmoded, appear to be a full-fledged aesthetic medium.

Compared to contemporary color, the quality of color in a successful autochome plate often takes on an otherworldly cast, a characteristic probably most apparent with hindsight. Now, autochromes sometimes recall early hand-colored photographs, in their low saturation and limited palette. A few autochromes, however, assume an amazing chromatic richness, as if patinated; this is most obvious when the primary hue is in the gold and red spectrum [no. 49].

The masters of the autochrome medium in the National Geographic Society's purview are generally photographers who, while pursuing exotic subjects, shared a patent interest in plain, descriptive composition, seldom yielding to the kind of self-conscious artistry associated with Stieglitz, Steichen, or Frank Eugene. Such photographers as Charles Martin, Jacob Gayer, Gervais Courtellemont, Franklin Price Knott, and Edwin L. Wisherd, like their more artistically ambitious peers, learned their craft by experimenting and struggling endlessly; theirs was a task comparable to that which confronted the pioneers of black-and-white photography. The photographer using autochrome equipment carried into the field "steamer trunks full of chemicals and a suitcase full of books to read on the voyage. His color plates alone weighed as much as 150 pounds."[3] The clumsiness, the exhausting inconvenience of creating these dimly toned glass plates usually shows in the result, but sometimes it does not. Some of the autochrome pictures here can seem as effortless, as inexorable, as one of Jacques-Henri Lartigue's classic images. It is worth noting that Lartigue is one of the few photographic masters associated with this medium in the public's or even specialists' minds.

As we can see in the examples at hand, many autochromes, whether depicting a child gazing at a bank of circus posters [no. 23], a water lily [no. 56], or a basket of fruit [no. 52], embody virtually every quality we ask for in a great photograph. This is a fact little emphasized until now.[4] The tangibly real and the apparently imagined fuse poignantly in successful autochromes. In its distinctive character of still, uneventful resonance, the autochrome differs from the fast-shutter, negative-color processes that so quickly rendered it obsolete. It may be that the autochrome is fundamentally an artificially colored variant of the early black-and-white camera product — but in its nature as such, it is at its best a thing of undeniable, if mysterious, aesthetic dignity.

But nostalgic luster was the last quality wanted by the editors and photographers of the 1920s. Several classes of photographic images swiftly superseded the photographic technology that culminated in the ponderously beautiful autochrome.

Color-film engineering progressed hand in hand with the National Geographic Society's needs. The early 1930s saw the brief use of Paget color, a forerunner of short-exposure Finlay color. Instead of deploying starch grains on a glass plate, Finlay color imposed a dot-pattern screen of the three primary colors. This made for a faster emulsion than that of the autochrome, but the image was usually coarser; often the screen showed even in a very small reproduction. One of the advances in color imaging was its ability to record interiors successfully, but Finlay color accomplished this feat without any significant advantage over the autochrome. The Finlay image included here [no. 67] happens to be a beautiful photograph, but might as well be an autochrome or Agfacolor image [no. 265].

Dufay color, faster still than Finlay, used film rather than glass as the filter base. Here, parallel lines of blue and green intersected with lines of red. Like Finlay and Agfacolor, Dufay was used for relatively few

years. In reproduction the one image made from this technique [no. 46] cannot be distinguished from Finlay color or the autochrome; it is in the original that these processes assert their individuality.

A problem quite aside from the technology of making color photographs was developing the technology required to print them. Color separating and engraving techniques continued to change and "improve," just as color photography did. But what would decisively replace these transitional color processes and revolutionize the entire color photography industry was Kodachrome film. This invention solved four practical problems at once: it could be used in much smaller, more portable camera equipment; its exposure time was faster; its translation from film to print resulted in a more "accurate" chromatic appearance; and it could be enlarged without losing resolution.

The story of Kodachrome's origins is fast becoming legend. Leopold Godowsky, Jr. and Leopold Mannes —two Rochester, New York, musicians — made an obsessive avocation of developing a subtractive color-film process. Eventually, using an Eastman Kodak Company laboratory, they perfected a film that incorporated three different superimposed black-and-white emulsions, each sensitive to one color — blue, green, and red. Through intricate processing the developed black-and-white image in each layer was selectively replaced by an appropriate dye-image — yellow, magenta, and cyan.

Working without a textured filter or a color dot or grid system, this Kodachrome film process solved the problems of graininess and dot patterns in color photography. Certain early problematic characteristics, such as the faster fading or changing character of one or two of the emulsions, were gradually improved. Today this invention remains the predominant method used with evermore satisfactory 35mm film (first released in 1936) and evermore sophisticated cameras.

Kodachrome's early appearance in *National Geographic* is associated primarily with W. Robert Moore and Luis Marden. Both adopted it immediately and showed its advantages by example. Some photographers took more easily than others to the new, tripod-free, fast-exposure approach. Among the other artists who relatively quickly mastered the medium were B. Anthony Stewart, Volkmar Wentzel, and Edwin Wisherd.

Still more important than its effect on individual photographers' careers and artistic achievement in the 1940s and '50s were the implications of Kodachrome film (and the new lightweight and optically sophisticated Leica camera) for certain subjects — primarily, nature itself, one of *National Geographic*'s central themes. The ability to capture animals moving in their natural habitats, to say nothing of geological or meteorologic cataclysms, has had momentous consequences for photography. To the staff of *National Geographic*, ever alert to *scientifically* descriptive technologies, the luxuries of fast-color film and acceptable color-printing methods seemed self-evidently expedient.

However, certain unexpected barriers impeded a rapid, wholesale adoption of the new color. Color work has often been more difficult to use successfully as an art form than black-and-white photography. Even photographers whose main work was photojournalism, magazine illustration, or scientific endeavor, have sometimes deliberately abjured color in favor of black-and-white film. Only since about 1978 has color photography seemed to firmly take its place in virtually every photographic mode, from the amateur to the commercial to the arcane.

Printing exciting color photographs, as much as making them, became the challenge. The pivotal era in printing color photography at *National Geographic* came later than might seem logical in terms of the purely technical history of color reproduction. There would be a twenty-year period of adjustment to the problem of translating the highly saturated, intense Kodachrome color to the printed page. The novelty of Kodachrome (and the faster if more spectrally limited Ektachrome) film, which produced a blocky, often garish palette, frequently overrode other photographic or pictorial values. What appears to be the

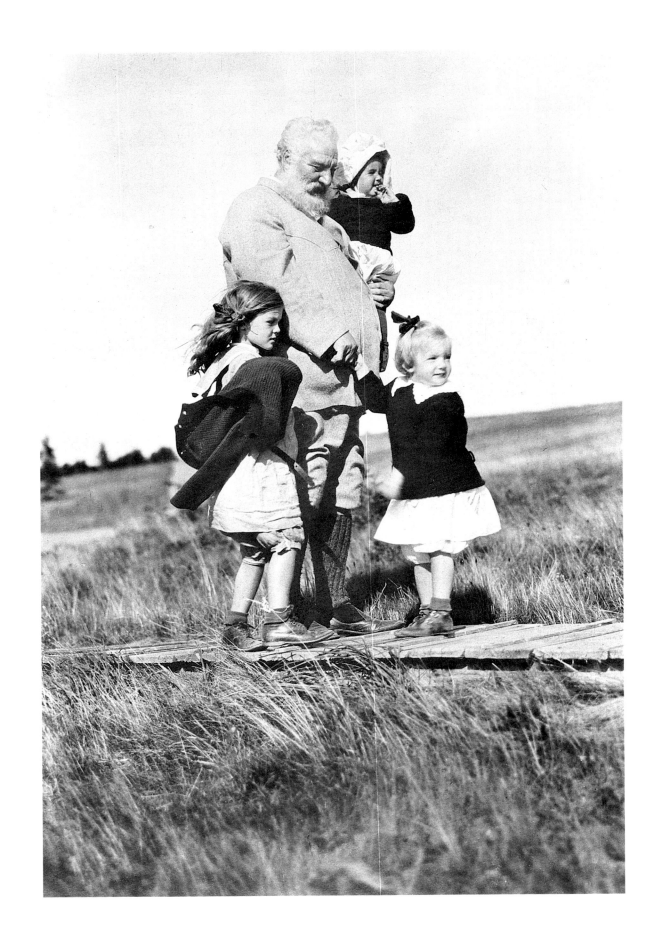

20. Gilbert H. Grosvenor, near Baddeck, Nova Scotia, Canada, 1908
Alexander Graham Bell and his grandchildren

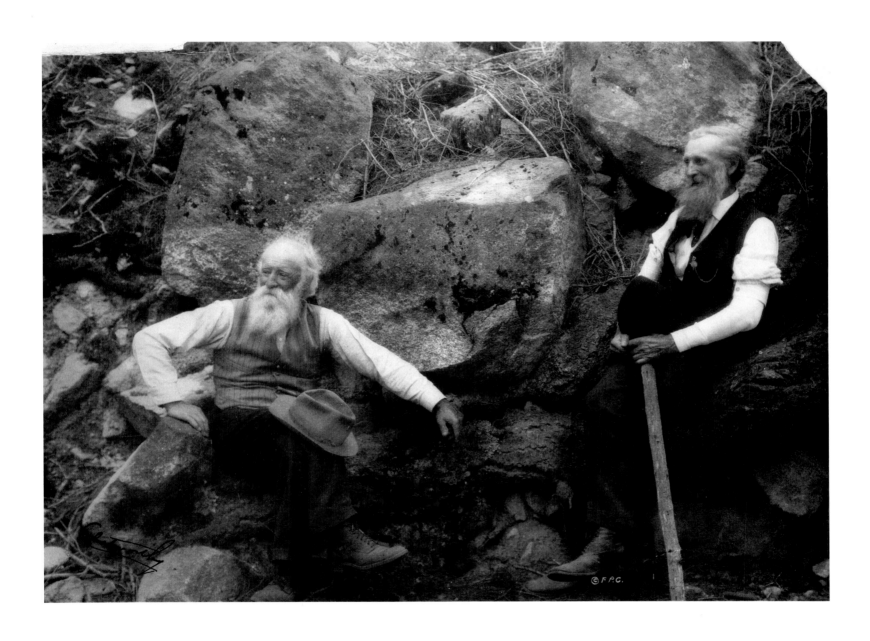

21. Fred Payne Clatworthy, Yosemite National Park, California, 1909
John Burroughs and John Muir

distorted gaudiness in the color film, far from being counteracted in the reproduction stages of presentation, was often heightened. The so-called "red shirt school" of editorial bias in color photography at *National Geographic* — encouraging a photographer to introduce a red, purple, or orange element into a dull landscape by draping a sweater over a rock or placing a model in front of a tree — testifies to the pressure to use color for color's sake.

From the 1940s, '50s, and '60s combined come fewer than forty images in this selection; the 1980s alone are represented by sixty-eight photographs; from 1900-1919 come fifty. Many color reproductions from *Geographic*'s long "early modern" era seem artificially heightened, while chromatically uneven and overly self-conscious; it is often as though the image, at least in its printed form, was composed in the spirit of a design lesson. This is the primary reason for our exhibition's proportionally small representation of images from the middle period.

Yet it would be a mistake to patronize the over-eager, or sometimes too-formularized look of the color reproduction of this period as "*moderne* color at *National Geographic*." It is also dangerous to dismiss the "middle age" of *National Geographic*'s photographic history as merely a passive episode, as though it were simply a groping preparatory phase. For much of what characterizes this transitional era of the 1940s and '50s lies at the heart of *National Geographic* photography itself. It was a time when the values and look of the magazine were imprinted on the huge public who now remember it with affection. Moreover, it would be simpler to dismiss it as an ostensibly depressed era in the history of *National Geographic* photography, if at the same time there had not been so many exceptional masters of camera technology practicing there.

We have found, especially in studying this middle period, what certain National Geographic Society staffers already know: a number of masterful Geographic photographers have been unappreciated beyond the organization's confines. The work of these individuals, though never widely reproduced or circulated outside *National Geographic*, is as stylistically developed as that of any of the internationally known photographers. Some are estimable artists by any standard. In most cases, however, either because they were fully employed, sometimes lifelong, by *National Geographic*, or worked only secondarily or briefly as photographers, they never published elsewhere. Certainly they were not in the practice of exhibiting their work, as were many of their contemporaries in New York and on the West Coast. Simply to have been identified with a Washington, D.C. institution seems to have isolated them from the world of art photography, and, in many cases, the personal dedication and the external demands placed upon them by the challenges of the National Geographic Society virtually consumed them.

In the earliest period covered here, from the 1870s to about World War II, most of the dominant photographers are drastically underrated; although perhaps familiar to a specialized audience, in some cases they are unknown outside the Geographic confines. Clifton Adams, Hiram Bingham, Hugo Brehme, Gervais Courtellemont, Jacob Gayer, Gustav Heurlin, Hans Hildenbrand, Franklin Price Knott, Justin Locke, Luis Marden, Donald McLeish, W. Robert Moore, Luigi Pellerano, J. Baylor Roberts, Vittorio Sella, B. Anthony Stewart, Volkmar Wentzel, Maynard Owen Williams, and Edwin L. Wisherd are merely the primary figures among the outstanding first- and second-generation photographers. All but a few of these did their best work under the auspices of the National Geographic Society. They were active generally between 1910 and 1950 or, in a few cases, 1960. Together they wrote an important and newly defined chapter in American photography between the Photo-Secession and the beginning of the contemporary age.

One of the first staff photographers and a long-time laboratory chief at *National Geographic* was Charles Martin, a man whose curiosity and interests ranged widely, and who later came to be thought of by

younger photographers as an artisan of "the old school: everything had to be in sharp focus from front to back."[5] Martin took the first successful undersea color photographs in 1927 [no. 58].

During the era of the autochrome, some of the most important contributions were made under the administration of Franklin Fisher in the 1920s and '30s. Fisher was illustrations chief during the beginnings of a great age of commissioned foreign work and the formation of a permanent staff of Washington based photographers. Franklin Fisher contracted abroad five masters of the autochrome: Luigi Pellerano of Italy, Hans Hildenbrand and William Tobien of Germany, Gustav Heurlin of Sweden, and perhaps the most extraordinary artist of them all, Gervais Courtellemont of France.

Edwin L. Wisherd, a talented, prolific contributor to the magazine and mentor as head of the laboratory, took his place as a special figure among this generation of *National Geographic* photographers. Two early photographers working in distinctly individual yet subtly influential styles are Maynard Owen Williams (role model to many younger photographers) and W. Robert Moore. Both were writers and photographers; both, along with Luis Marden, were hired to serve as home-based foreign correspondents. Also active in this period was the prodigious and inexplicably obscure Clifton Adams, an artist whose black-and-white work ranks him as one of the finest artists who ever worked for *National Geographic* [nos. 22, 54, 64, 72, 231, and 261].

From the 1930s well into the 1960s, three especially versatile figures, all staff photographers and accultured men of prodigious energy and dedication, created a legacy that reverberates to this day in the photography of *National Geographic*. B. Anthony Stewart, who joined the staff in 1927 and became probably the Society's most frequently published photographer, worked masterfully in black and white and color alike. Volkmar Wentzel, scholarly, attuned to the image in a painterly sense, and as perceptive of others' talent as any talented editor, brought a dimension of refinement and literary discipline to *National Geographic* photography. His contemporary at *National Geographic*, Luis Marden, may well stand as the exemplar of the protean photographer we associate with *National Geographic* at its best. Marden's amazing reach, his studied expertise in the medium, combined with a breadth of intuitive vision, place him among the greatest field photographers.

Others who worked primarily in the 1940s and '50s and whose artistic contributions emerge insistently are the gifted artist Justin Locke and the pioneering technician Willard Culver, an early photographer of industrial America.

Virtually all of the photographers of this generation of regular contributors to *National Geographic* were superb practitioners, both in the field and in the darkroom. One senses that their goals as photographers often had less to do with envisaging their images in the pages of *National Geographic* than with the personal and technical challenges of the assignment. Many of these men were *generalists* by nature. They experimented in their photography, as in other endeavors. The workmanlike and often astonishingly unaffected imaging that results from this underlying attitude, though difficult to discern in single photographs, emerges in the process of viewing the cumulative work of these individuals and becomes a kind of stylistic hallmark for the era that ended sometime in the 1960s.

Of course, these photographers worked hand in hand with editors and staff department heads, taking their lead from successive people or policies, sometimes changing their approaches according to directives from above — and sometimes influencing their editors and higher management by their own breakthroughs.

Faced with the mass retreat from color reproduction by many American and European publications in the 1950s, it was Melville Grosvenor, son of the early editor Gilbert H. Grosvenor and the brilliant leader of the National Geographic Society in its crucial transition from the black-and-white to the color era, who

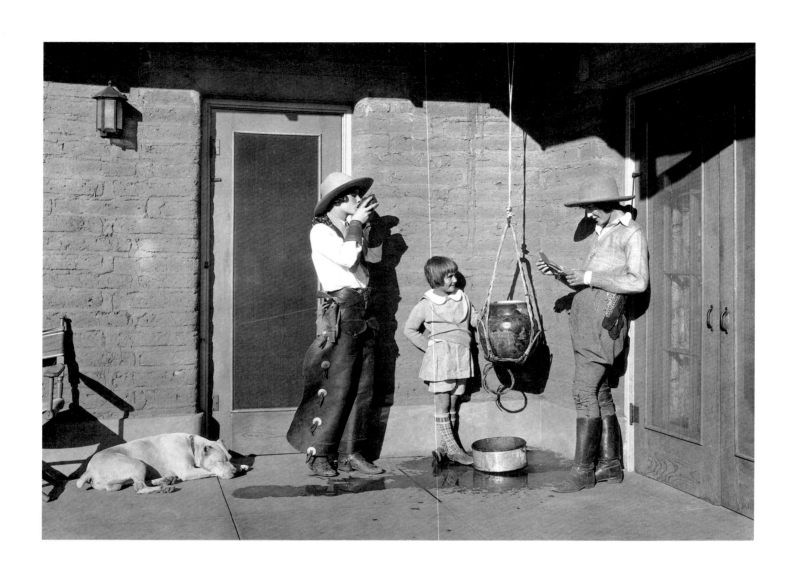

22. Clifton Adams, near Patagonia, Arizona, c. 1928

continued to emphasize the necessity at any cost of keeping color in the magazine. In 1960 Melville Grosvenor made a decision to use color exclusively; he was also a tenacious champion of straight descriptive values and an enemy of faddishness in photographic presentation, including the use of wide-angle or fisheye lenses. Simultaneously, a new attitude of greater competitiveness and individual ambition gradually emerged in the ranks of photographers at the National Geographic Society.

In the years from 1958 to 1962, profound changes took place at *National Geographic.* The magazine abandoned black-and-white photography altogether with a radical shift to huge, new Web presses at R. R. Donnelly & Sons in Chicago.[6] It also seemed to ignore the mainstream "advanced photojournalism" of the time. At this moment the National Geographic Society began slowly to move in its own direction, becoming less rigid, more responsive to the complexities of the political world, and more varied and experimental in its photographic approach.

The history of the development of photography in American magazines in the 1940s and '50s, primarily in *Life, Look, Fortune,* and *National Geographic,* is a story in itself that embodies many of the aesthetic concerns we are touching upon here. Of course *Life* and *National Geographic* were very distinct organizations, one producing a weekly news and human-interest magazine, the other a monthly world-geographic specialty magazine. But the photographically relevant differences between *Life* and *National Geographic* start with their respective physical qualities. First and foremost was *Life's* use of a large format expressly to showcase photography. *Life's* production techniques thus required relatively large-format presses; it used thin paper with mostly black-and-white printing and met short deadlines. On the other hand, *National Geographic* used clay-coated paper, printed in small format, employed old-fashioned engraving techniques, and often allowed more lengthy scheduling.

In its latter days, *Life* began, often under pressure, to treat its most successful photographers as artist-stars. Both the personalities and their work were given a deference completely unknown at most other magazines. In the 1940s and '50s not only *Life* and *Fortune,* but the new photo agencies, notably Magnum and Black Star, created a powerful mystique about the profession, promoting a whole generation of eminent and audacious photographers. A group of serious and noted American magazine photographers, among them Eugene Smith, Alfred Eisenstadt, Philippe Halsmann, and Arnold Newman, came into maturity in the 1950s and '60s. Their values were those of journalism, but they were also grounded in the democratized artistic striving that took hold in American culture after World War II. In stark contrast, *National Geographic* photographers until the late 1970s continued to view their photographs as illustrations, not as self-contained essays like the *Life* picture stories.

Another distinctive aspect of *National Geographic* in the 1950s and '60s is its place in the venerable culture of American nature photography. *National Geographic* photographers have participated in this tradition in its most serious and its most lighthearted manifestations. To compare the nature photographs in *National Geographic* with those in *Arizona Highways* or *The Sierra Club Bulletin* in their prime is to see a fundamental difference between the popular publication that wishes primarily to give information and the publication that is interested in persuasion through aesthetic values. *Arizona Highways* seemed to have reversed the general order of photographic methodology by taking studio techniques back into the field in order to obtain some of its almost incredibly sublime, theatrical, perfectly lighted images. In fact its photographers in the field often did use special reflectors, lights, large-format cameras — whatever was needed to paint the picture. Yet somehow the far less patently gorgeous, less picturesque images of nature made by National Geographic, now seem more artful than those glamorous pictures. By virtue of their straightforwardness, by the integrity of their concern for a tradition of naturalism, by their

seeming indifference to compositional allure, by their unpretentiousness, the *National Geographic* pictures triumph.

The distinction between the outdoor studio shot and the candid nature shot perhaps marks a contrast between two basic tendencies in American photography. One is the "art-for-art's sake" legacy of the American landscape masters: Edward Weston, Ansel Adams, Eliot Porter, Ernst Haas, Paul Caponigro. The other is the older, scientific and commercial tradition of Eadweard Muybridge, Timothy O'Sullivan, William Henry Jackson, William Bell, Edward Curtis, et al. The latter historical preoccupation with documenting nature and selling a point of view about its conservation through photography resonates everywhere among *National Geographic* photographers. The former rarefied sensibility echos there only faintly. *National Geographic* resisted the seductions of glossy nature photography because many of its key editors in this period came from either the toughly objective newspaper world or the equally demanding realm of first-rate layout and design.

Laying the groundwork for a new era was James M. Godbold, who became director of photography in 1958, replacing the revered laboratory head and chief of photography, Edwin L. Wisherd. Godbold was the first photo editor to be put in charge of photography more as an arbiter of visual judgment than as a technical expert. Under his tenure (though instigated by Melville B. Grosvenor), the house policy prohibiting staff photographers from entering outside photojournalistic competitions was abandoned. Not only did many National Geographic Society photographers fast become recipients of key awards and honors, but this simple license to gain recognition abroad changed the character of the *National Geographic* photographers' output. Photographers began to be more attuned to each image's artistic merit. New photographers, mainly newspapermen, were recruited based on their prize-winning histories.

Godbold was succeeded as director of photography in 1963 by Robert Gilka, a news-sensitive picture editor from the *Milwaukee Journal*. Gilka recruited such talents as Bruce Dale, Emory Kristof, Jim Stanfield, Jim Amos, Bob Madden, Gordon Gahan, Steve Raymer, Jodi Cobb, and David Alan Harvey. Under Gilka's leadership, more and more freelancers were hired, tempering the ascendancy of staff photographers. He also instituted the internship program, attracting the nation's best young photojournalists to work at the magazine in the summer. Gilka became a father figure to *National Geographic* photographers, their champion in administrative issues, and a keen judge of photographic abilities. By the early 1970s, he had become a legendary figure in the nation's photographic community.

Melville Grosvenor retired in 1967. By then the styles of the incomparable William Albert Allard, as well as Thomas J. Abercrombie, Dean Conger, James Blair, Winfield Parks, and Emory Kristof set the tone in the magazine. They and their editors spawned another generation of extraordinary artists. Sam Abell, Cary Wolinsky, Nathan Benn, David Doubilet — some of whose work in recent color photojournalistic photography or in nature photography is unsurpassed — all emerged in the 1970s. In this decade, Editor Wilbur E. Garrett was the primary defender of an increased responsiveness to tough journalistic issues and loyalty to color photography in a climate of obdurate and powerful blindness to its artistic potential.

Garrett, like Gilbert H. Grosvenor some eighty years before him, was a photographer, and based many of his instinctive priorities on this important part of his experience and vision. Like Grosvenor, he has sought to take the magazine beyond established National Geographic Society boundaries, even at risk of controversy. He has been a crucial force in shaping the magazine as we know it today, and it has never been better in terms of layout and picture selection. Working alongside Gilka and Garrett in the capacities of photographer, editor, president, and chairman, has been Gilbert M. Grosvenor, grandson and son of the two leaders of the National Geographic Society and a mainstay of the organization. The profound, if

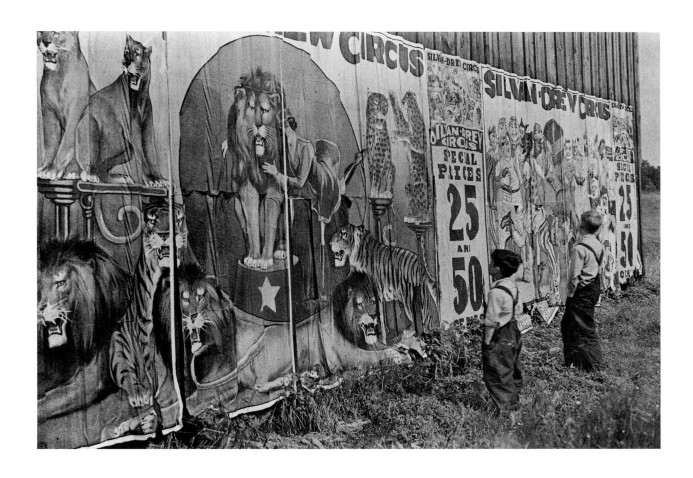

23. Jacob Gayer, Ohio, 1929, *autochrome*

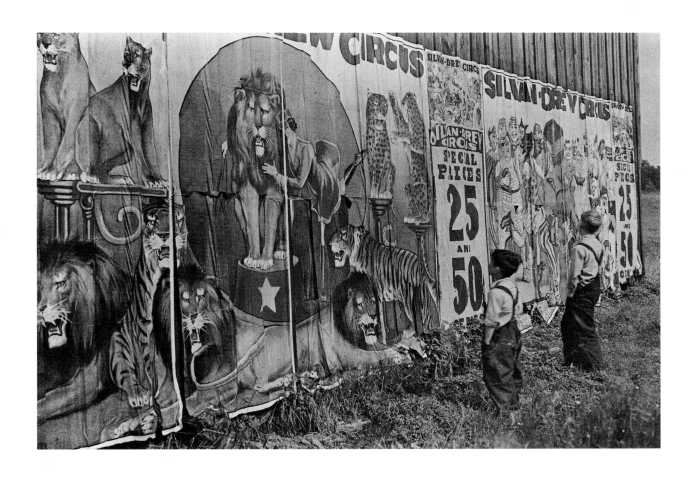

23. Jacob Gayer, Ohio, 1929, *autochrome*

gradual, changes at *National Geographic* in the 1970s and '80s took place under the direction of this third-generation Society leader.

The task of selecting images from the contemporary period led us to a new understanding of *National Geographic* photography. Looking carefully at each image, we were challenged to re-examine the premise of our endeavor, for photography now more than ever is accepted solely for its aesthetic appeal. The photographers entering the domain of art, or at least that of the institutionalized art world, now range from those who trained as artists, to those who make documentary work, to those who practice commercial advertising.

What has recently seemed necessary to photography's admittance into the domain of high art is a certain *radicalness*. The art-photography academy often favors trends at the extremes of the medium, whether they be technically innovative, stylistically rebellious, or depictive of the brutal or shocking. Many images here confront wrenchingly painful realities, even though we may perceive them as "conventional" pictures. Others are gentle, understated, or unashamedly beautiful. Both the brutal and the beautiful images, the more we absorb and compare them, take their place among those of their more established artistic peers. These *National Geographic* photographs and the plain reality of their subjects are as compelling as any honest or contrived art photographs can ever be.

The recent period of *National Geographic* photography is in essence not so different from what came before. The magazine has displayed a continued loyalty to the values of objective, though often creative, journalism. Simultaneously, it has steadfastly rejected the new journalistic star system. Today, as in every other era, *National Geographic* photographers deliberately minimize personal editorializing, allowing the subject of an assignment to dictate the nature of the photographs. This commitment to the subjugating of an assertively recognizable artistic eye continues to underlie photographic policy at *National Geographic*. From the evidence, we must now acknowledge the enduring power of this illustrational imperative.

J.L.

[1] C.D.B. Bryan, *The National Geographic Society: 100 Years of Adventure and Discovery,* Harry N. Abrams, Inc., (New York) 1987, p. 124.

[2] Eliza Scidmore, an early member of the National Geographic Board of Trustees, is known as a photographer only through these works, which were unusual for *National Geographic* in having been both shot and tinted by the same hand.

[3] Priit Vesilind, "National Geographic and Color Photography," unpublished manuscript for the Graduate School of Syracuse University, 1977, p. 49, discussing Robert Moore's field practices.

[4] One exception is the Library of Congress, which organized a major exhibition of autochromes from its collection in 1980. As a result, further Library of Congress exhibitions are planned. Volkmar Wentzel of *National Geographic* has also been involved in the development of exhibitions and publications focusing on the autochrome.

[5] Volkmar C. Wentzel, interview with the author, November 1987.

[6] Another milestone occurred in 1976, with the conversion of its color printing to special gravure presses at W. H. Hall Printing in Corinth, Mississippi.

24. Tamotsu Enami, Japan, 1920

25. Cary Wolinsky, Varanasi, India, 1983

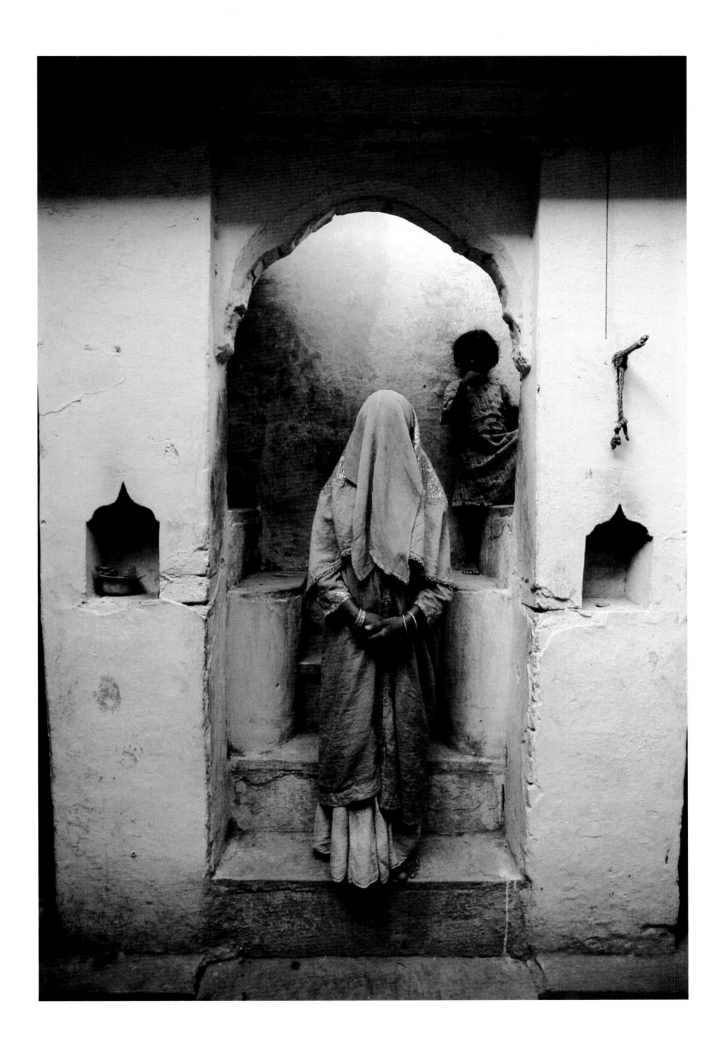

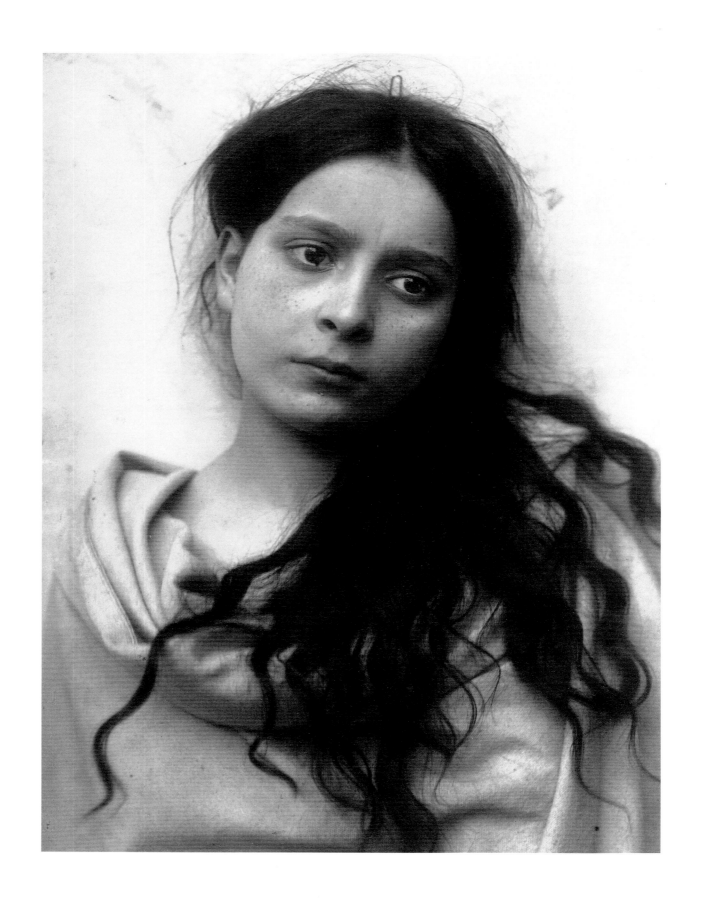

26. Baron Wilhelm von Gloeden, Taormina, Sicily, Italy, c. 1903

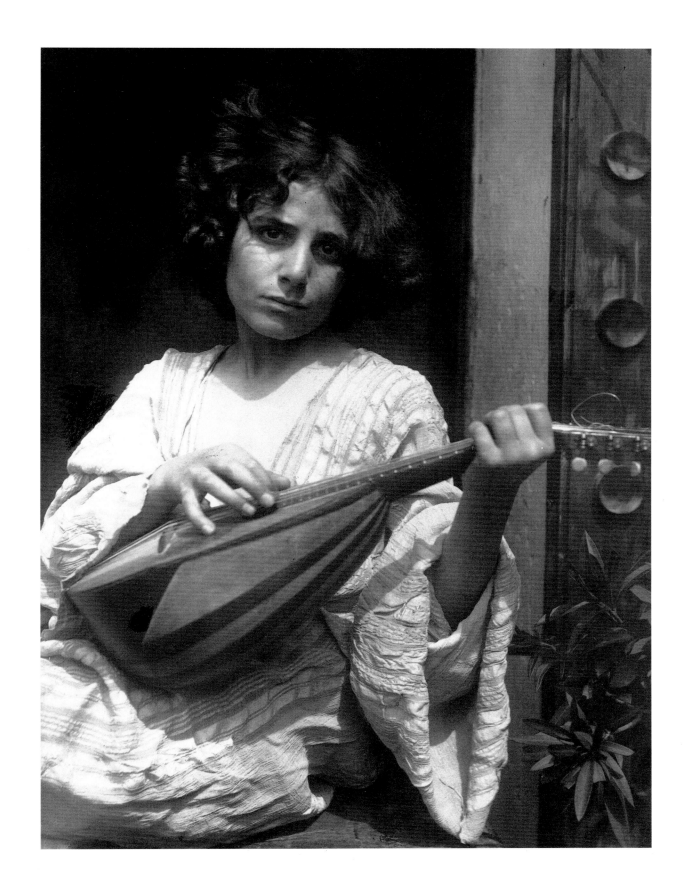

27. Baron Wilhelm von Gloeden, Taormina, Sicily, Italy, c. 1903

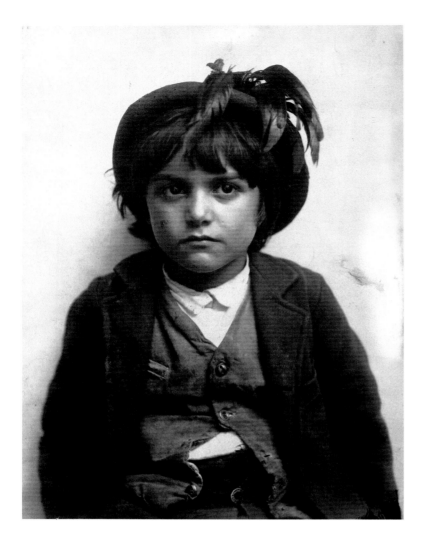

28. Baron Wilhelm von Gloeden,
Taormina, Sicily, Italy, c. 1903

29. Baron Wilhelm von Gloeden,
Taormina, Sicily, Italy, c. 1903

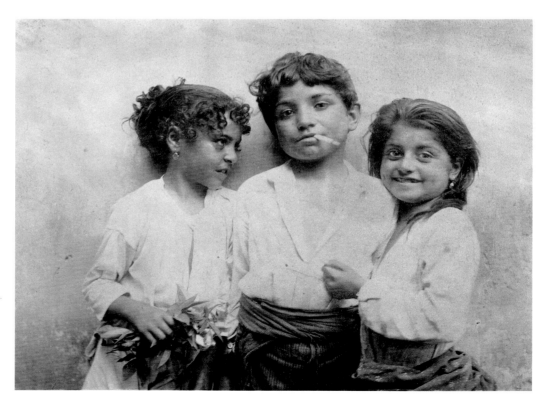

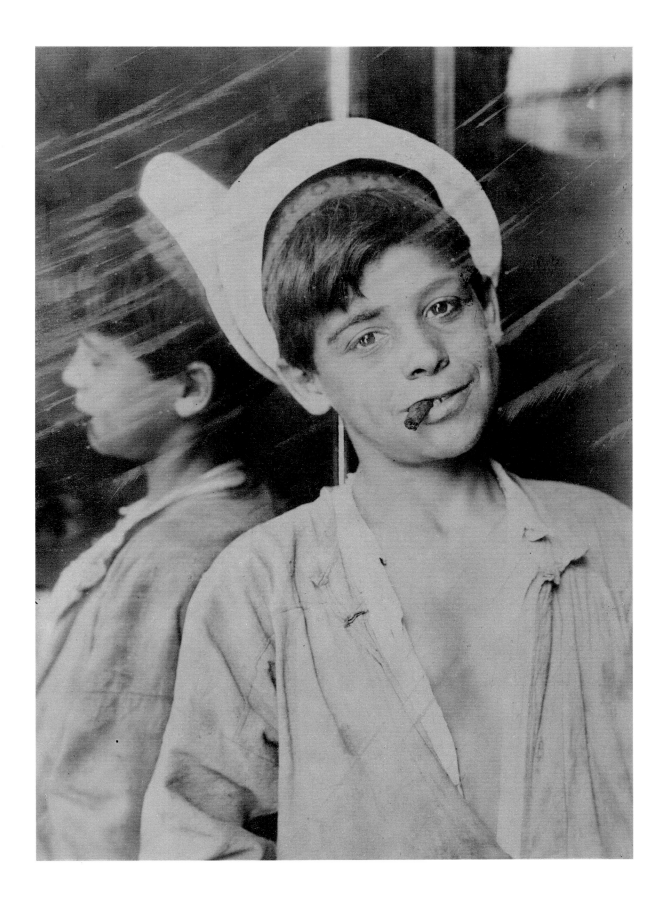

30. Baron Wilhelm von Gloeden, Taormina, Sicily, Italy, 1903

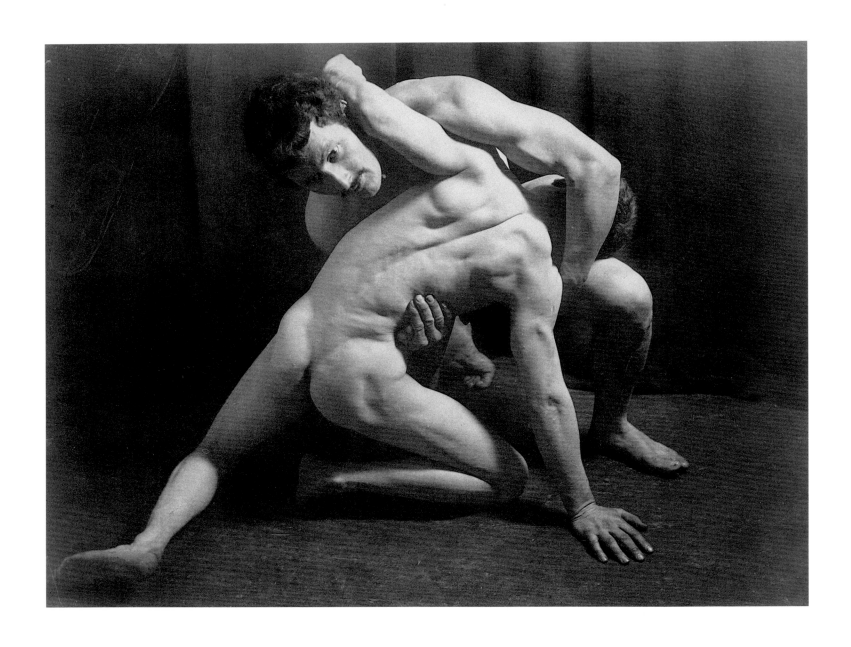

31. Baron Wilhelm von Gloeden, Taormina, Sicily, Italy, c. 1903

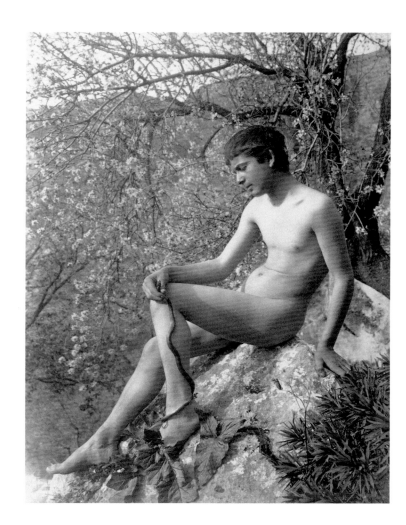

32. Baron Wilhelm von Gloeden,
Taormina, Sicily, Italy, c. 1903

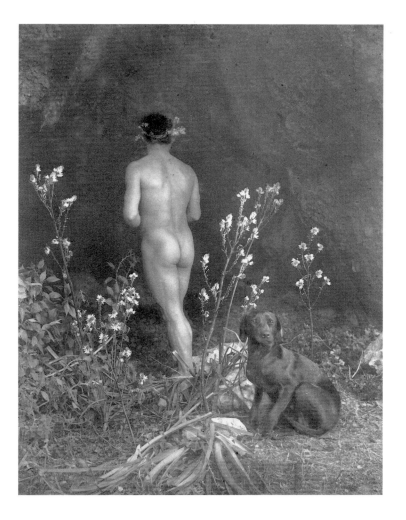

33. Baron Wilhelm von Gloeden,
Taormina, Sicily, Italy, c. 1903

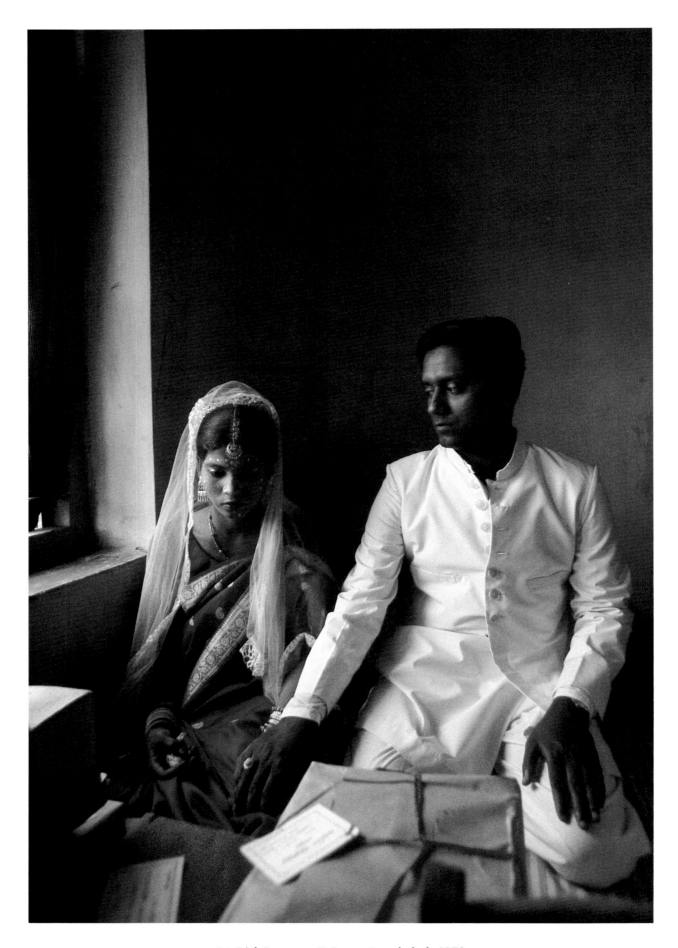

34. Dick Durrance II, Dacca, Bangladesh, 1972

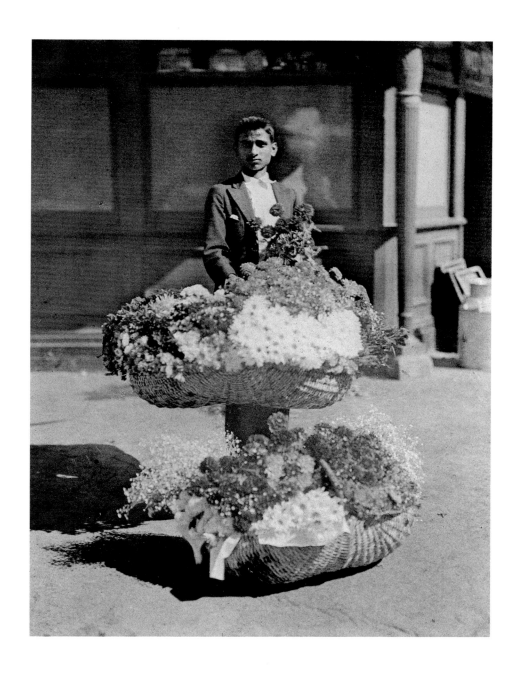

35. Melville Chater, Durban, South Africa, 1930, *autochrome*

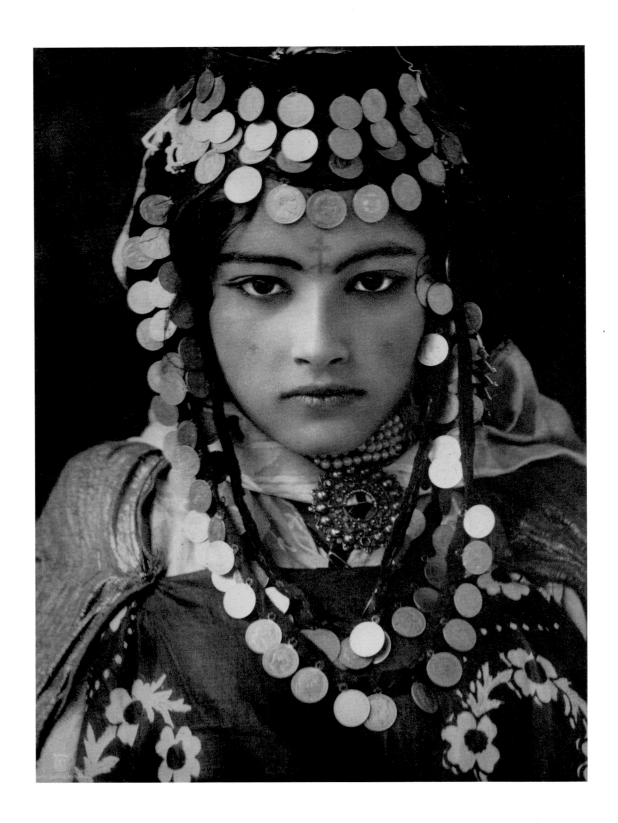

36. Lehnert & Landrock, Algeria, n.d.

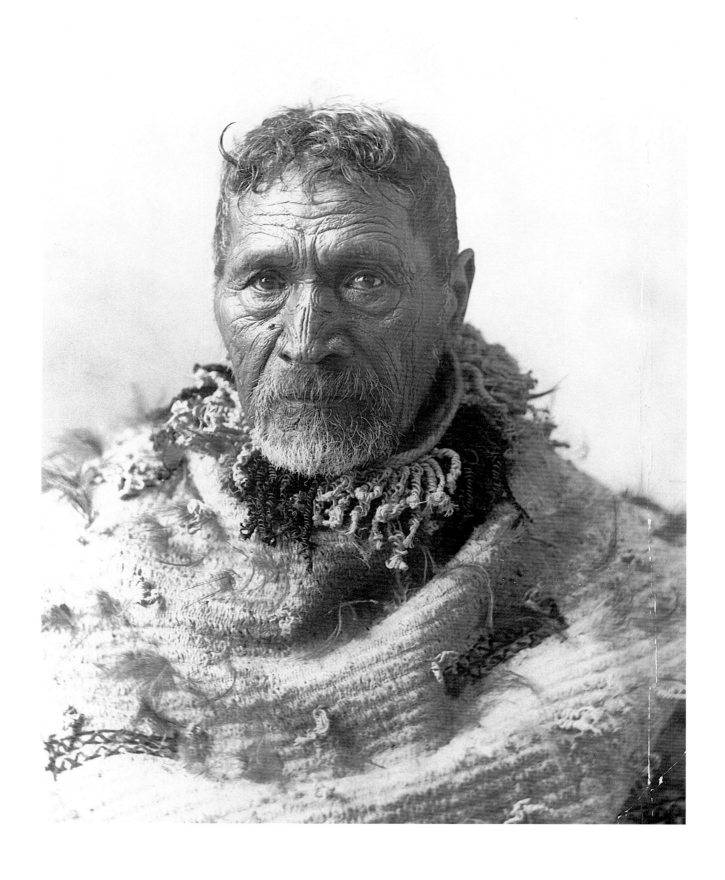

37. Photographer unknown, New Zealand, 1901

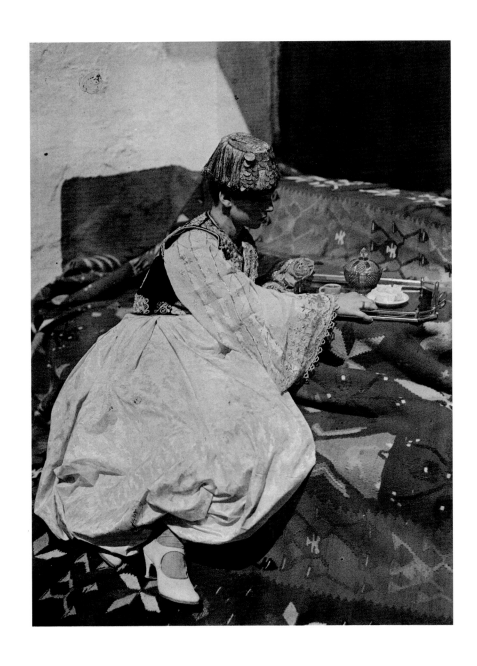

38. Luigi Pellerano, Albania, 1929, *autochrome*

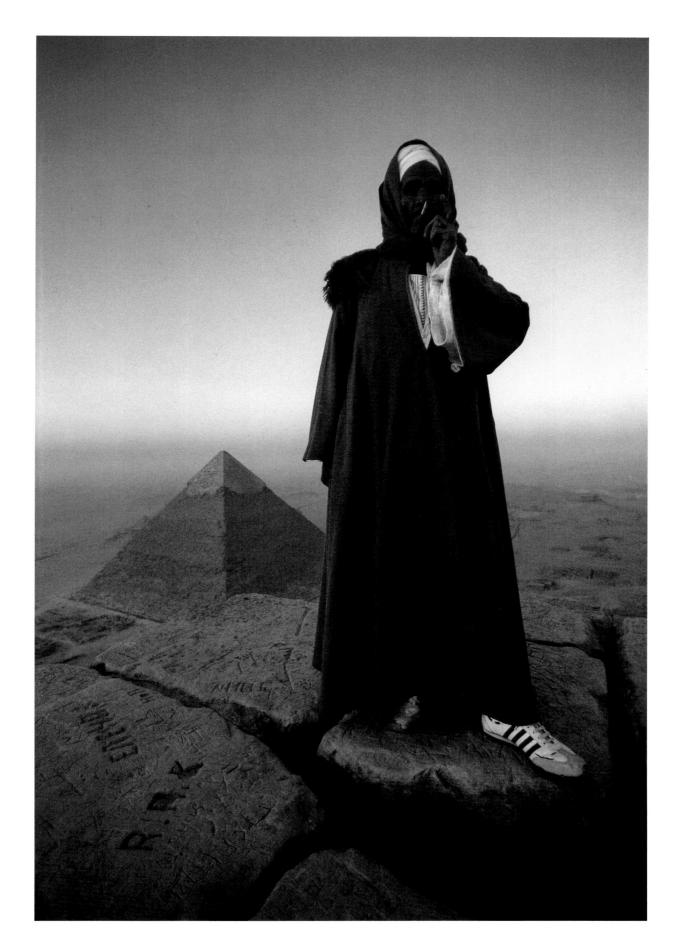

39. Louie Psihoyos, Giza, Egypt, 1981

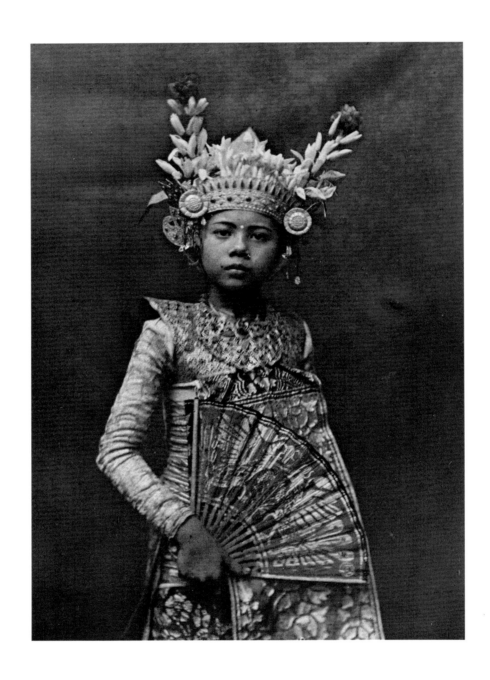

40. Franklin Price Knott, Bali, Dutch East Indies (Indonesia), c. 1927, *autochrome*

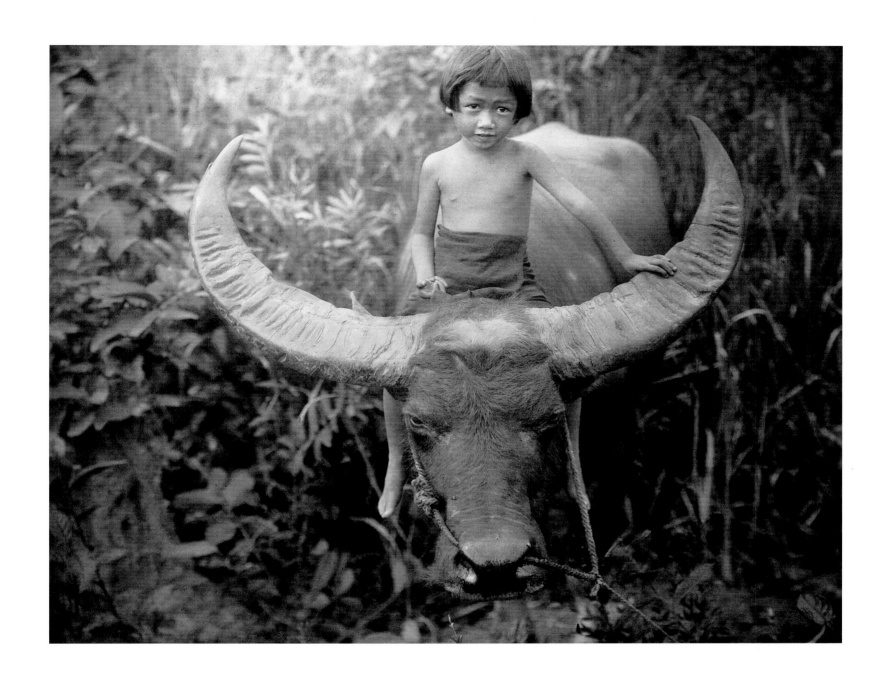

41. Ernest B. Schoedsack, Siam (Thailand), n.d.

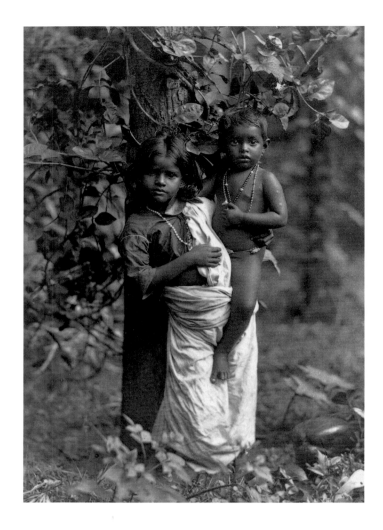

42. Photographer unknown, Ceylon (Sri Lanka), n.d.

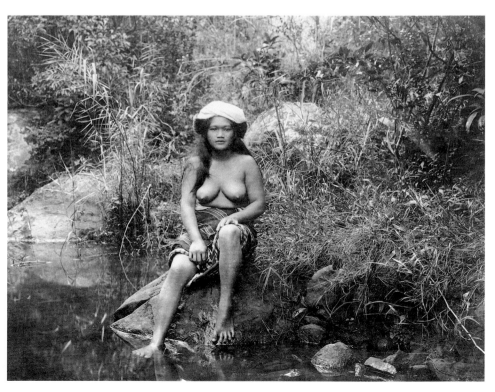

43. Charles Martin, Philippines, 1920

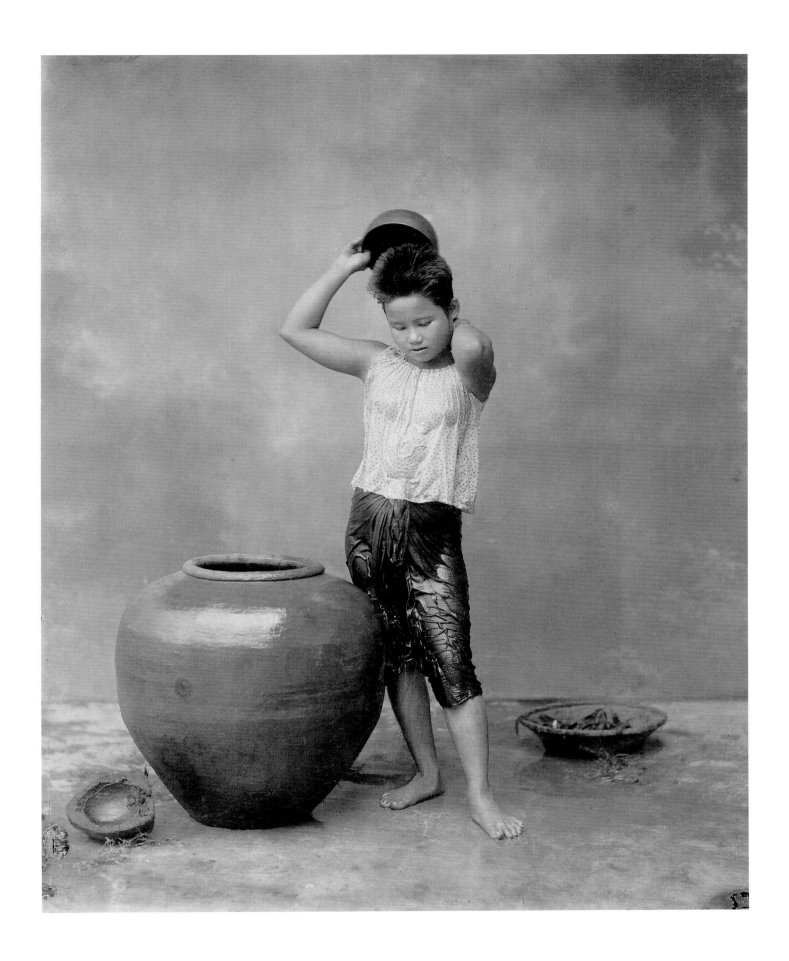

44. R. Senz & Company, Bangkok, Siam (Thailand), 1911

45. Hans Hildenbrand, Austria, 1929, *autochrome*

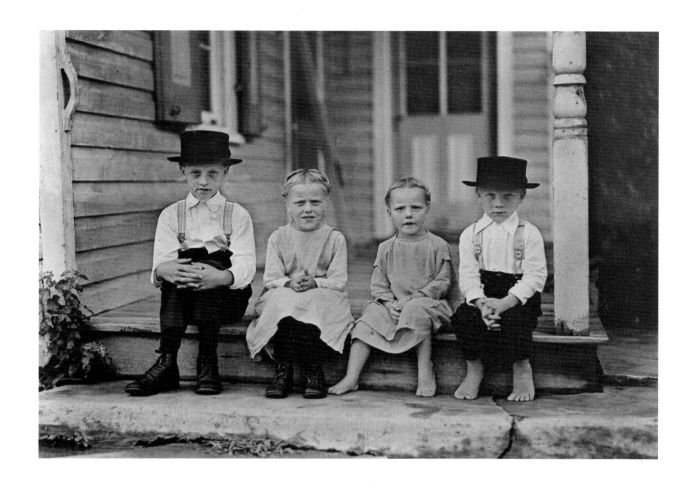

46. J. Baylor Roberts, Lancaster, Pennsylvania, 1937, *Dufay color*

47. Steve McCurry, Kathmandu, Nepal, 1983

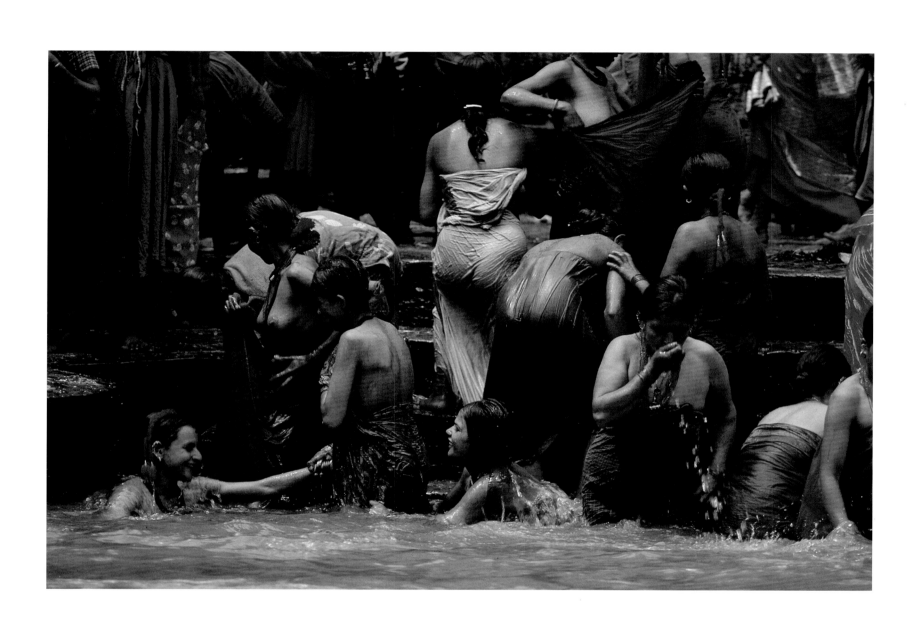

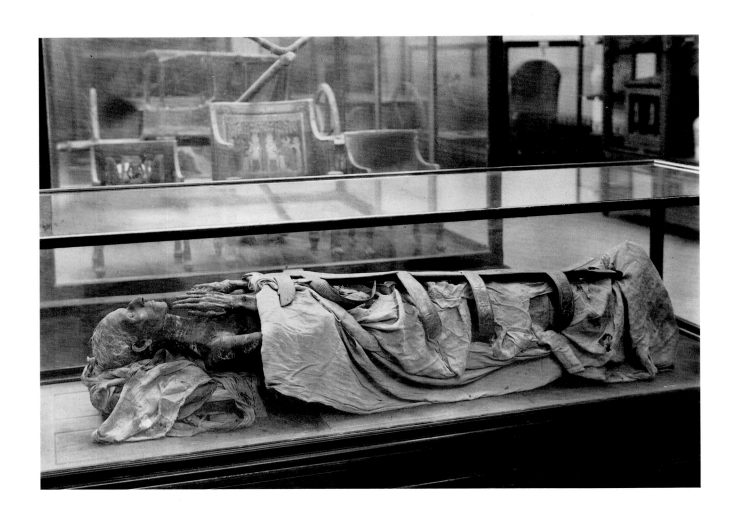

48. Earle Harrison, Cairo, Egypt, c. 1919

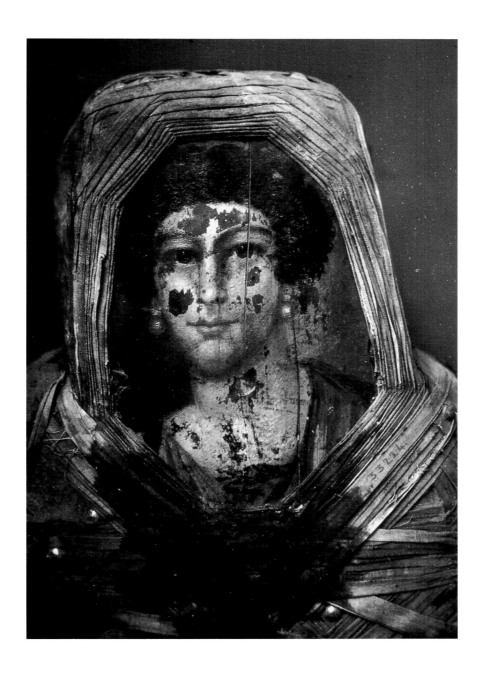

49. Gervais Courtellemont, Egypt, 1920s, *autochrome*

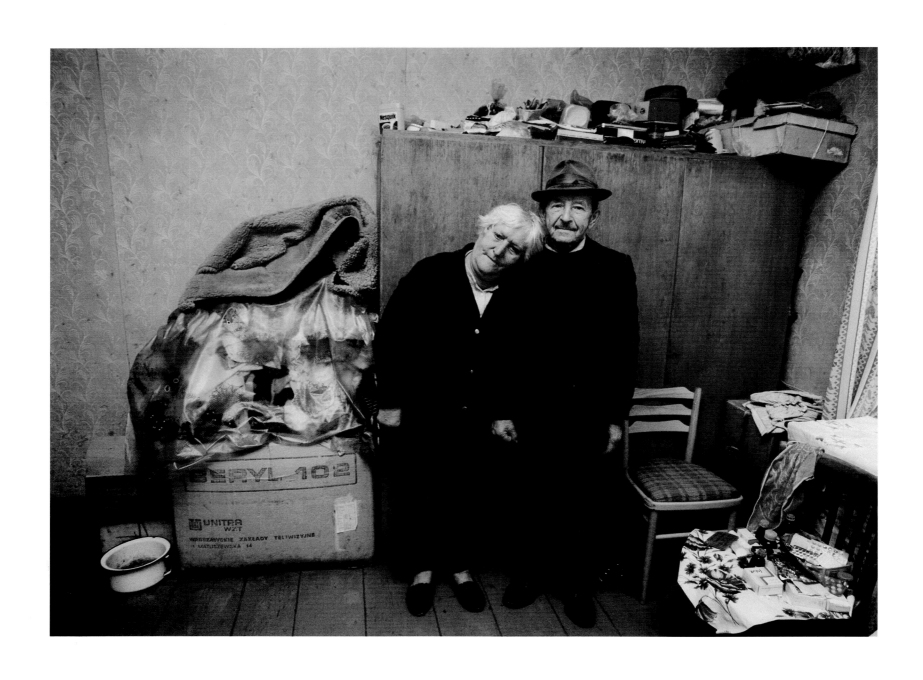

50. Tomasz Tomaszewski, Wtodawa, Poland, 1986

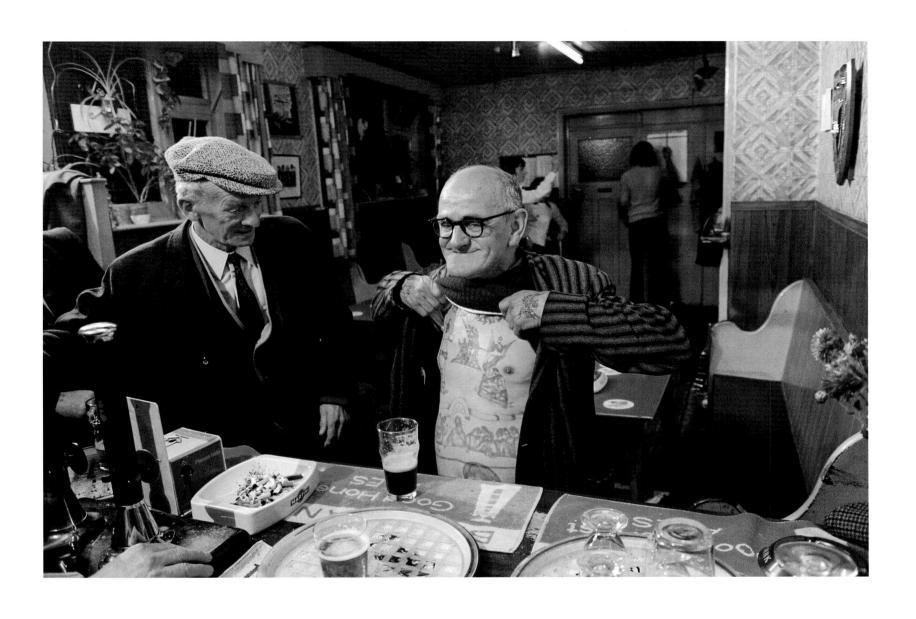

51. James Amos, Boston, Lincolnshire, England, 1973

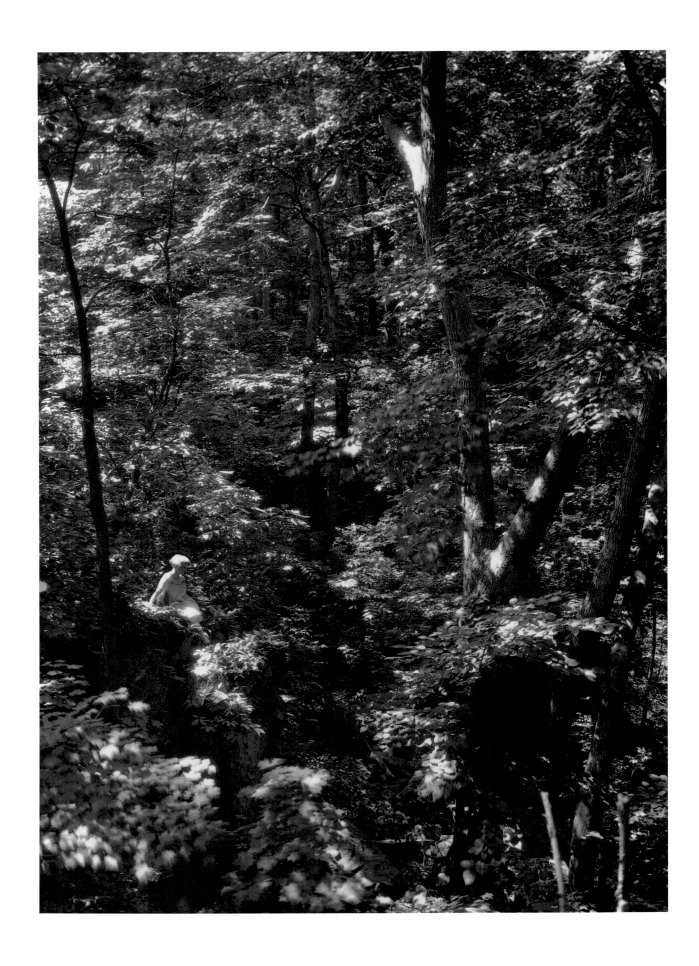

54. Clifton Adams, Plummer Island, Maryland, c. 1927

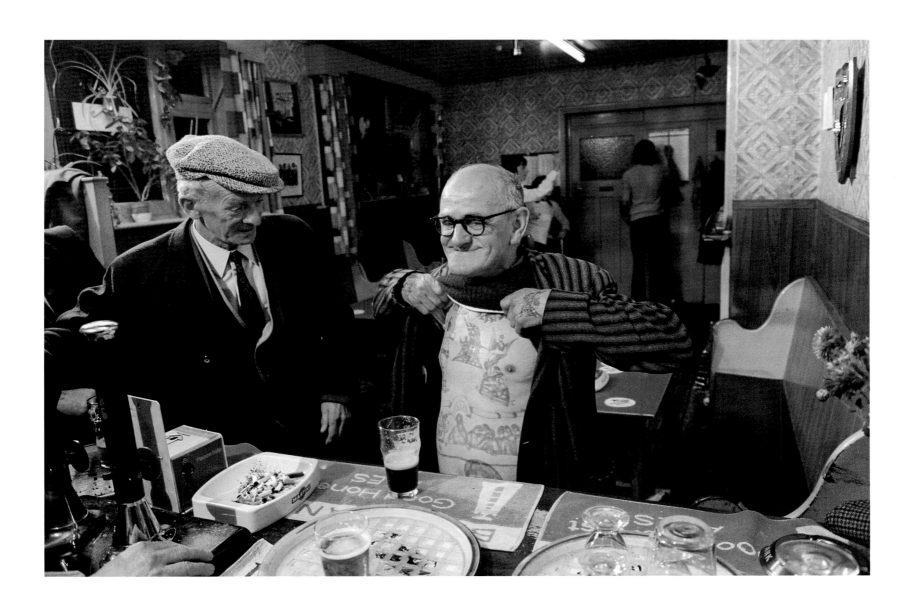

51. James Amos, Boston, Lincolnshire, England, 1973

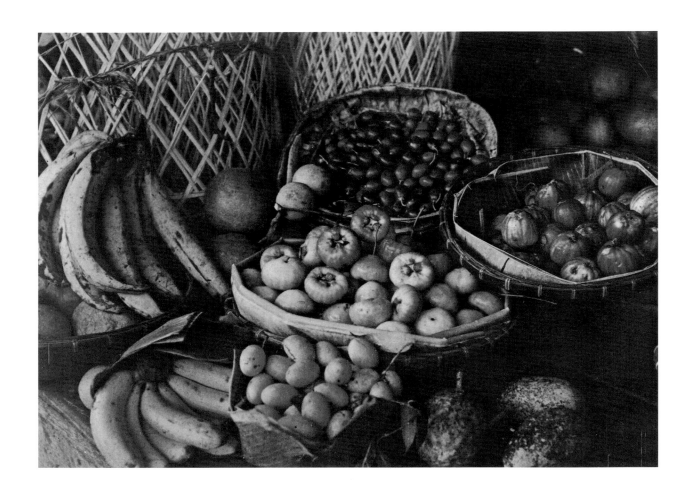

52. Gervais Courtellemont, Bangkok, Siam (Thailand), 1927, *autochrome*

53. Annie Griffiths Belt, Bakewell, Derbyshire, England, 1984

54. Clifton Adams, Plummer Island, Maryland, c. 1927

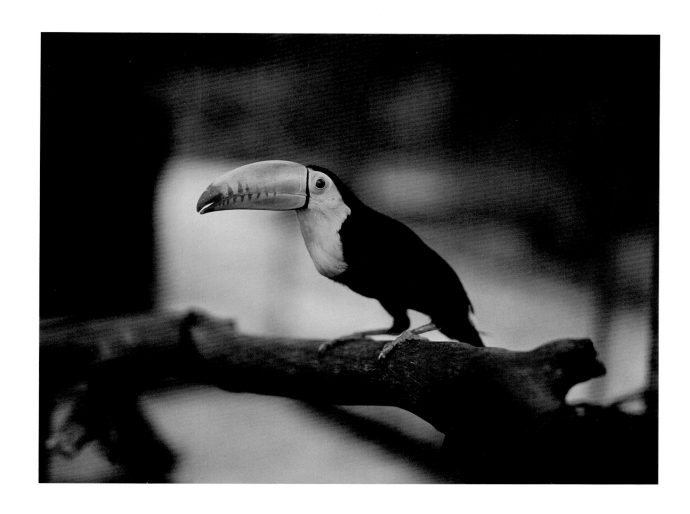

55. Luis Marden, Panama, 1941

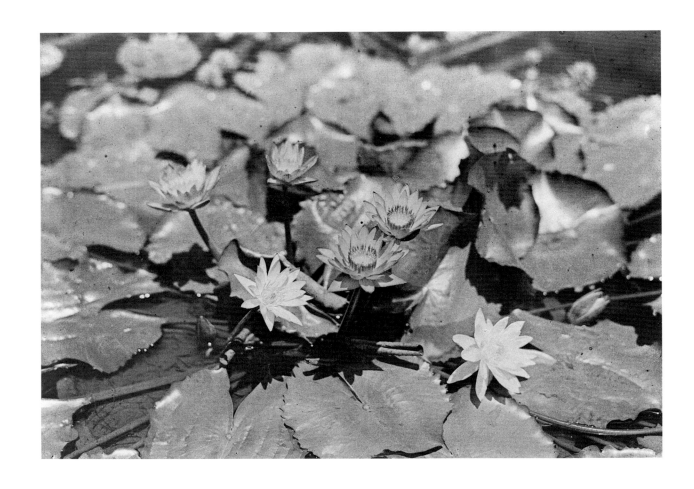

56. Edwin L. Wisherd, Louisiana, 1929, *autochrome*

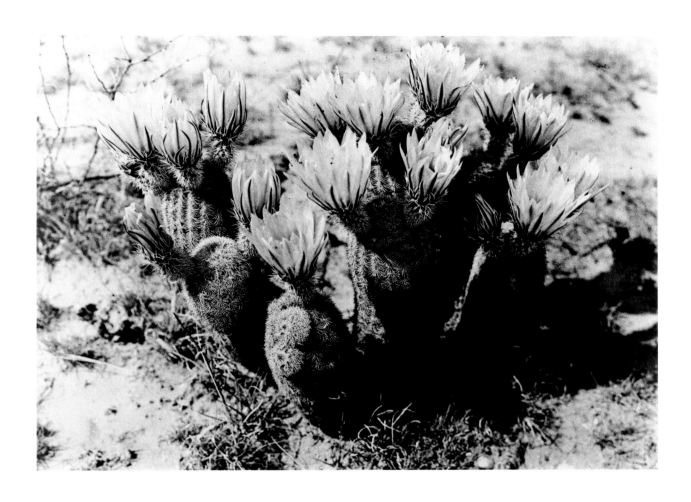

57. Jacob Gayer, American Southwest, 1920s, *autochrome*

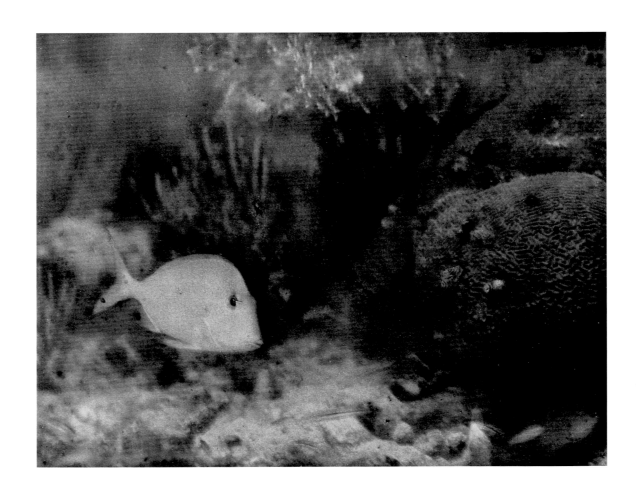

58. Charles Martin, Dry Tortugas, Florida, 1927, *autochrome*

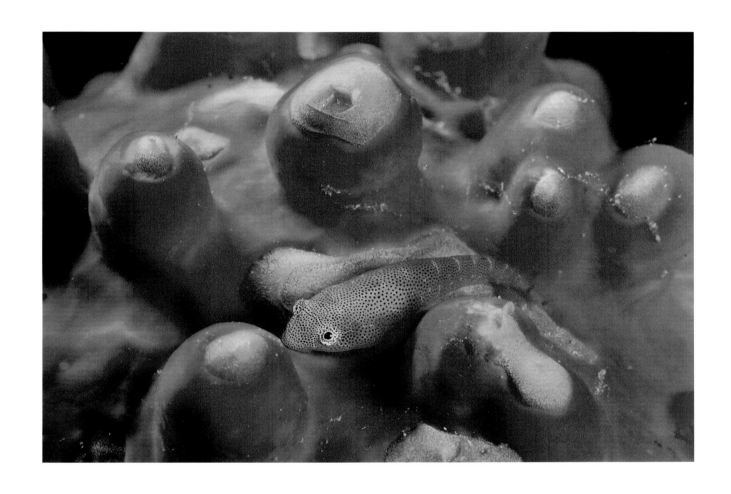

59. David Doubilet, Jervis Bay, New South Wales, Australia, 1985

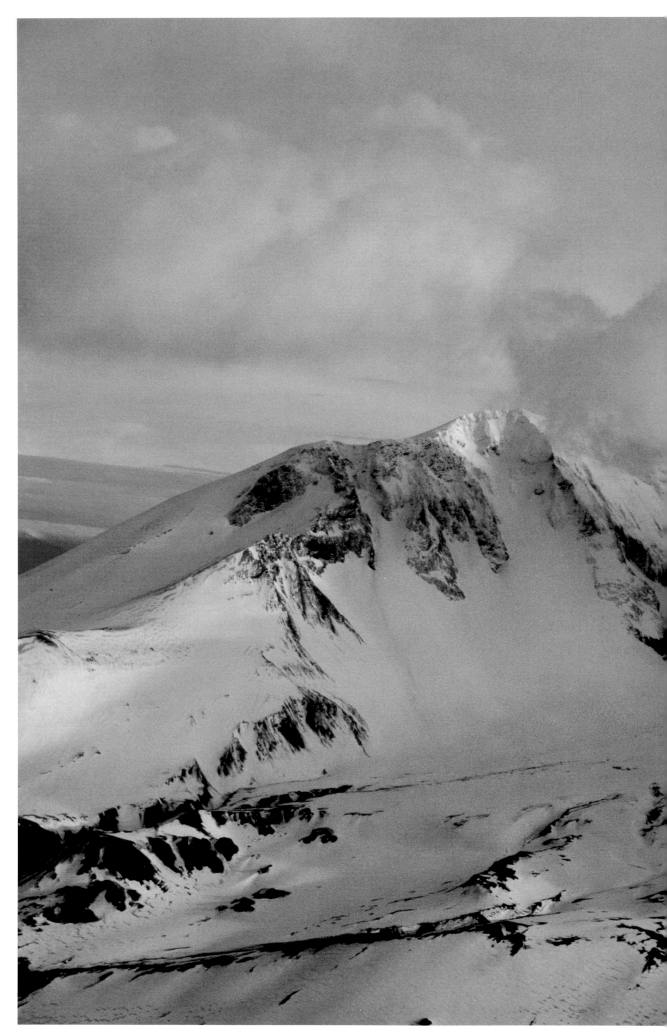

60. David Falconer, Mount St. Helens, Washington, 1984

63. Maynard Owen Williams, Jerusalem, Palestine (Israel), 1927

62. Gervais Courtellemont, France, 1920s, *autochrome*

61. Jacob Gayer, Washington, D.C., 1928, *autochrome*

64. Clifton Adams, Washington, D.C., 1923

65. Donald McLeish,
London, England, 1936

66. Donald McLeish,
Vannes, Brittany, France, 1930

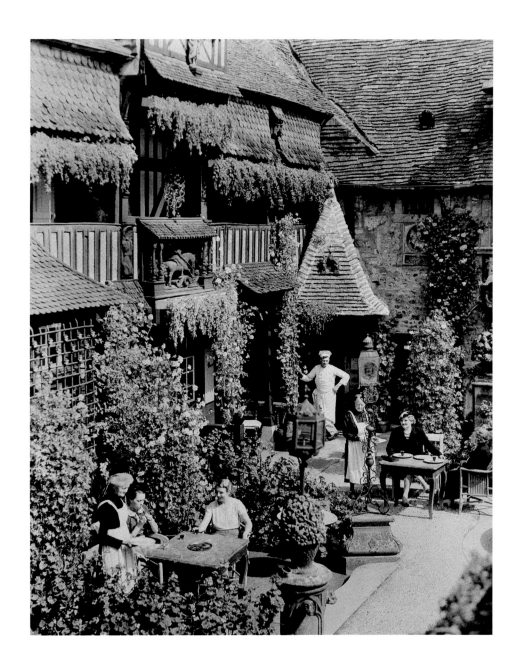

67. W. Robert Moore, Dives-sur-Mer, Normandy, France, n.d., *Finlay color*

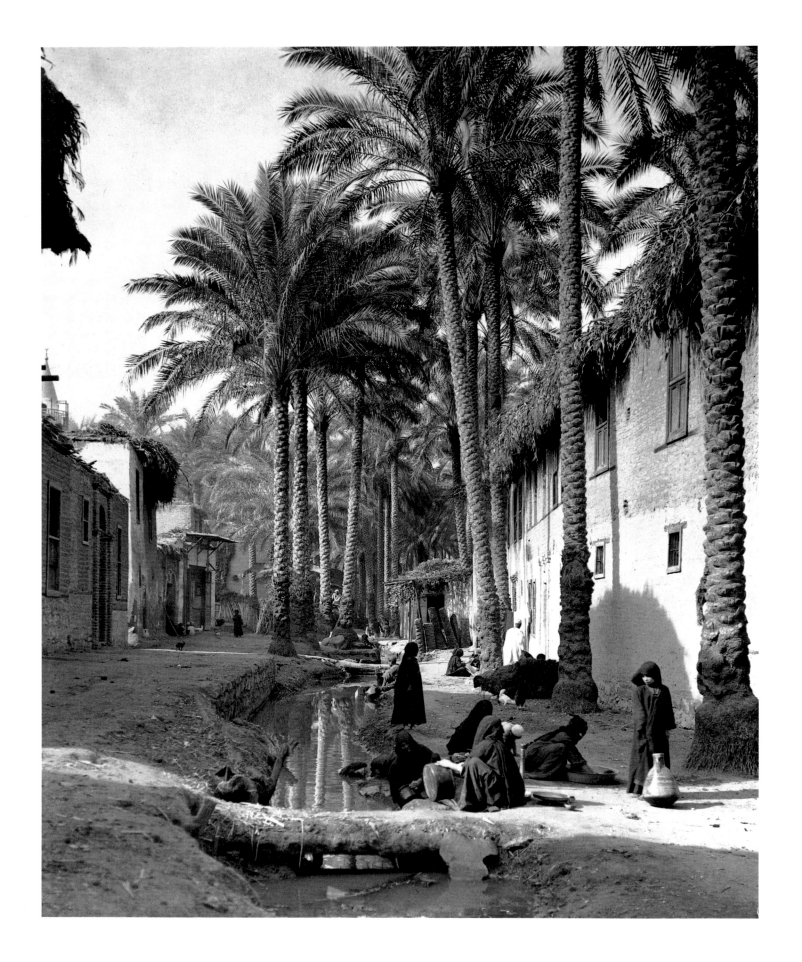

68. Donald McLeish, Marg, Egypt, 1920

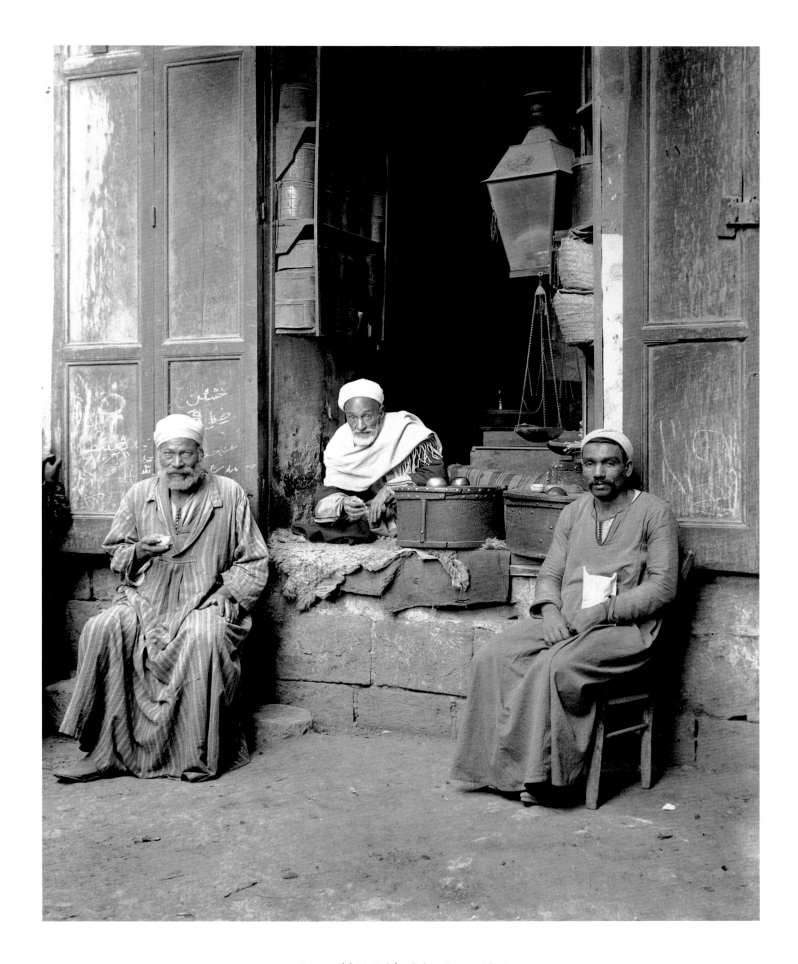

69. Donald McLeish, Cairo, Egypt, 1920

70. David L. Brill, Aphrodisias, Turkey, 1980

71. Jonathan Blair, Santo Domingo, Dominican Republic, 1978

72. Clifton Adams, Roanoke Island, North Carolina, c. 1933

73. Roland McKee, United States, c. 1920

74. Justin Locke, Paris, France, 1951

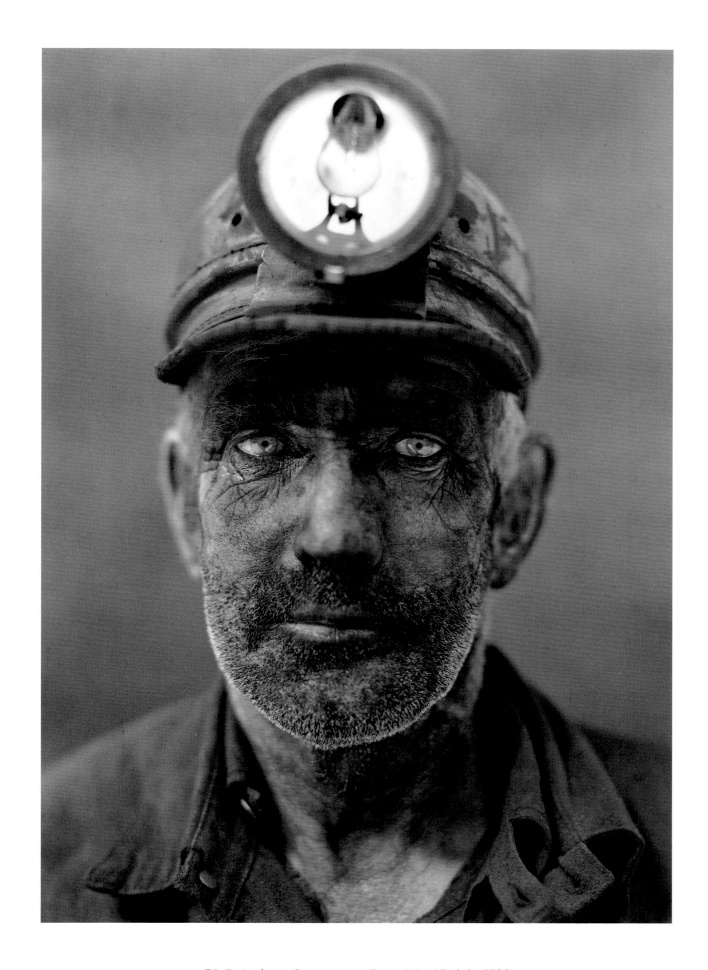

78. B. Anthony Stewart, near Omar, West Virginia, 1938

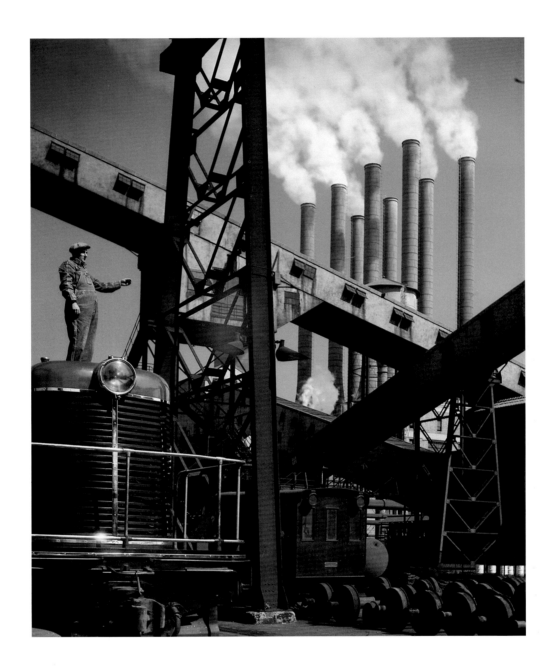

77. B. Anthony Stewart, Dearborn, Michigan, 1944

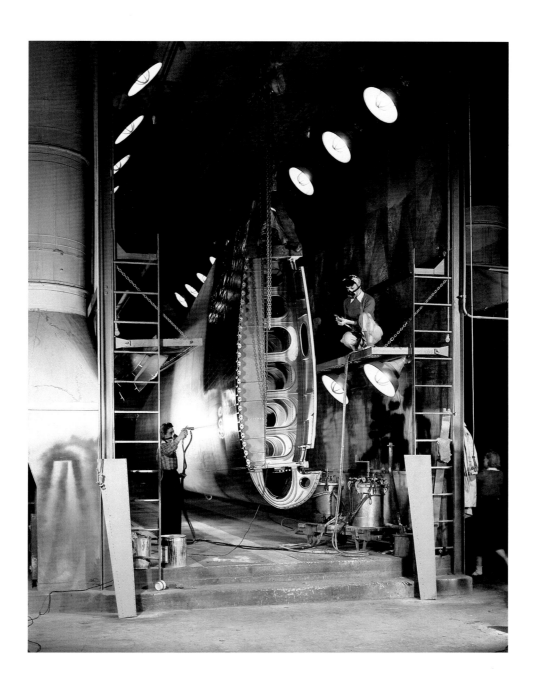

76. Willard R. Culver, Hagerstown, Maryland, c. 1942

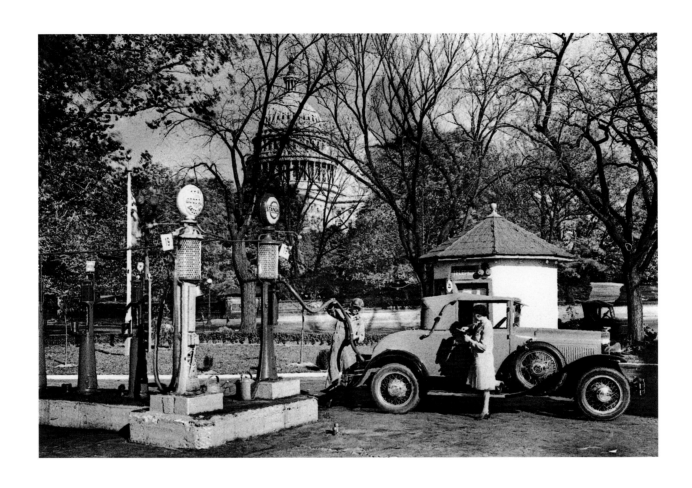

75. Edwin L. Wisherd, Washington, D.C., 1929, *autochrome*

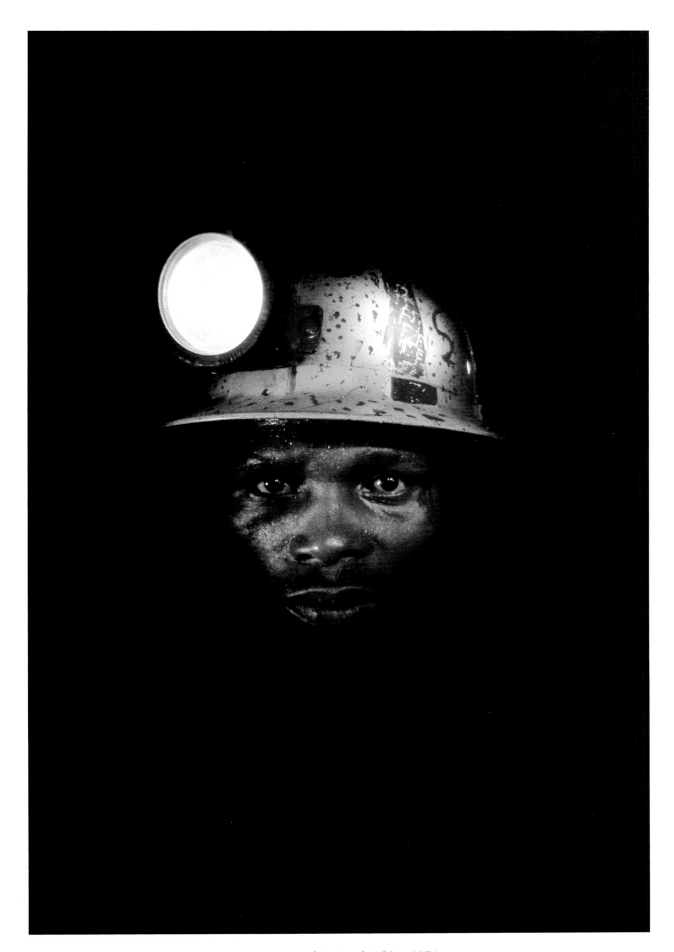

79. James P. Blair, South Africa, 1976

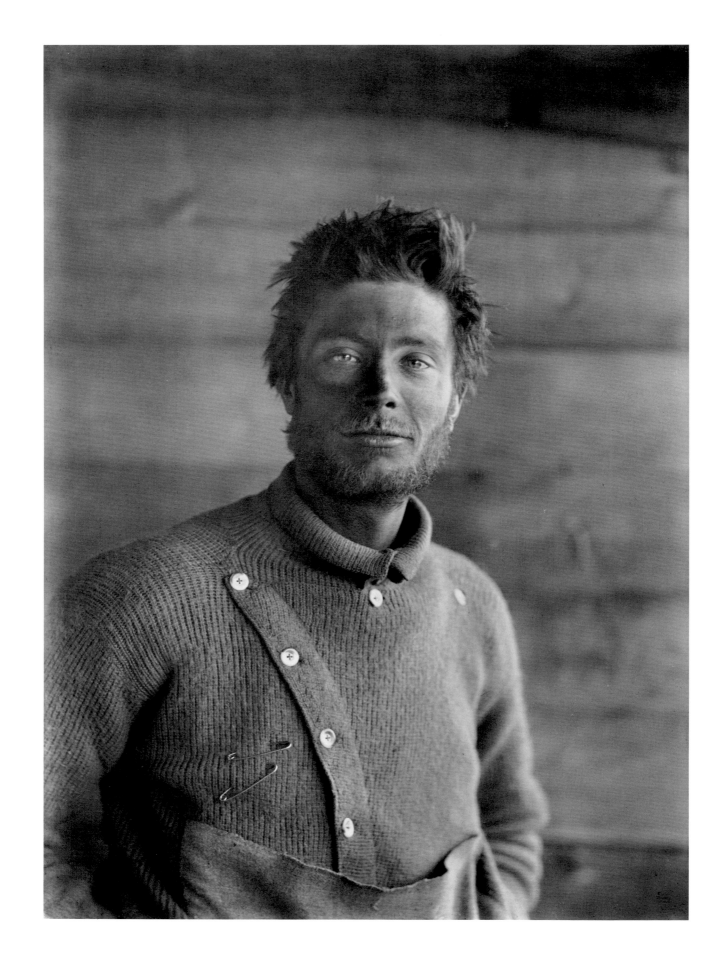

80. Herbert G. Ponting, Antarctica, 1911

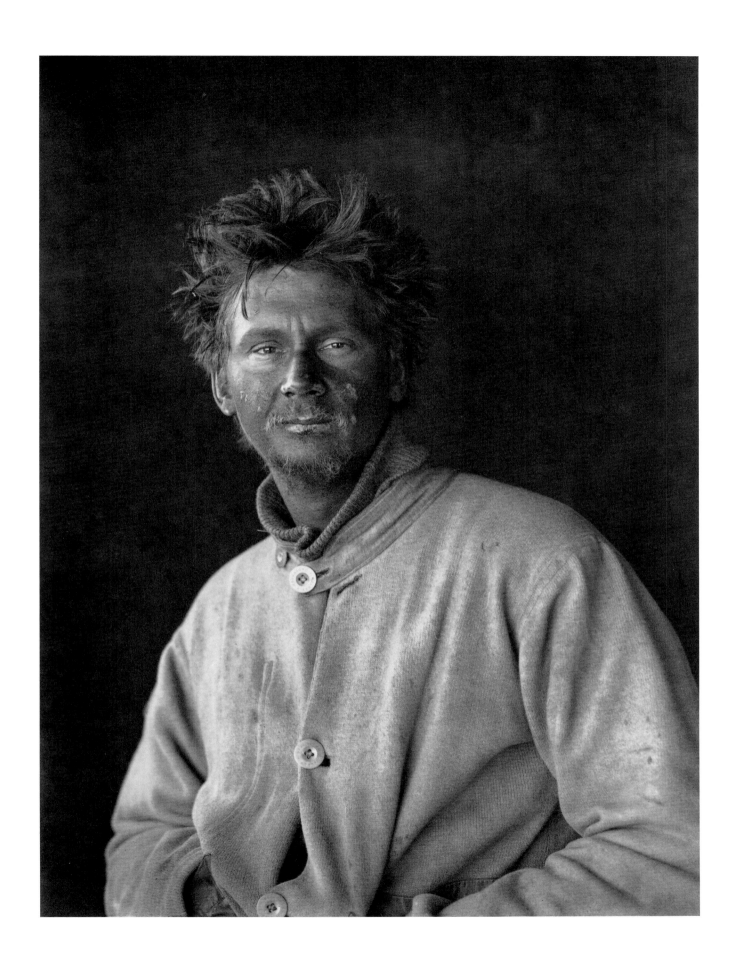

81. Herbert G. Ponting, Antarctica, 1912

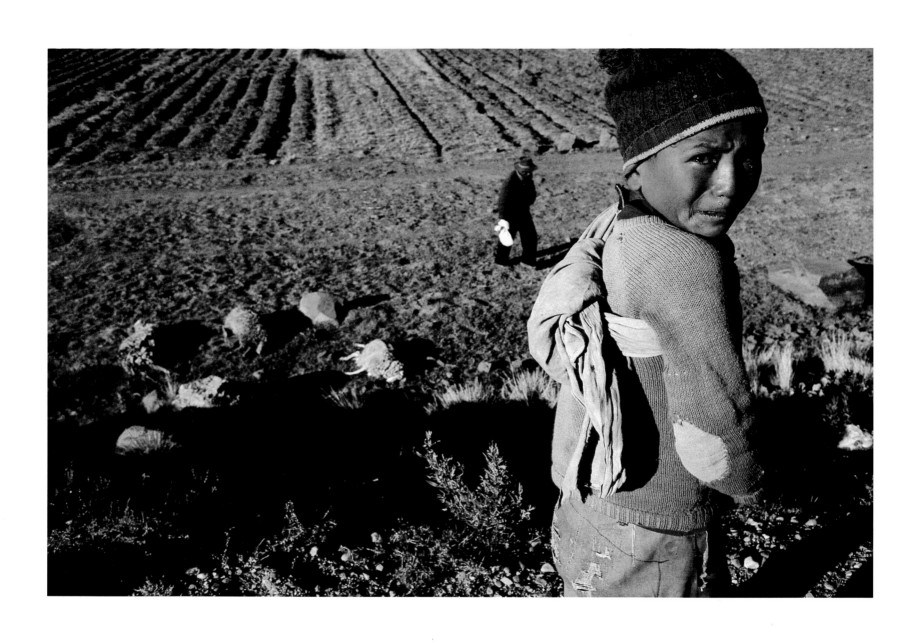

82. William Albert Allard, Peru, 1981

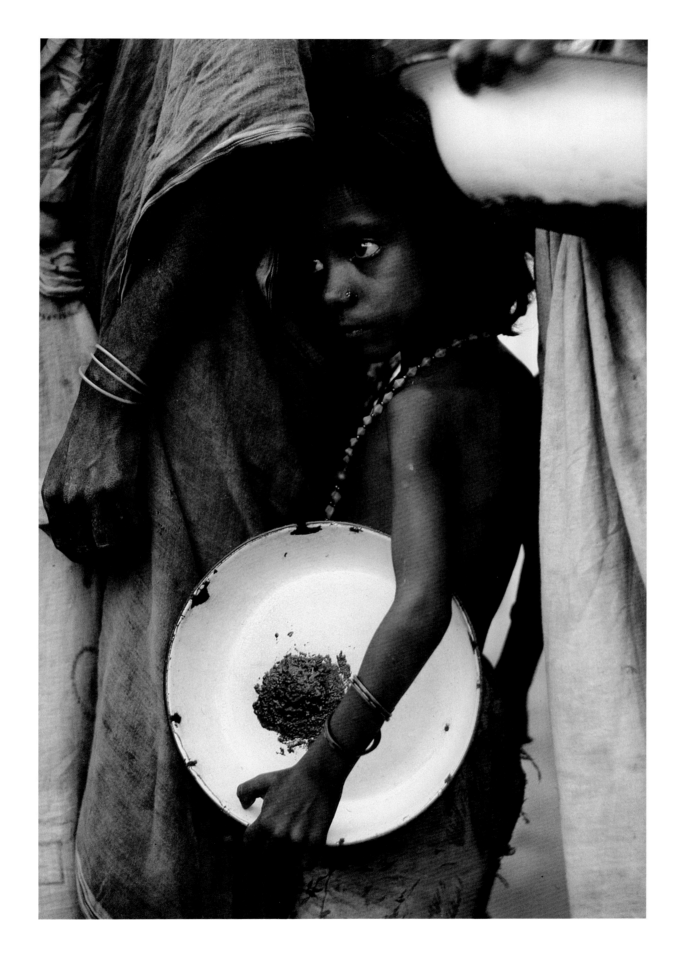

83. Steve Raymer, Bangladesh, 1974

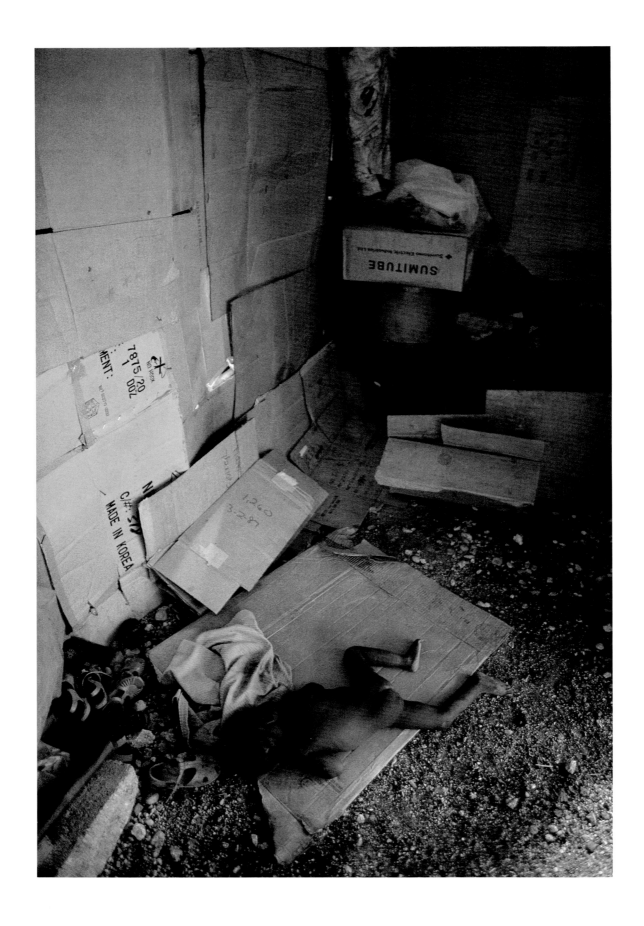

84. James P. Blair, Port-au-Prince, Haiti, 1987

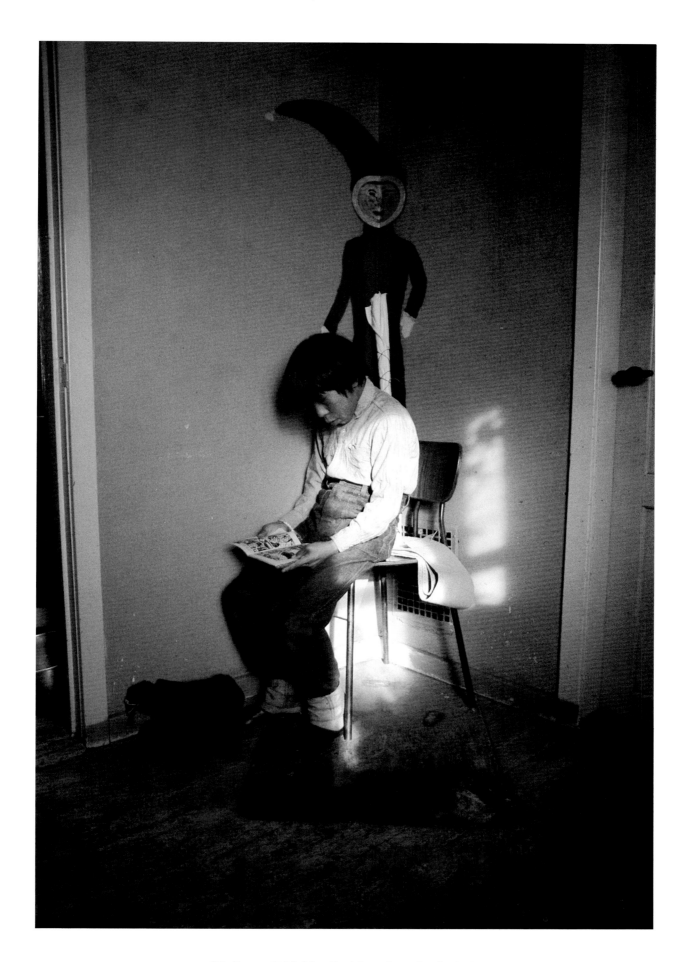

85. George F. Mobley, Rodebay, Greenland, 1974

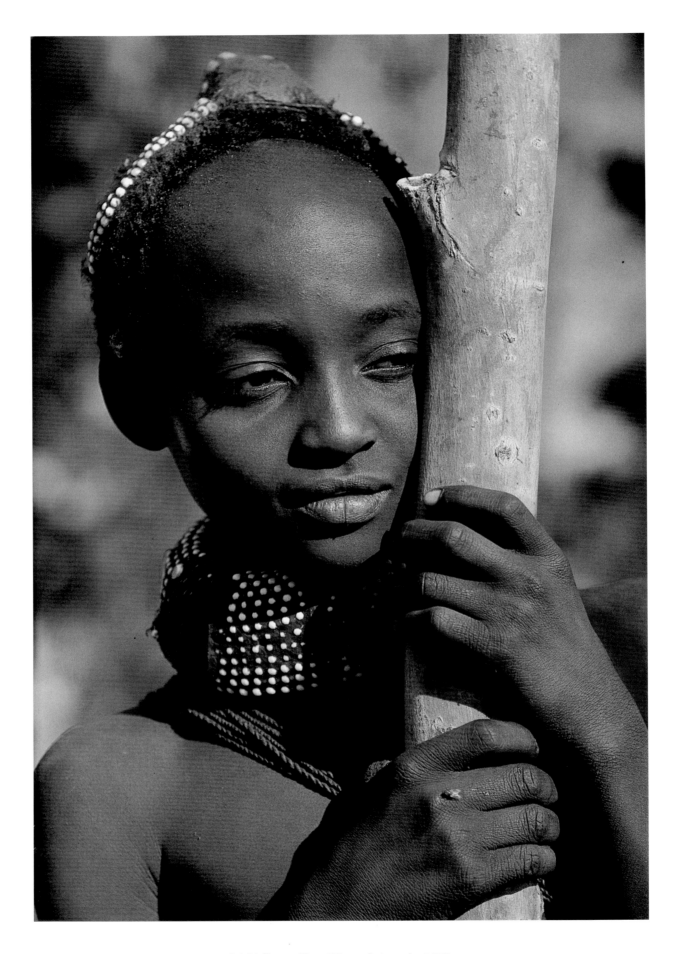

86. Volkmar Kurt Wentzel, Angola, 1959

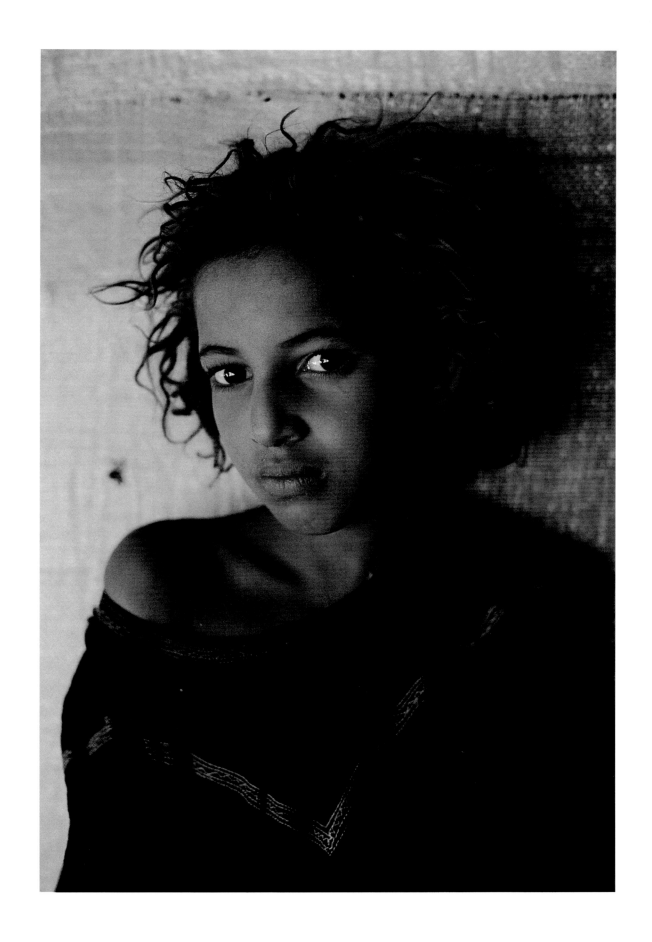

87. Steve McCurry, near Timbuktu, Mali, 1986

88. Yva Momatiuk/John Eastcott, Chochotowska, Poland, 1980

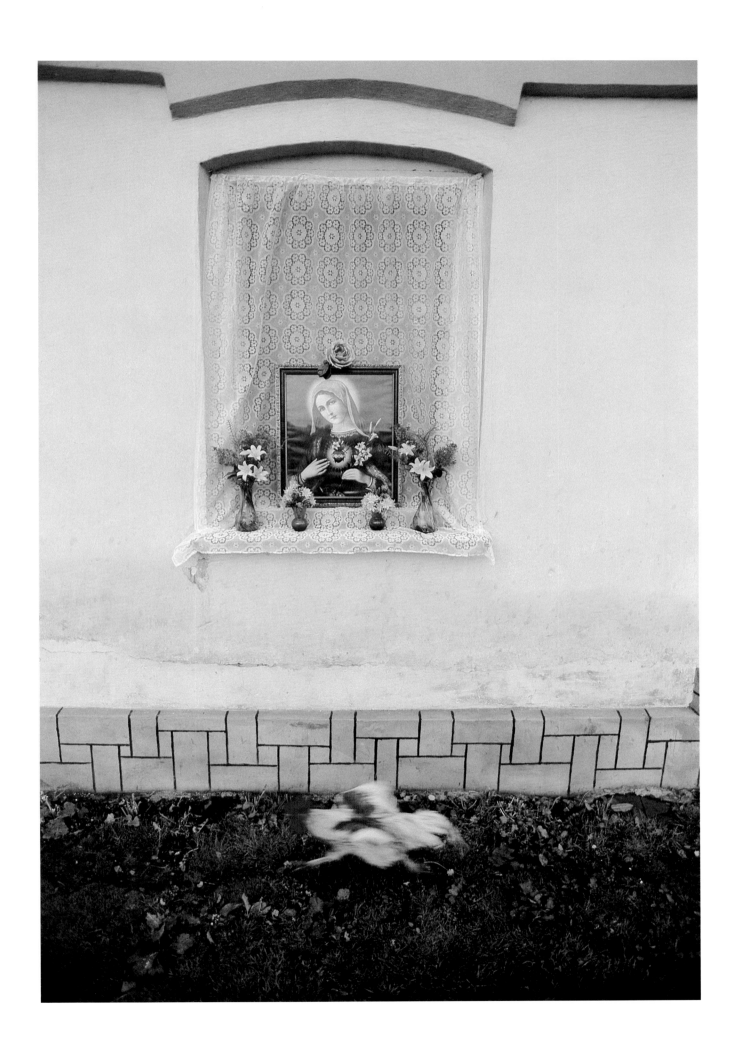

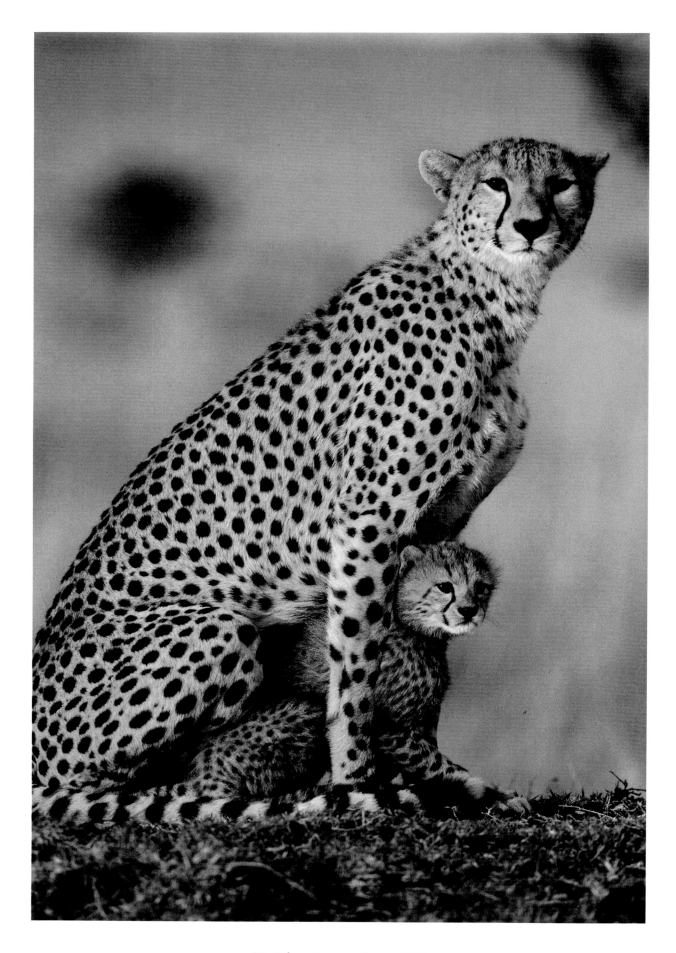

89. Robert Caputo, Kenya, 1985

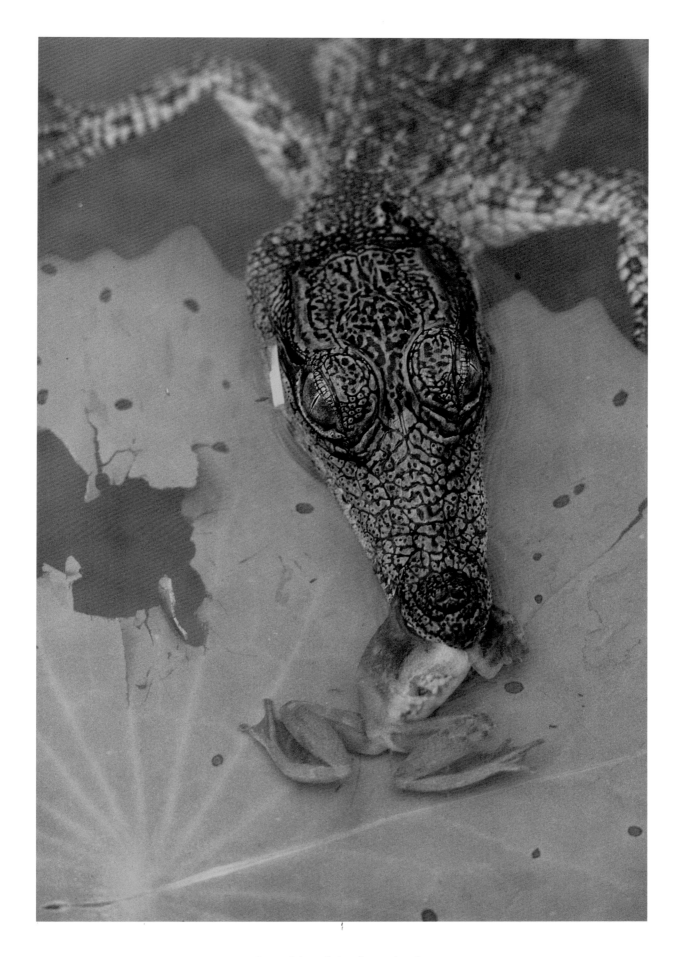

90. Jonathan Blair, Zululand, South Africa, 1977

91. David Doubilet, Red Sea, Sinai, Israel (Egypt), 1979

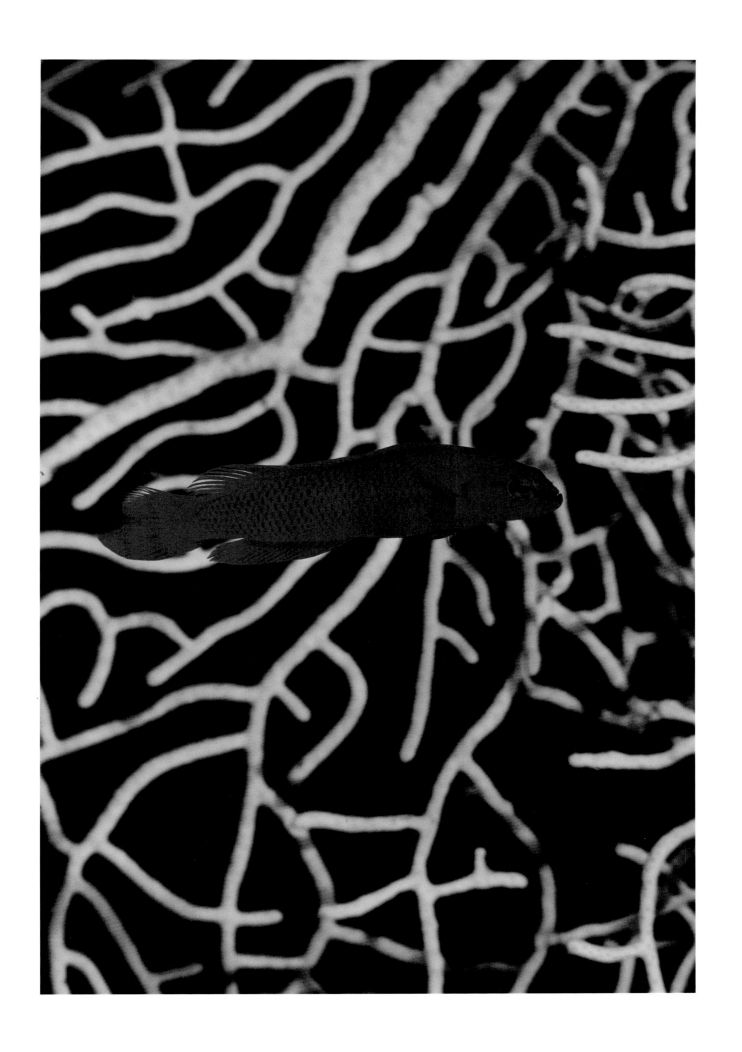

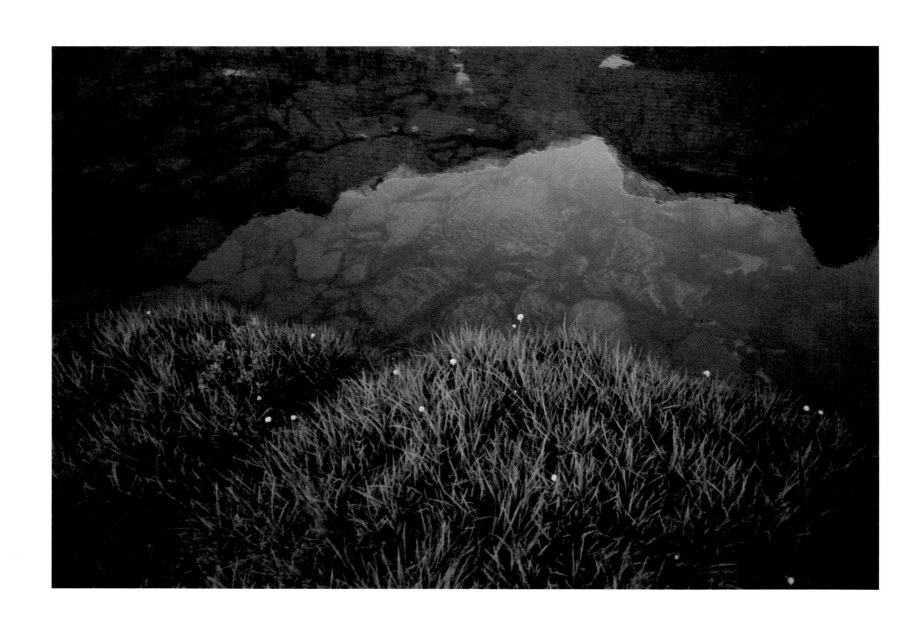

92. Paul Chesley, San Juan Mountains, Colorado, 1979

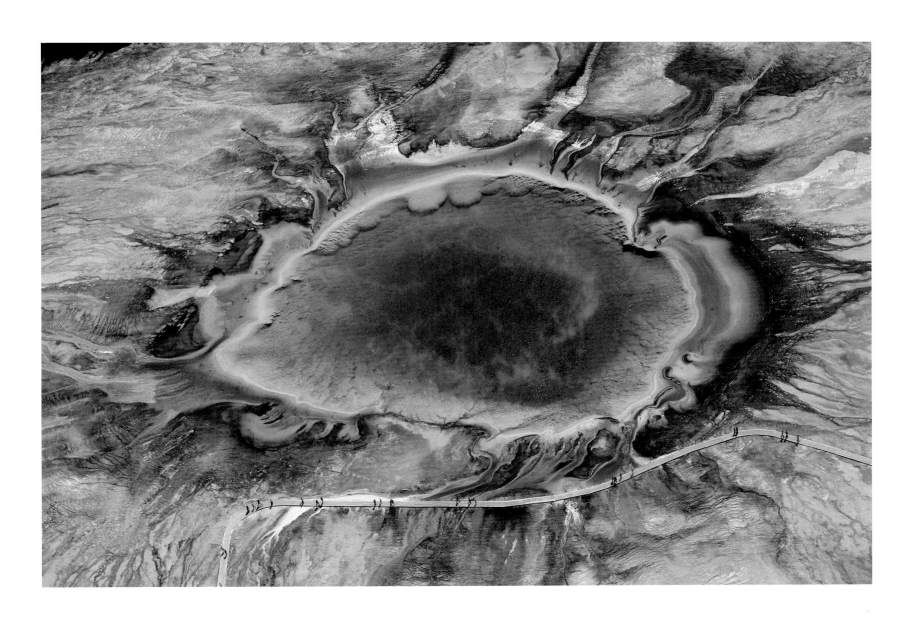

93. Paul Chesley, Yellowstone National Park, Wyoming, 1979

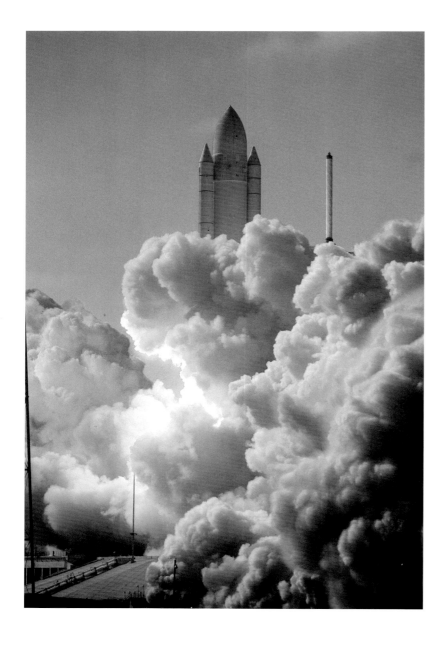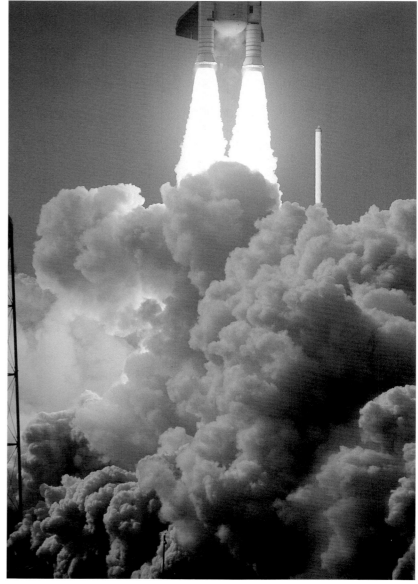

94-95. Jon Schneeberger with Ted Johnson and Anthony Peritore, John F. Kennedy Space Center, Florida, 1981

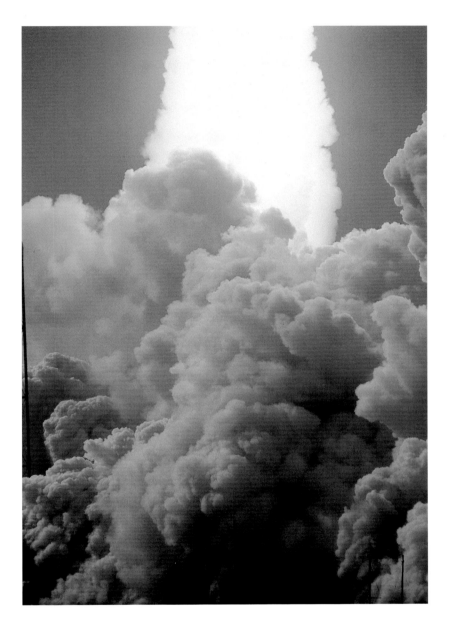
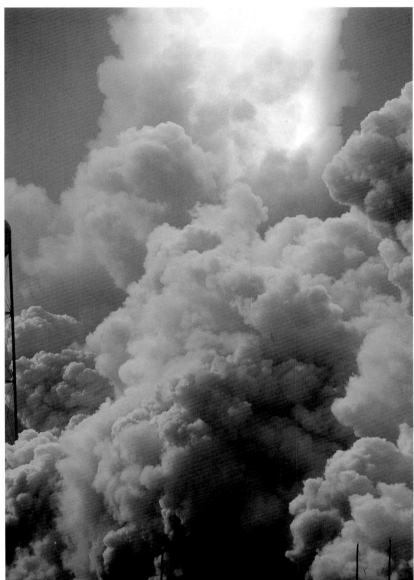

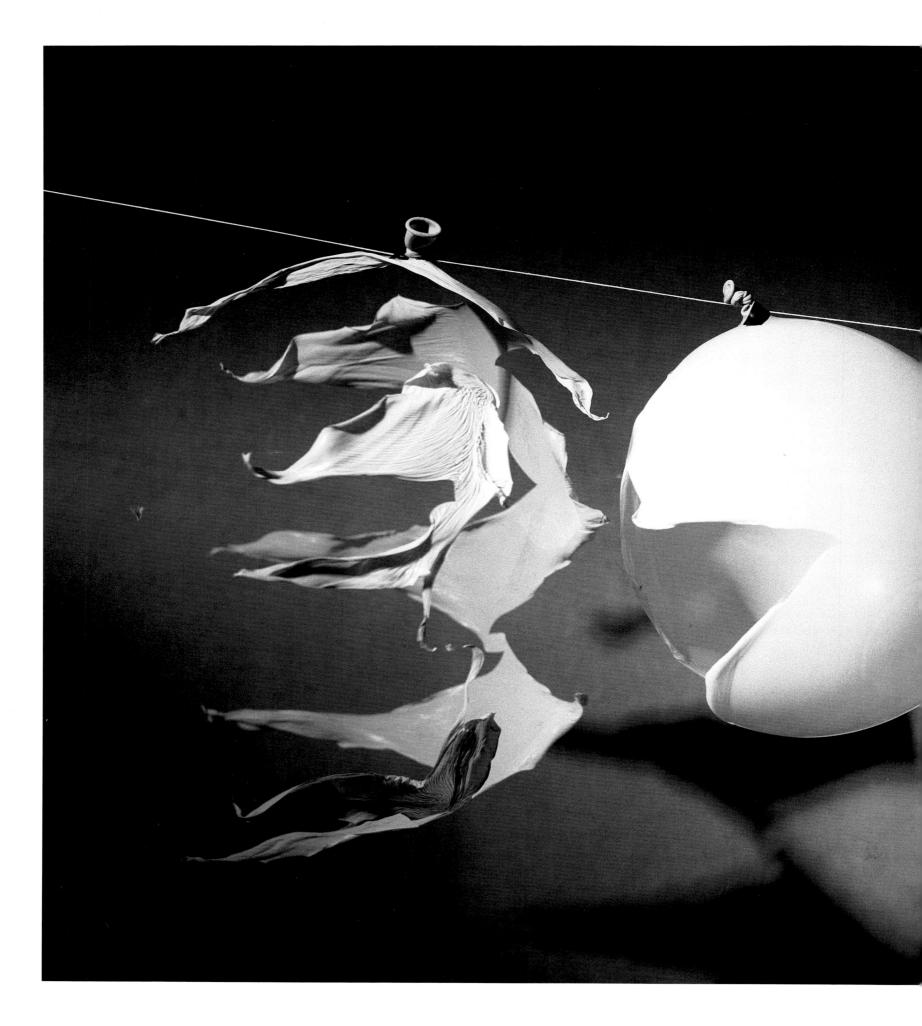

96. Harold E. Edgerton,
 Cambridge, Massachusetts,
 1959

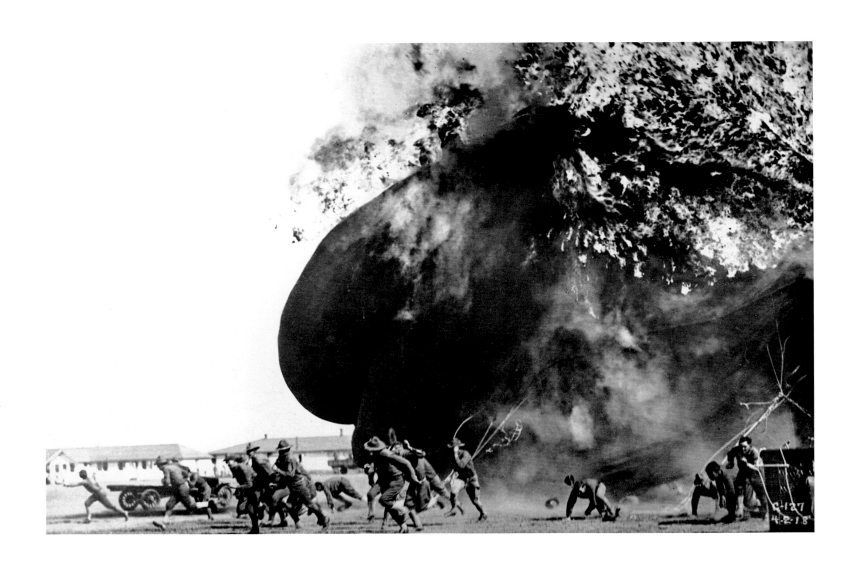

97. Photographer unknown, Fort Sill, Oklahoma, n.d.

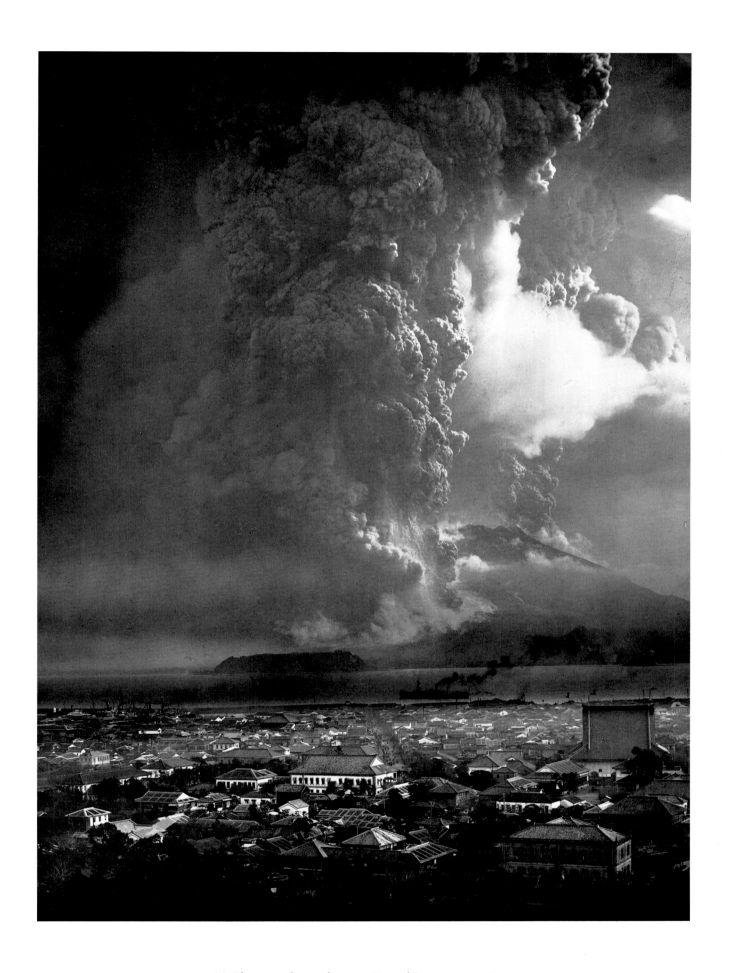

98. Photographer unknown, Kagoshima, Japan, 1914

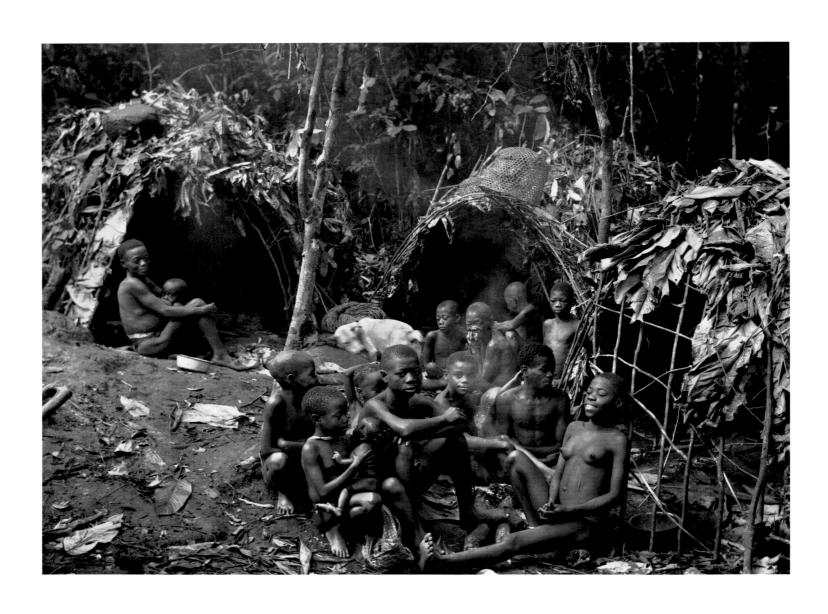

99. Fred A. Wardenburg, Belgian Congo (Zaire), n.d.

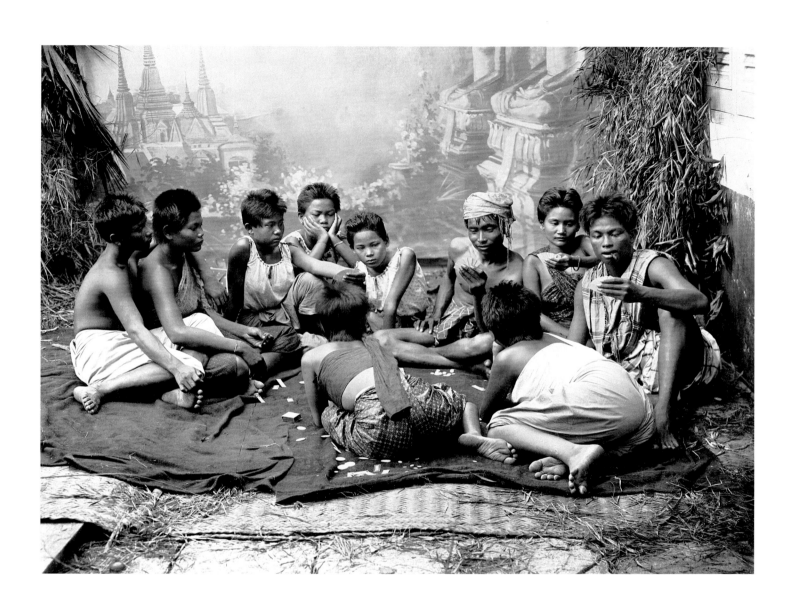

100. R. Senz & Company, Bangkok, Siam (Thailand), 1911

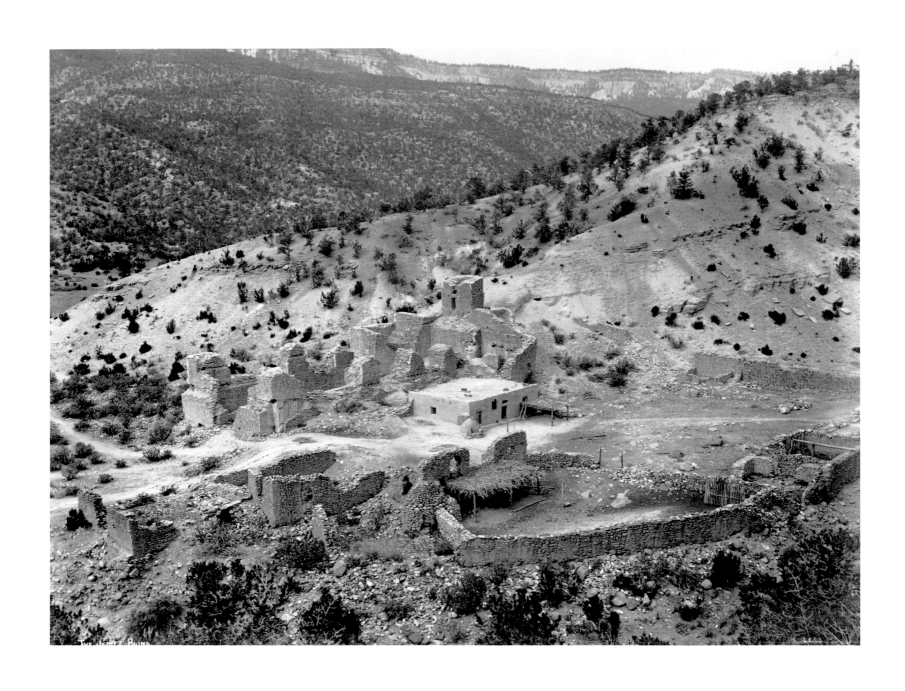

101. Jack Hillers, New Mexico, c. 1875

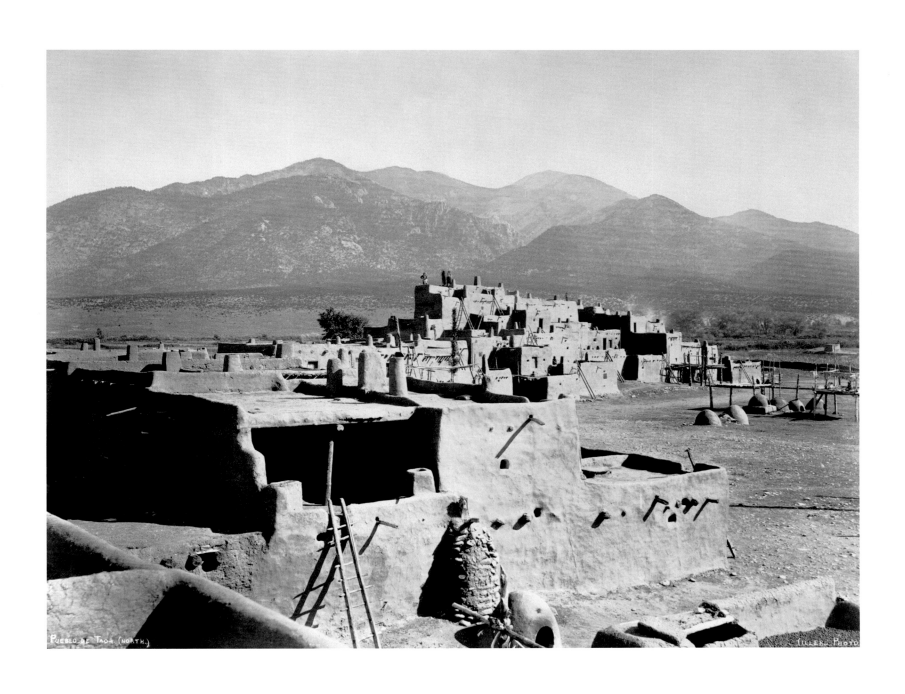

102. Jack Hillers, New Mexico, c. 1875

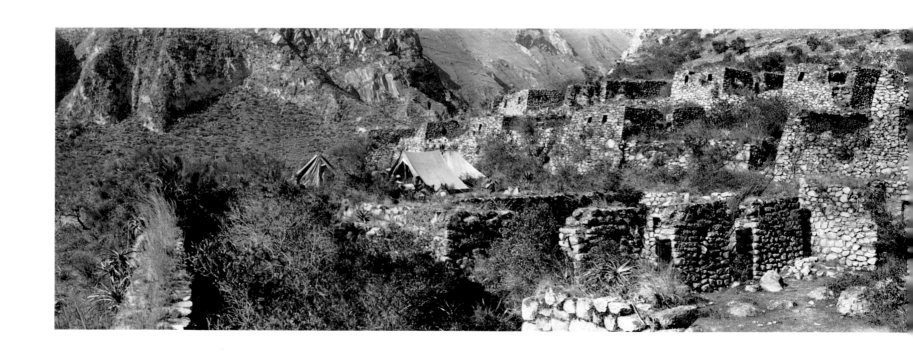

103. Hiram Bingham, Machu Picchu, Peru, c. 1912

104. Hiram Bingham, Patallacta, Peru, c. 1912

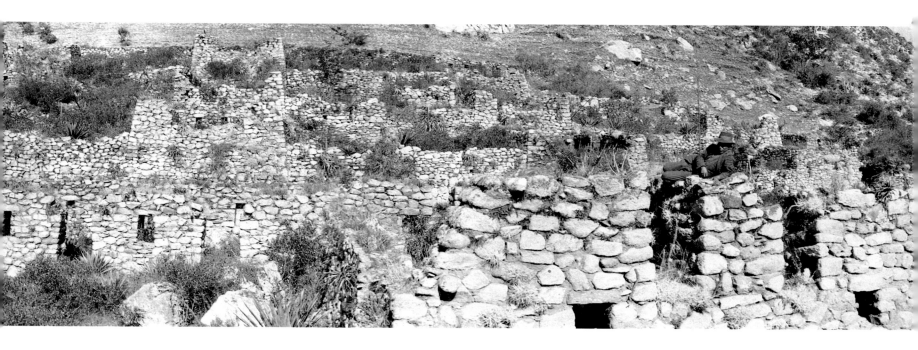

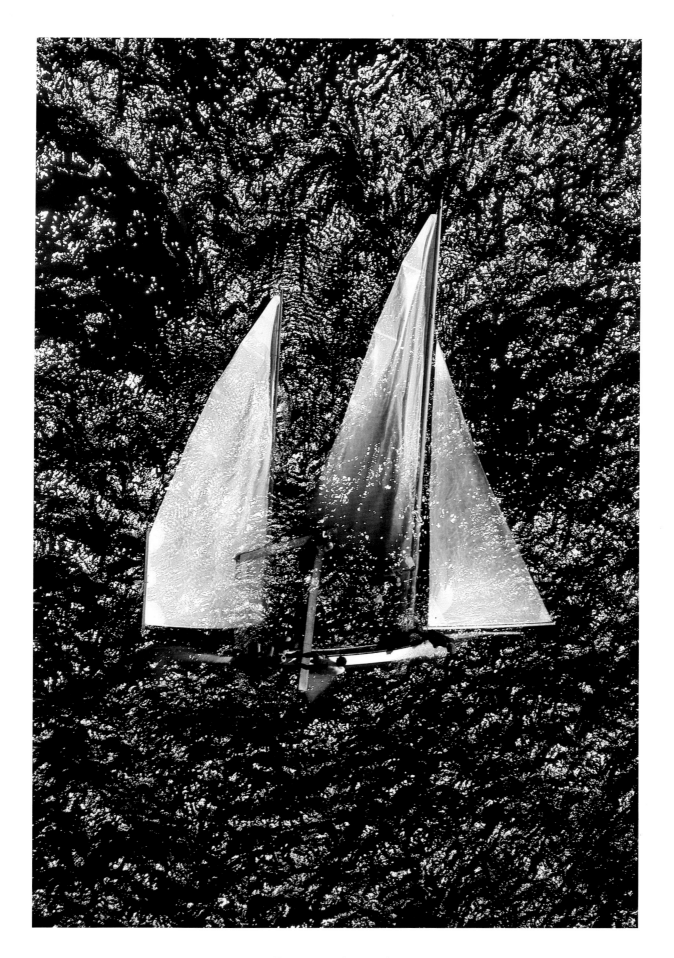

105. Lowell Georgia, Chesapeake Bay, 1979

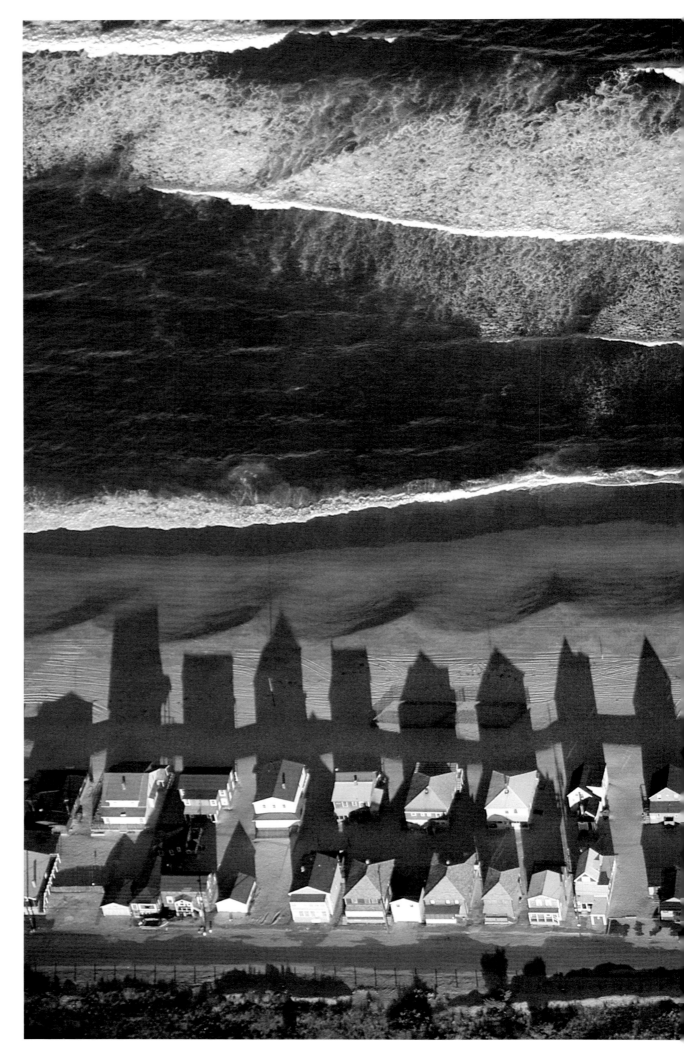

106. Nathan Benn,
Salisbury Beach,
Massachusetts, 1978

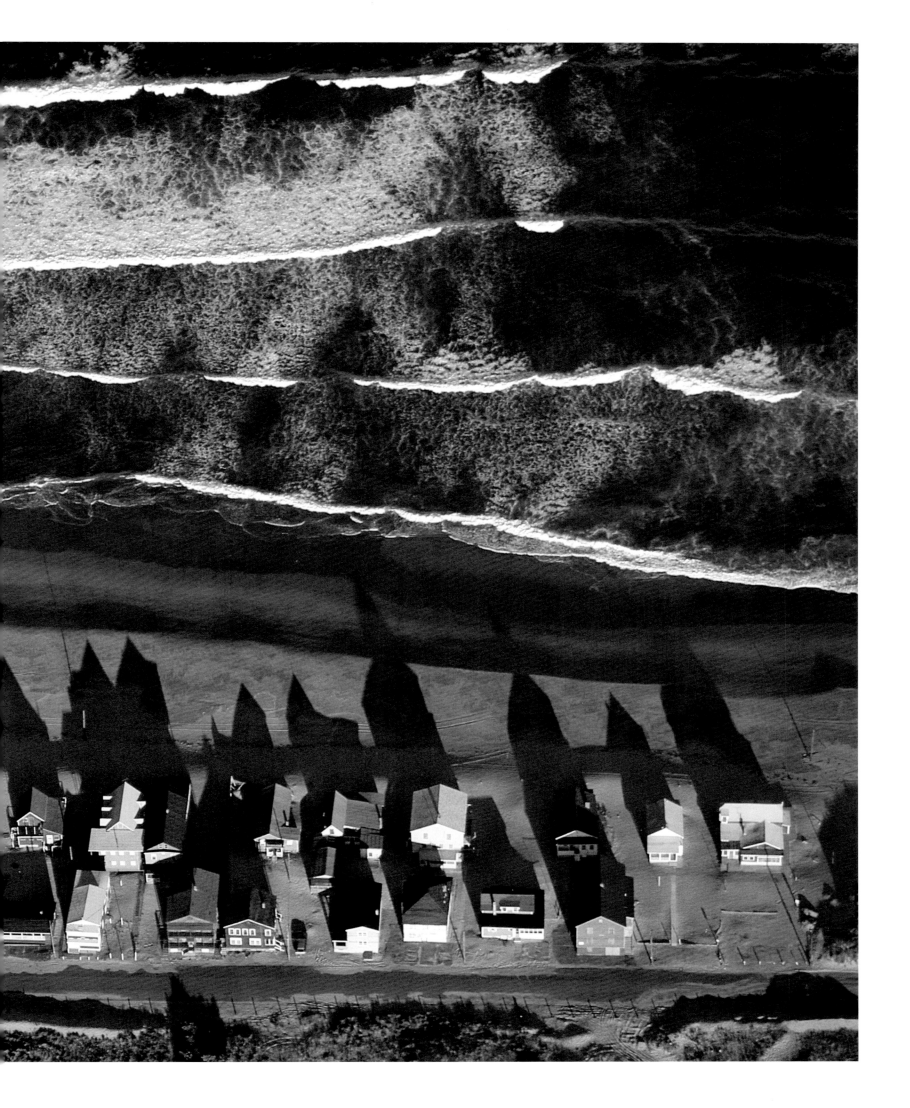

107. Photographer unknown, Long Island, New York, 1932

108. Jacob Gayer, Fort Valley, Georgia, 1935, *autochrome*

109. Volkmar Kurt Wentzel, Kentucky, 1940

110. George R. King, Zuider Zee, Netherlands, n.d.

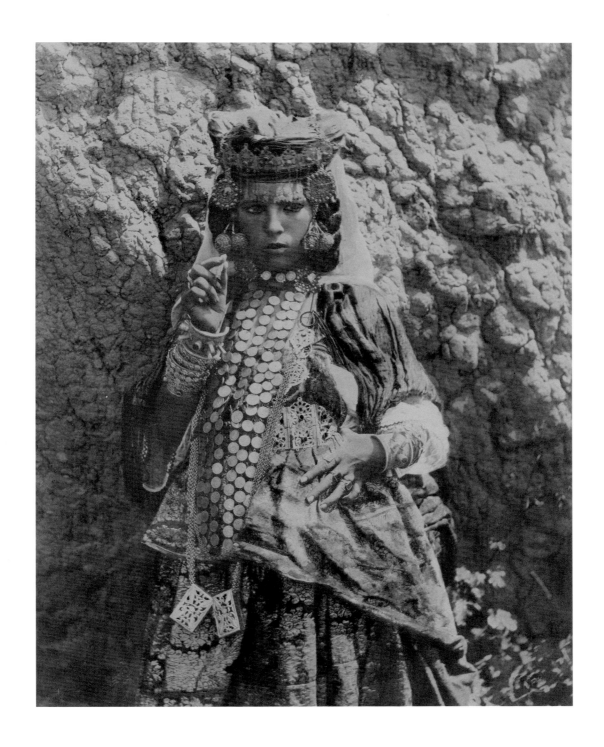

111. Photographer unknown, Algeria, n.d.

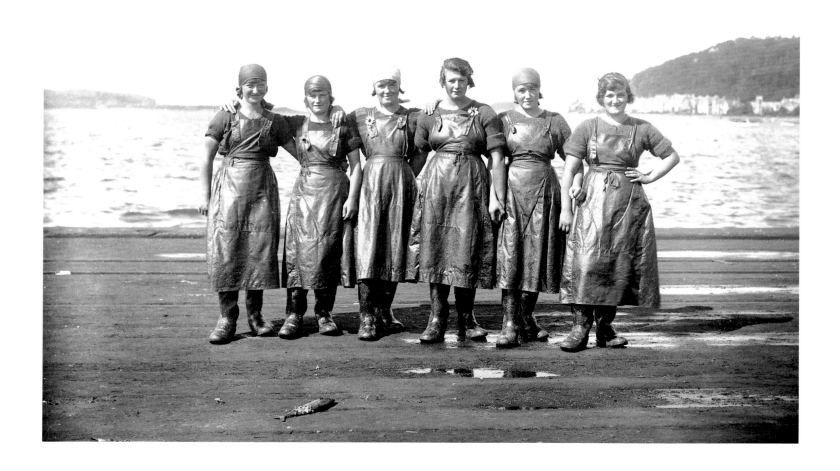

112. Robert Reid, Banffshire, Scotland, 1928

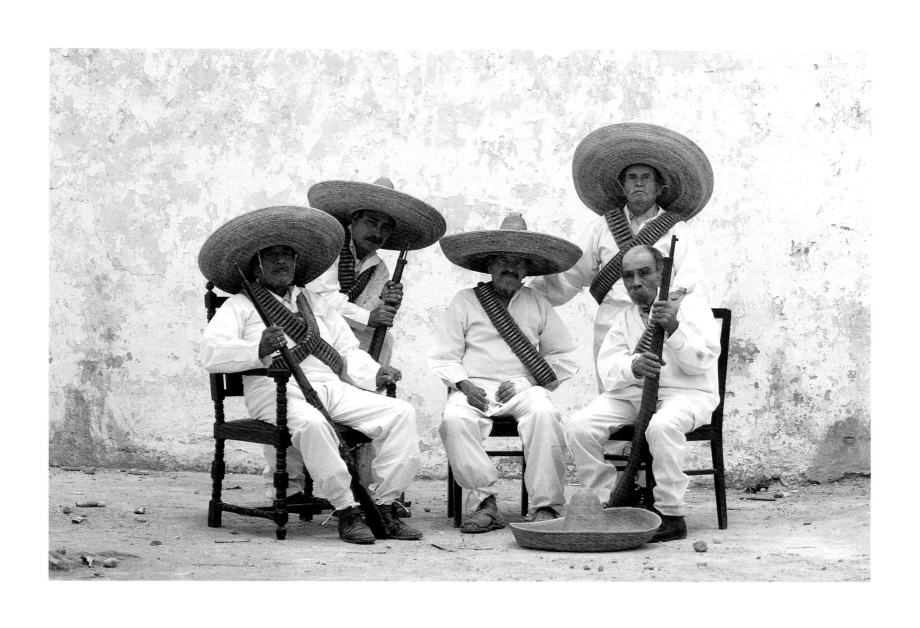

113. Tom Nebbia, Cuautla, Mexico, 1977

114. James L. Stanfield, New Orleans, Louisiana, 1970

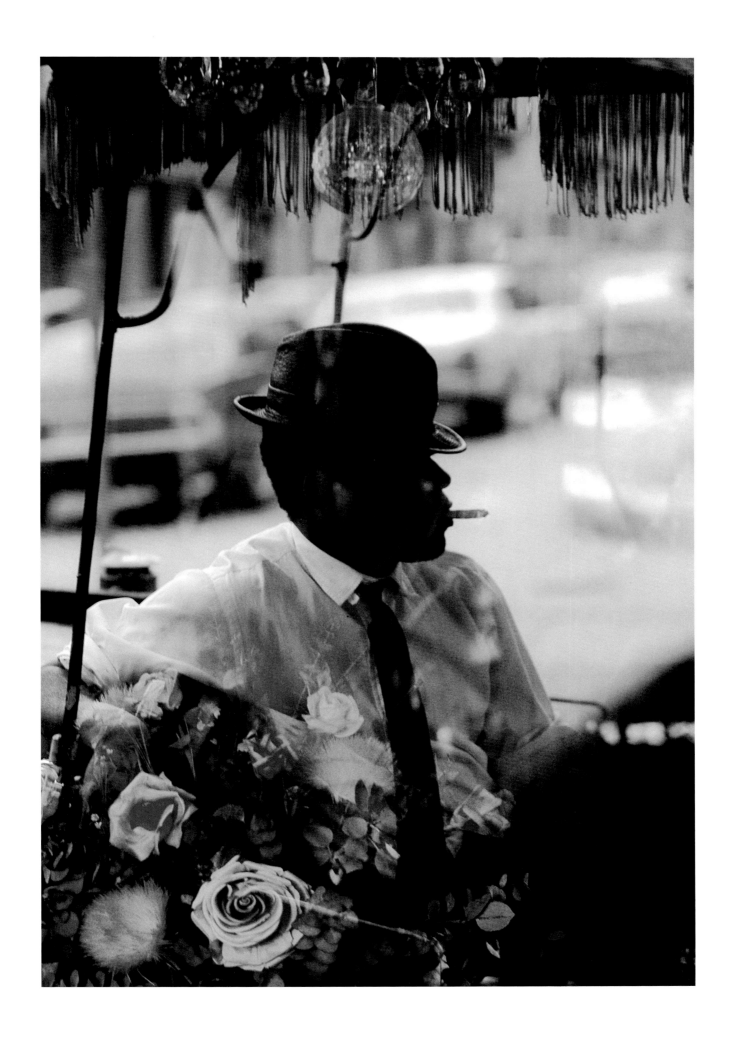

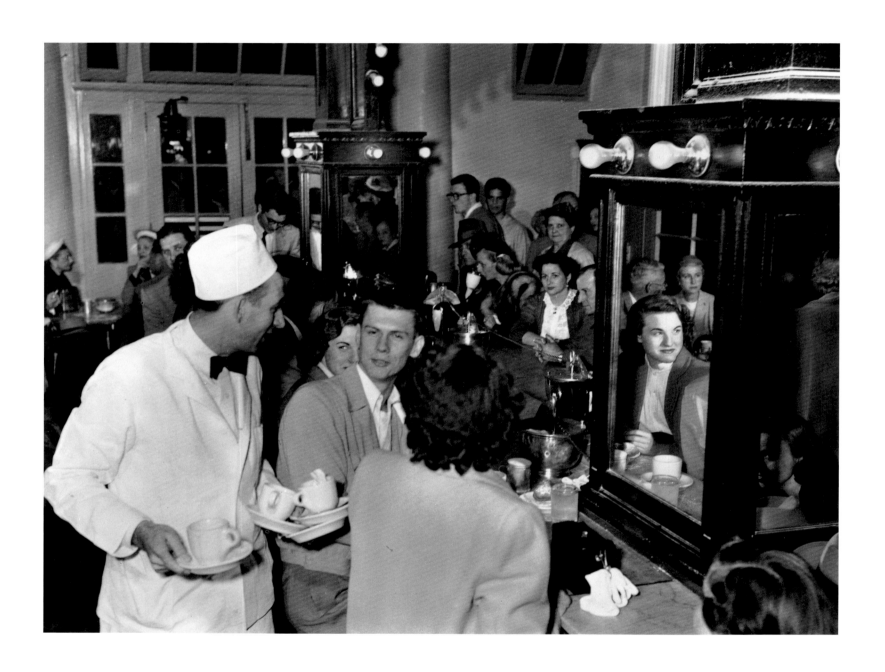

115. Justin Locke, New Orleans, Louisiana, 1952

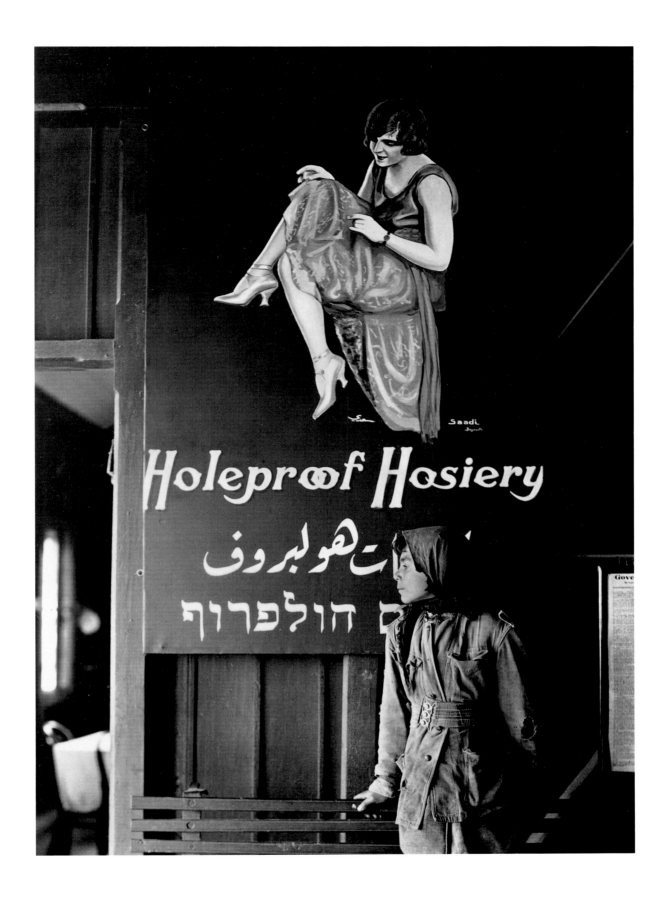

116. Maynard Owen Williams, Semakh, Palestine (the Golan), 1927

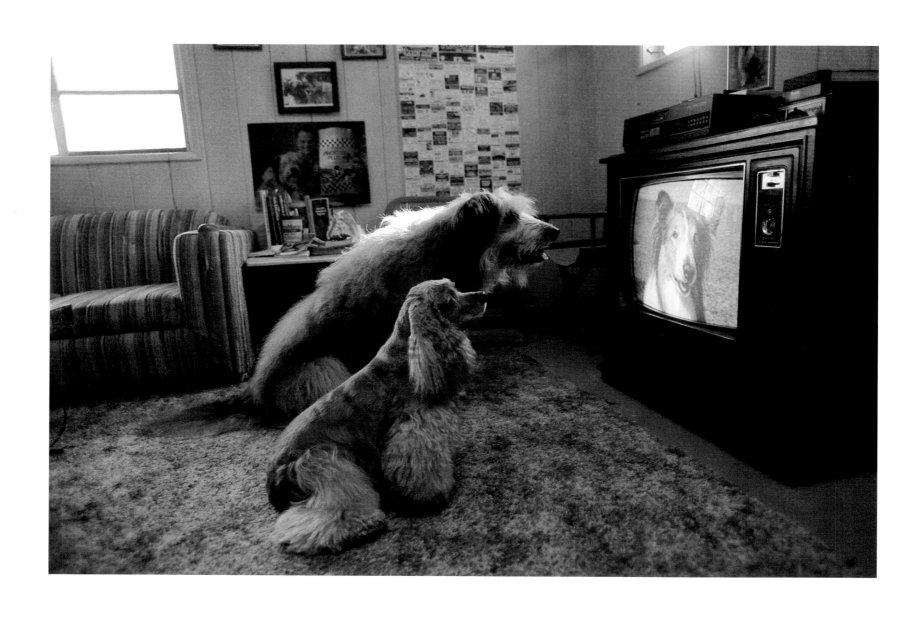

117. Tom Nebbia, Los Angeles, California, 1984

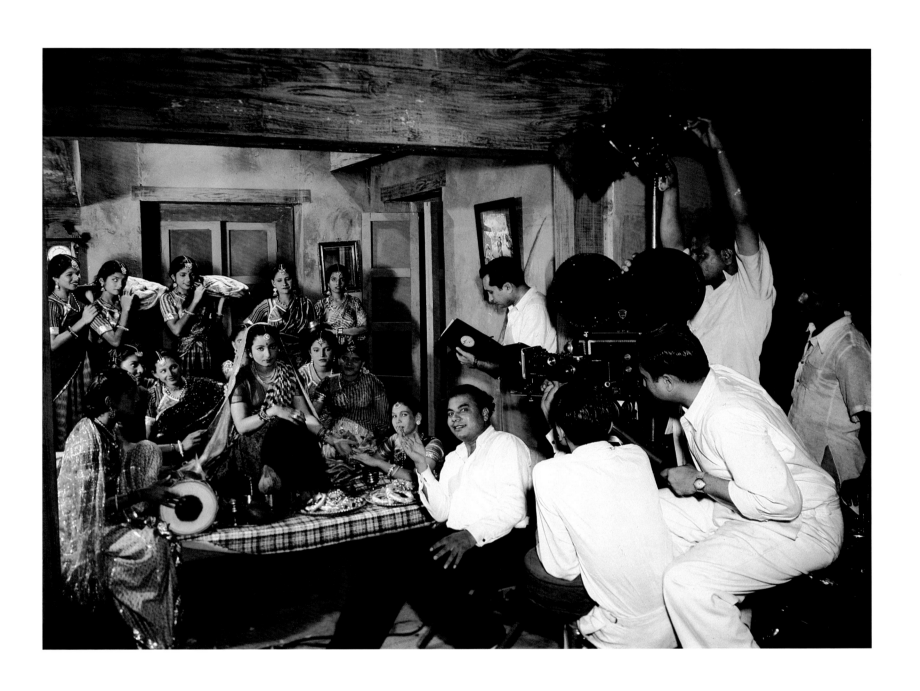

118. Volkmar Kurt Wentzel, India, 1948

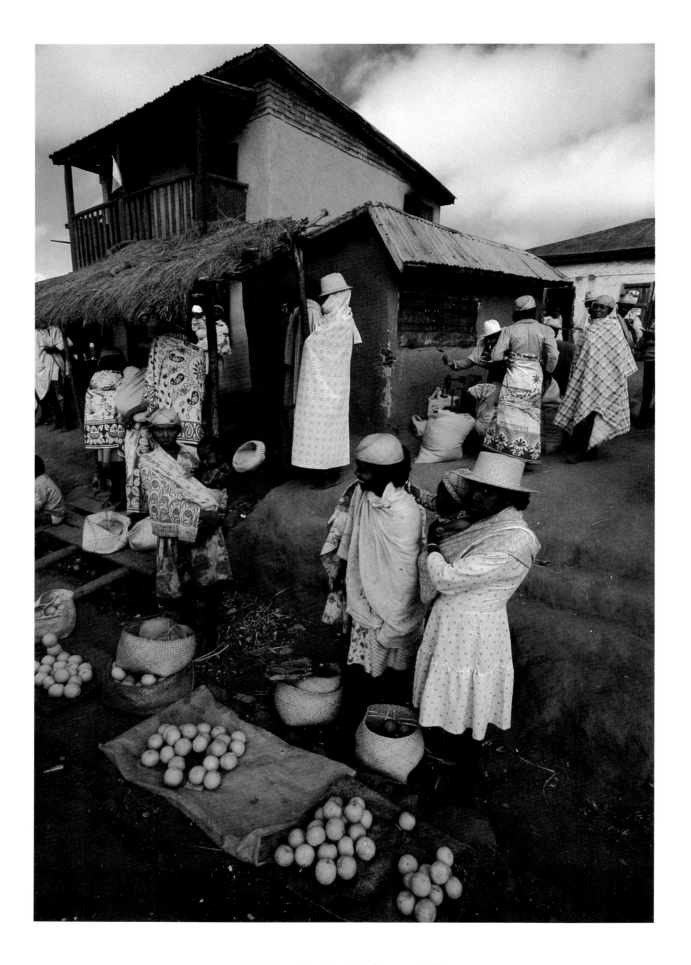

119. Frans Lanting, Madagascar, 1986

120. William Albert Allard, Paris, France, 1986

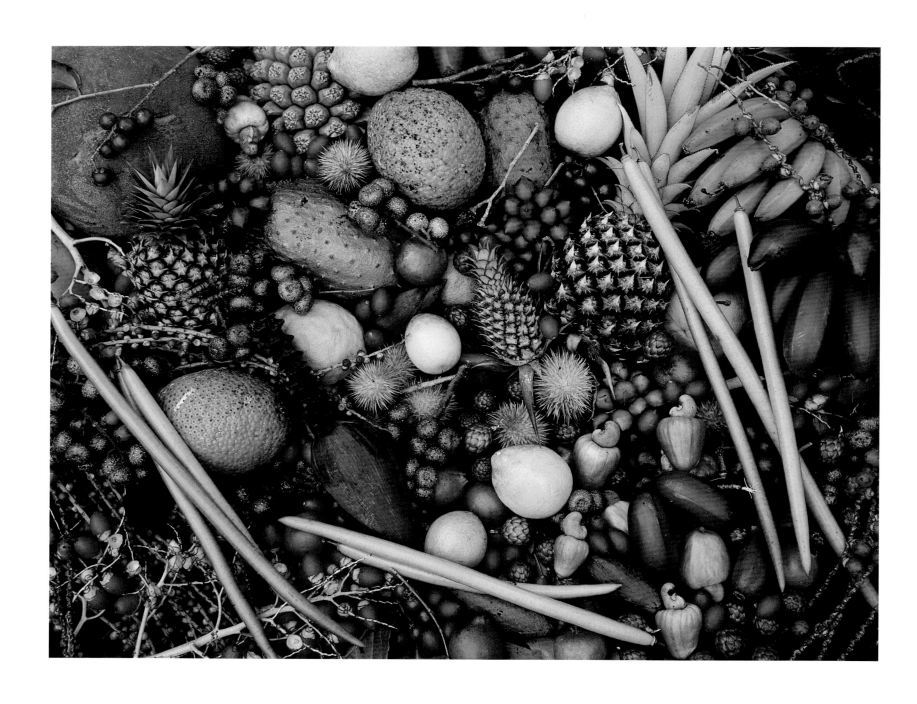

121. Luis Marden, Panama, 1941

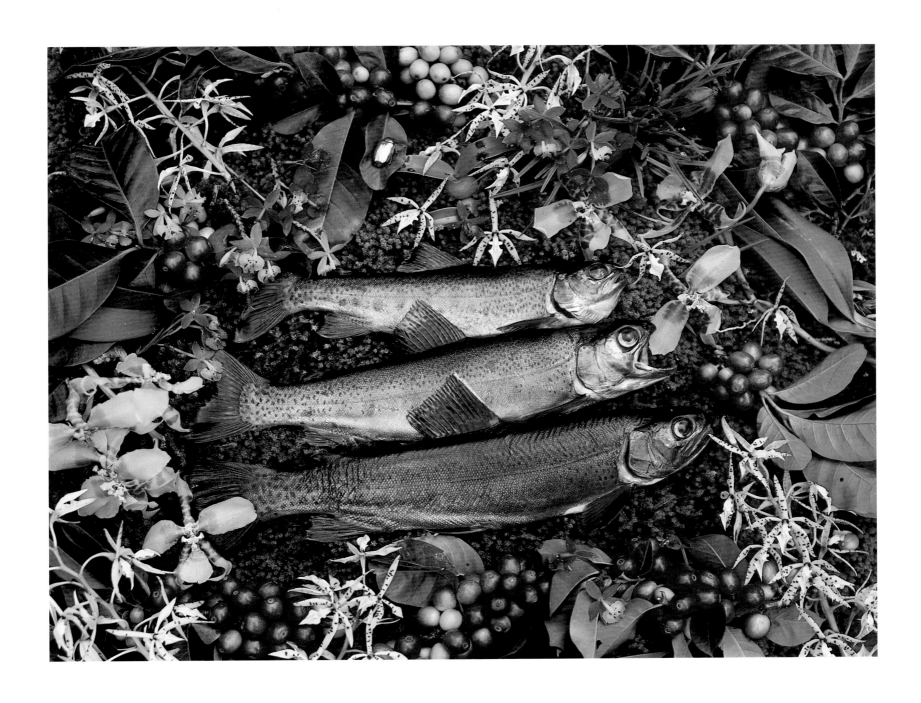

122. Luis Marden, Panama, 1941

123. Emory Kristof, Ocean City, Maryland, 1975

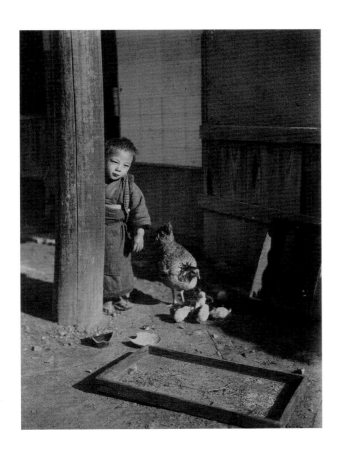

124-127. Eliza R. Scidmore, Japan, n.d.

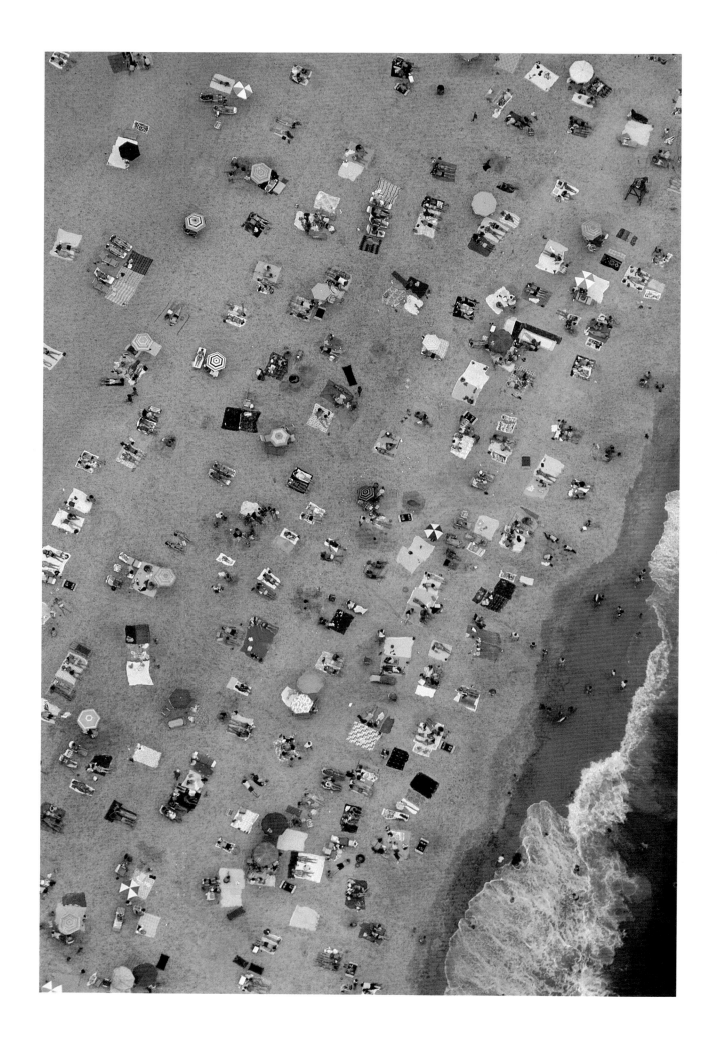

128. Gustav Heurlin, Sweden, c. 1920

129. Harry F. Blanchard, United States, c. 1915

130. B. Anthony Stewart, England, 1948

131. Nathan Benn, Middlebury, Vermont, 1973

132. J. Baylor Roberts, Wakulla Springs, Florida, n.d.

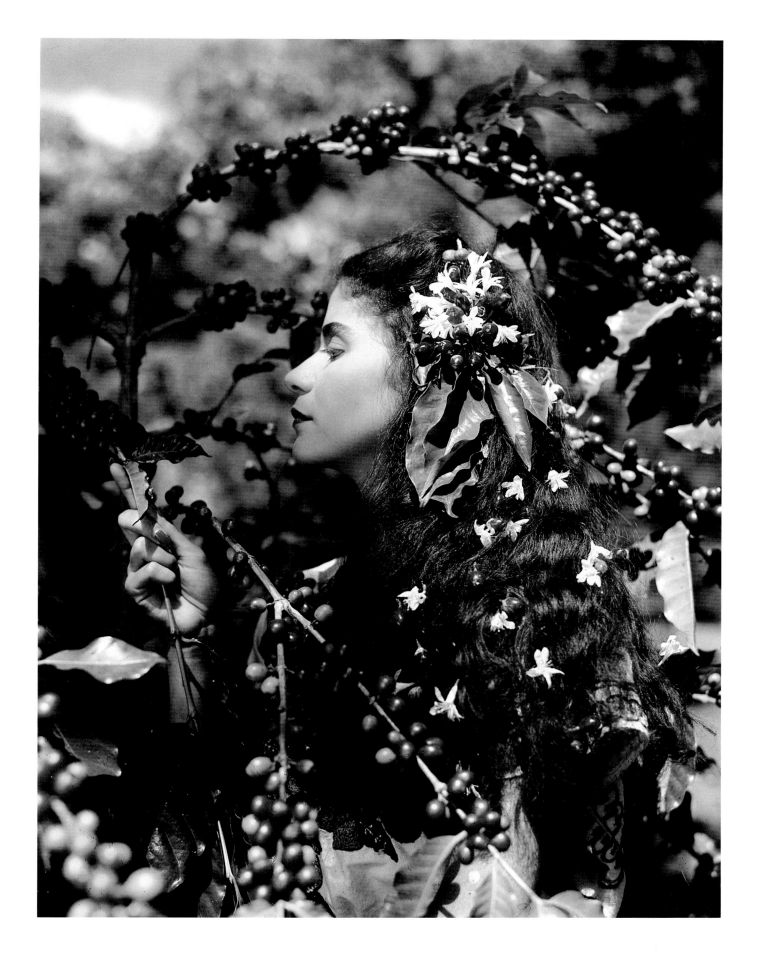

133. Luis Marden, El Salvador, 1944

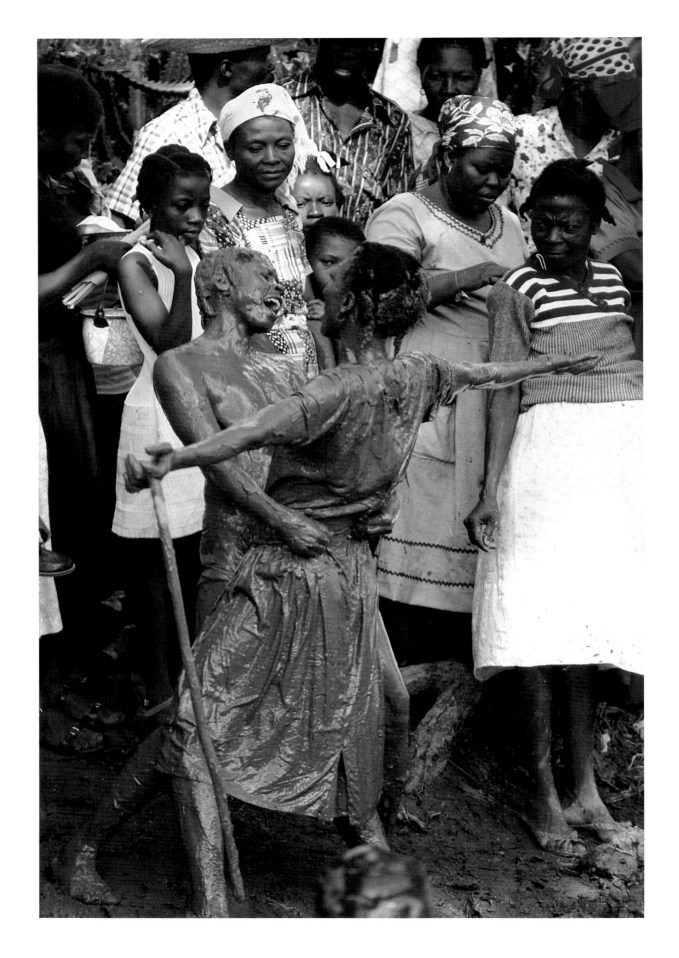

134. Carole Devillers, Haiti, 1985

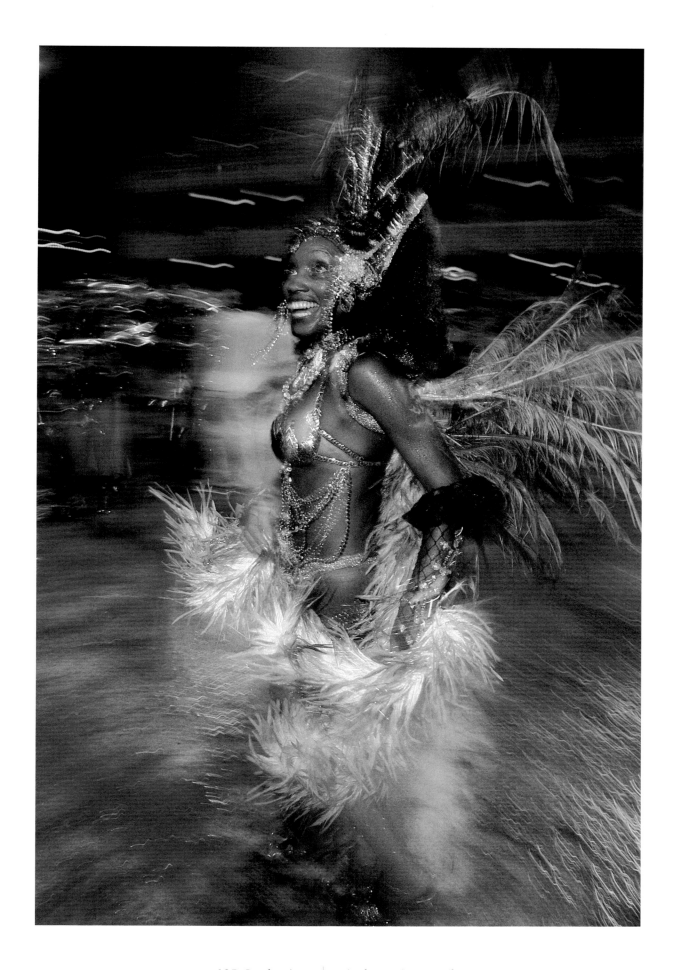

135. Stephanie Maze, Rio de Janeiro, Brazil, 1985

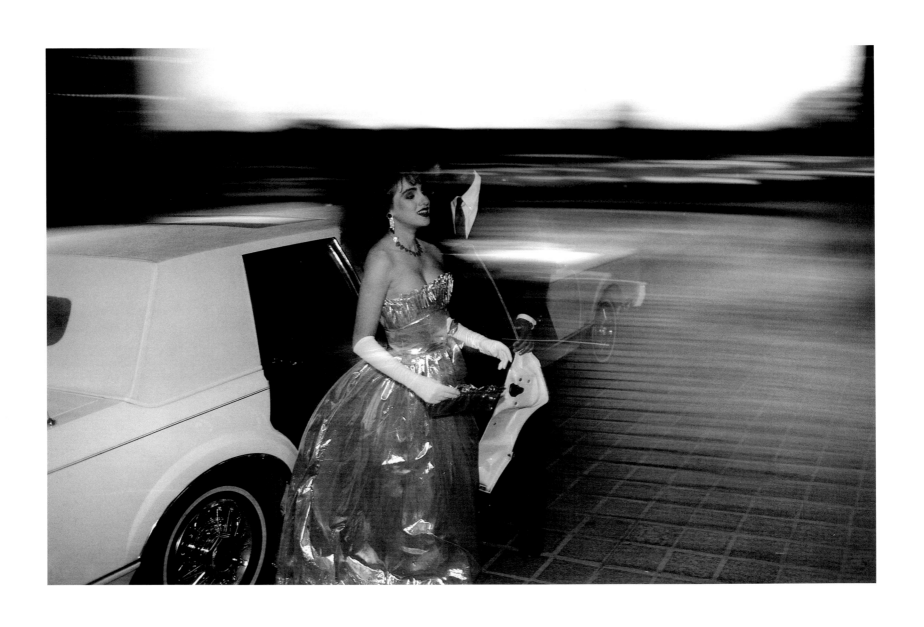

136. David Alan Harvey, Dallas, Texas, 1984

137. Nathan Benn, Palm Beach, Florida, 1981

138. Edwin L. Wisherd, San Juan, Puerto Rico, c. 1935

139. Farrell Grehan, Stavoren, Netherlands, 1985

140. Gail Mooney, Montreal, Quebec, Canada, 1983

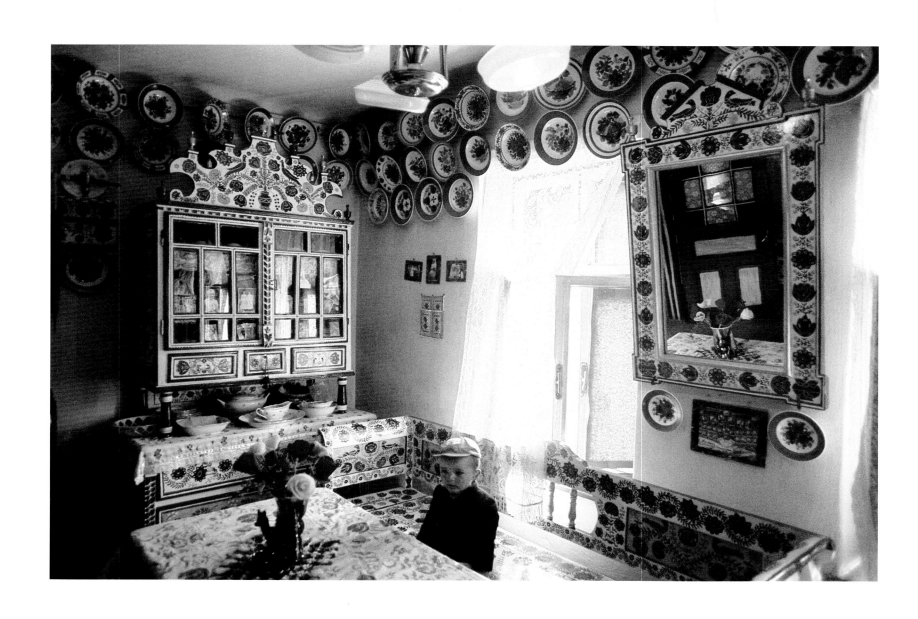

141. Bruce Dale, Mera, Romania, 1969

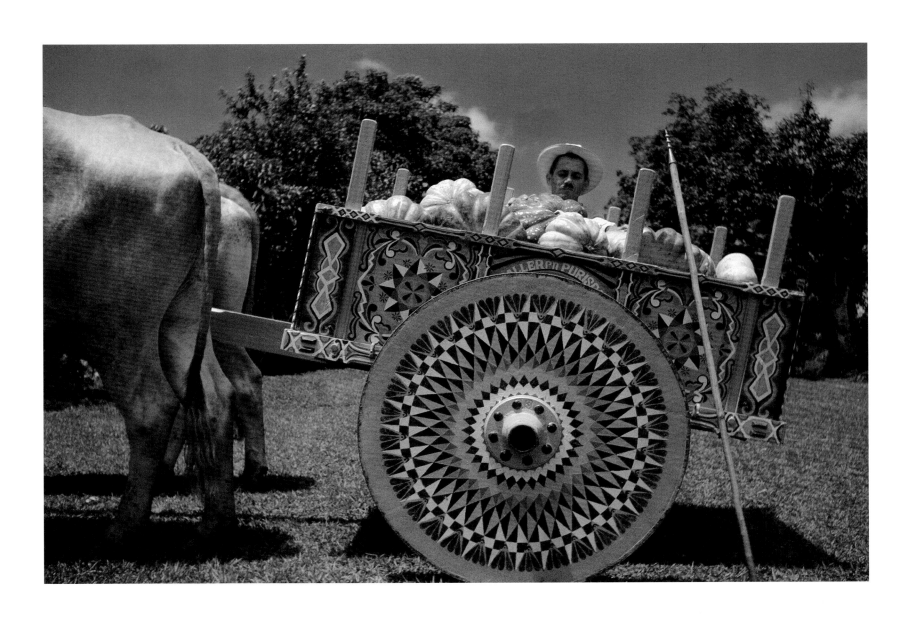

142. Luis Marden, Costa Rica, c. 1945

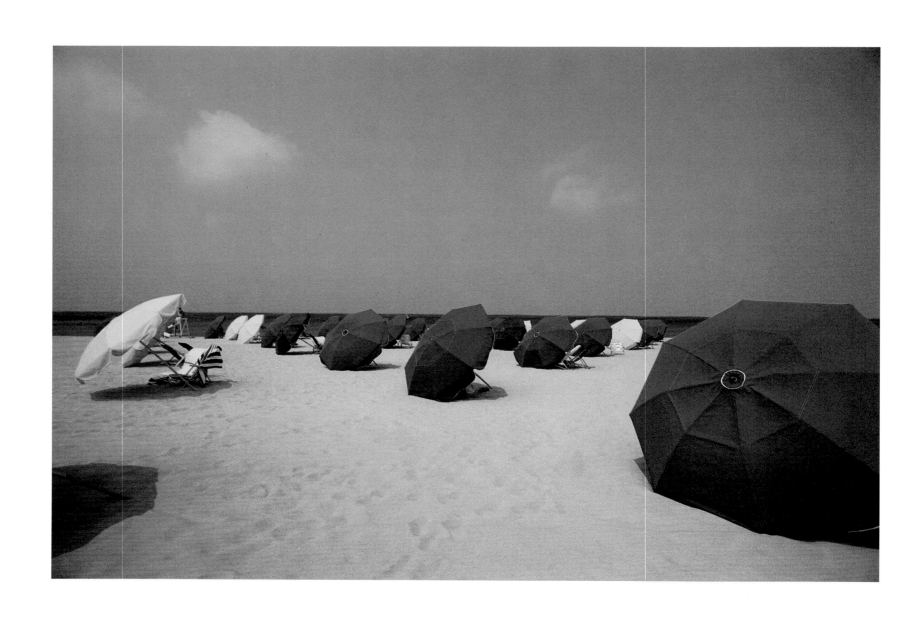

143. Stephen R. Brown, Nantucket, Massachusetts, 1985

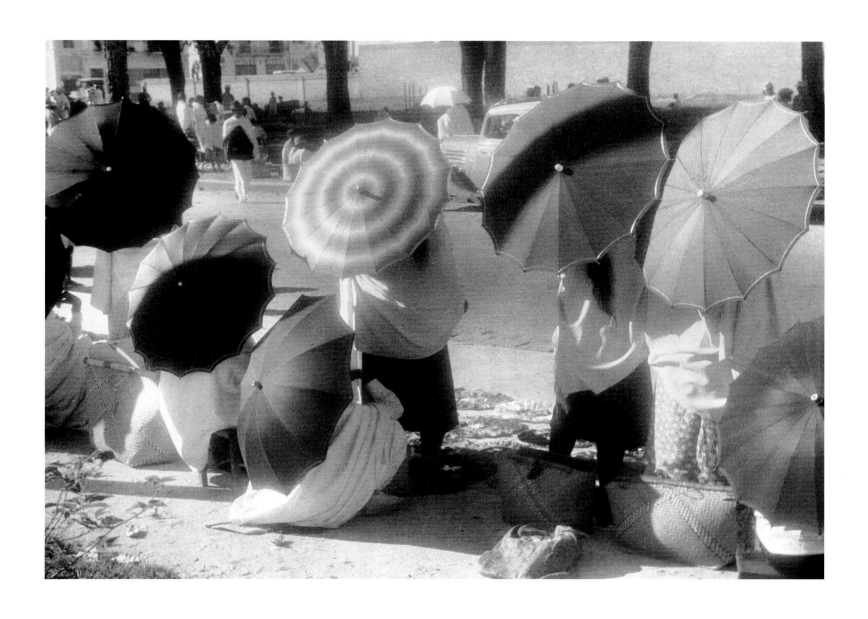

144. Paul Almasy, Madagascar, 1938

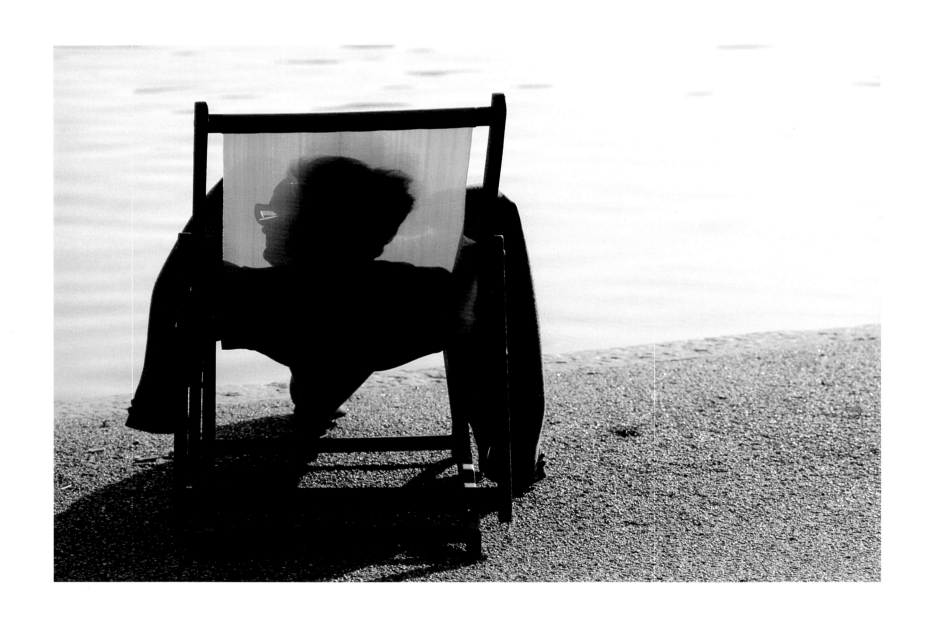

145. Jodi Cobb, London, England, 1984

146. Steven C. Wilson, Matagorda, Texas, 1979

147. O. F. Cook, Peru, c. 1916

148. Frans Lanting, Madagascar, 1986

149. James P. Blair, Cape Cod, Massachusetts, 1972

150. Steven C. Wilson, Texas, 1979

151. Lynwood M. Chace, Swansea, Massachusetts, c. 1930

152. William L. Finley and H. T. Bohlman, California, 1905

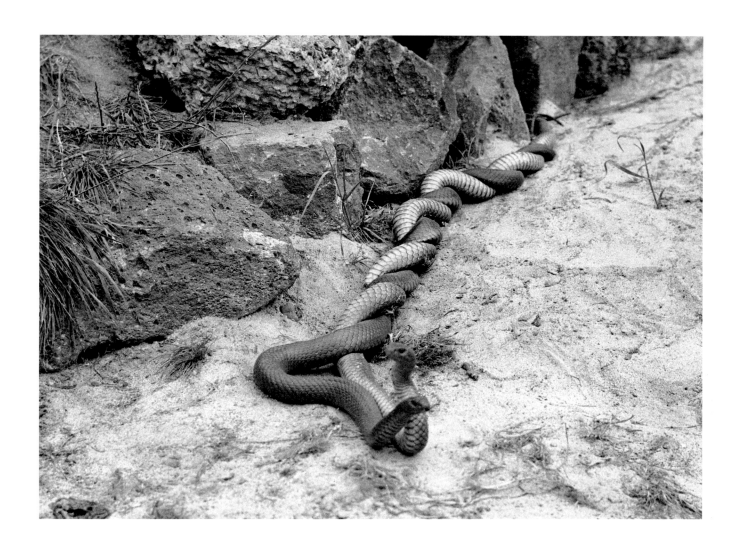

153. David Fleay, New South Wales, Australia, 1950

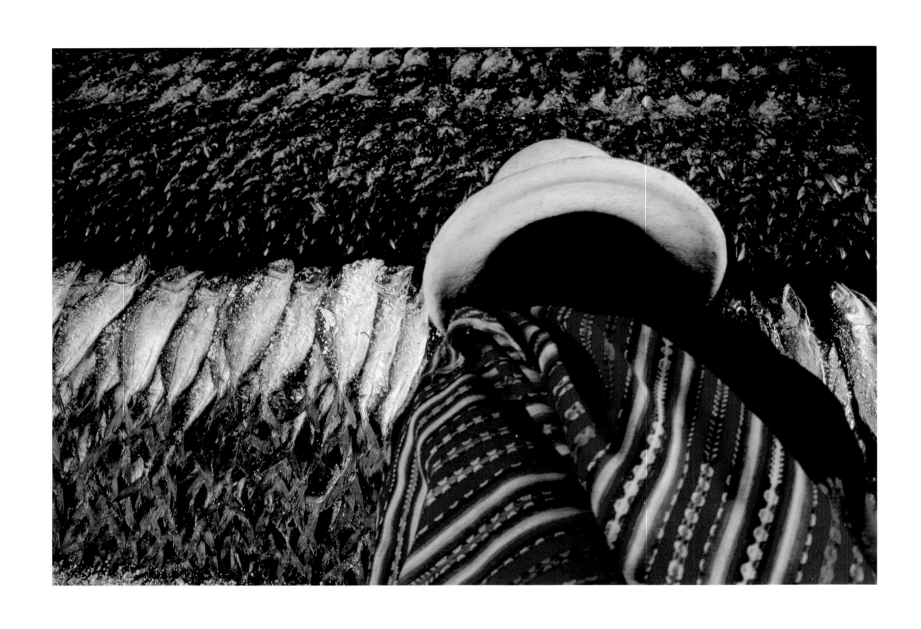

154. William Albert Allard, Peru, 1981

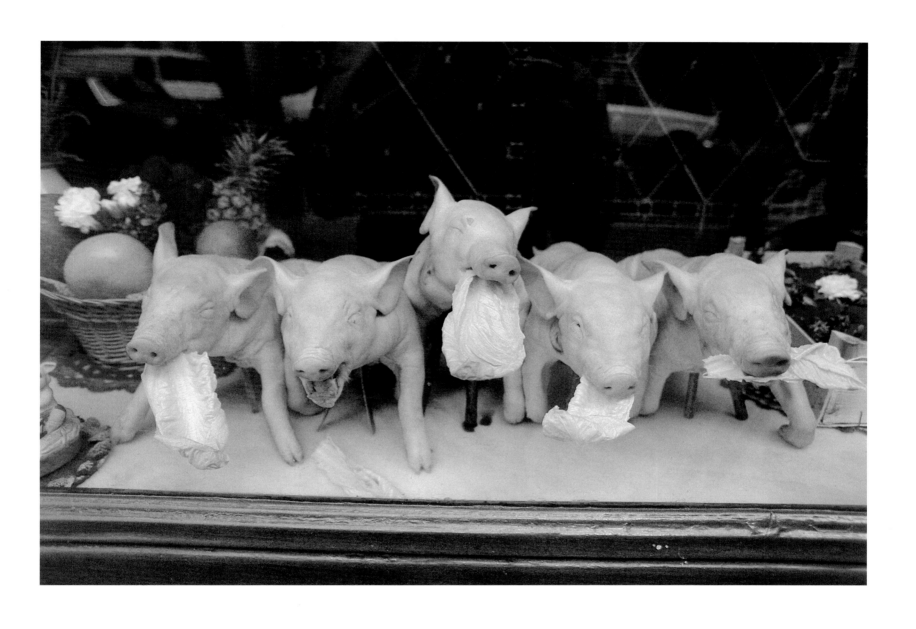

155. O. L. Mazzatenta, Madrid, Spain, 1985

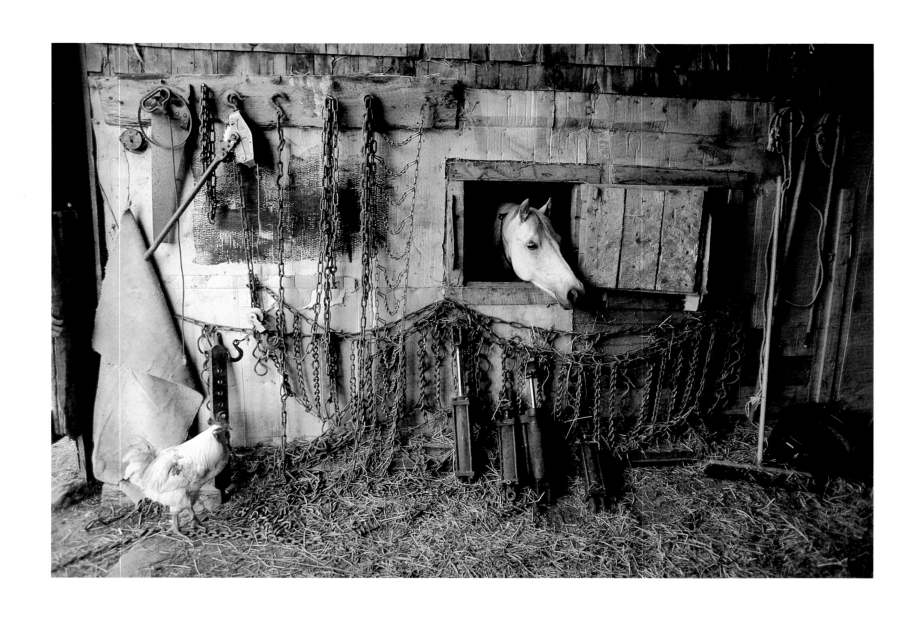

156. Cary Wolinsky, near St. Agatha, Maine, 1978

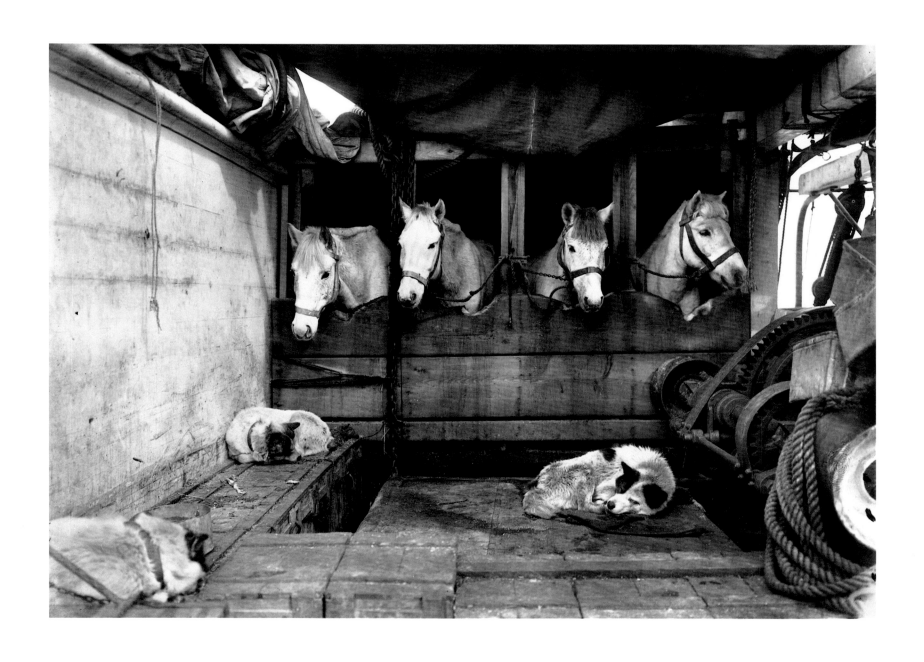

157. Herbert G. Ponting, Antarctica, 1910

158. Peter Magubane, South Africa, 1985

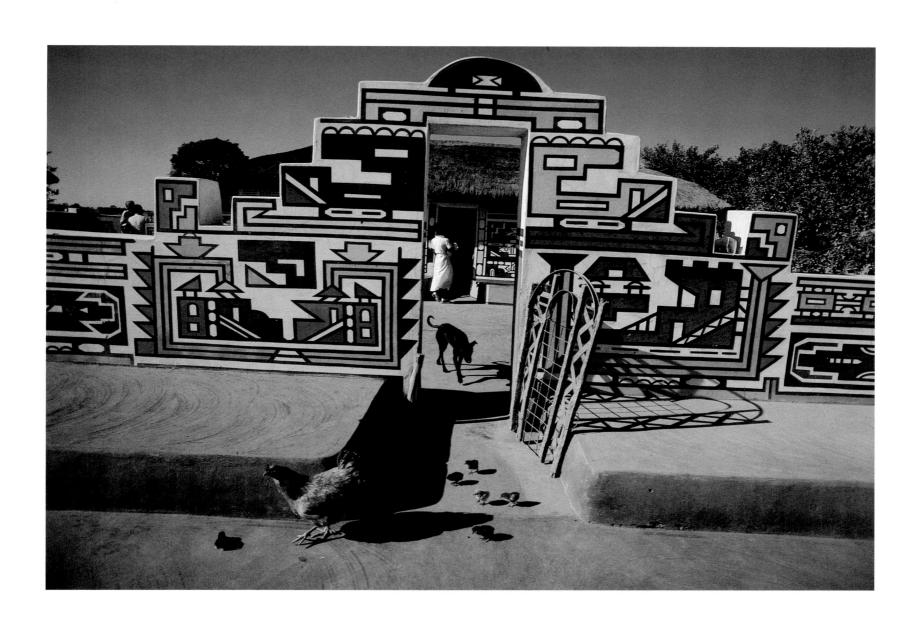

159. William Belknap, Jr., Las Vegas, Nevada, c. 1948

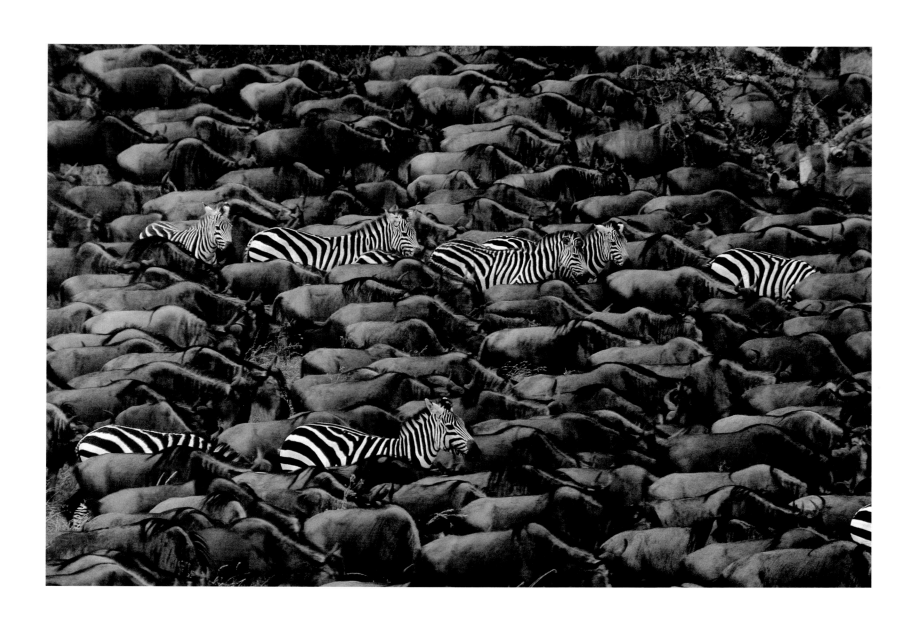

160. Mitsuaki Iwago, Serengeti National Park, Tanzania, 1985

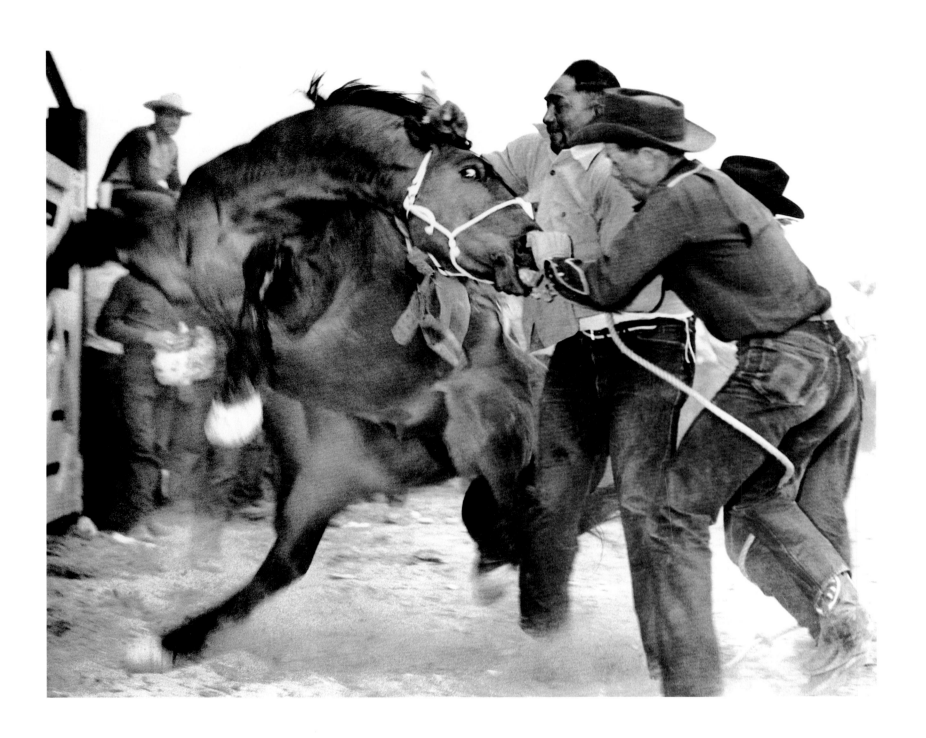

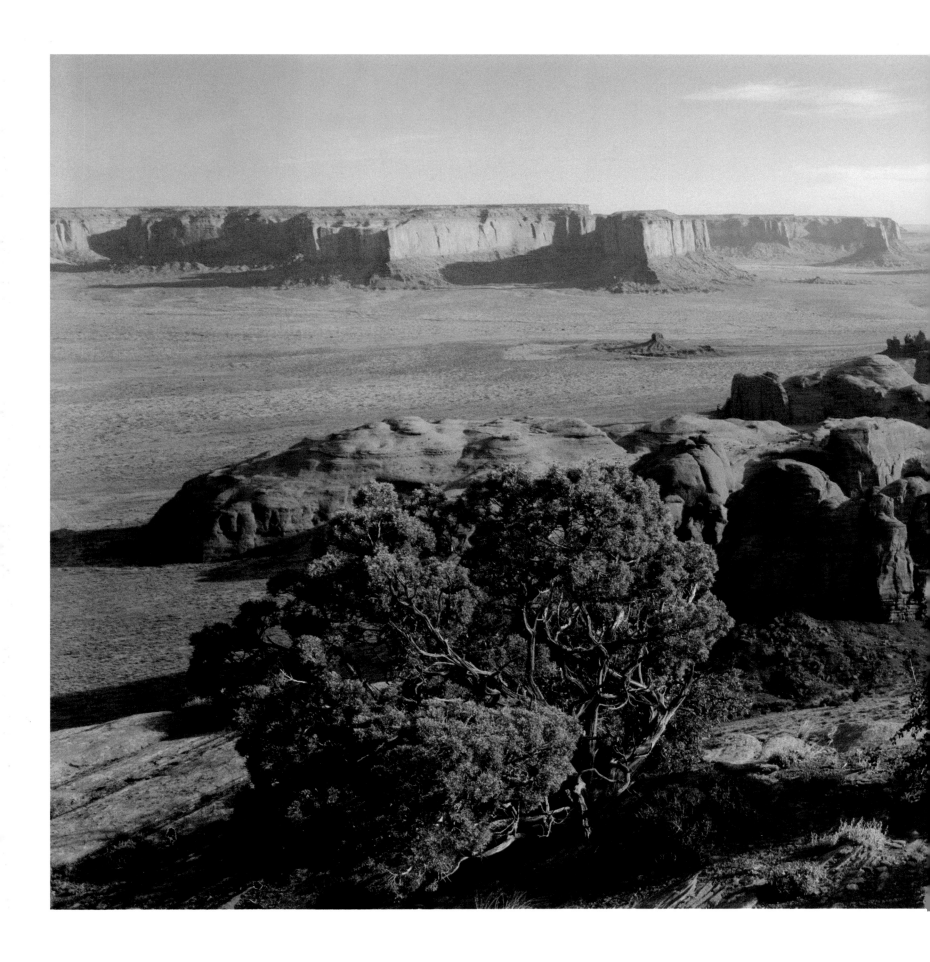

162. Ric Ergenbright, Monument Valley, Utah/Arizona border, 1985

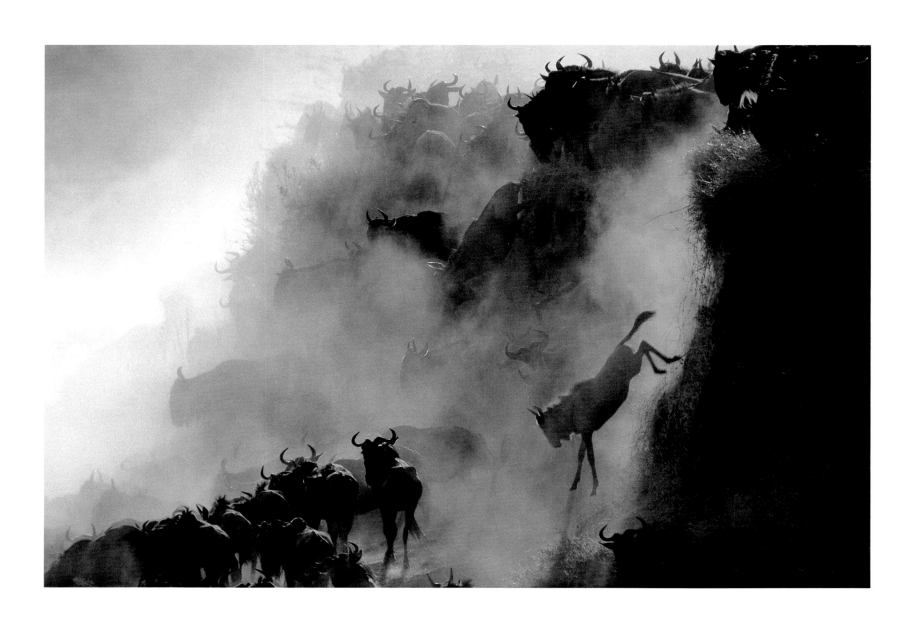

161. Mitsuaki Iwago, Serengeti National Park, Tanzania, 1985

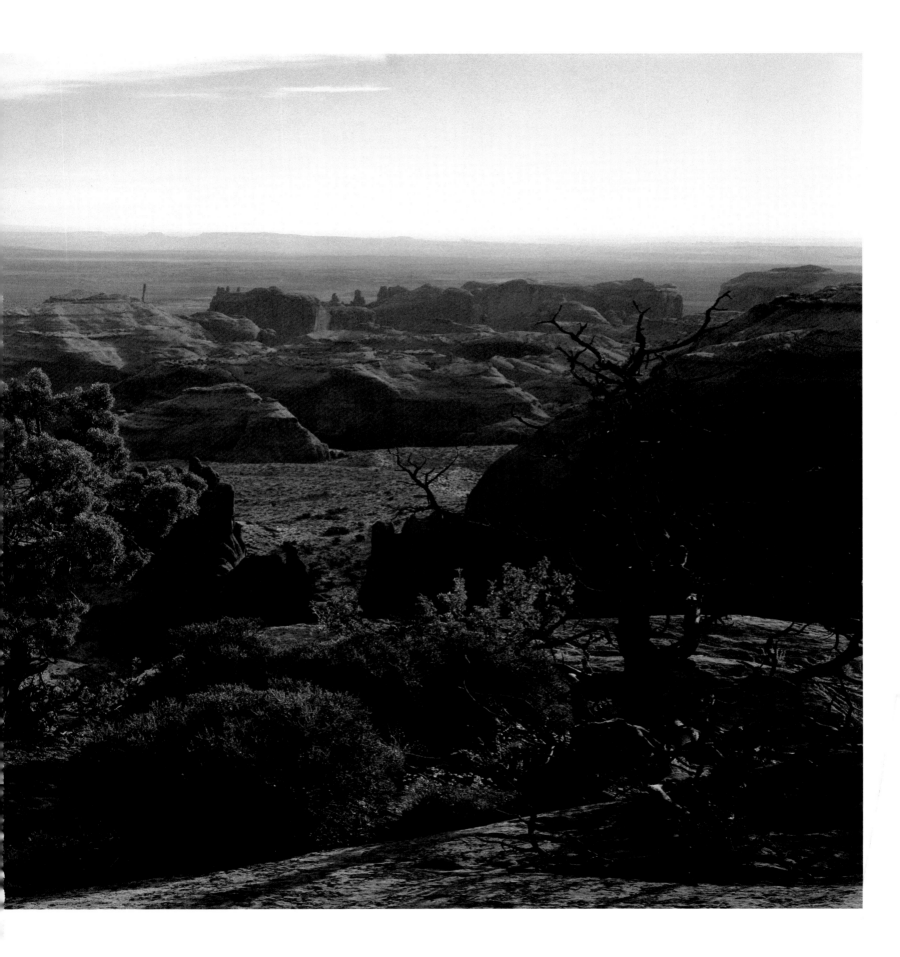

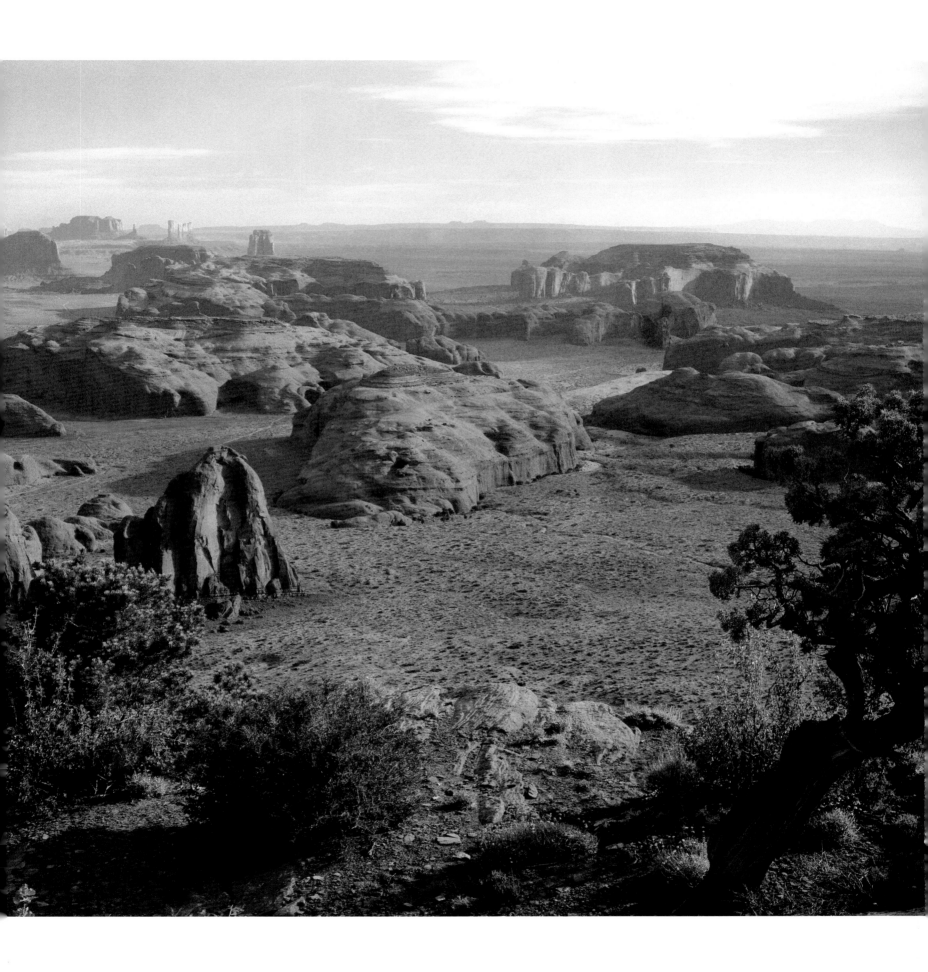

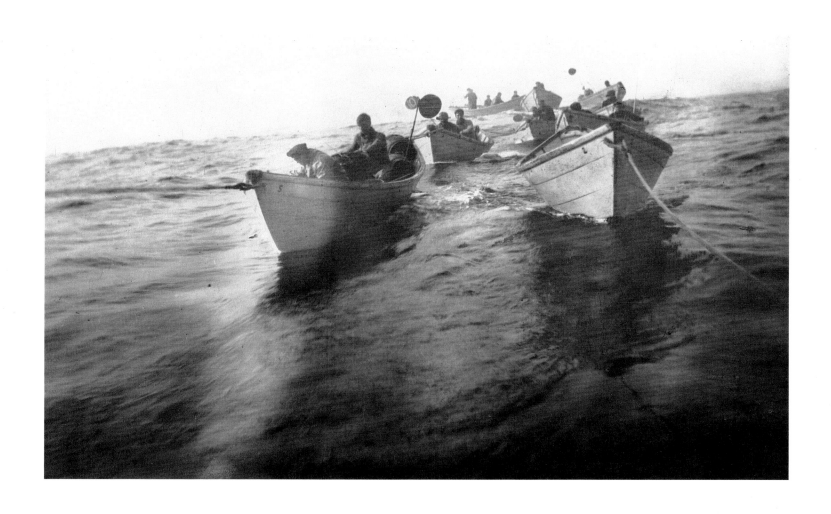

163. Frederick William Wallace, Grand Banks, Atlantic Ocean, n.d.

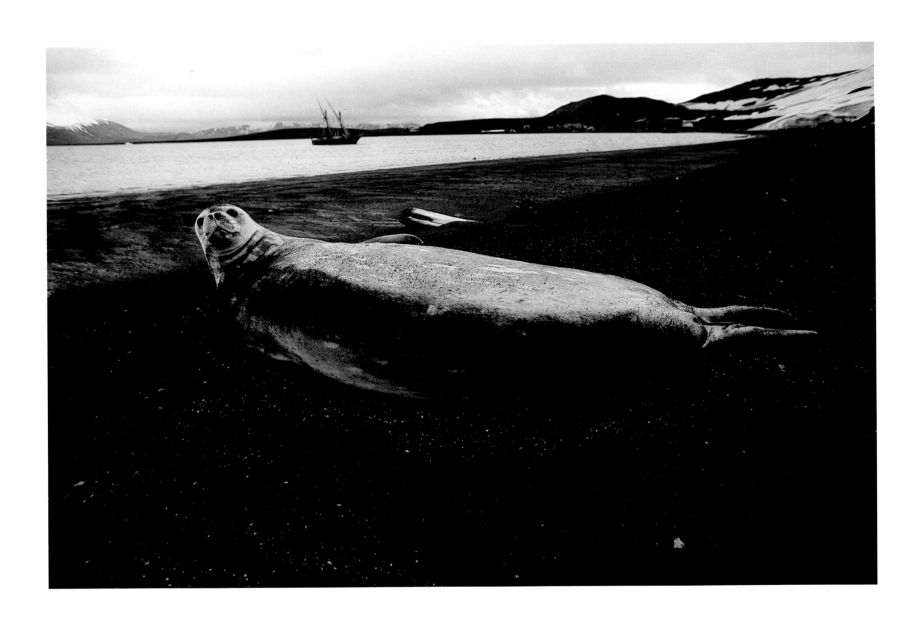

164. Bill Curtsinger, Deception Island, Antarctica, 1979

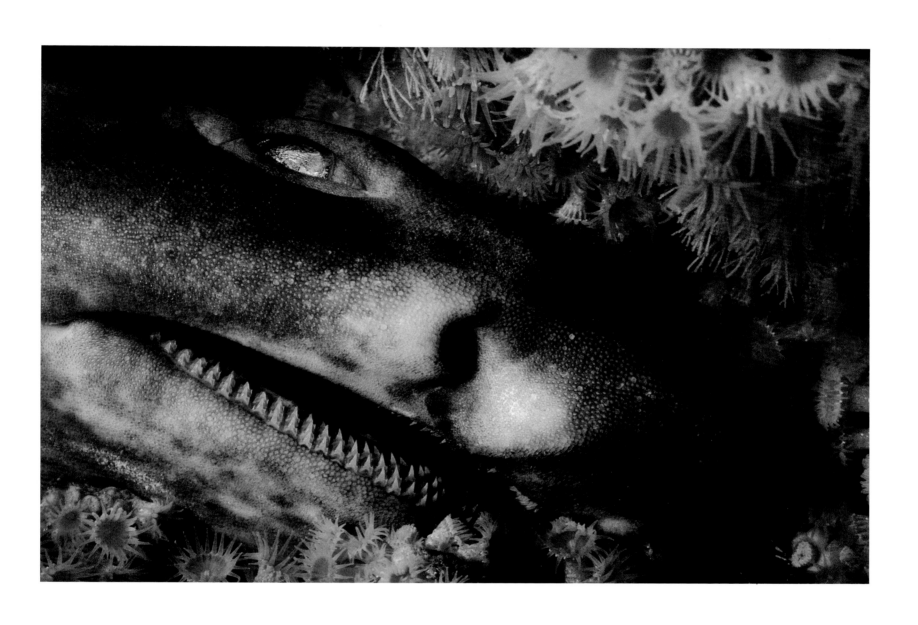

165. Flip Nicklin, California, 1980

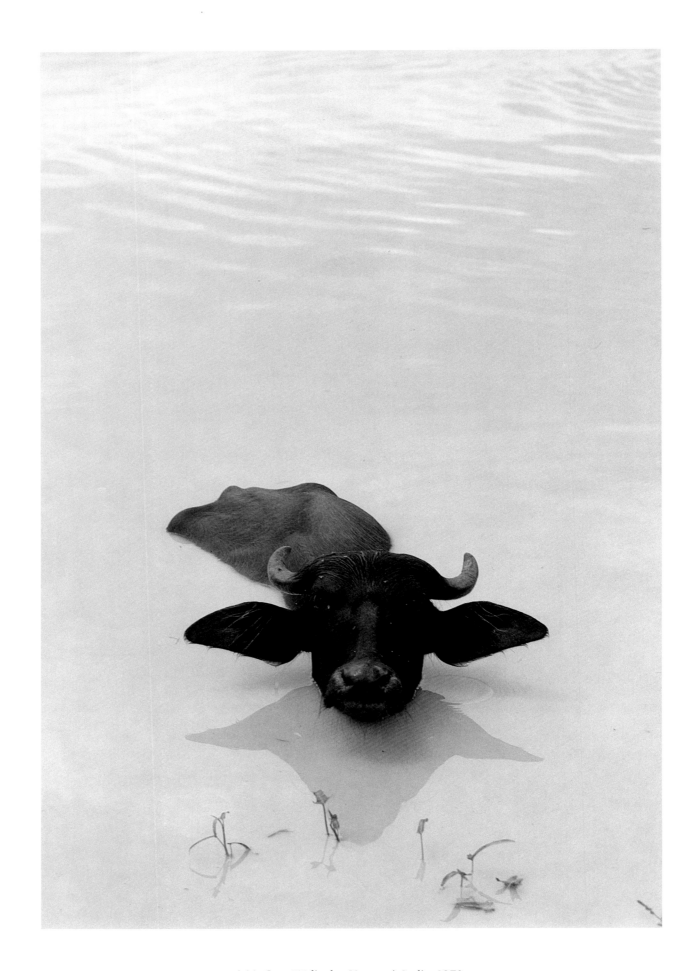

166. Cary Wolinsky, Varanasi, India, 1973

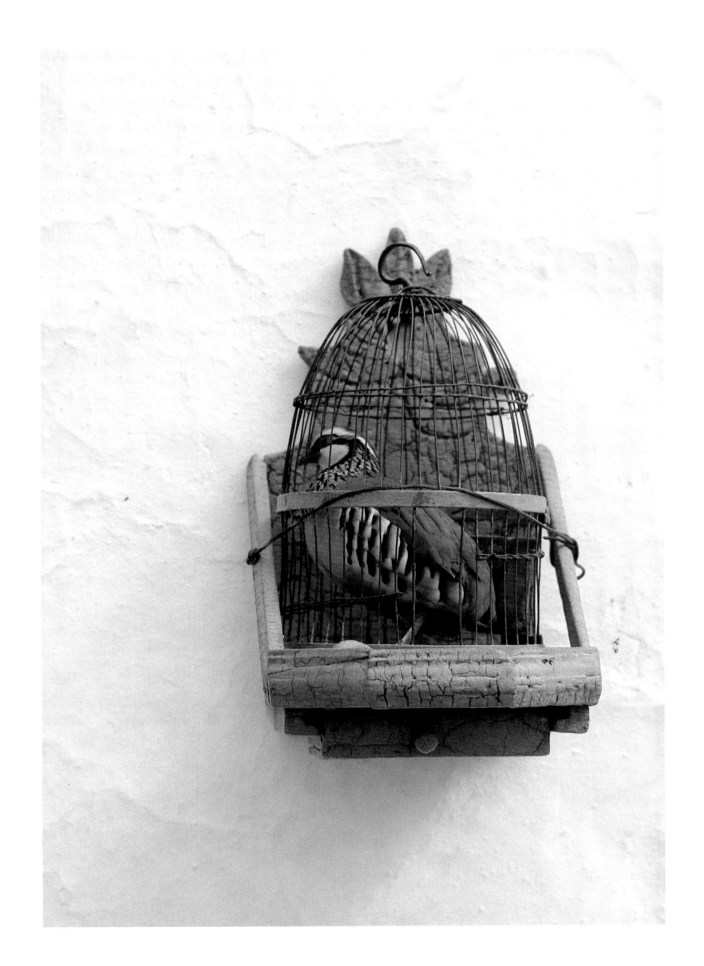

167. Joe Scherschel, Andalusia, Spain, 1972

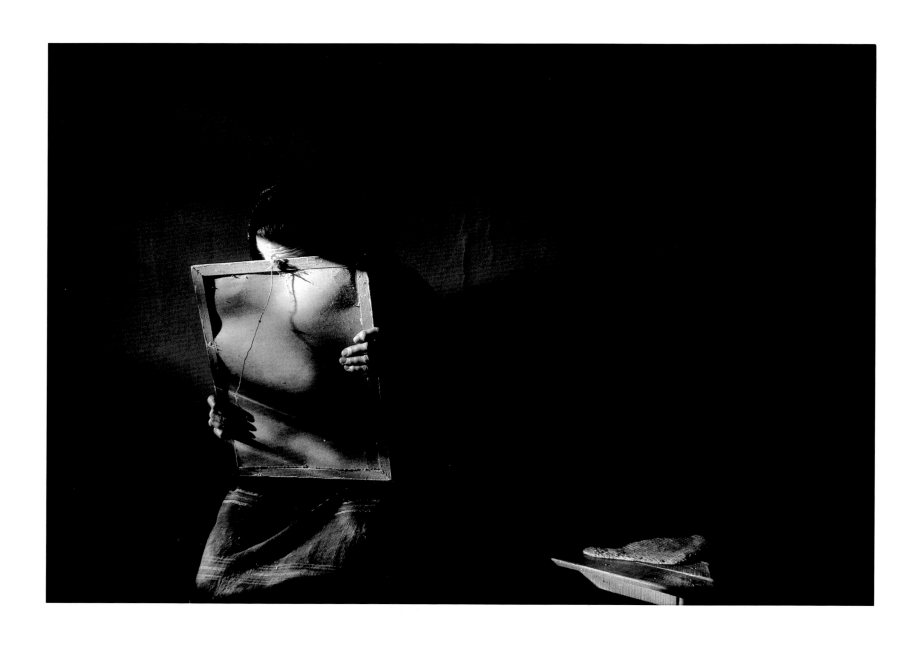

168. James L. Stanfield, Goma Sushitsa, Bulgaria, 1978

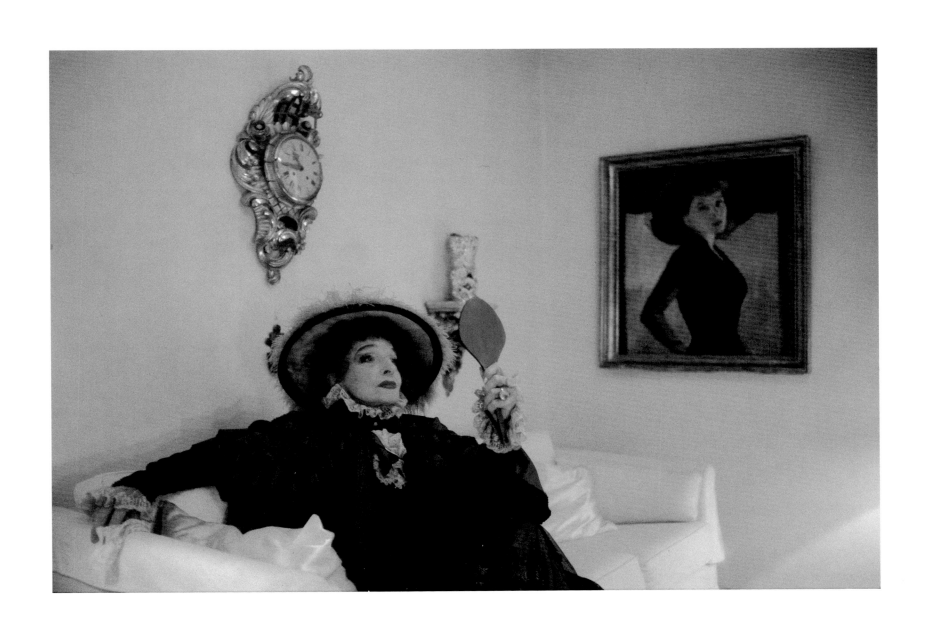

169. Jodi Cobb, Helsinki, Finland, 1980

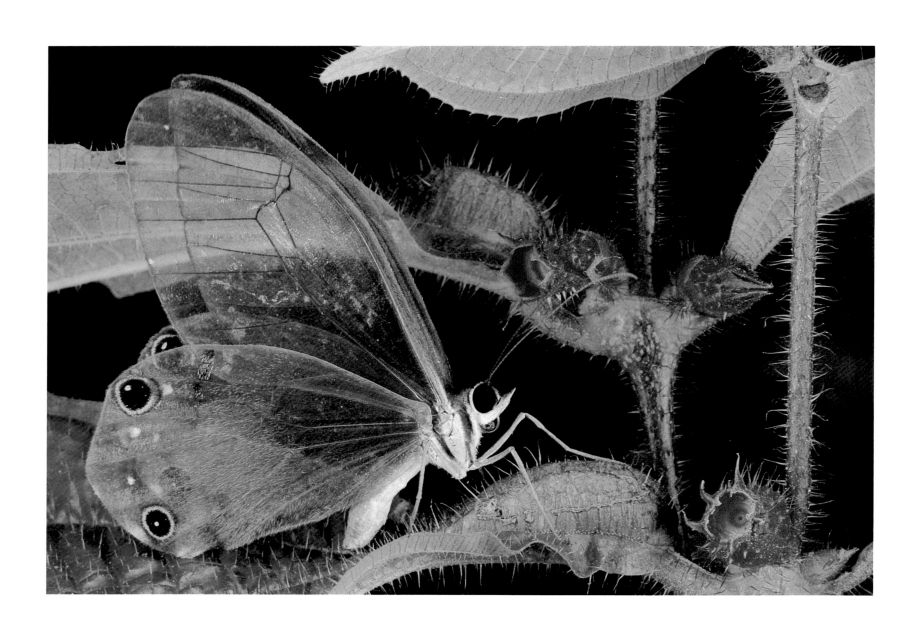

170. Paul Zahl, Brazil, c. 1958

171. Sam Abell, London, England, 1980

172. Rear Admiral Donald B. MacMillan, Etah, Greenland, n.d.

173. Cary Wolinsky, Ulyanovsk, Soviet Union, 1983

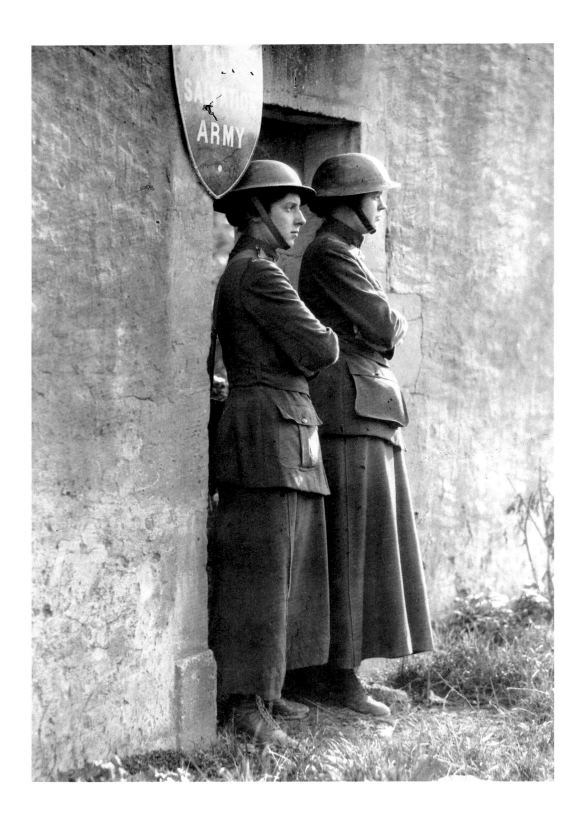

174. Colonel E. J. Parker, France, 1918

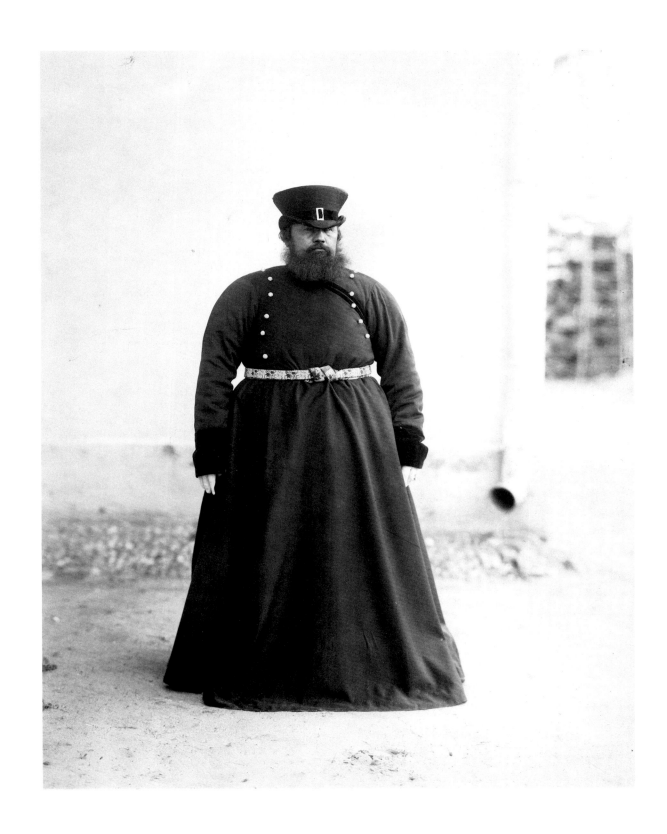

175. Photographer unknown, Russia (Soviet Union), n.d.

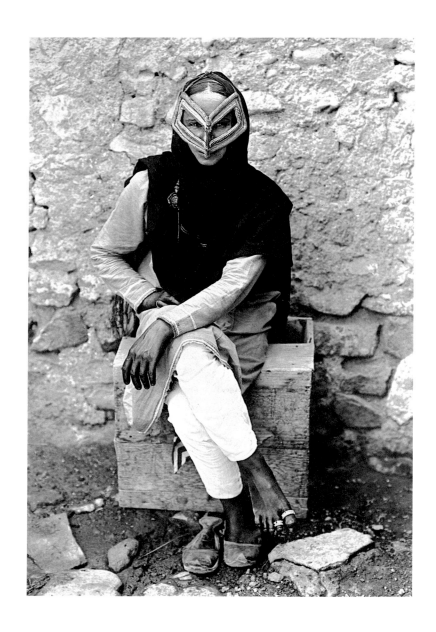

176. Photographer unknown, Oman, 1917

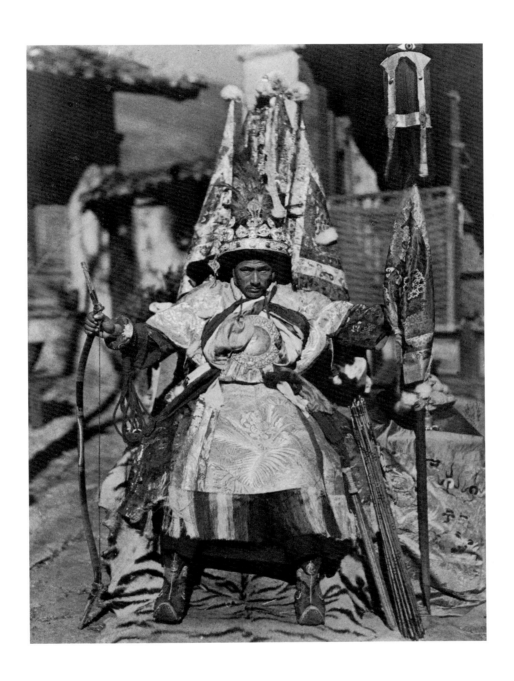

177. Joseph F. Rock, China, 1928, *autochrome*

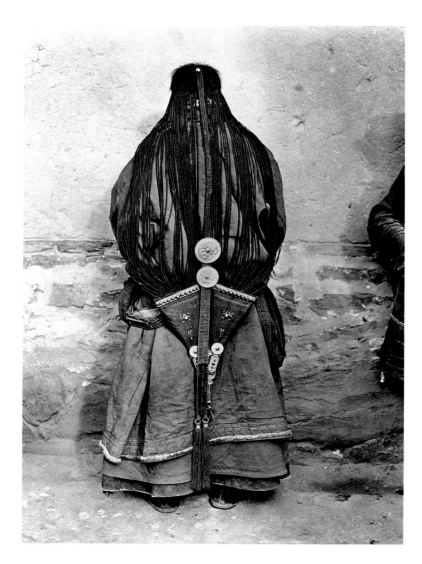

178. Joseph F. Rock, Choni, China, 1925

179. Joseph K. Dixon, North America, c. 1913

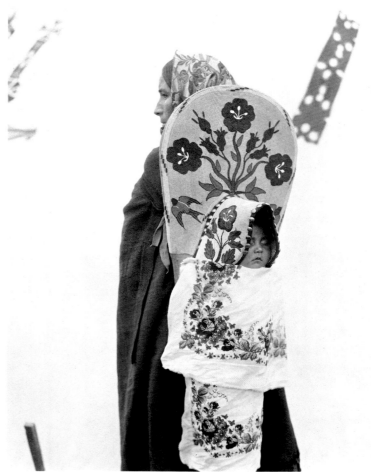

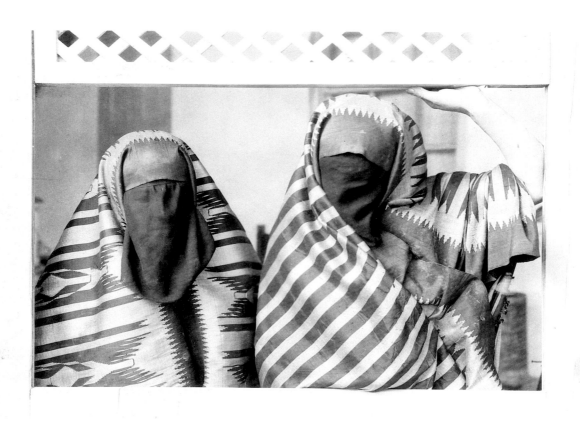

180. Ernest B. Schoedsack, Turkey, 1925

181. Joseph F. Rock, Choni, China, 1925

182. Jacob Gayer, Rio de Janeiro, Brazil, 1930

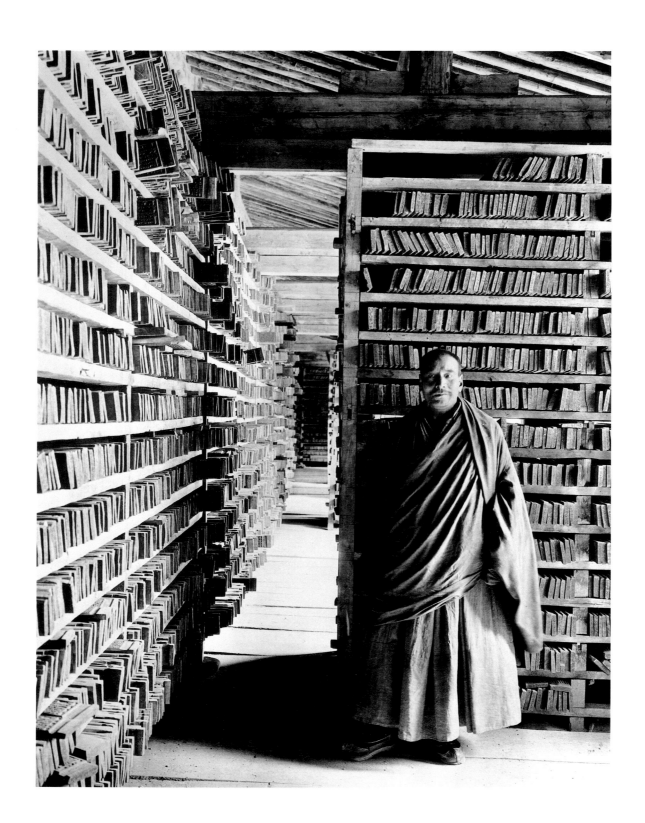

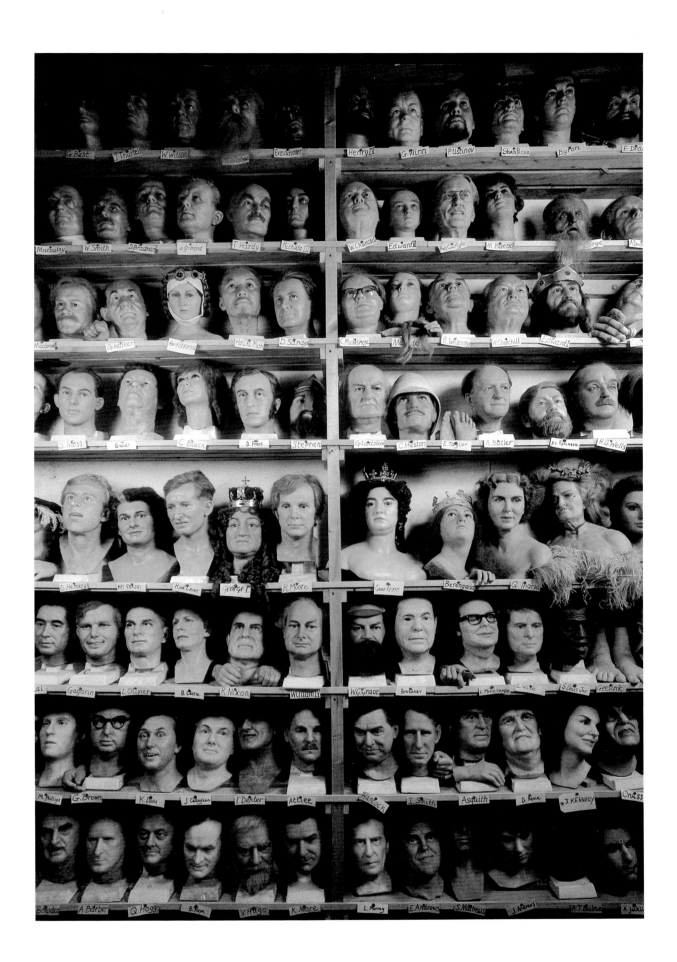

183. Cary Wolinsky, Wookey Hole, Somerset, England, 1978

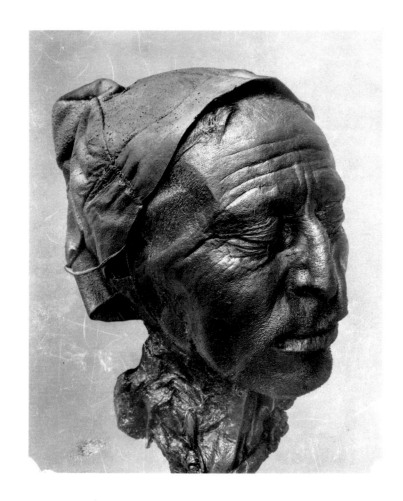

184. Lennart Larsen, Denmark, 1952

185. P. V. Glob, Denmark, 1952

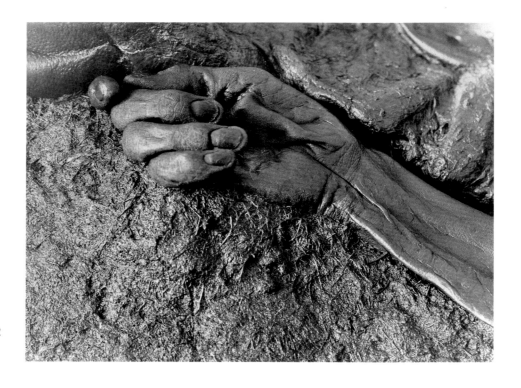

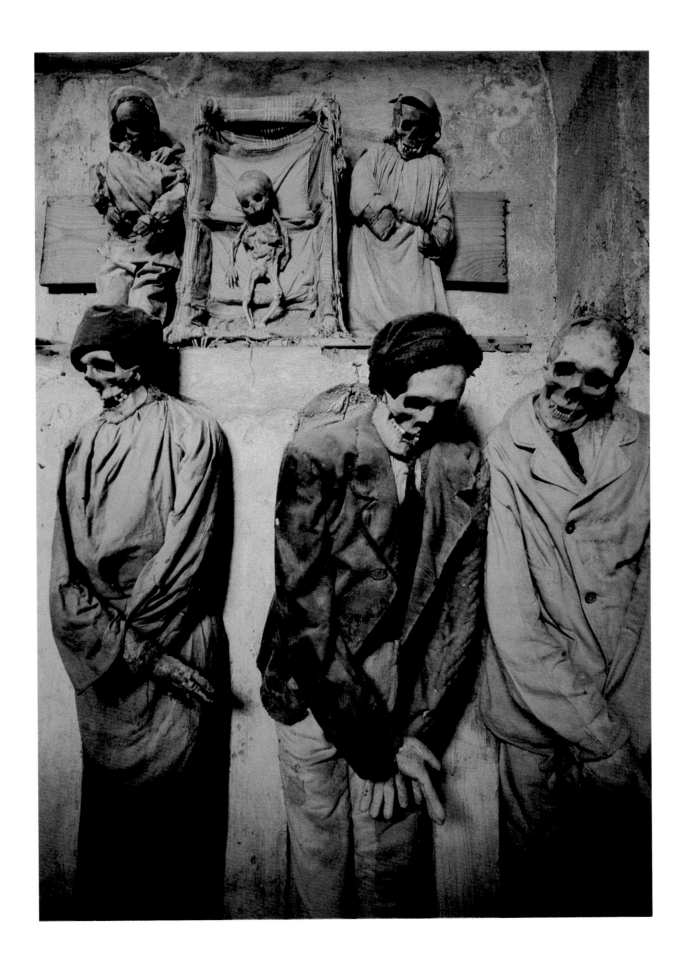

186. Jonathan Blair, Palermo, Sicily, Italy, 1974

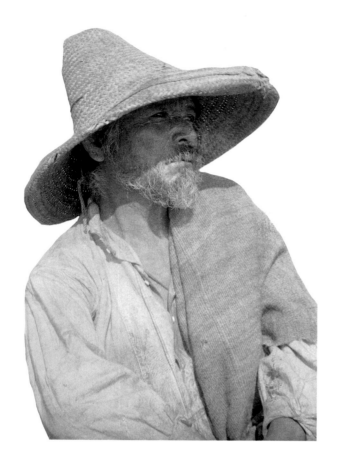

187. Hugo Brehme, Mexico, c. 1915

188. Hugo Brehme, Mexico, c. 1915

189. Luis Marden, Chichicastenango, Guatemala, 1936

190. Admiral Robert E. Peary, Greenland, 1892

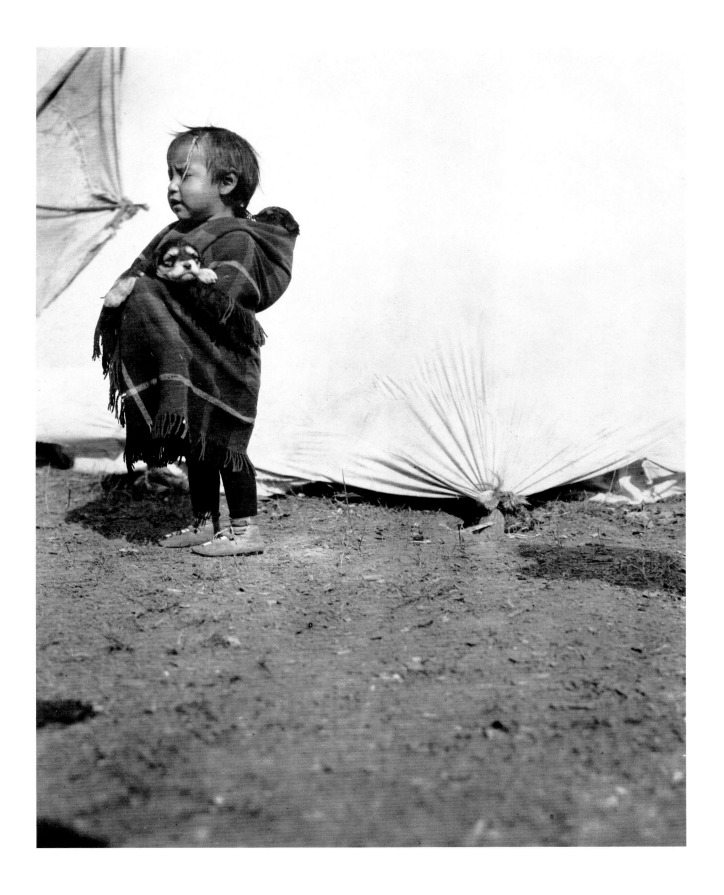

191. Joseph K. Dixon, North America, c. 1913

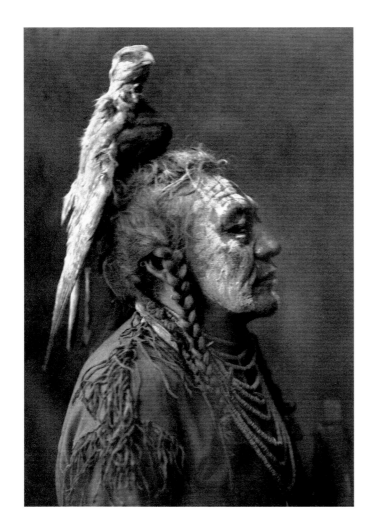

192. Edward S. Curtis, Montana, 1908

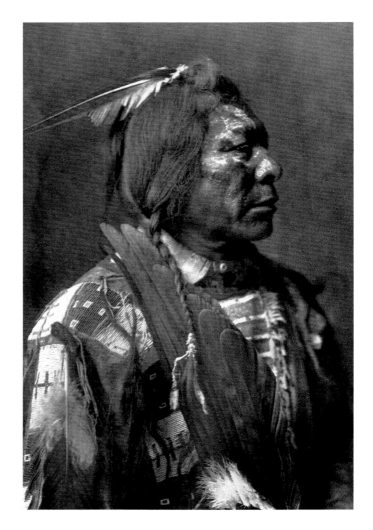

193. Edward S. Curtis, Montana, 1908

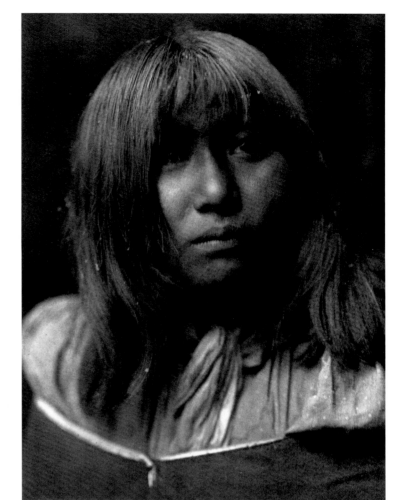

195. Edward S. Curtis, Arizona, 1907

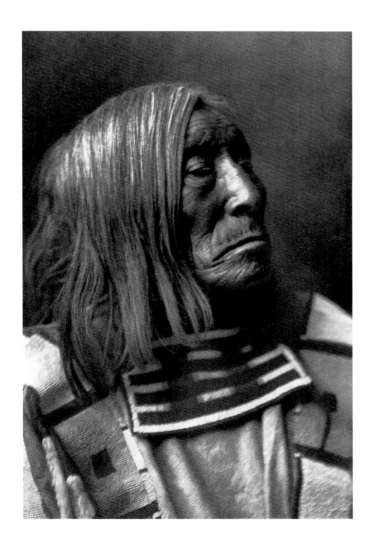

194. Edward S. Curtis, Montana, 1908

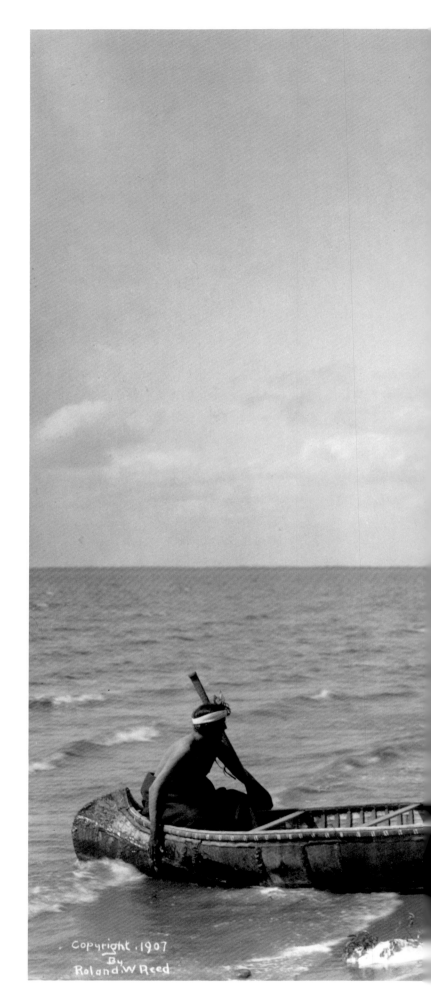

196. Roland W. Reed, North America, 1907

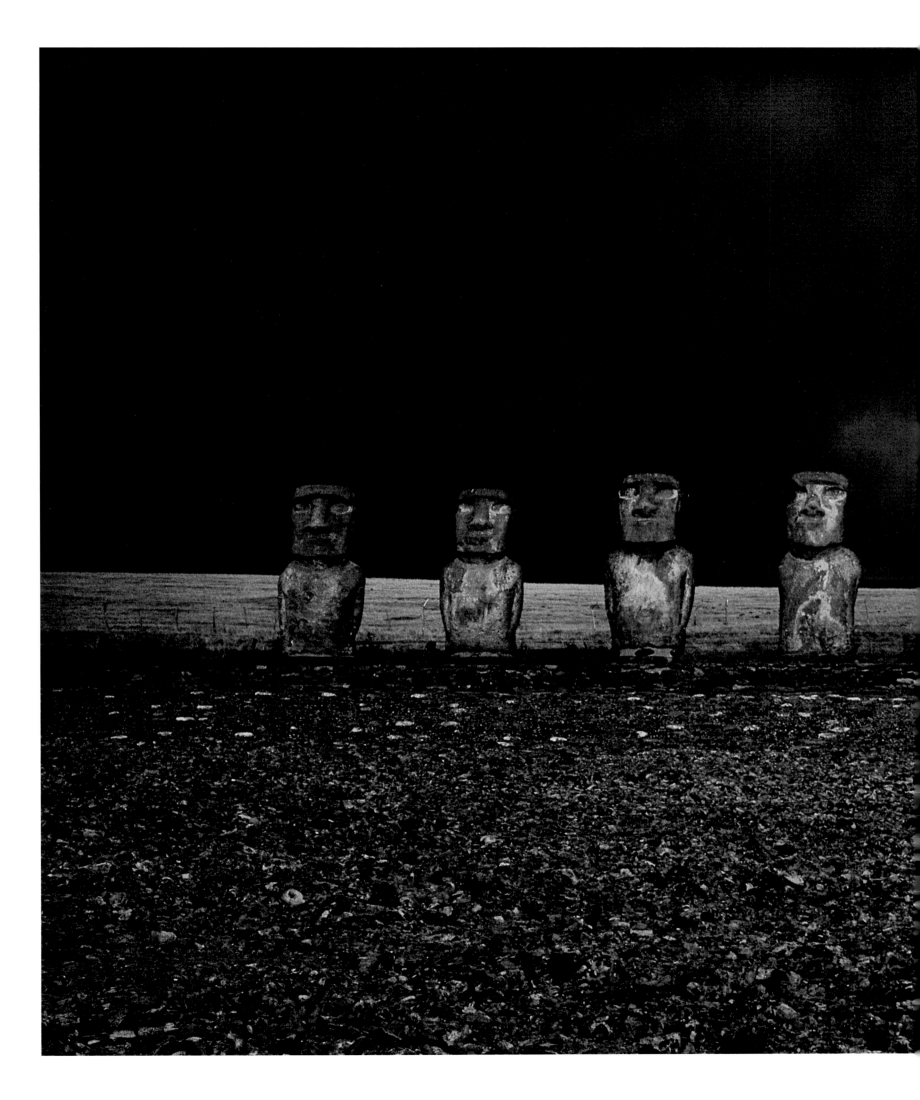

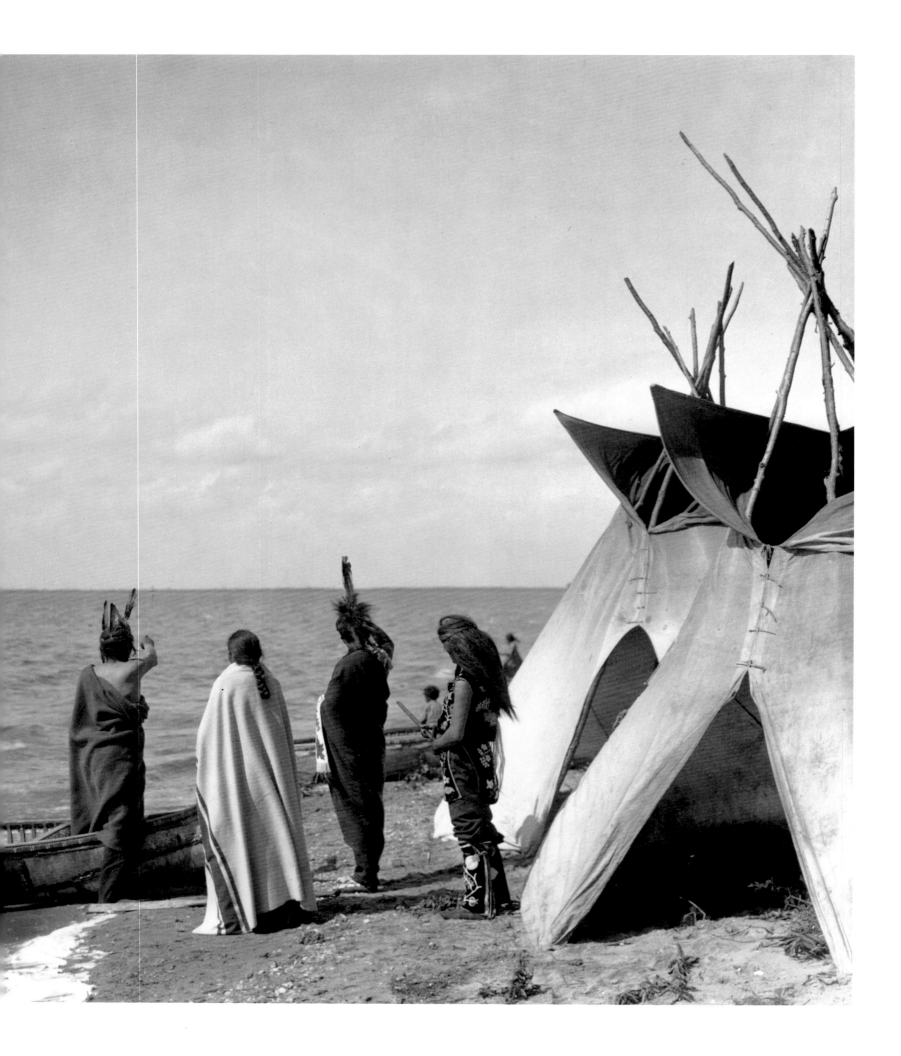

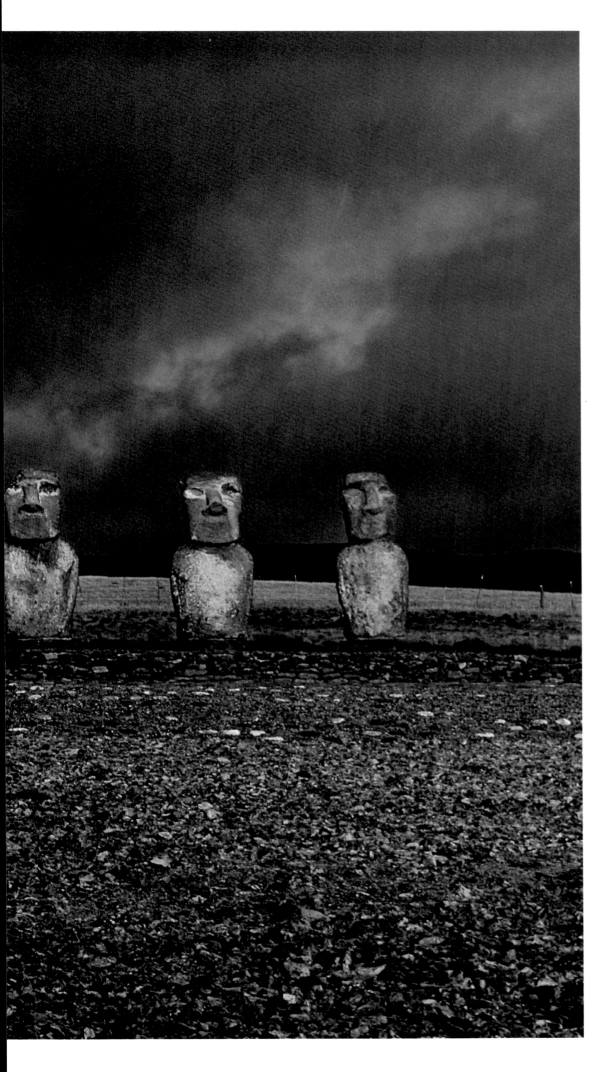

197. Thomas J. Abercrombie,
Easter Island, Pacific Ocean, 1961

198. Jim Brandenburg, Namibia, 1981

199. Wolfgang Kaehler, Bransfield Strait, 1985

200. Alan Root, Mzima Springs, Kenya, 1971

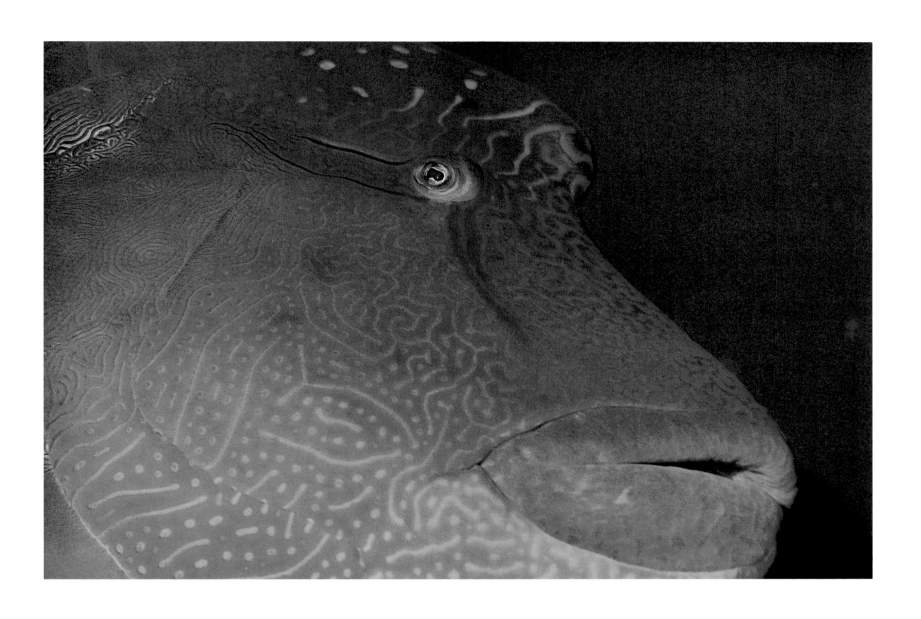

201. David Doubilet, Red Sea, Sinai, Israel (Egypt), 1981

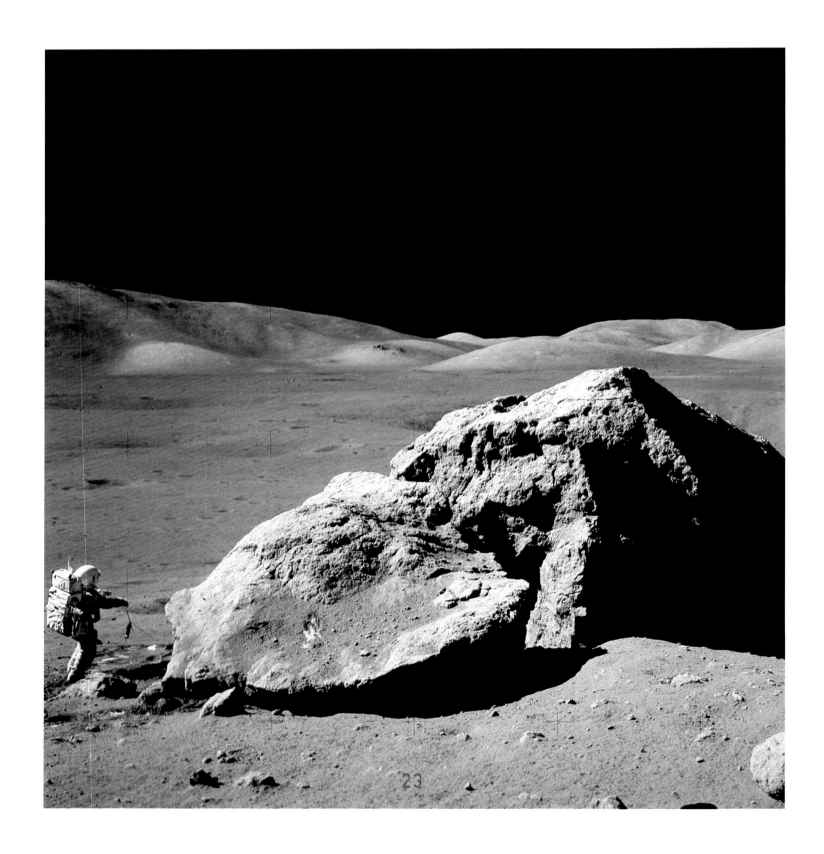

202. Eugene A. Cernan, Moon, 1972

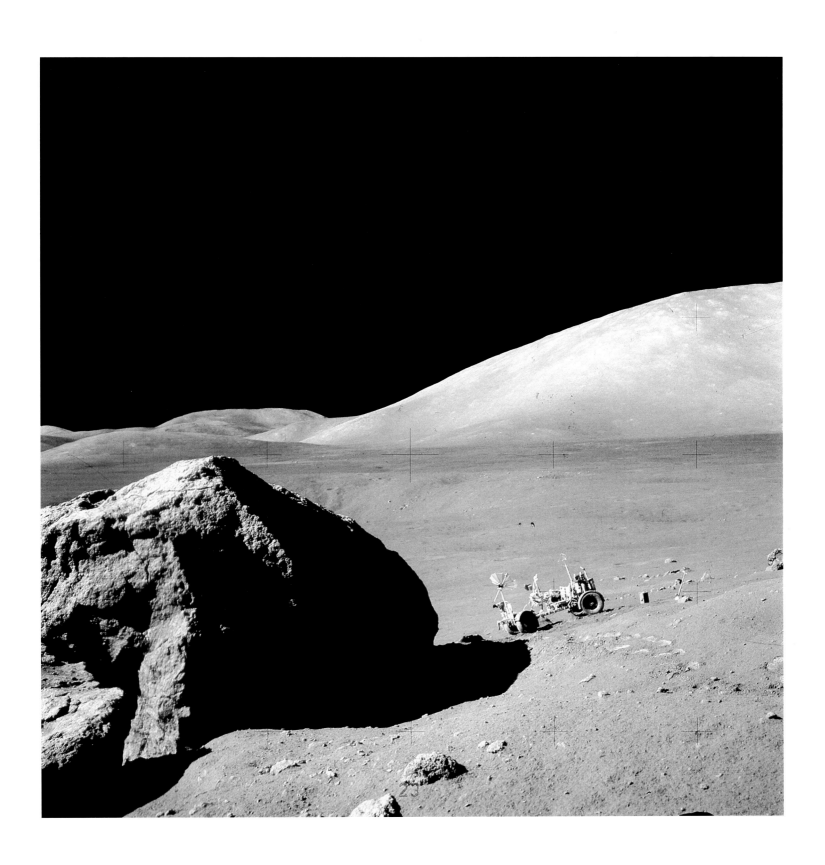

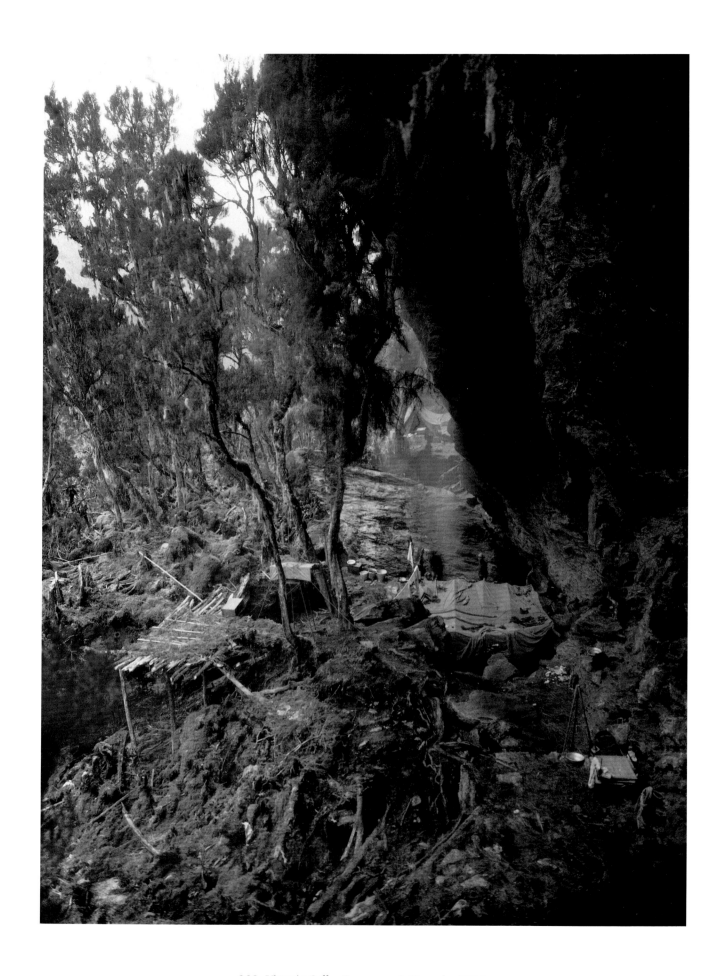

203. Vittorio Sella, Ruwenzori, Uganda, 1906

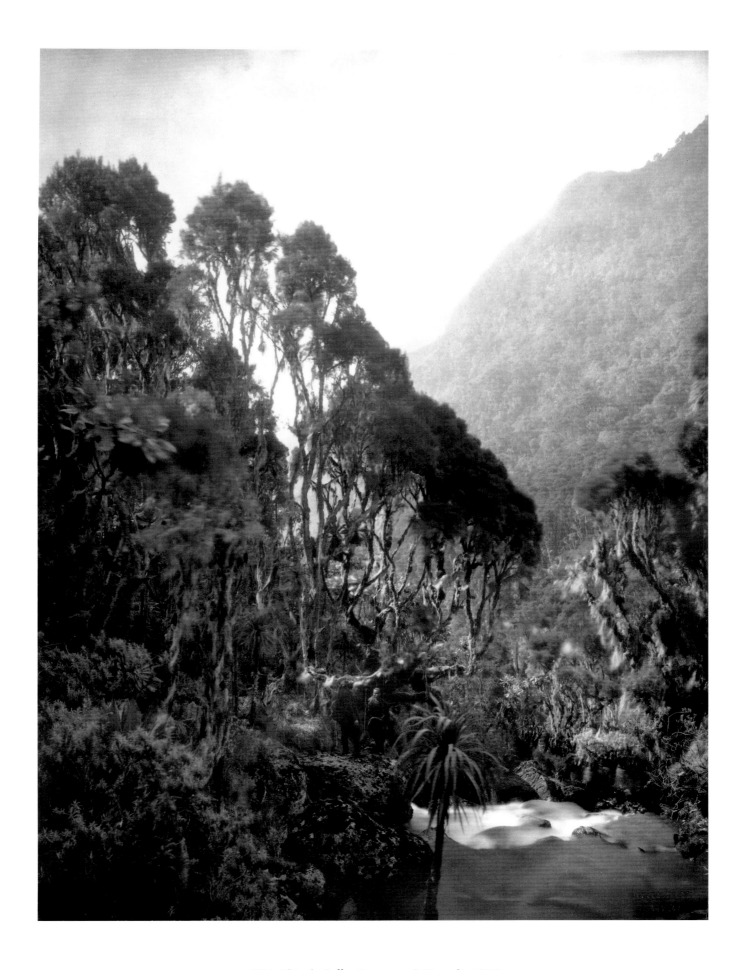

204. Vittorio Sella, Ruwenzori, Uganda, 1906

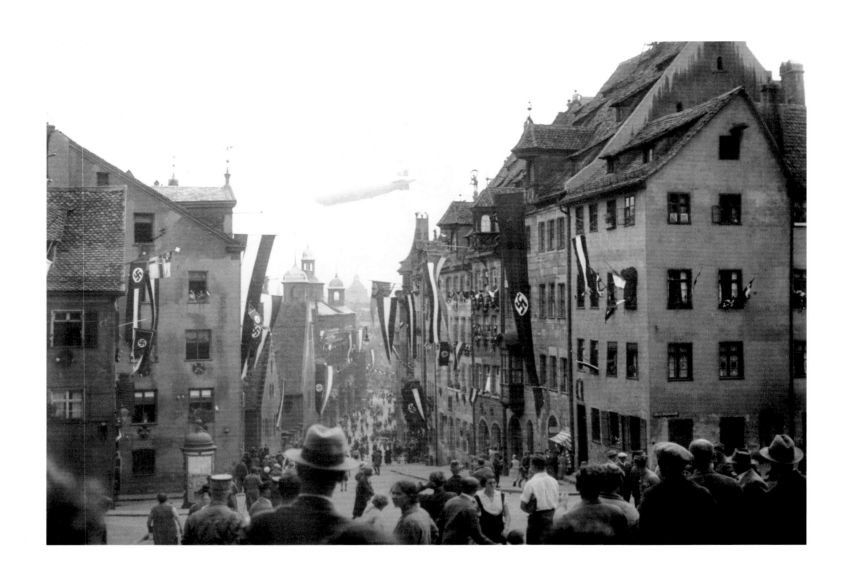

205. Merlin Minshall, Nürnberg, Germany (West Germany), c. 1936

206. Photographer unknown, Frankfurt, Germany (West Germany), n.d.

207. Nicholas John Caire, Australia, n.d.

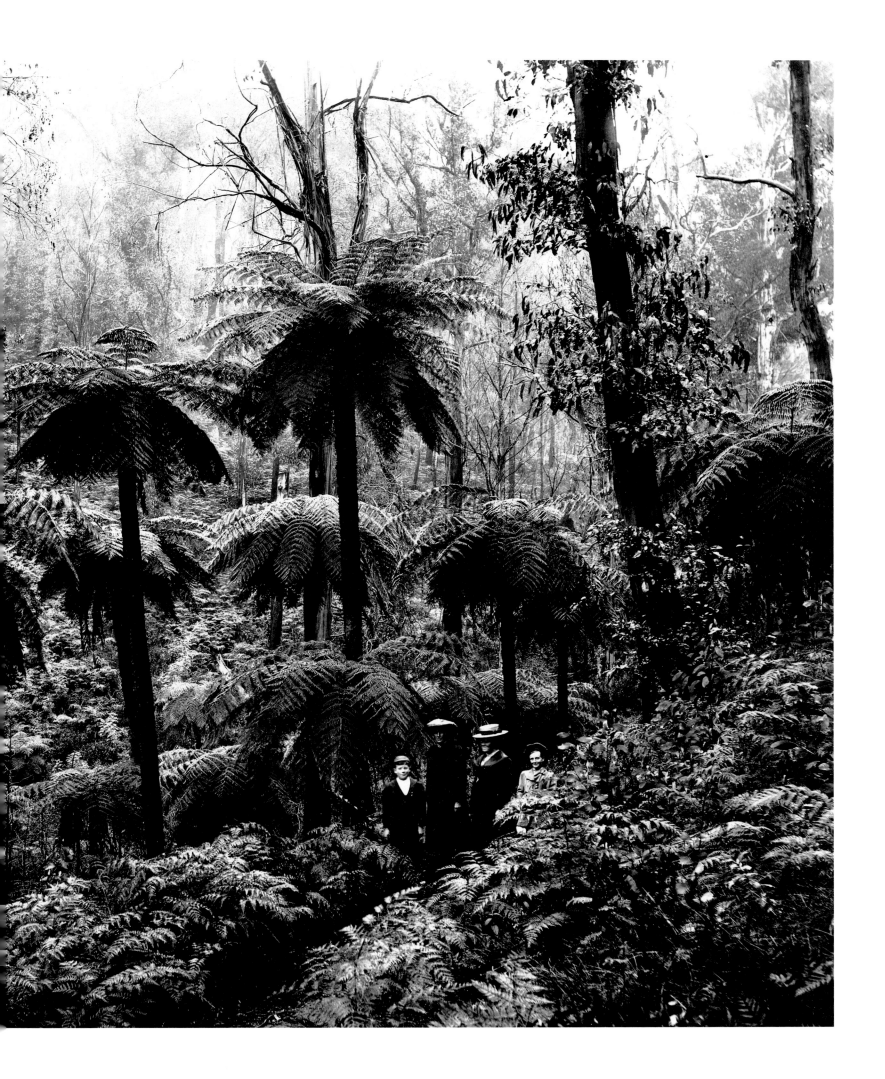

208. Steve Wall, California, 1982

209. Rear Admiral Donald B. MacMillan, Etah, Greenland, n.d.

211. Hiram Bingham, Tiahuanaco, Peru, c. 1912

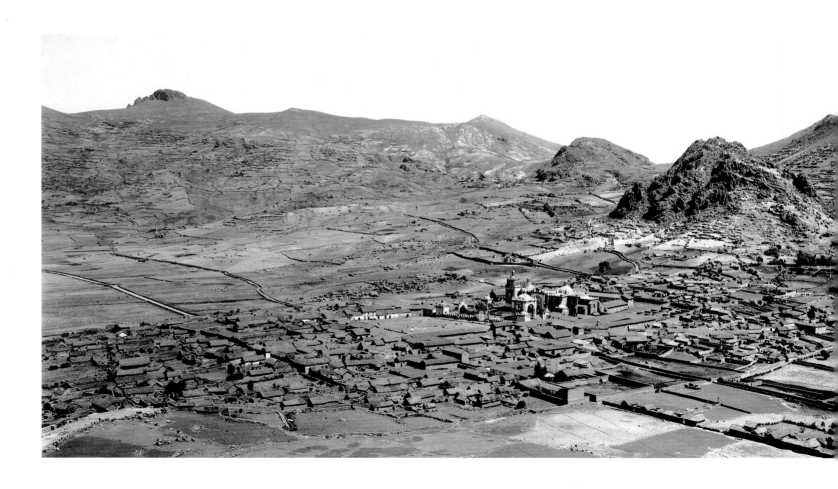

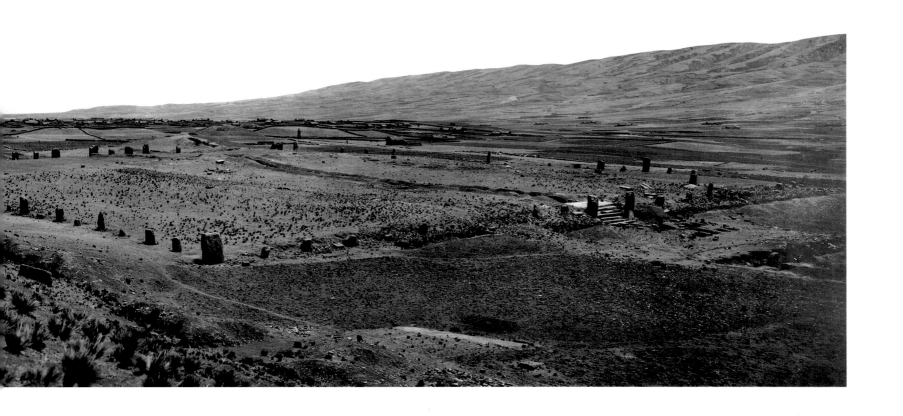

210. Hiram Bingham, Copacavana, Peru, c. 1912

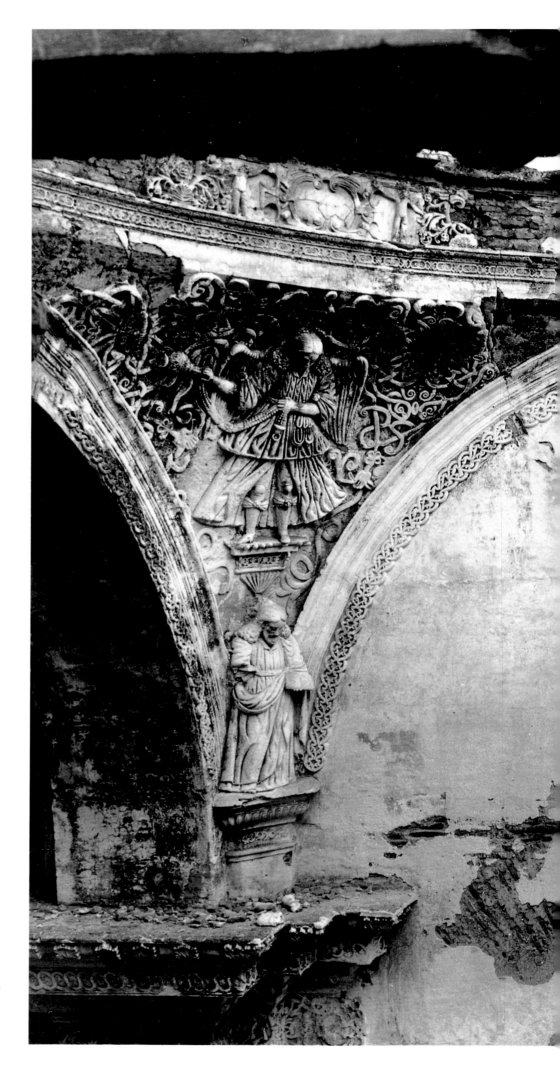

212. Luis Marden, Antigua, Guatemala, 1936

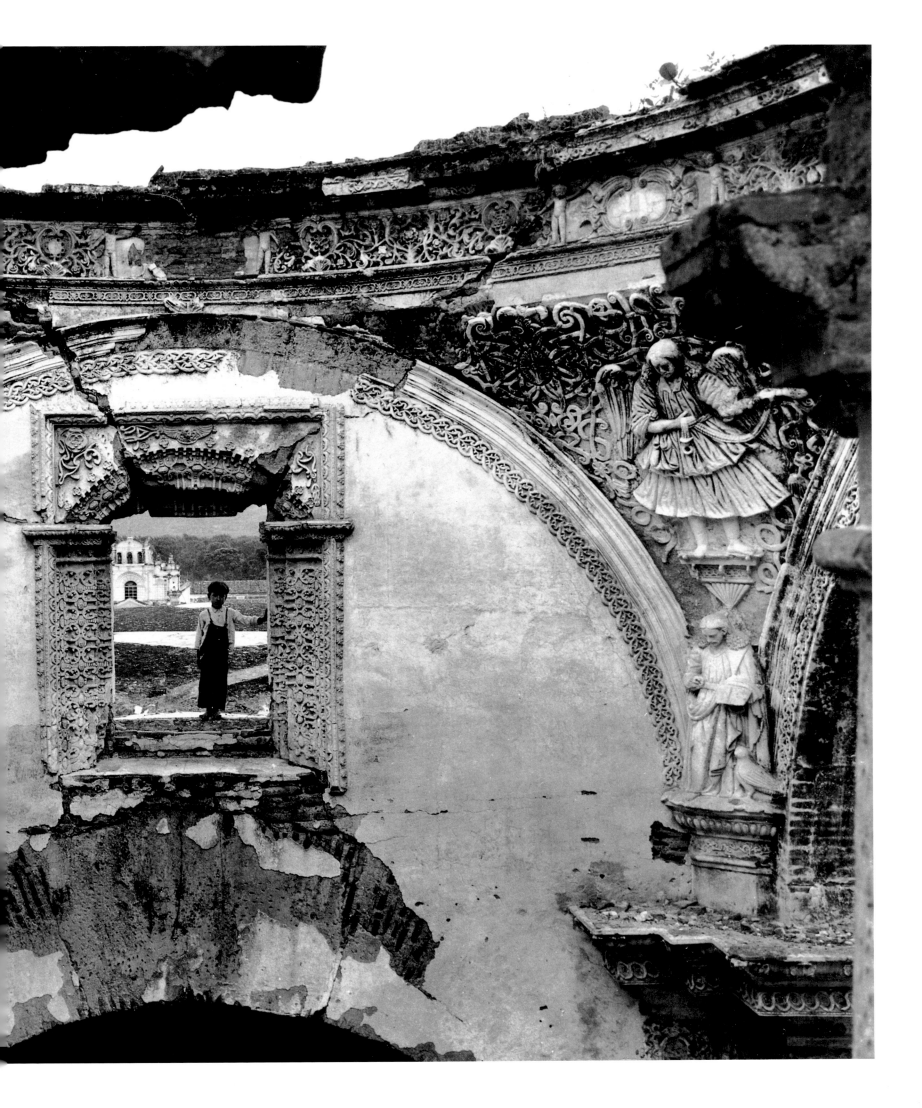

213. Steve McCurry, Rajasthan, India, 1983

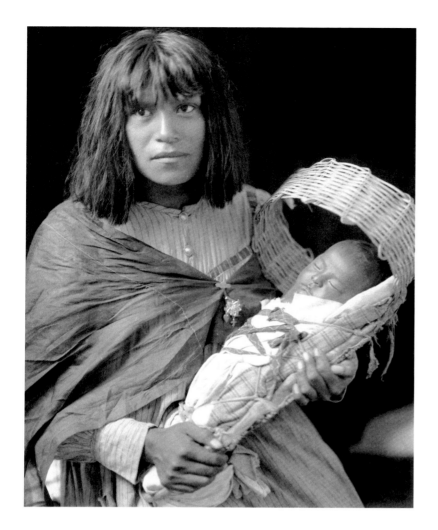

214. Joseph K. Dixon, Arizona, c. 1913

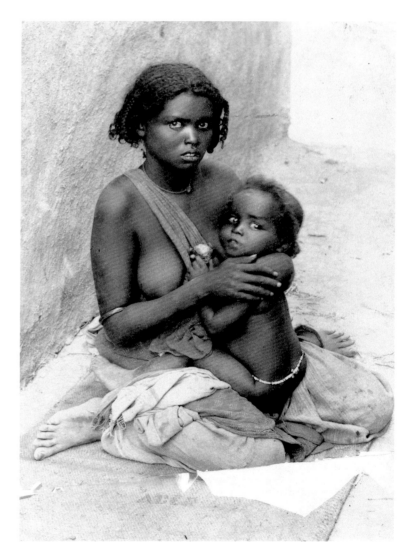

215. Helen Marian Place Moser, Aden (Yemen), c. 1909

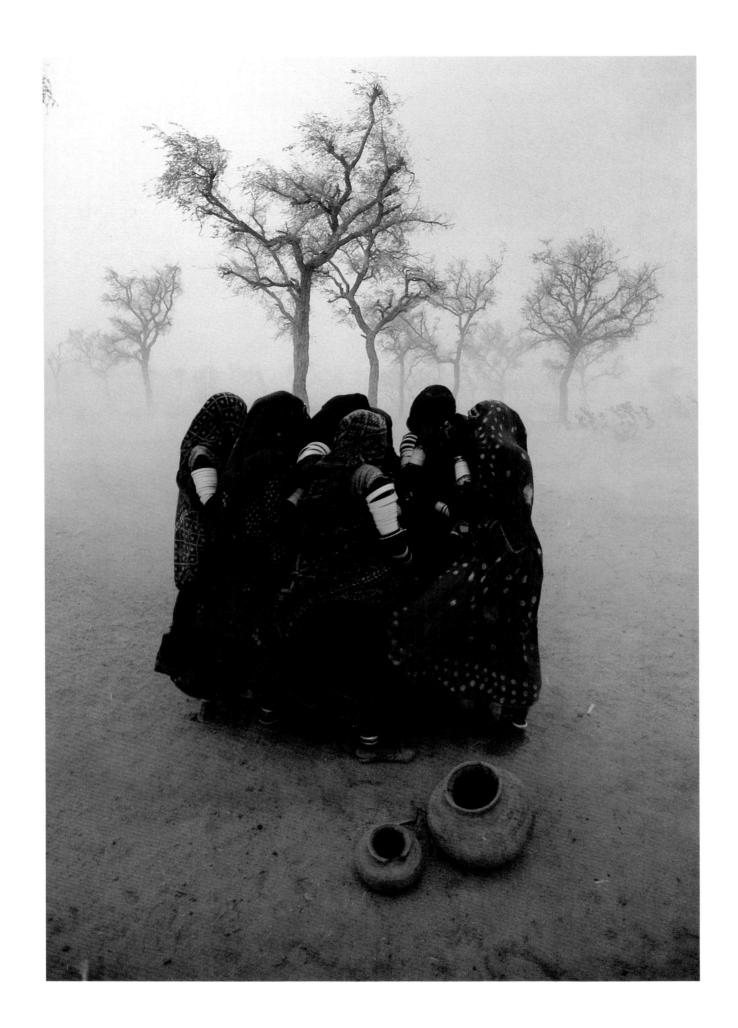

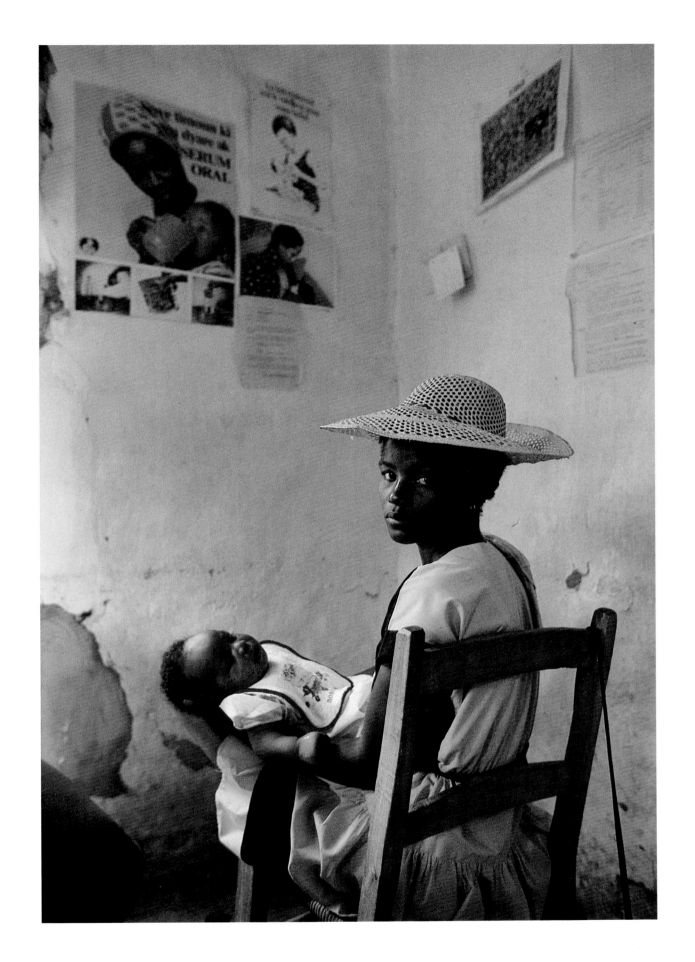

216. James P. Blair, Haiti, 1987

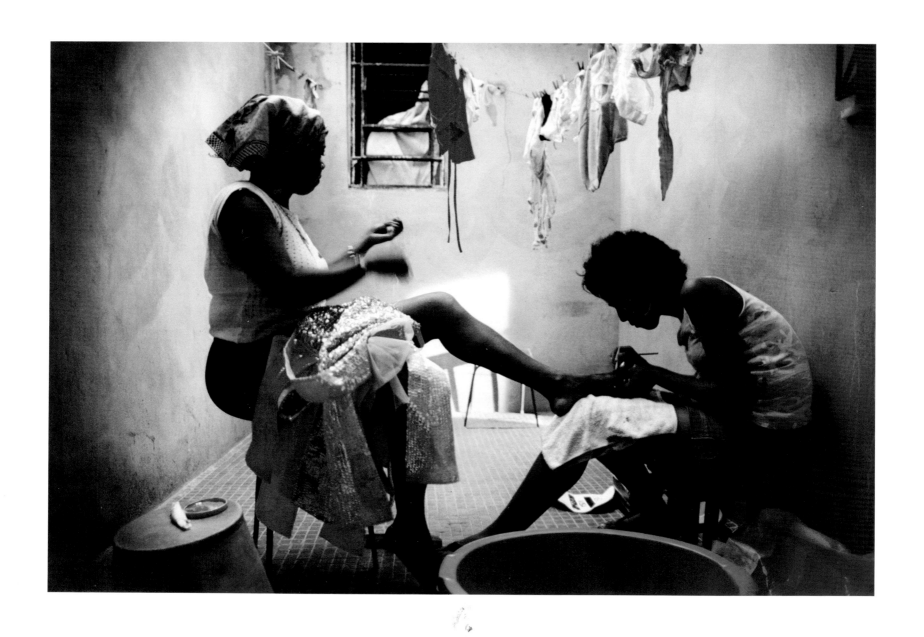

217. Stephanie Maze, Rio de Janeiro, Brazil, 1985

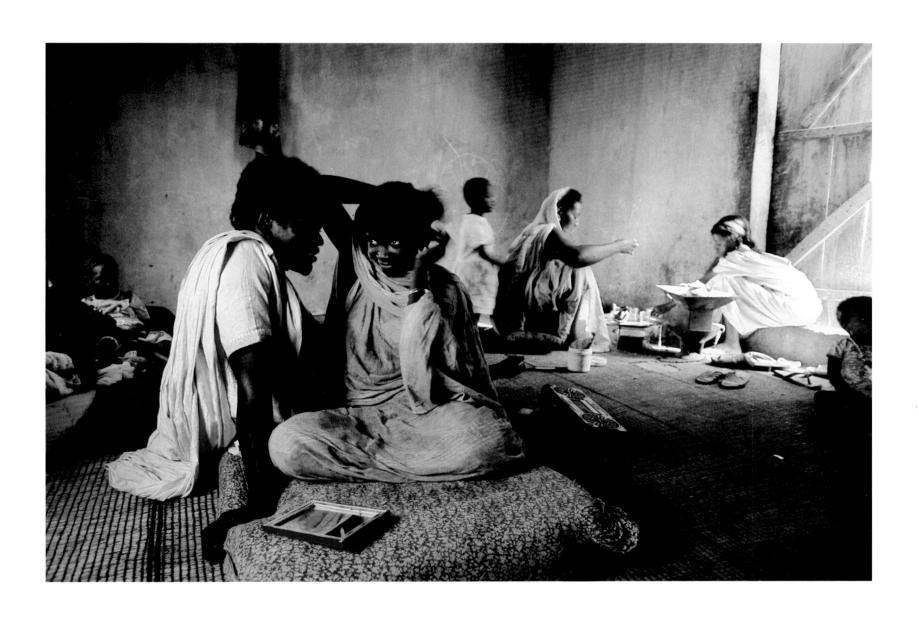

218. Steve McCurry, Tiguent, Mauritania, 1986

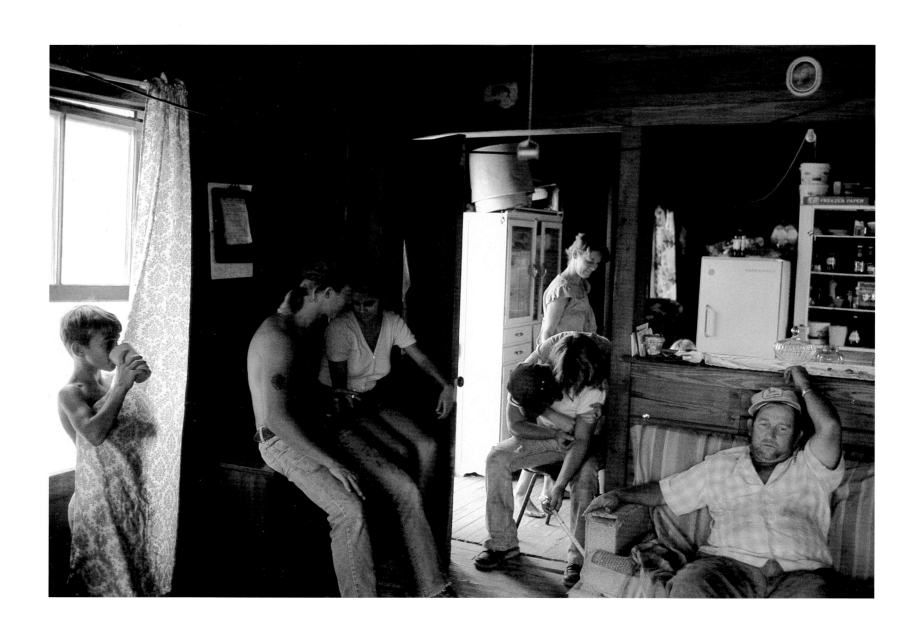

219. Jodi Cobb, Suwannee, Florida, 1976

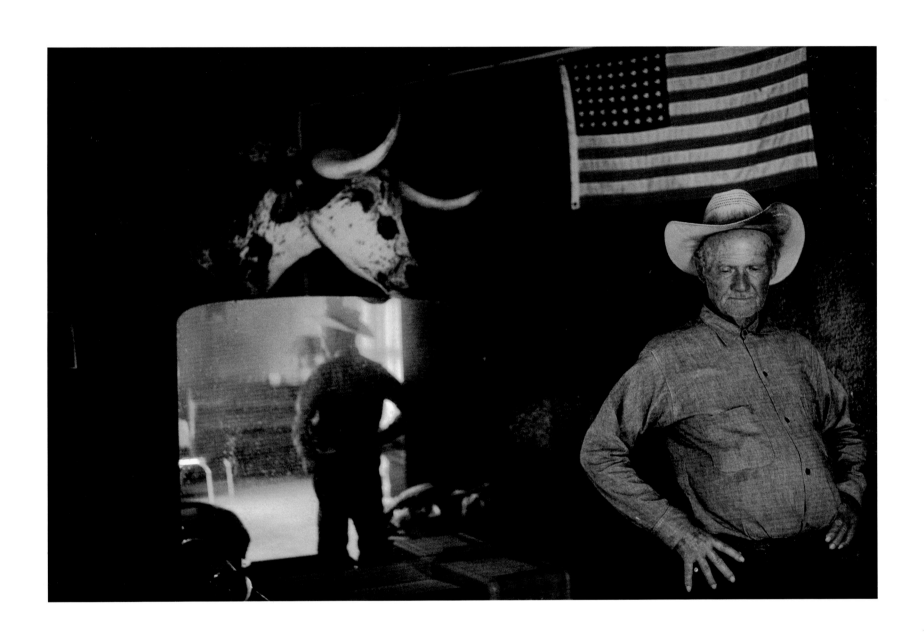

220. William Albert Allard, Arizona, 1970

221. Craig Aurness, Britt, Iowa, 1980

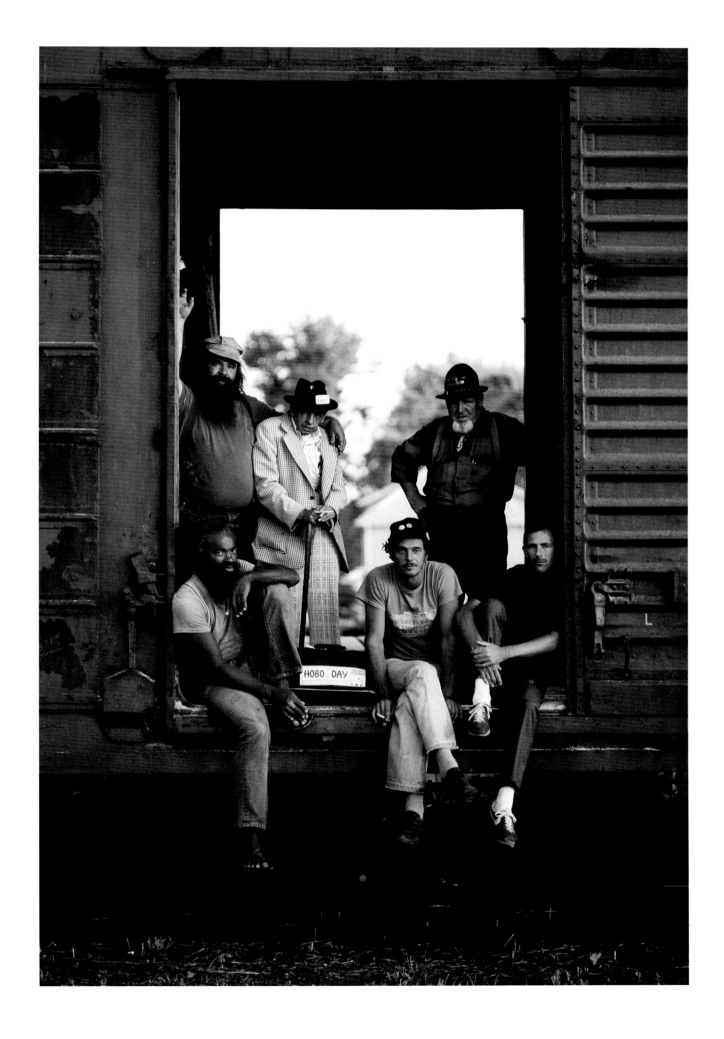

222. Photographer unknown, Denver, Colorado, n.d.

223. Chris Johns, Vancouver, British Columbia, Canada, 1984

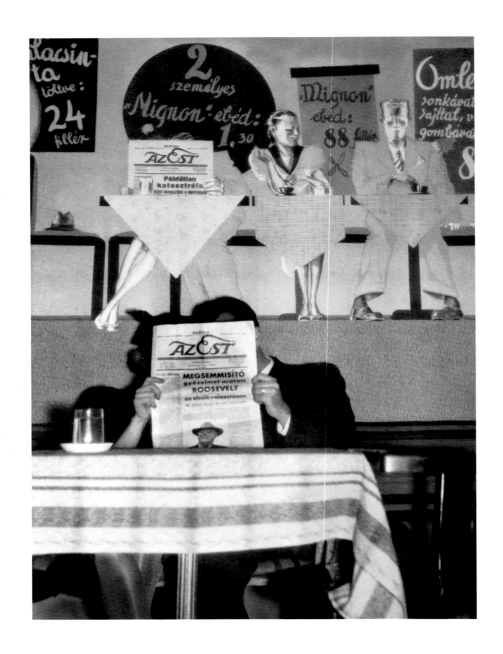

224. John Patric, Budapest, Hungary, n.d.

225. Cotton R. Coulson, East Berlin, 1981

226. Harry A. McBride, Warsaw, Poland, 1921

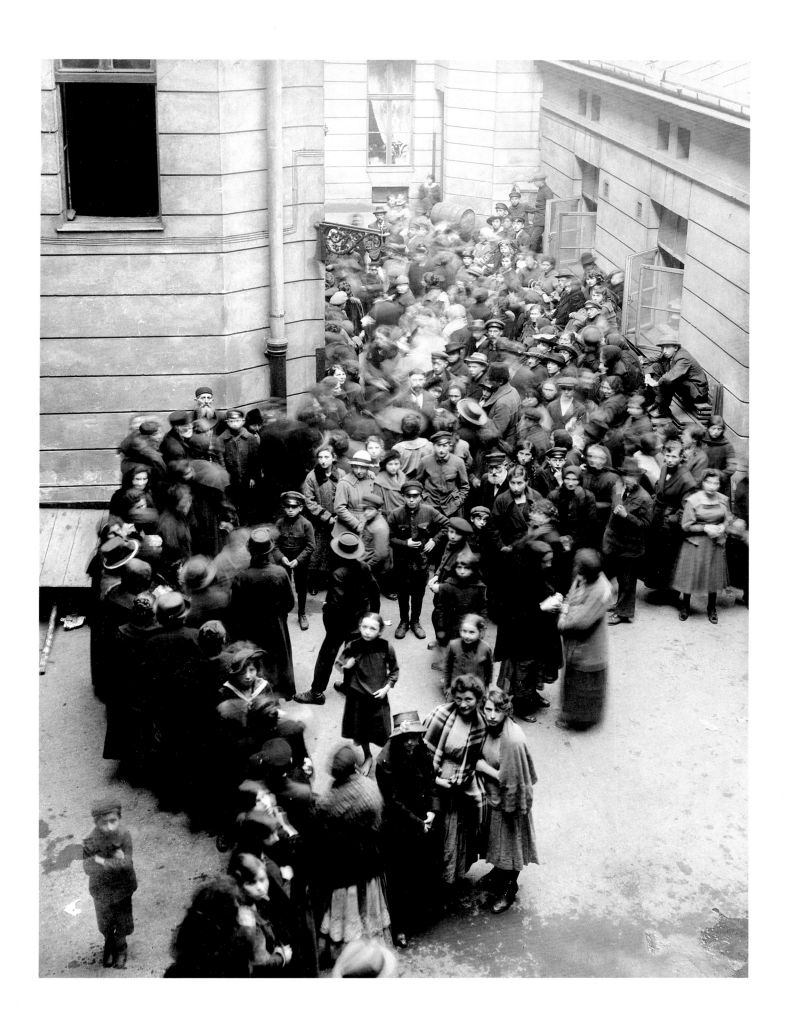

227. Edmond Sacre, Ghent, Belgium, n.d.

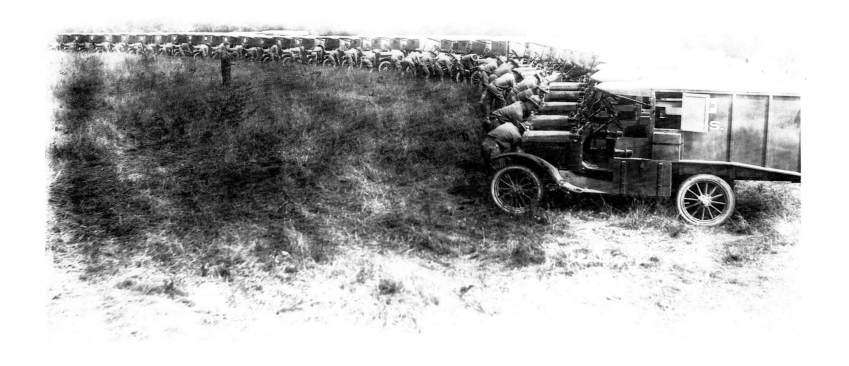

228. Photographer unknown, Morristown, New Jersey, n.d.

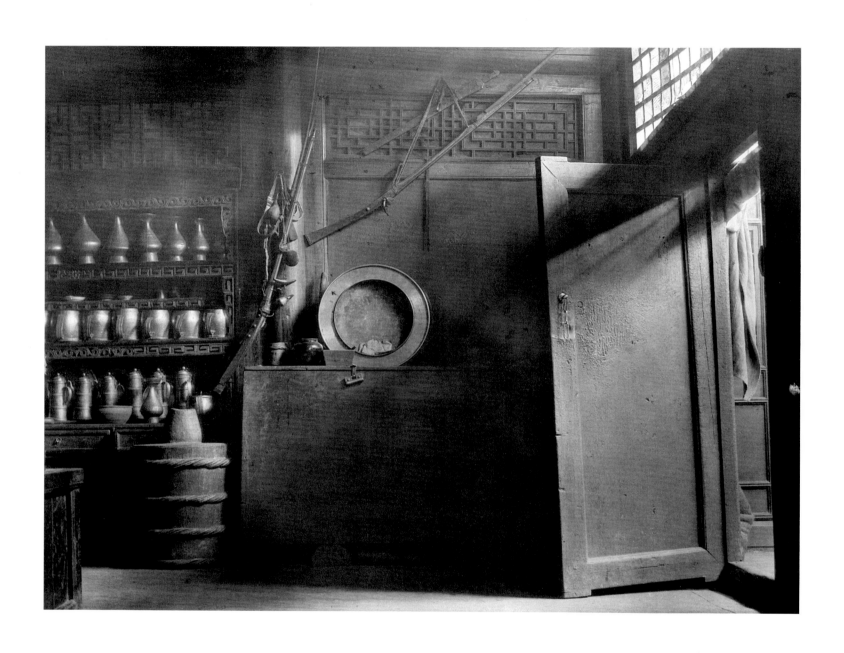

229. Frederick R. Wulsin, Choni, China, 1923

230. Annie Griffiths Belt, Bodie, California, 1983

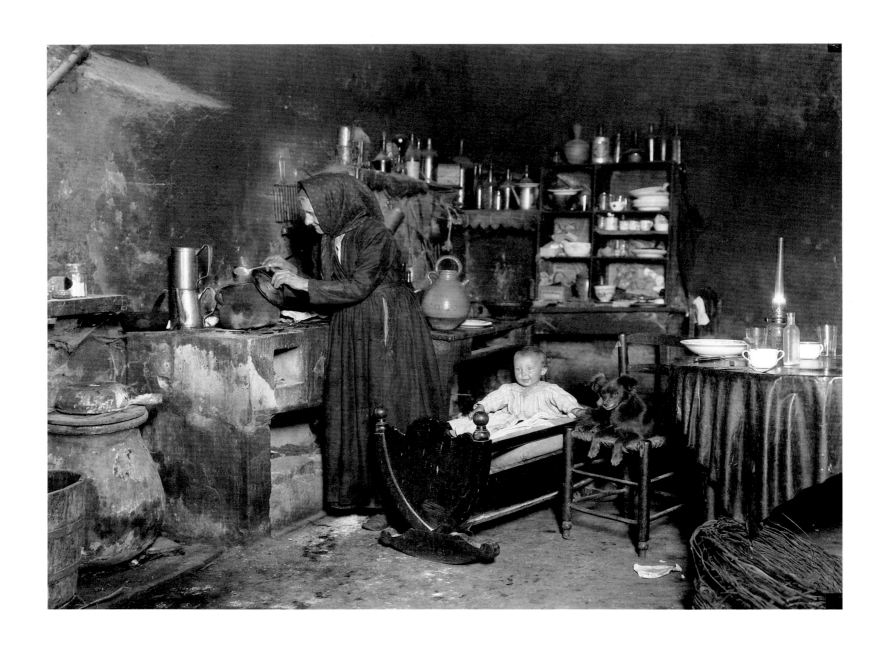

231. Clifton Adams, Corsica, France, c. 1921

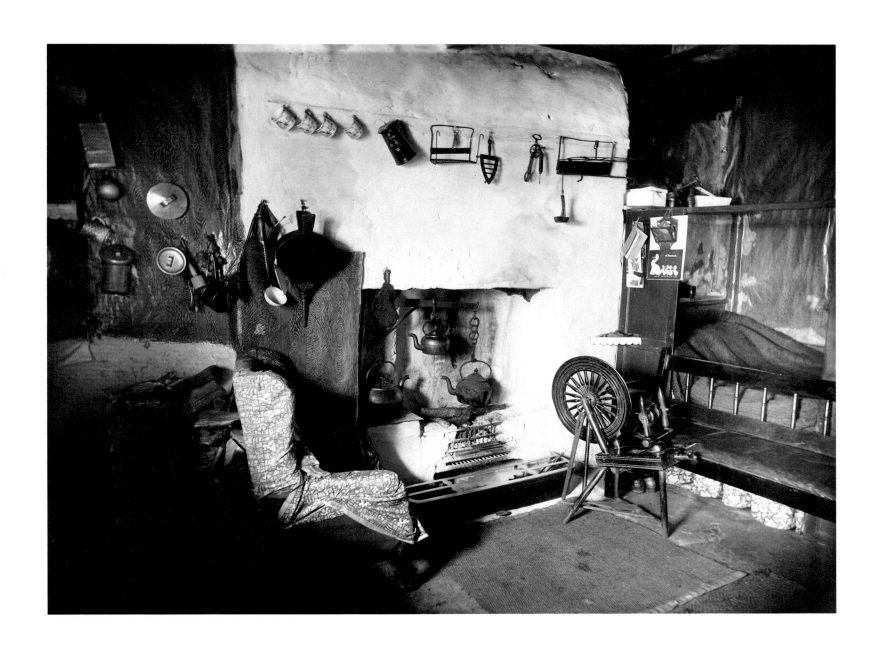

232. Robert Reid, Argyll, Scotland, 1927

233. Sam Abell, Hagi, Japan, 1980

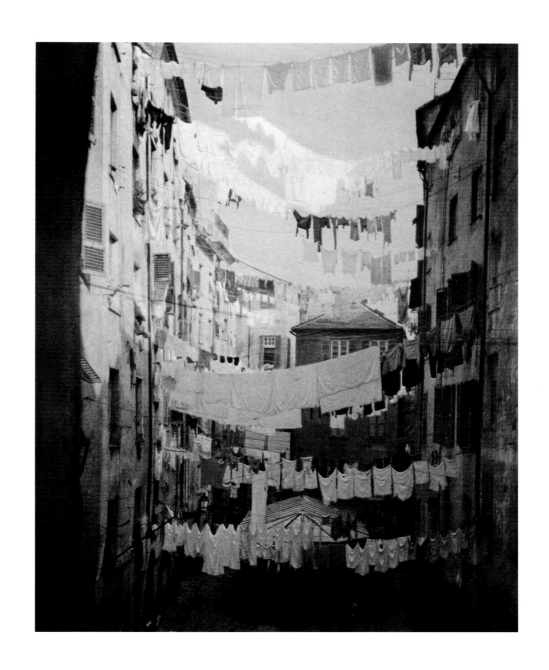

234. Hans Hildenbrand, Italy, 1927, *autochrome*

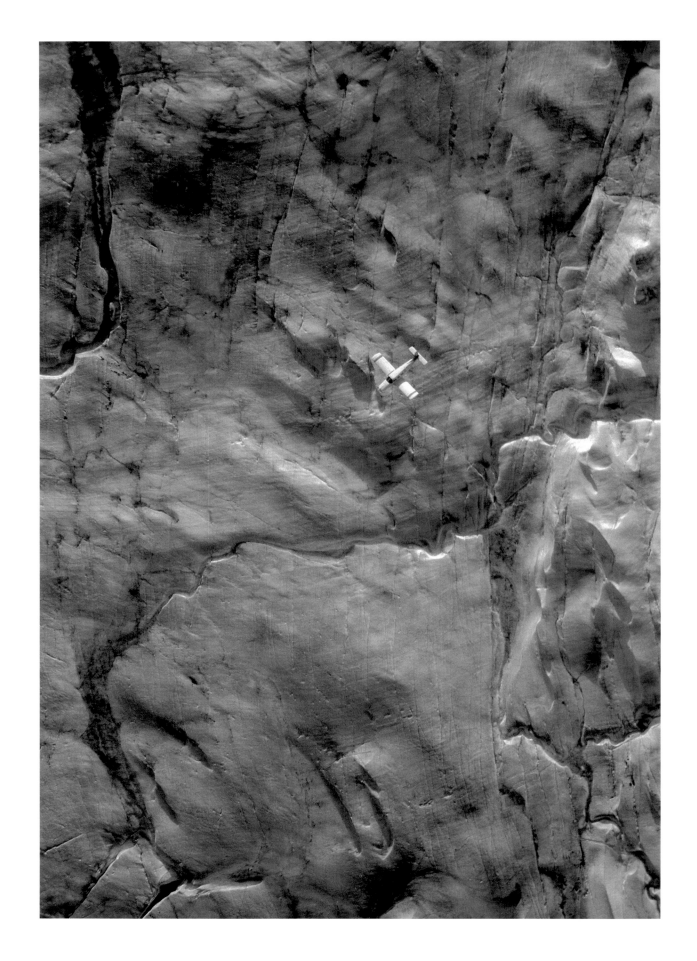

235. William Thompson, Alaska, 1983

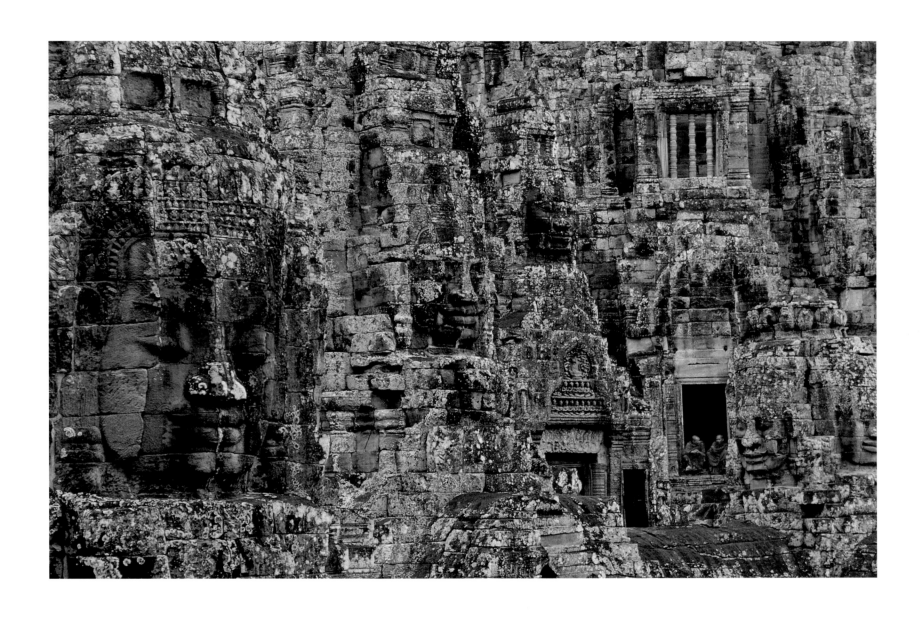

236. Wilbur E. Garrett, Mekong River, Cambodia (Kampuchea), 1968

237. Gordon Gahan,
 Dusky Sound, New Zealand, 1970

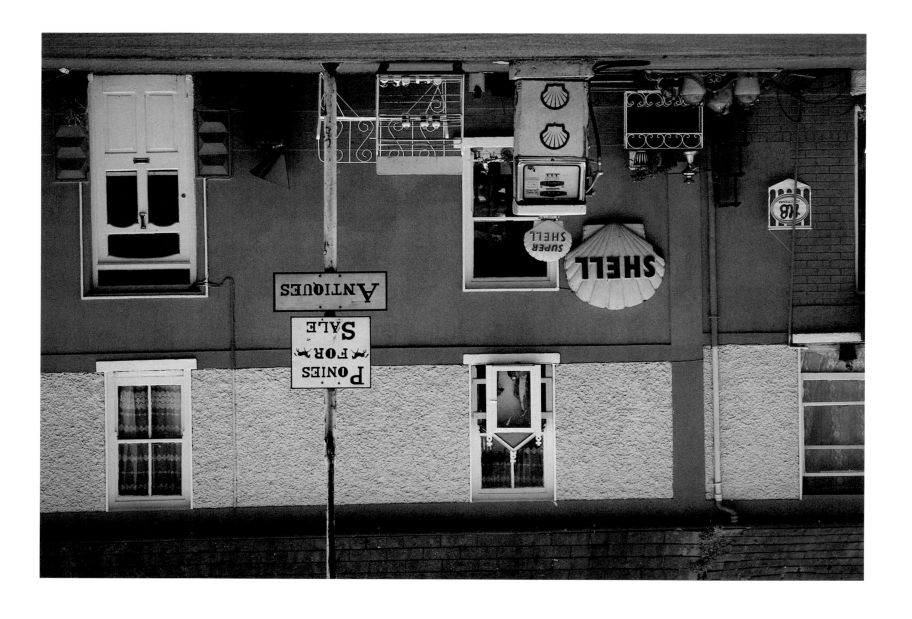

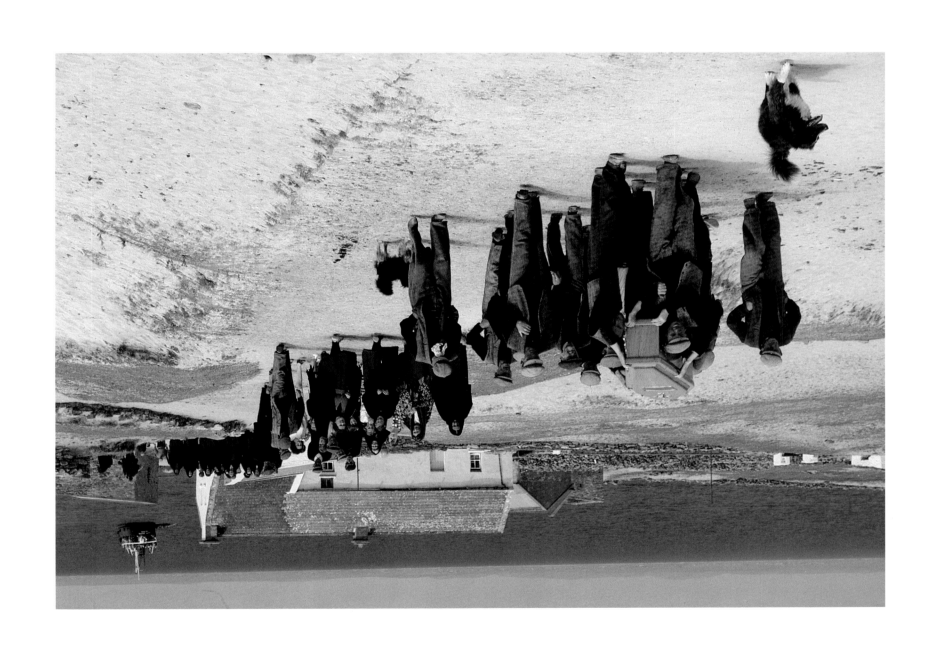

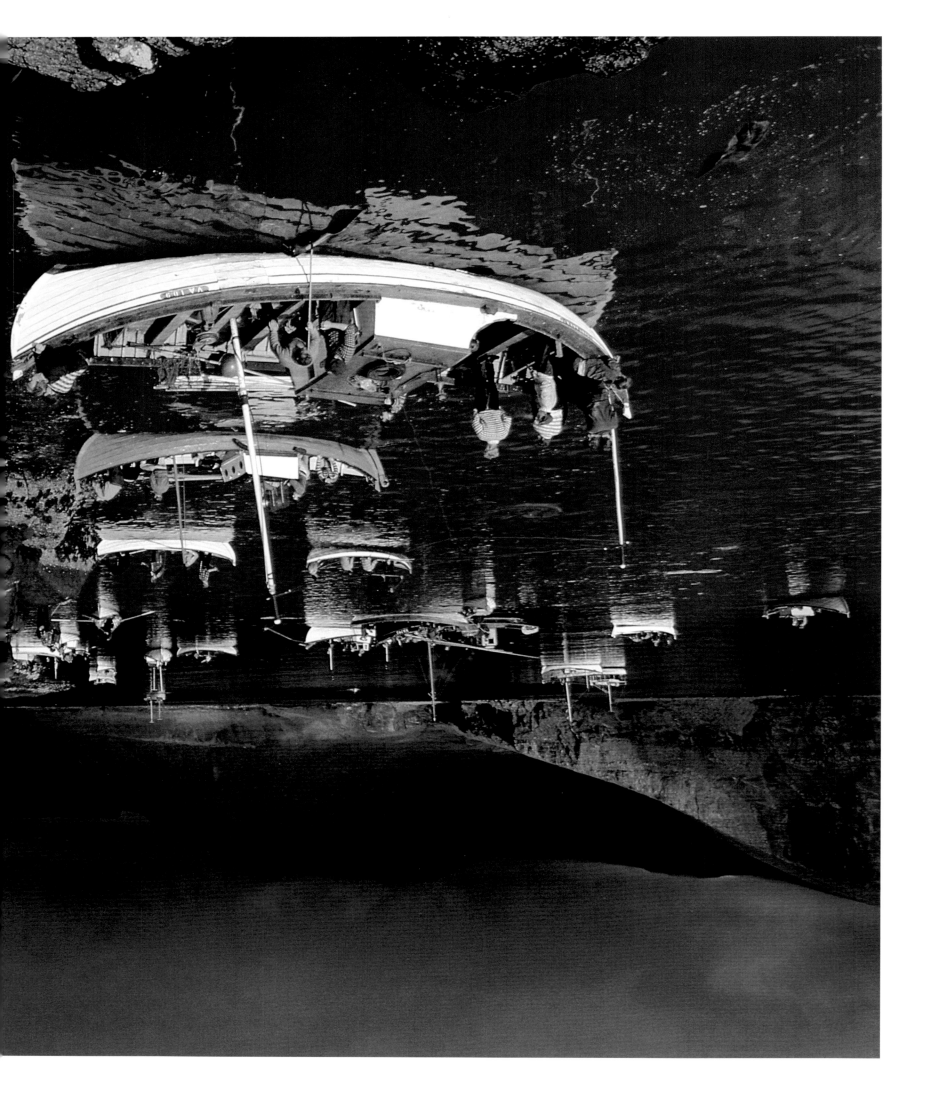

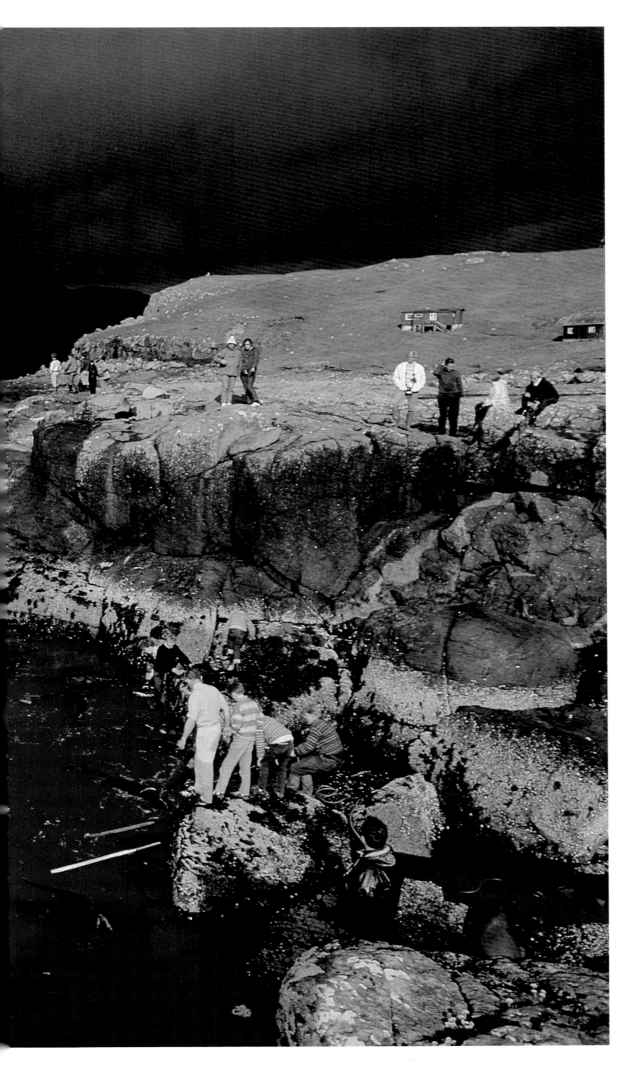

240. Adam Woolfitt,
Faeroe Islands, North Atlantic Ocean, 1968

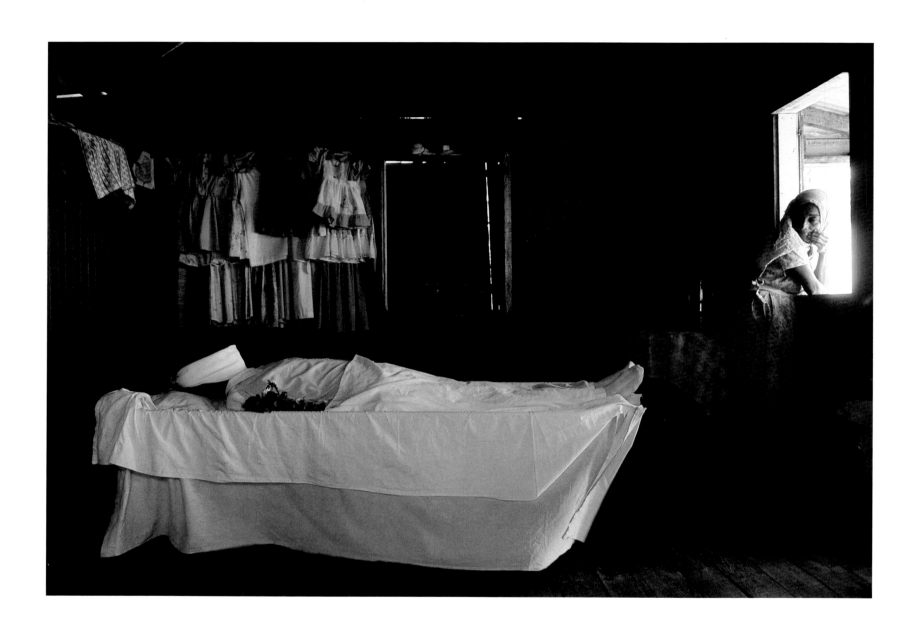

241. James Nachtwey, Krukira, Nicaragua, 1985

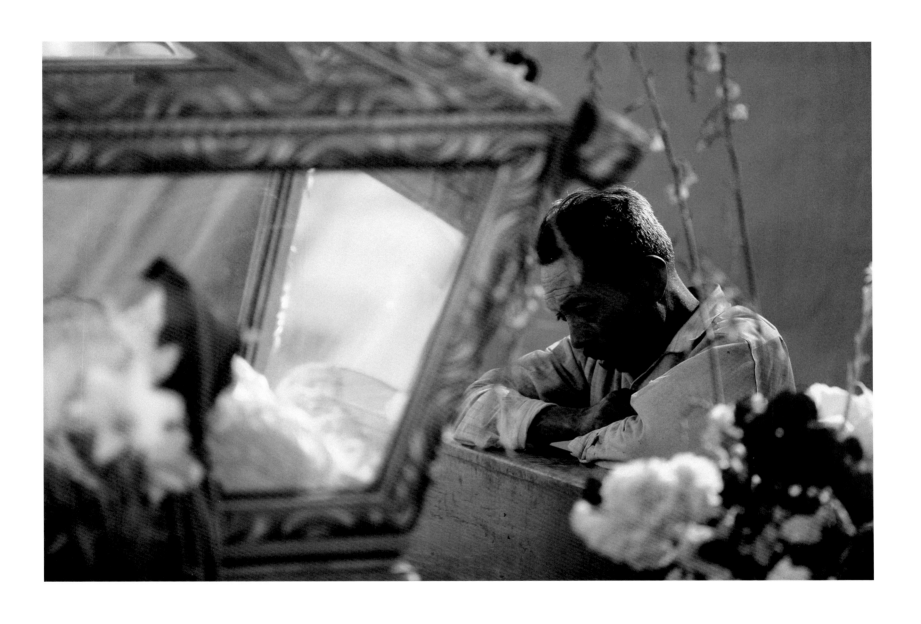

242. Robert Madden, Chichicastenango, Guatemala, 1976

243. James P. Blair, Capetown, South Africa, 1976

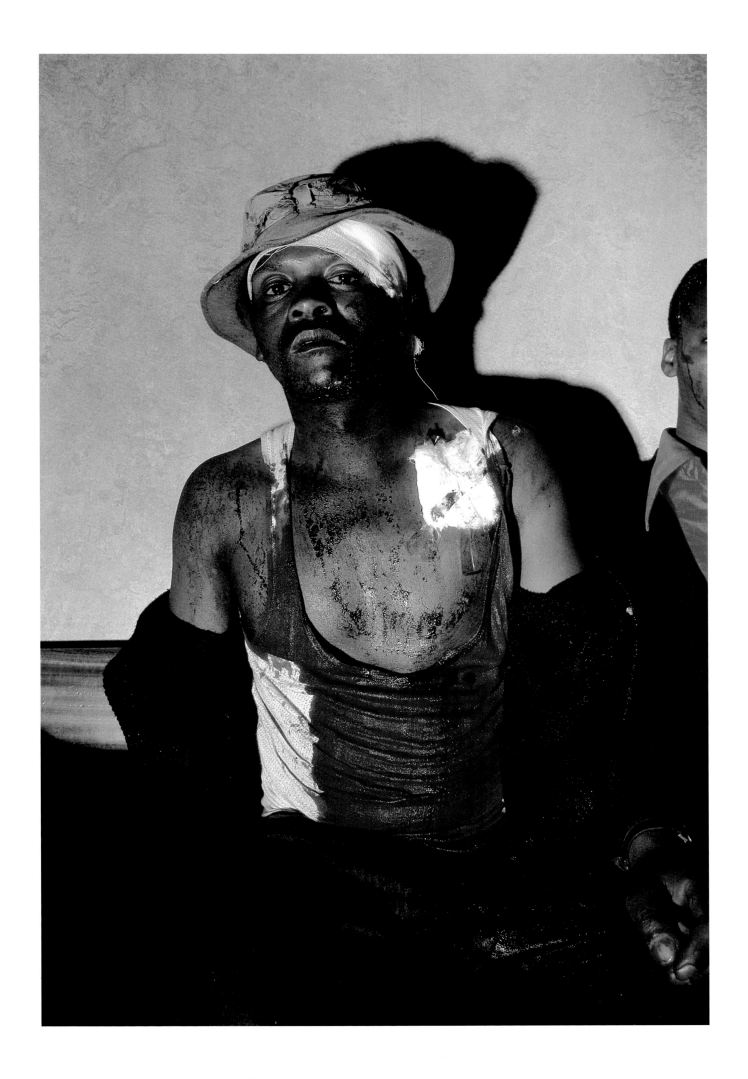

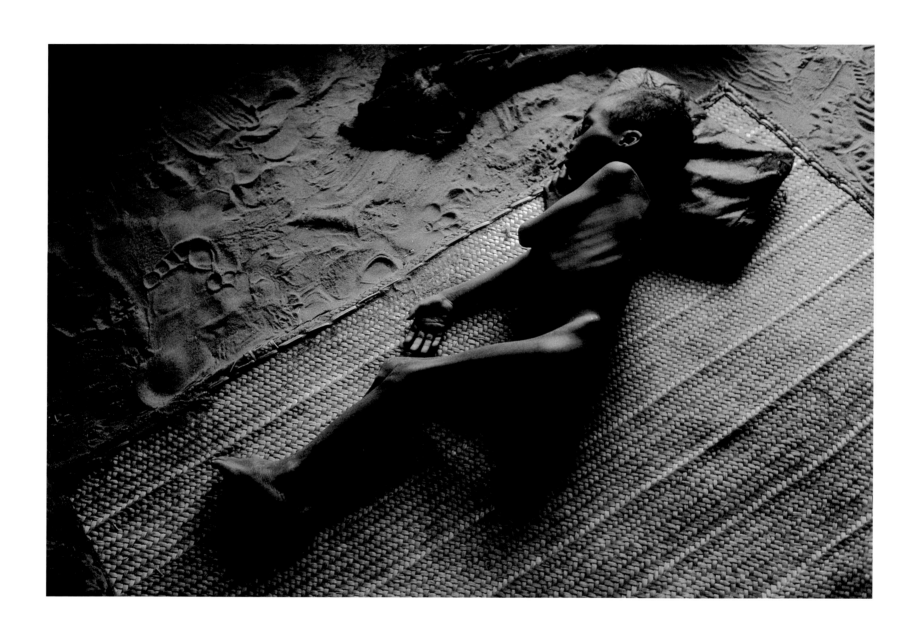

244. Farrell Grehan, Nigeria, 1973

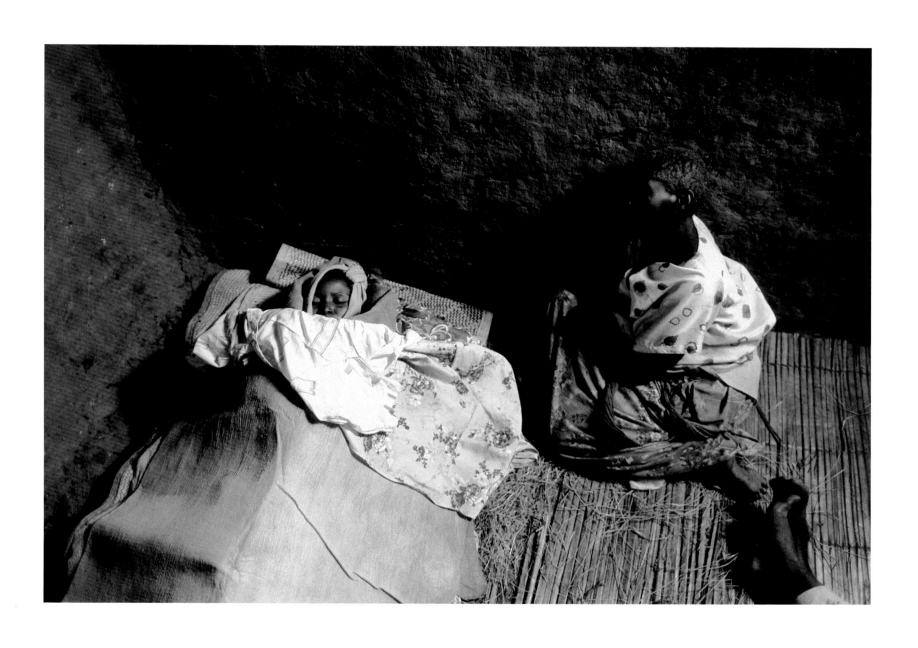

245. Robert Caputo, Uganda, 1987

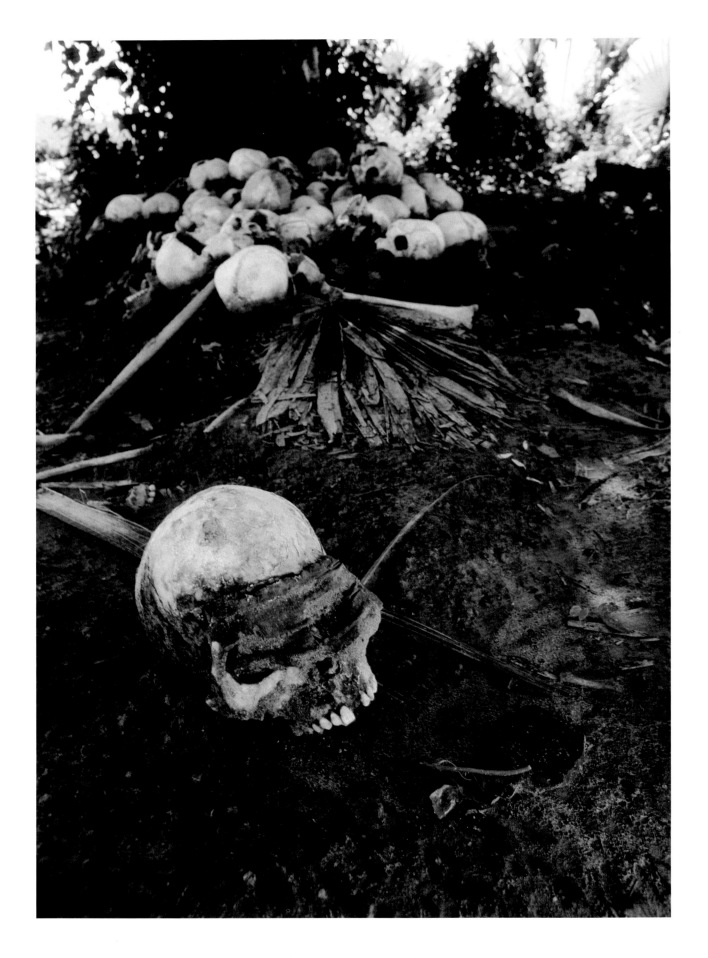

246. Wilbur E. Garrett, Kampuchea, 1981

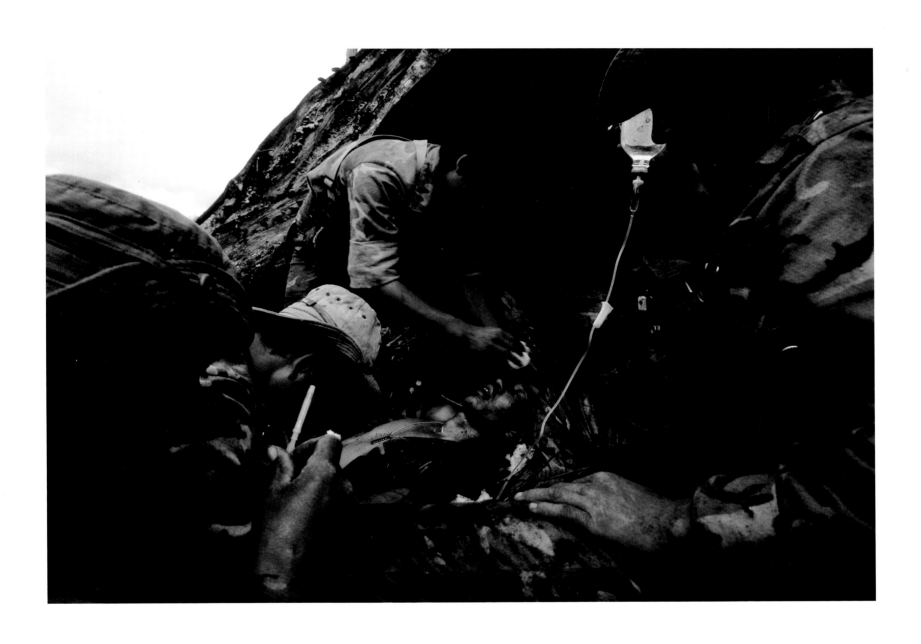

247. James Nachtwey, Nicaragua, 1985

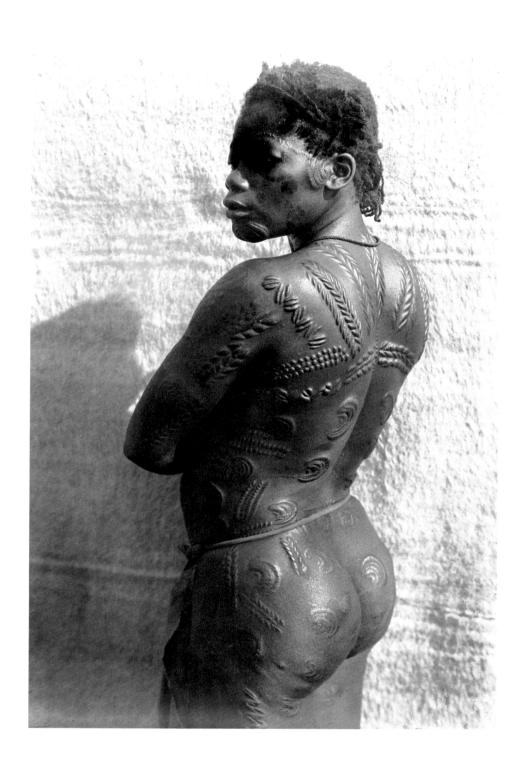

248. Albert Couturiaux, Belgian Congo (Zaire), 1920s

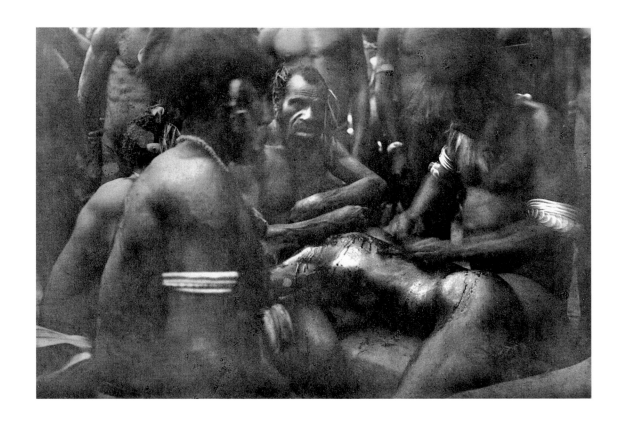

249. Father F. J. Kirschbaum, New Guinea, c. 1928

250. Dickey Chapelle,
South Vietnam, 1964

251. Jodi Cobb,
Lake Thun,
Switzerland, 1986

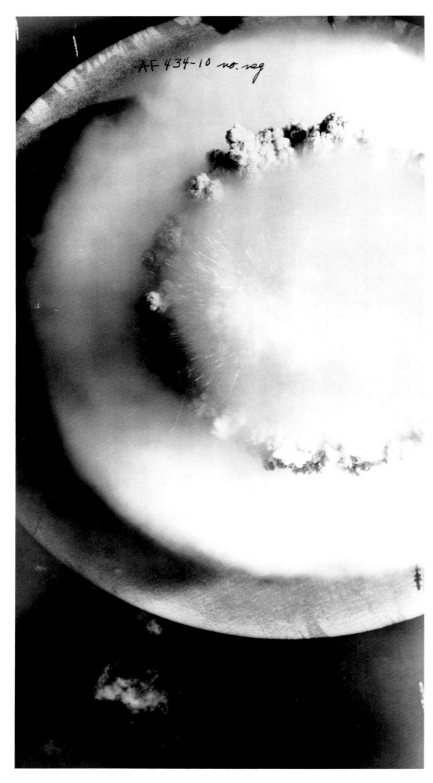

AF 434-10 no. neg

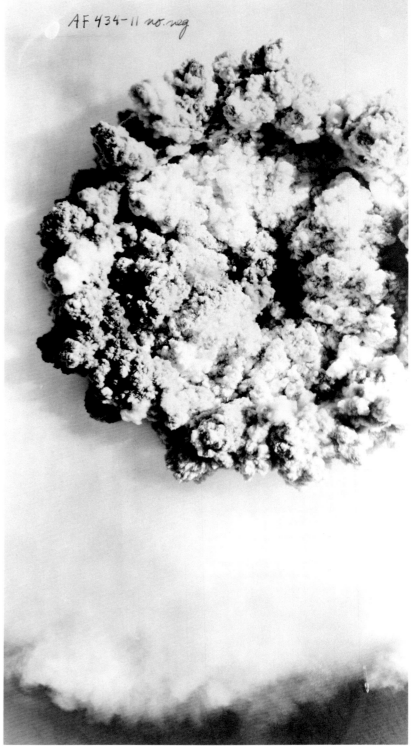

AF 434-11 no. neg

252-254. Photographer unknown, Bikini Atoll, Marshall Islands, Pacific Ocean, 1946

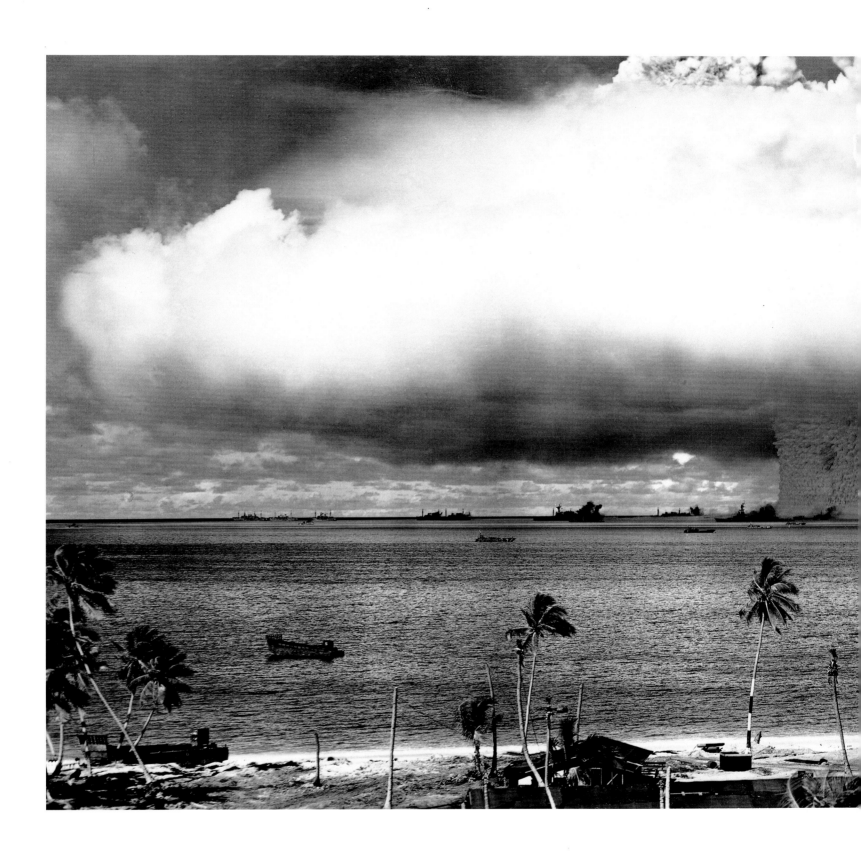

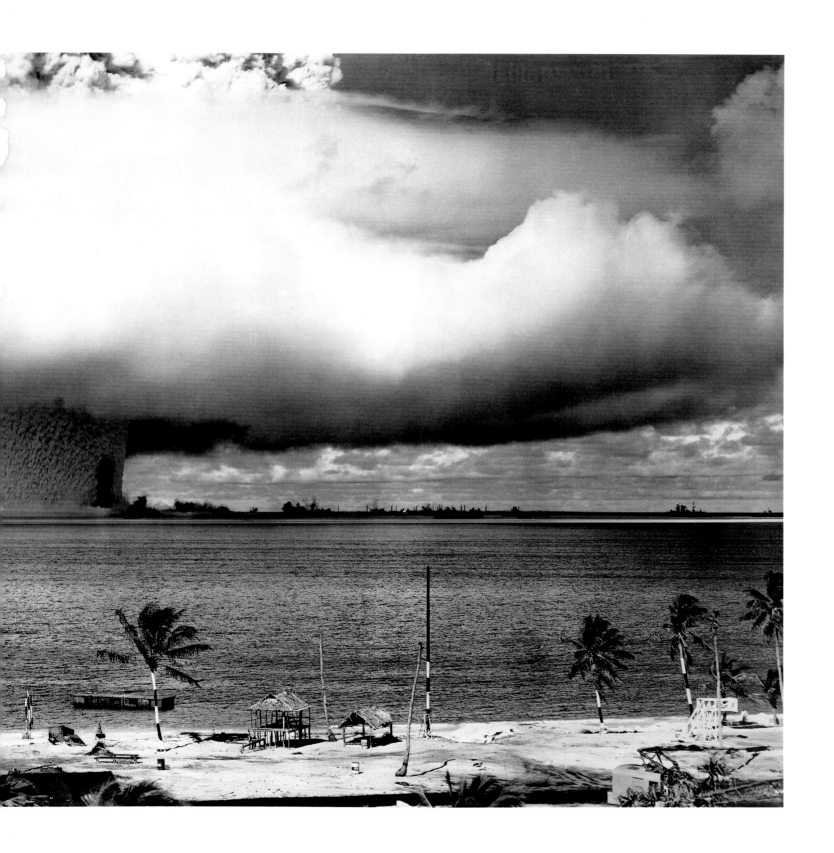

• page folds out •

255. David Doubilet, Marsa Mukabela, Sinai Coast, Israel (Egypt), 1982

256. Vittorio Sella, Ruwenzori, Uganda, 1906

257. Vittorio Sella, Ruwenzori, Uganda, 1906

258. Nicholas Morant, Lake Louise, Alberta, Canada, 1946

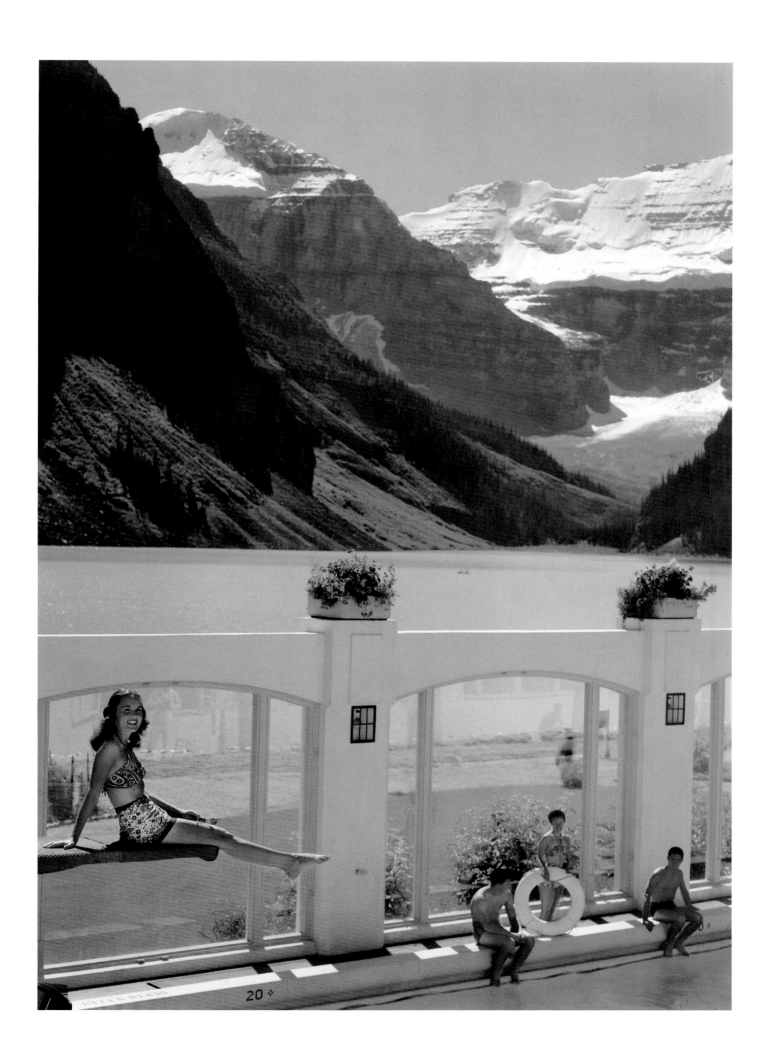

259. Wilbur E. Garrett,
Canada, 1969

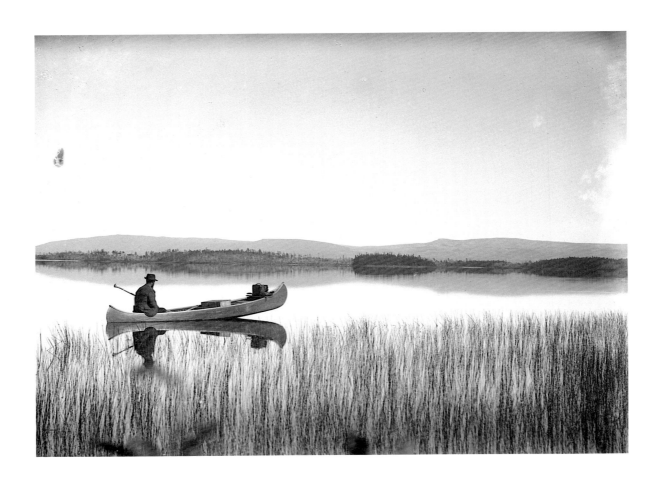

260. George Shiras III, Sandy Lake, Newfoundland, Canada, n.d.

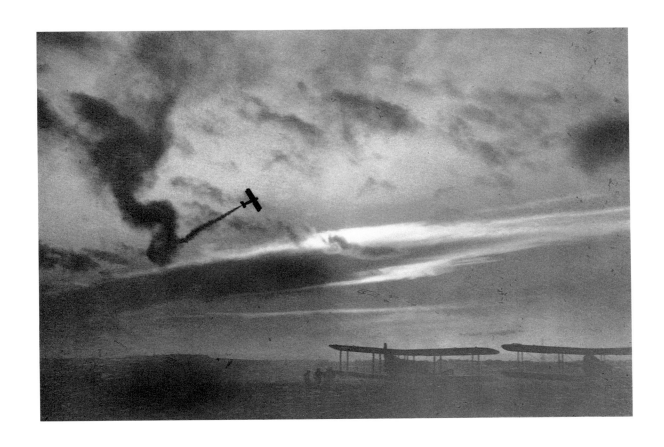

261. Clifton Adams, Washington, D.C., 1924

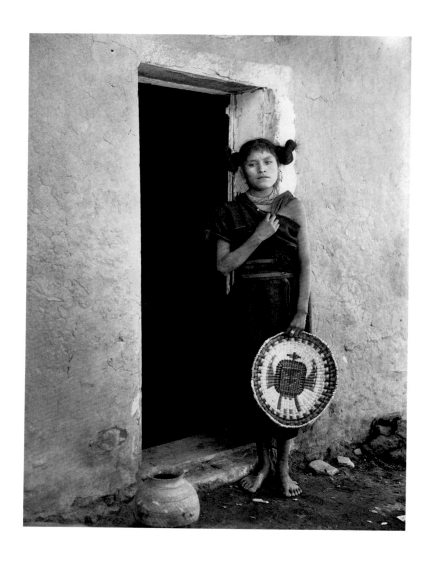

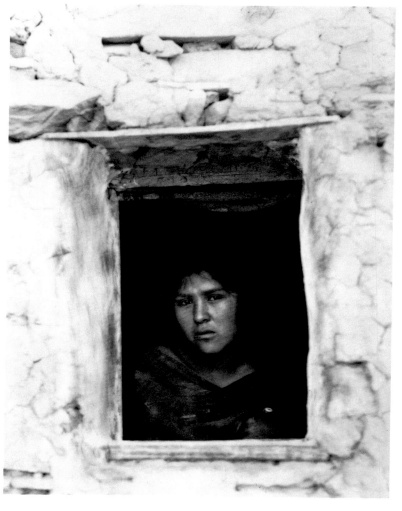

262. Homer E. Hoopes, Arizona, 1902

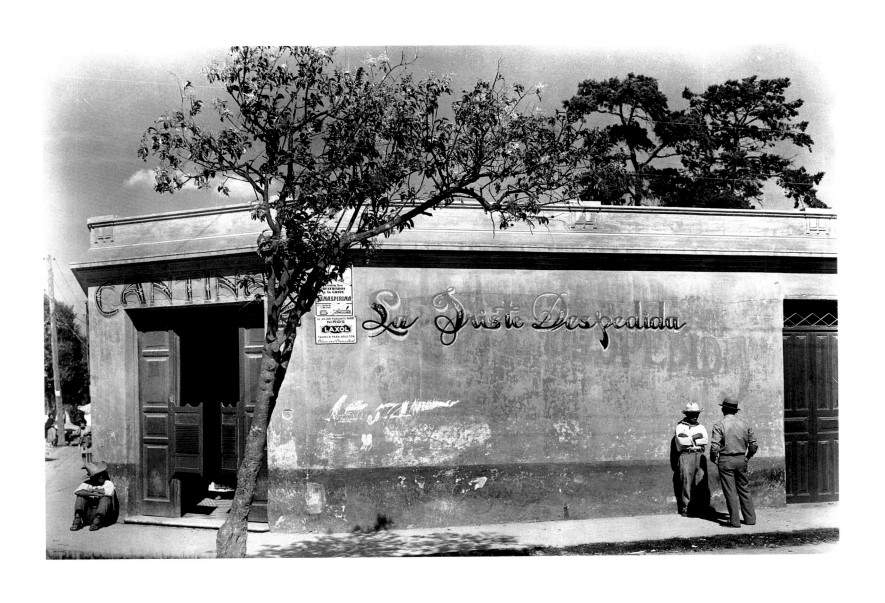

263. Luis Marden, Guatemala City, Guatemala, 1936

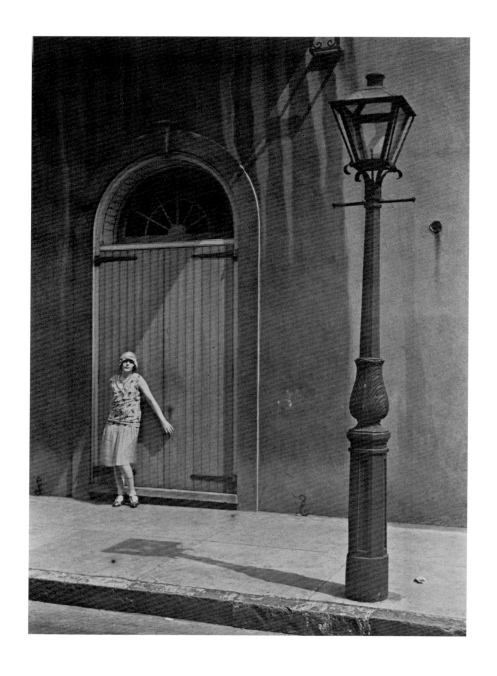

264. Edwin L. Wisherd, New Orleans, Louisiana, 1929, *autochrome*

265. Clifton Adams, Washington, D.C., 1930, *Agfacolor*

266. Hugo Brehme, Candelaria, Mexico, c. 1915

267. Hugo Brehme, Mexico, c. 1915

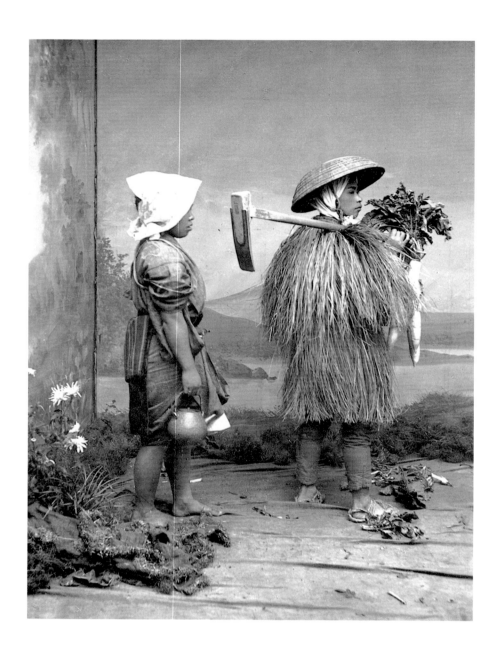

268. Tamotsu Enami, Japan, 1920

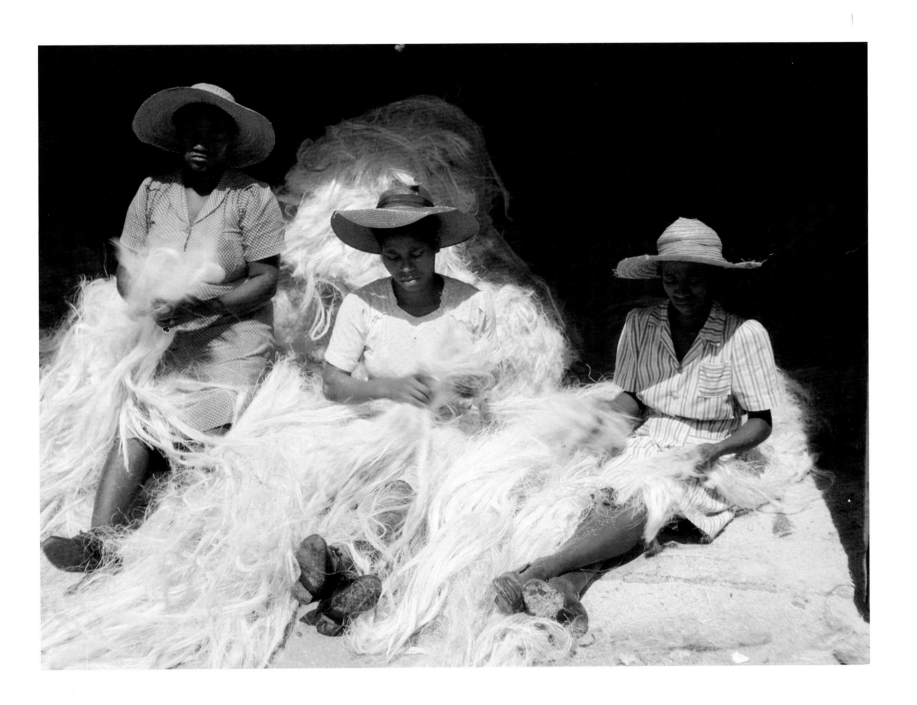

269. W. Robert Moore, Jamaica, 1947

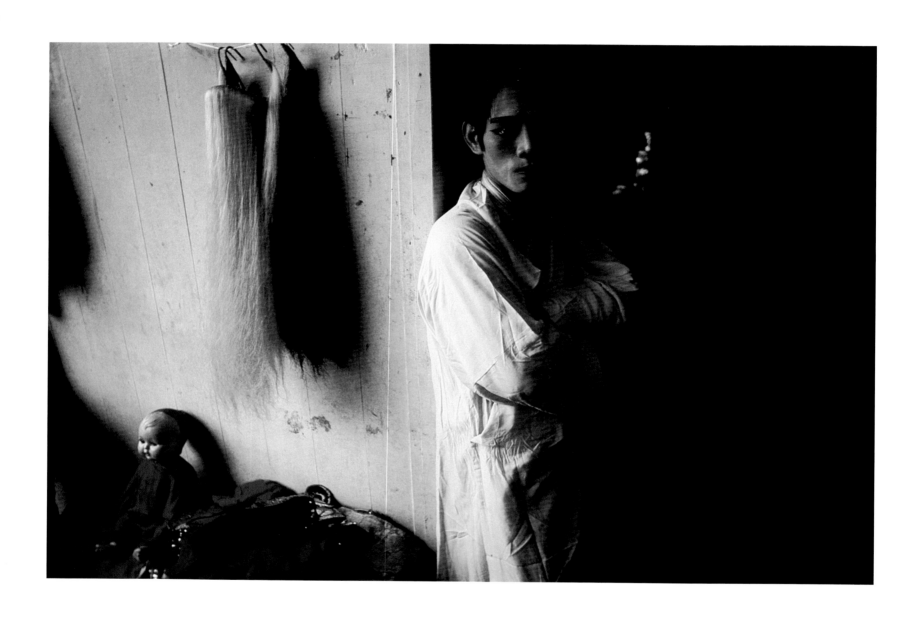

270. David Alan Harvey, Malaysia, 1977

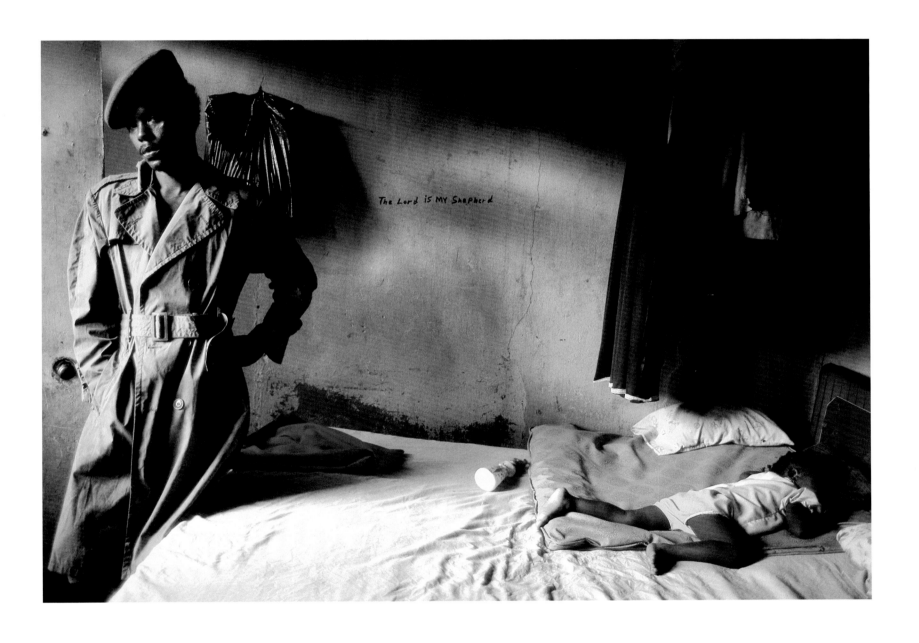

The Lord is MY Shepherd

271. David Burnett, Kingston, Jamaica, 1981

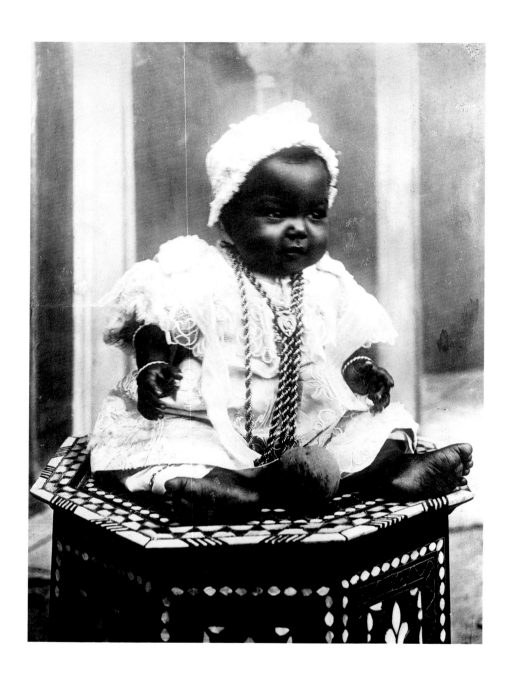

272. Lehnert & Landrock, Tunis, Tunisia, n.d.

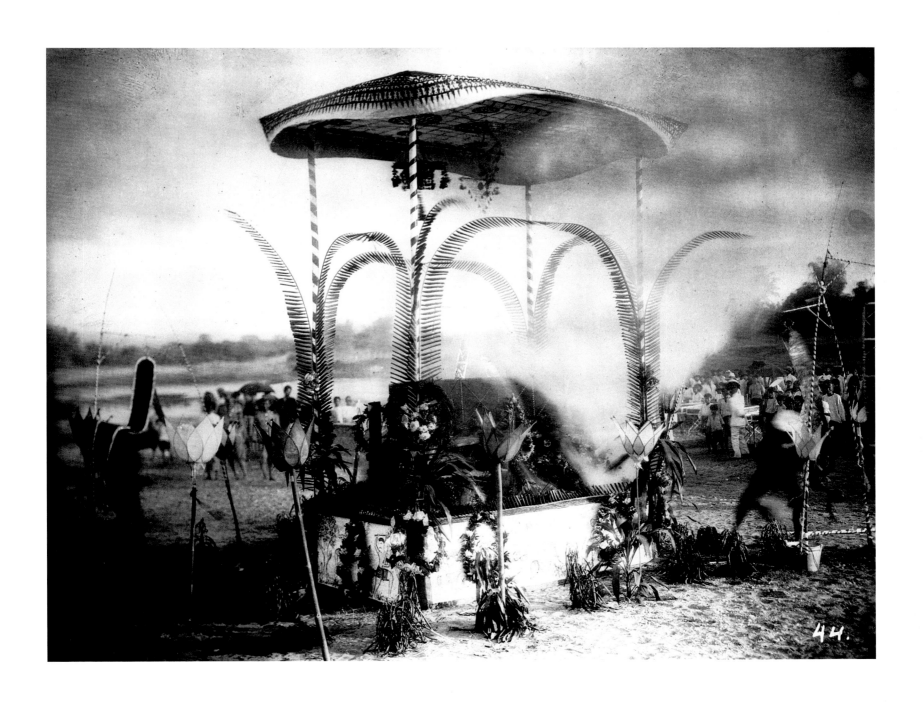

273. Ernest B. Schoedsack, Siam (Thailand), 1927

274. Melville Chater, Durban, South Africa, 1930, *autochrome*

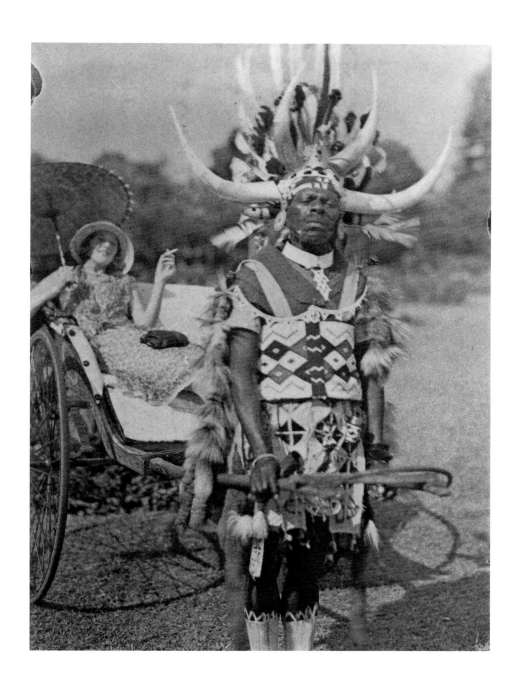

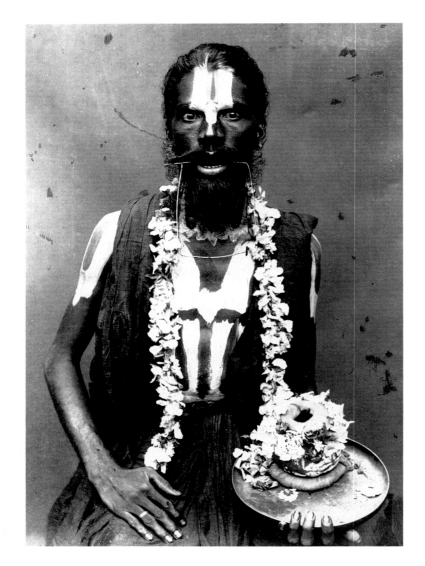

275. Wiele & Klein, India, n.d.

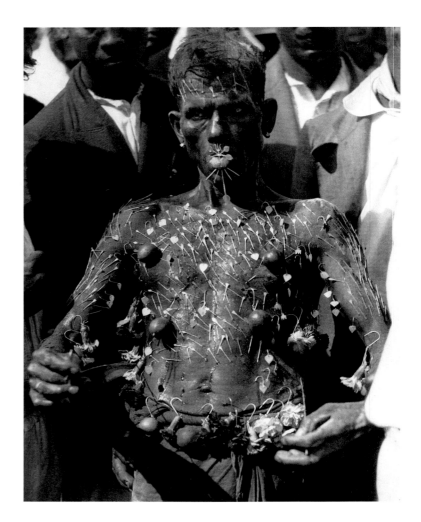

276. Lynn Acutt, Durban, South Africa, n.d.

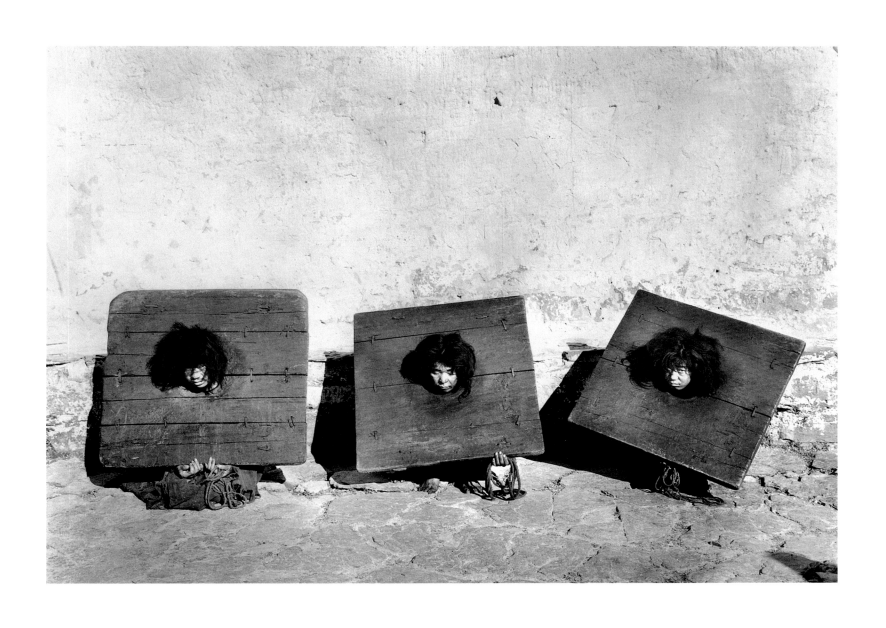

277. Joseph F. Rock, China, 1928

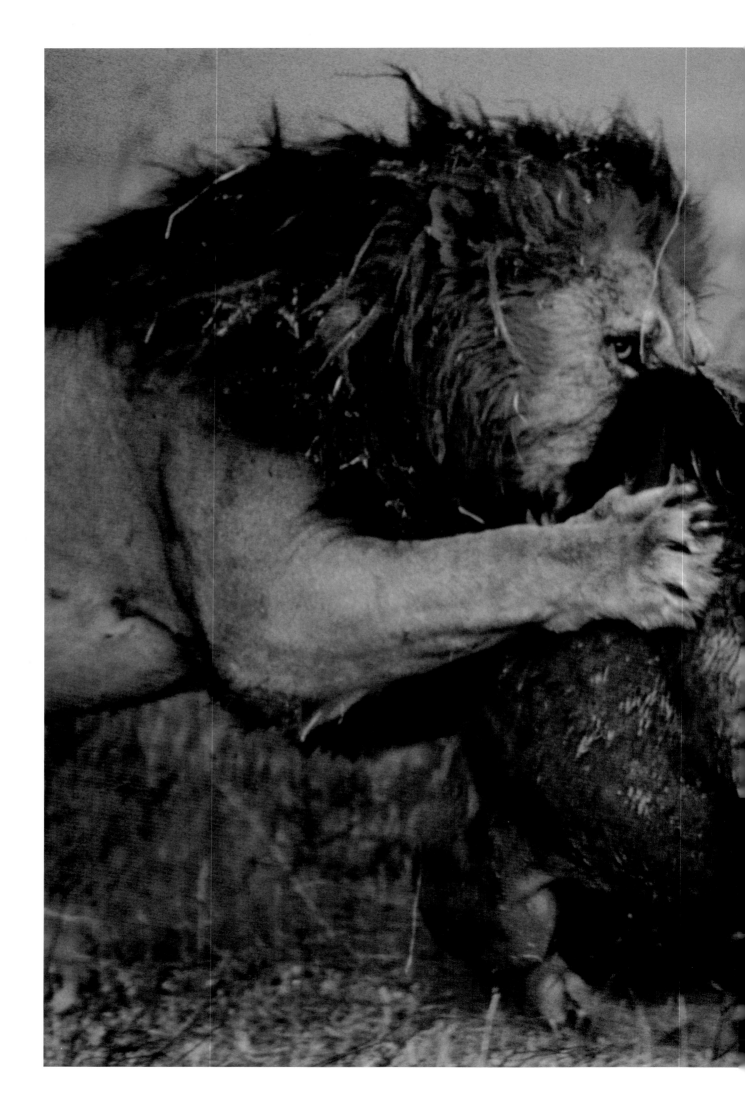

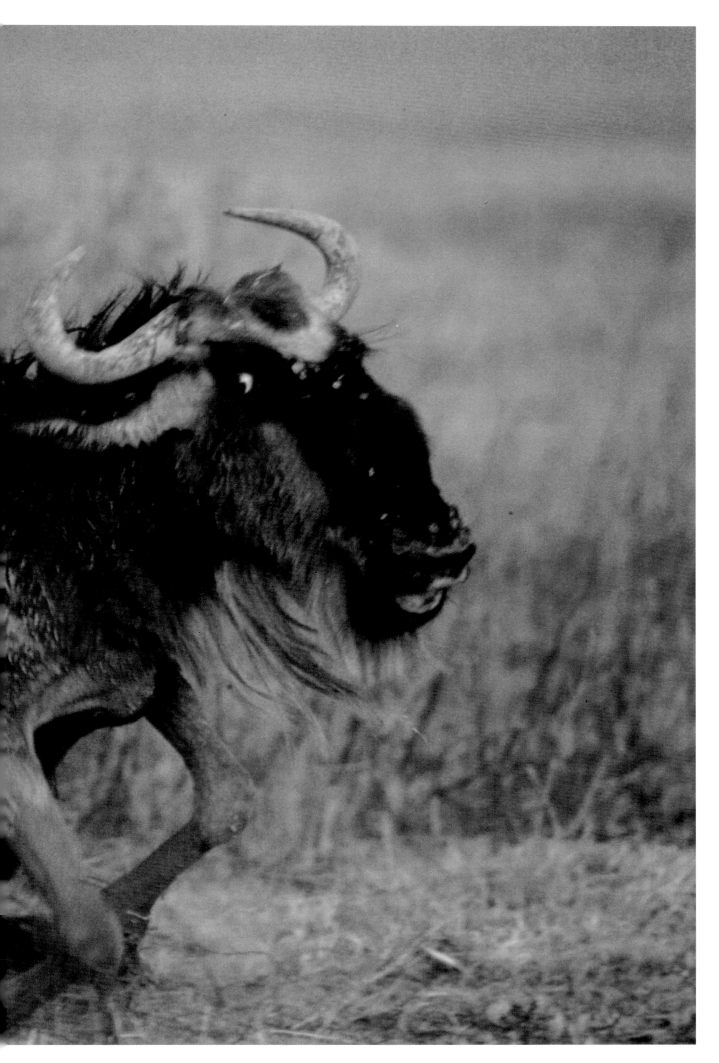

278. Mitsuaki Iwago,
 Serengeti National Park,
 Tanzania, 1985

279. William Albert Allard, Peru, 1981

280. William Albert Allard, Peru, 1981

281. Robert F. Sisson, Washington, D.C., 1978

282. Paul Zahl, location unknown, 1974

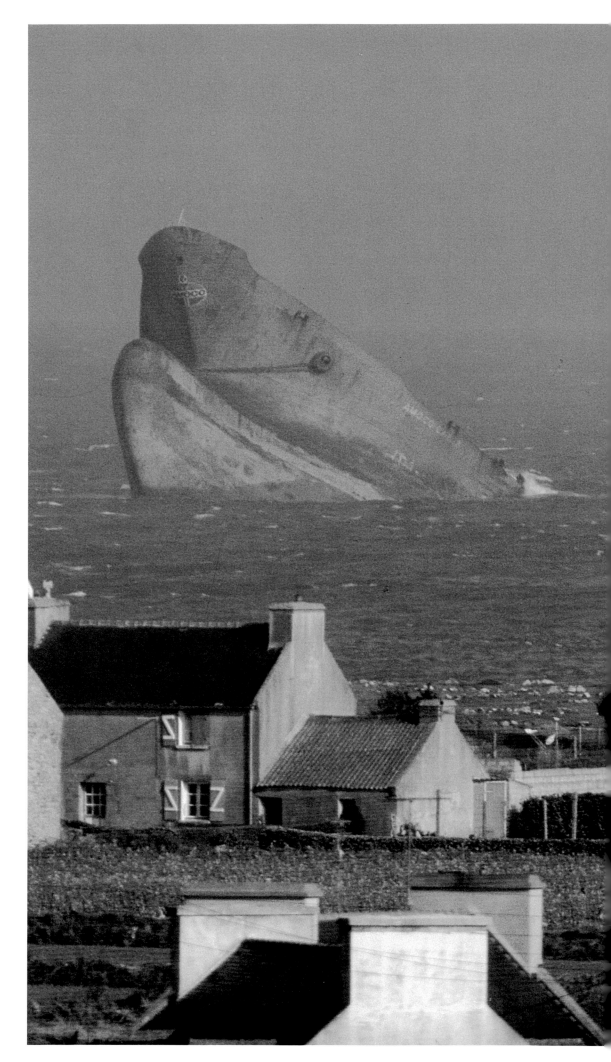

283. Martin Rogers,
Portsall, Brittany, France, 1978

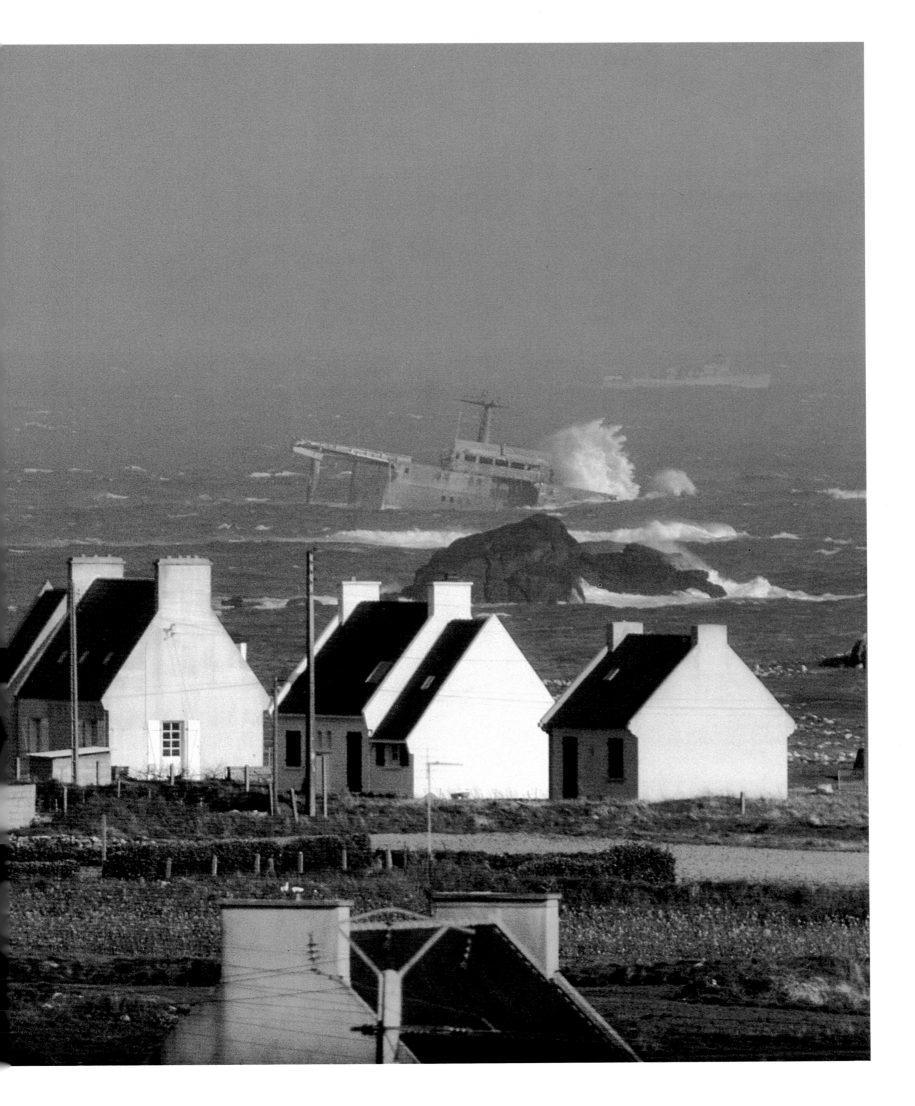

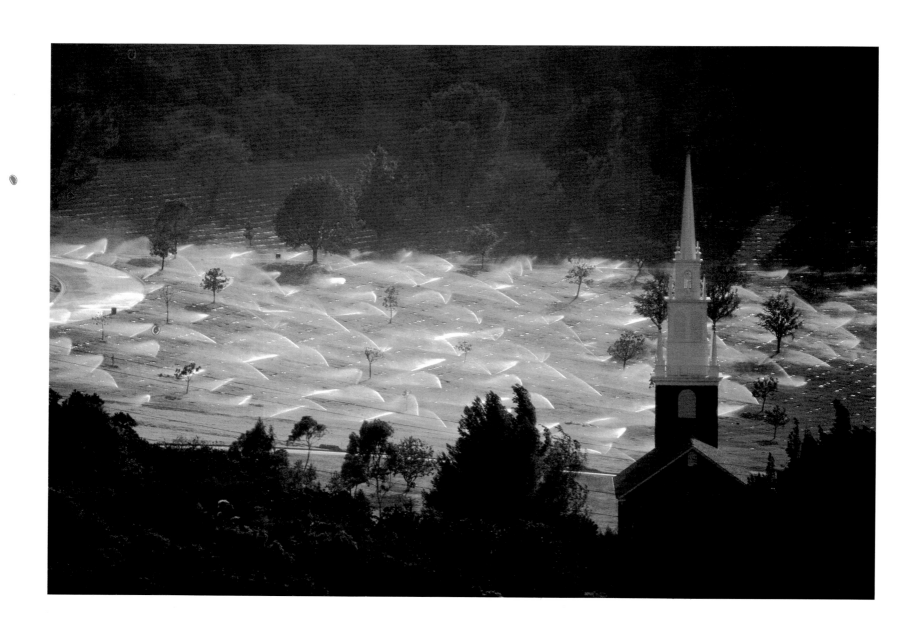

284. José Azel, Burbank, California, 1985

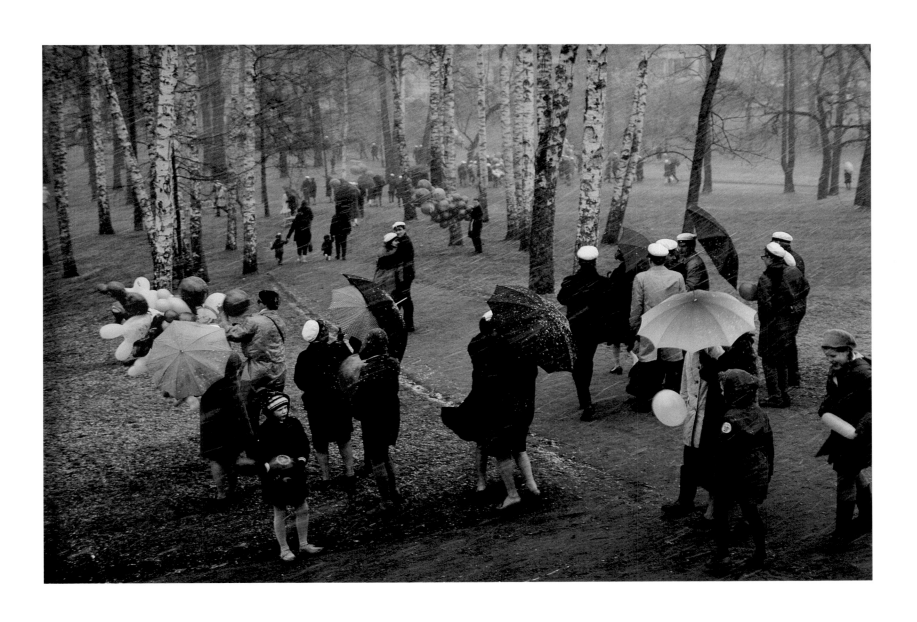

285. George F. Mobley, Helsinki, Finland, 1967

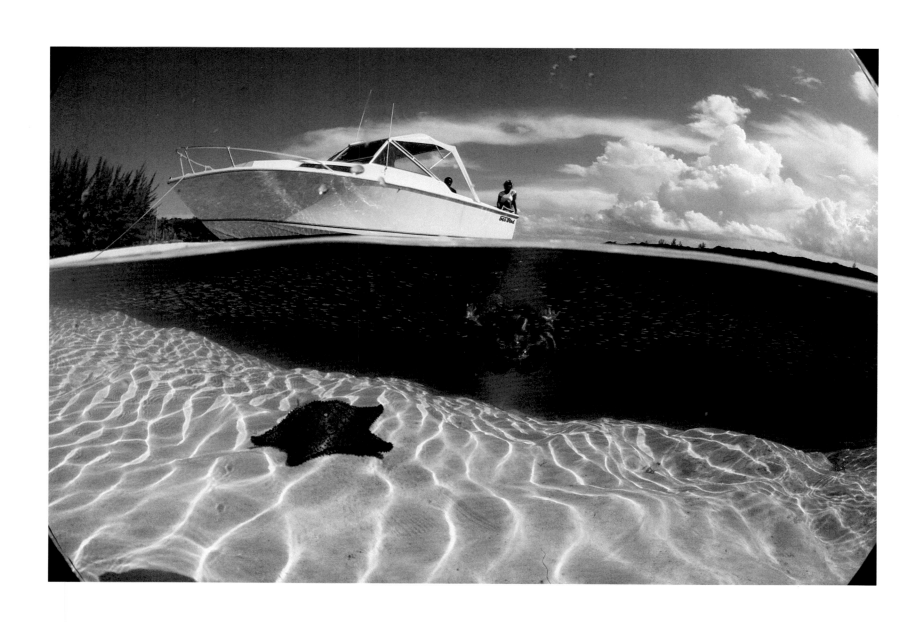

286. Bruce Dale, Bahamas, 1981

287. Douglas Miller, Ephrata, Washington, 1980

288. Bradford Washburn, Chitina Glacier, Alaska, 1938

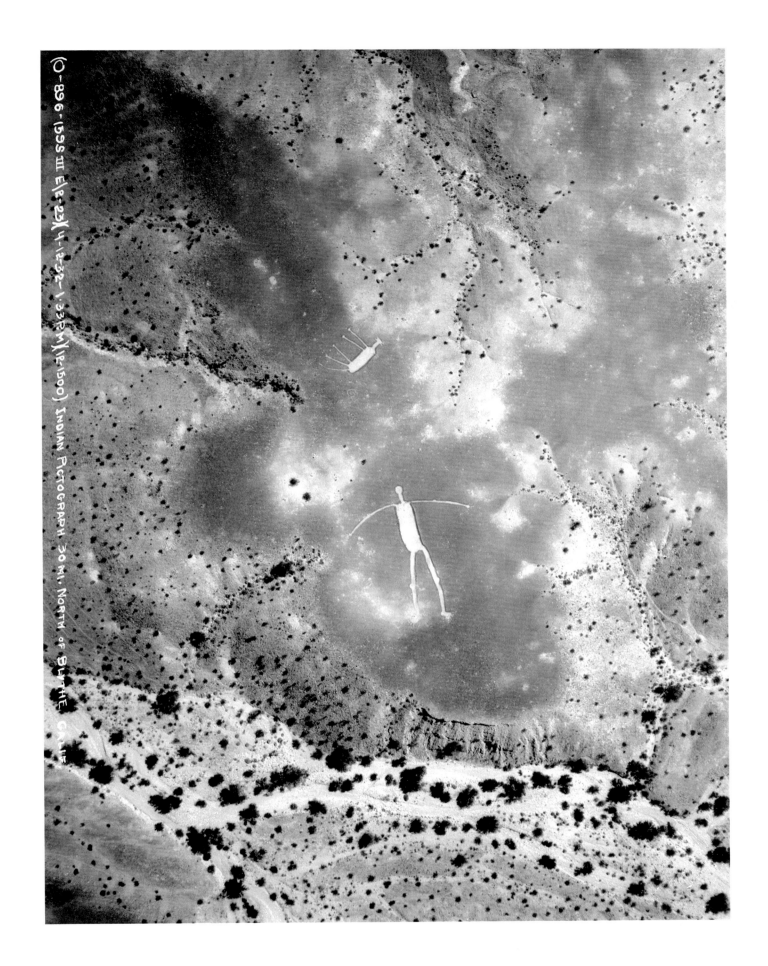

289. Stephen McAlko, near Blythe, California, c. 1943

INDEX

The photographs are listed by their plate numbers.

Sam Abell: 8, 10, 171, 233

Thomas J. Abercrombie: 197

Lynn Acutt: 276

Clifton Adams: 22, 54, 64, 72, 231, 261, 265

William Albert Allard: 82, 120, 154, 220, 279, 280

Paul Almasy: 144

James Amos: 51

Craig Aurness: 221

José Azel: 284

Henri Béchard: 13, 14

William Belknap, Jr.: 159

Annie Griffiths Belt: 53, 230

Nathan Benn: 106, 131, 137

Mehmet Biber: 2

Hiram Bingham: 103, 104, 210, 211

James P. Blair: 79, 84, 149, 216, 243

Jonathan Blair: 71, 90, 186

Harry F. Blanchard: 129

Jim Brandenburg: 198

Hugo Brehme: 187, 188, 266, 267

David L. Brill: 70

Horace Bristol: 4

Stephen R. Brown: 143

David Burnett: 271

Nicholas John Caire: 207

Robert Caputo: 89, 245

Eugene A. Cernan: 202

Lynwood M. Chace: 151

Dickey Chapelle: 250

Melville Chater: 35, 274

Paul Chesley: 92, 93

Fred Payne Clatworthy: 21

Jodi Cobb: 145, 169, 219, 251

Dean Conger: 7

O. F. Cook: 147

Cotton R. Coulson: 225, 238

Gervais Courtellemont: 49, 52, 62

Albert Couturiaux: 248

Willard R. Culver: 76

Edward S. Curtis: 192, 193, 194, 195

Bill Curtsinger: 164

Bruce Dale: 141, 286

Carole Devillers: 134

Joseph K. Dixon: 179, 191, 214

David Doubilet: 59, 91, 201, 255

Dick Durrance II: 34

Harold E. Edgerton: 96

Tamotsu Enami: 24, 268

Ric Ergenbright: 162

David Falconer: 60

William L. Finley and H. T. Bohlman: 152

David Fleay: 153

Gordon Gahan: 237

Wilbur E. Garrett: 236, 246, 259

Jacob Gayer: 23, 57, 61, 108, 182

Lowell Georgia: 105

P. V. Glob: 185

Farrell Grehan: 139, 244

Gilbert H. Grosvenor: 20

Earle Harrison: 48

David Alan Harvey: 136, 270

Gustav Heurlin: 128

Hans Hildenbrand: 45, 234

Jack Hillers: 101, 102

Homer E. Hoopes: 262

Mitsuaki Iwago: 160, 161, 278

Chris Johns: 223

Wolfgang Kaehler: 199

George R. King: 110

Father F. J. Kirschbaum: 249

Franklin Price Knott: 1, 40

Emory Kristof: 123

Frans Lanting: 119, 148

Lennart Larsen: 184

Lehnert & Landrock: 15, 16, 36, 272

Justin Locke: 74, 115

Rear Admiral Donald B. MacMillan: 172, 209

Robert Madden: 242

Peter Magubane: 158

Luis Marden: 55, 121, 122, 133, 142, 189, 212, 263

Charles Martin: 43, 58

Stephanie Maze: 135, 217

O. L. Mazzatenta: 155

Stephen McAlko: 289

Harry A. McBride: 226

Steve McCurry: 47, 87, 213, 218

Roland McKee: 73

Donald McLeish: 65, 66, 68, 69

Douglas Miller: 287

Merlin Minshall: 205

George F. Mobley: 85, 285

Yva Momatiuk/John Eastcott: 88

Gail Mooney: 140

W. Robert Moore: 67, 269

Nicholas Morant: 258

Helen Marian Place Moser: 215

James Nachtwey: 241, 247

Tom Nebbia: 113, 117

Flip Nicklin: 165

Colonel E. J. Parker: 174

Winfield Parks: 3

John Patric: 224

Admiral Robert E. Peary: 190

Luigi Pellerano: 38

Photographer unknown: 11, 37, 42, 97, 98, 107, 111, 175, 176, 206, 222, 228, 252, 253, 254

Herbert G. Ponting: 80, 81, 157

Louie Psihoyos: 39

Steve Raymer: 83

Roland W. Reed: 9, 196

Robert Reid: 112, 232

J. Baylor Roberts: 46, 132

Joseph F. Rock: 177, 178, 181, 277

Martin Rogers: 283

Alan Root: 200

Edmond Sacre: 227

Joe Scherschel: 167

Jon Schneeberger: 94, 95

Ernest B. Schoedsack: 41, 180, 273

Eliza R. Scidmore: 19, 124, 125, 126, 127

Sebah & Joaillier: 12

Vittorio Sella: 203, 204, 256, 257

R. Senz & Company, Bangkok: 44, 100

George Shiras III: 17, 18, 260

Robert F. Sisson: 281

James L. Stanfield: 114, 168

B. Anthony Stewart: 77, 78, 130

James A. Sugar: 239

George Tairraz: 5, 6

William Thompson: 235

Tomasz Tomaszewski: 50

Baron Wilhelm von Gloeden: 26, 27, 28, 29, 30, 31, 32, 33

Steve Wall: 208

Frederick William Wallace: 163

Fred A. Wardenburg: 99

Bradford Washburn: 288

Volkmar Kurt Wentzel: 86, 109, 118

Wiele & Klein: 275

Maynard Owen Williams: 63, 116

Steven C. Wilson: 146, 150

Edwin L. Wisherd: 56, 75, 138, 264

Cary Wolinsky: 25, 156, 166, 173, 183

Adam Woolfitt: 240

Frederick R. Wulsin: 229

Paul Zahl: 170, 282

THE PHOTOGRAPHS

Unless otherwise noted the black-and-white photographs are silver gelatin prints.
The color prints are dye transfers made from transparencies or glass plates.

1. Franklin Price Knott
 Bali, Dutch East Indies (Indonesia). c. 1927
 Autochrome
 Unpublished
 © NGS
2. Mehmet Biber
 Inside the Holy Mosque, Mecca, Saudi Arabia. 1980
 Muslim pilgrims during Hajj making *s'ai,* running seven times
 between Mt. Safa and Mt. Marwa.
 Unpublished
 © Mehmet Biber
3. Winfield Parks
 Istanbul, Turkey. 1973
 Published October 1973, "Istanbul, the City That Links Europe
 and Asia"
 © NGS
4. Horace Bristol
 Honshū, Japan. 1946
 During the Lunar New Year ceremony at the Kwannon Temple,
 Saidaiji, young men file into the temple grounds to pray. A
 struggle for a pair of sacred batons, known as *Shingi,* follows in
 the darkened temple.
 Unpublished
 © Horace Bristol
5. George Tairraz
 French Alps. 1890s
 Unpublished
 Collection National Geographic Society
6. George Tairraz
 French Alps. 1890s
 Unpublished
 Collection National Geographic Society
7. Dean Conger
 Siberia, Soviet Union. 1974
 Published August 1977, "Five Times to Yakutsk"
 © NGS
8. Sam Abell
 Square Butte, Montana. 1984
 Published January 1986, "C.M. Russell, Cowboy Artist"
 © NGS
9. Roland W. Reed
 Minnesota. 1907
 Enemy Wind
 Ojibway Tribe.
 Unpublished
 Collection National Geographic Society
10. Sam Abell
 Moscow, Soviet Union. 1983
 Red Square seen from a hotel window.
 Published June 1986, "The World of Tolstoy"
 © NGS
11. Photographer unknown
 Turkey. 1870s
 Albumen print
 Unpublished
 Collection National Geographic Society
12. Sebah & Joaillier
 Turkey. 1880s
 Unpublished
 Collection National Geographic Society
13. Henri Béchard
 Cairo, Egypt. 1880s
 Mashrabiyahs, or wooden balcony gratings, on the windows of
 Arab homes.
 Albumen print
 Unpublished
 Collection National Geographic Society
14. Henri Béchard
 Cairo, Egypt. 1880s
 Mashrabiyahs, or wooden balcony gratings, on the windows of
 Arab homes.
 Albumen print
 Unpublished
 Collection National Geographic Society
15. Lehnert & Landrock
 Sahara Desert. c. 1905
 Published December 1911, "The Sacred City of the Sands"
 Collection National Geographic Society
16. Lehnert & Landrock
 Sahara Desert. c. 1905

Published December 1911, "The Sacred City of the Sands"
Collection National Geographic Society

17. George Shiras III
Loon Lake, Ontario, Canada. n.d.
The Camera Catches a Canadian Lynx Off Guard
Published July 1906, "Photographing Wild Game with
Flashlight and Camera"
© NGS

18. George Shiras III
Lake Superior. 1893
White-tailed deer.
Published August 1921, "The Wild Life of Lake Superior, Past
and Present: The Habits of Deer, Moose, Wolves, Beavers,
Muskrats, Trout, and Feathered Wood-Folk Studied with
Camera and Flashlight"
© NGS

19. Eliza R. Scidmore
Japan. n.d.
At the Photograph Gallery
Hand-colored silver gelatin print
Unpublished, received 1918
Collection National Geographic Society

20. Gilbert H. Grosvenor
Near Baddeck, Nova Scotia, Canada. 1908
Alexander Graham Bell with his grandchildren Gertrude (left),
Lilian, and Mabel Grosvenor at his home, Beinn Bhreagh.
Published October 1963, "The Romance of the Geographic"
Library of Congress

21. Fred Payne Clatworthy
Yosemite National Park, California. 1909
John Burroughs and John Muir
Unpublished
Collection National Geographic Society

22. Clifton Adams
Near Patagonia, Arizona. c. 1928
Unpublished
© NGS

23. Jacob Gayer
Ohio. 1929
Autochrome
Unpublished
© NGS

24. Tamotsu Enami
Japan. 1920
Japanese Junks
Unpublished
Collection National Geographic Society

25. Cary Wolinsky
Varanasi, India. 1983
Silk dyer's wife wearing purdah presenting herself for a
portrait in her home.
Unpublished
© Cary Wolinsky

26. Baron Wilhelm von Gloeden
Taormina, Sicily, Italy. c. 1903
Albumen print
Unpublished
Collection National Geographic Society

27. Baron Wilhelm von Gloeden
Taormina, Sicily, Italy. c. 1903
Albumen print
Published October 1916, "Inexhaustible Italy"
Collection National Geographic Society

28. Baron Wilhelm von Gloeden
Taormina, Sicily, Italy. c. 1903
Albumen print
Published October 1916, "Inexhaustible Italy"
Collection National Geographic Society

29. Baron Wilhelm von Gloeden
Taormina, Sicily, Italy. c. 1903
Albumen print
Published December 1909, "Emigration to America an
Industry"
Collection National Geographic Society

30. Baron Wilhelm von Gloeden
Taormina, Sicily, Italy. 1903
Albumen print
Published December 1909, "Emigration to America an
Industry"
Collection National Geographic Society

31. Baron Wilhelm von Gloeden
Taormina, Sicily, Italy. c. 1903
Albumen print
Unpublished
Collection National Geographic Society

32. Baron Wilhelm von Gloeden
Taormina, Sicily, Italy. c. 1903
Albumen print
Unpublished
Collection National Geographic Society

33. Baron Wilhelm von Gloeden
Taormina, Sicily, Italy. c. 1903
Albumen print
Unpublished
Collection National Geographic Society

34. Dick Durrance II
Dacca, Bangladesh. 1972
Bride and groom after the ceremony at the bride's home.
Unpublished
© NGS

35. Melville Chater
Durban, South Africa. 1930
Autochrome
Published April 1931, "Faces and Flowers Below the Tropics"
© NGS

36. Lehnert & Landrock
Algeria. n.d.
Published October 1922, "Peoples and Places of Northern
Africa"
Collection National Geographic Society

37. Photographer unknown
New Zealand. 1901
Chief Kewene Te Haho
Unpublished
Collection National Geographic Society

38. Luigi Pellerano
Albania. 1929
Autochrome
Published February 1931, "Europe's Newest Kingdom"
© NGS

39. Louie Psihoyos
Giza, Egypt. 1981
Pyramid guide atop the Great Pyramid.
Unpublished
© Louie Psihoyos

40. Franklin Price Knott
Bali, Dutch East Indies (Indonesia). c. 1927
Nine-year-old dancer wearing a gown of gold leaf hammered
on silk.
Autochrome
Published March 1928, "Artist Adventures on the Island of
Bali"
© NGS

41. Ernest B. Schoedsack
Siam (Thailand). n.d.
Published February 1928, "The Warfare of the Jungle Folk"
Collection National Geographic Society

42. Photographer unknown
Ceylon (Sri Lanka). n.d.
Published April 1907, "Women and Children of the East"
Collection National Geographic Society

43. Charles Martin
Philippines. 1920
Benguet Woman
Unpublished
© NGS

44. R. Senz & Company, Bangkok
Siam (Thailand). 1911
Unpublished
Collection National Geographic Society

45. Hans Hildenbrand
Austria. 1929
Autochrome
Unpublished
© NGS

46. J. Baylor Roberts
Lancaster, Pennsylvania. 1937
Amish Children
Dufay color
Unpublished
© NGS

47. Steve McCurry
Kathmandu, Nepal. 1983
Rejoicing after the monsoon, women gather at Baghmati River
for a ceremonial to honor Parvati, wife of the Hindu god Siva.
Unpublished
© Steve McCurry

48. Earle Harrison
Cairo, Egypt. c. 1919
Mummy of Yuaa at the Cairo Museum.
Published May 1923, "At the Tomb of Tutankhamen"
Collection National Geographic Society

49. Gervais Courtellemont
Egypt. 1920s
Wax painting on a Ptolemaic sarcophagus.
Autochrome
Published September 1926, "Along the Banks of the Colorful
Nile"
© NGS

50. Tomasz Tomaszewski
Wtodawa, Poland. 1986
Published September 1986, "Remnants: The Last Jews of
Poland"
© Tomasz Tomaszewski

51. James Amos
Boston, Lincolnshire, England. 1973
Near closing time at a pub.
Unpublished
© NGS

52. Gervais Courtellemont
Bangkok, Siam (Thailand). 1927
Autochrome
Published May 1934, "Temples and Ceremonies of
Kaleidoscopic Bangkok"
© NGS

53. Annie Griffiths Belt
Bakewell, Derbyshire, England. 1984
Skidmore's grocery store.
Similar photograph published March 1986, "Walking Britain's
Pennine Way"
© Annie Griffiths Belt

54. Clifton Adams
Plummer Island, Maryland. c. 1927
Published March 1928, "The Great Falls of the Potomac"
© NGS

55. Luis Marden
Panama. 1941
Toucan.
Unpublished
© NGS

56. Edwin L. Wisherd
Louisiana. 1929
Autochrome
Unpublished
© NGS

57. Jacob Gayer
American Southwest. 1920s
Echinocereus dasyacanthus.
Autochrome
Published September 1925, "Canyons and Cacti of the
American Southwest"
© NGS

58. Charles Martin
Dry Tortugas, Florida. 1927
Saucer-eye porgy beside a corrugated brain coral.
Autochrome
Published January 1927, "The First Autochromes from the
Ocean Bottom"
© NGS

59. David Doubilet
Jervis Bay, New South Wales, Australia. 1985
Clingfish, less than one inch long, on top of a sea tulip.
Published March 1987, "Australia's Southern Seas"
© David Doubilet

60. David Falconer
Mount St. Helens, Washington. 1984
On the fourth anniversary of the eruption, fumes from within the crater rise in early evening with the full moon.
Unpublished
© David Falconer

61. Jacob Gayer
Washington, D.C. 1928
Rotunda of the Corcoran Gallery of Art.
Autochrome
Published April 1929, "Unique Gifts of Washington to the Nation"
© NGS

62. Gervais Courtellemont
France. 1920s
Autochrome
Unpublished
© NGS

63. Maynard Owen Williams
Jerusalem, Palestine (Israel). 1927
Student at the Bezalel School of Arts and Crafts.
Unpublished
© NGS

64. Clifton Adams
Washington, D.C. 1923
Canal Boat Children and Their Pet
Unpublished
© NGS

65. Donald McLeish
London, England. 1936
The Old Dove's Inn by the Thames, near Hammersmith.
Unpublished
© NGS

66. Donald McLeish
Vannes, Brittany, France. 1930
Townswomen doing their weekly wash.
Unpublished
© NGS

67. W. Robert Moore
Dives-sur-Mer, Normandy, France. n.d.
Normandy Garden
Finlay color
Published August 1943, "Normandy and Brittany in Brighter Days"
© NGS

68. Donald McLeish
Marg, Egypt. 1920
Life in a typical village near Cairo.
Unpublished
© NGS

69. Donald McLeish
Cairo, Egypt. 1920

Coffee shop in the Arab quarter.
Unpublished
© NGS

70. David L. Brill
Aphrodisias, Turkey. 1980
Medusa carved in Aphrodisian marble.
Unpublished
© NGS

71. Jonathan Blair
Santo Domingo, Dominican Republic. 1978
Dinnerware from the Spanish ship *Tolosa* sunk off Hispaniola in 1724.
Unpublished
© Jonathan Blair

72. Clifton Adams
Roanoke Island, North Carolina. c. 1933
Unpublished
© NGS

73. Roland McKee
United States. c. 1920
The Inky Coprinus
Published May 1920, "Common Mushrooms of the United States"
Collection National Geographic Society

74. Justin Locke
Paris, France. 1951
Newspaper stand on Boulevard des Capucines.
Unpublished
© NGS

75. Edwin L. Wisherd
Washington, D.C. 1929
Autochrome
Unpublished
© NGS

76. Willard R. Culver
Hagerstown, Maryland. c. 1942
Women employees at Fairchild Aircraft painting the wing of a Navy plane.
Published July 1945, "George Washington's Historic River"
© NGS

77. B. Anthony Stewart
Dearborn, Michigan. 1944
Published December 1944, "Great Lakes and Great Industries"
© NGS

78. B. Anthony Stewart
Near Omar, West Virginia. 1938
Published May 1944, "Coal: Prodigious Worker for Man"
© NGS

79. James P. Blair
South Africa. 1976
Gold miner a mile beneath the surface.
Unpublished
© NGS

80. Herbert G. Ponting
Antarctica. 1911
B. Day, member of the Scott South Polar Expedition, on his return from the Barrier.
Unpublished
© NGS

81. Herbert G. Ponting
Antarctica. 1912
C. S. Wright, member of the Scott South Polar Expedition, on his return from the Barrier.
Unpublished
© NGS

82. William Albert Allard
Peru. 1981
Published March 1982, "The Two Souls of Peru"
© NGS

83. Steve Raymer
Bangladesh. 1974
Bengali girl waiting for relief food.
Published July 1975, "Can the World Feed Its People?"
© NGS

84. James P. Blair
Port-au-Prince, Haiti. 1987
Three-year-old child on cardboard cartons to protect her from the mud floor of her family's shack in Cité Soleil.
Similar photograph published November 1987, "Haiti — Against All Odds"
© NGS

85. George F. Mobley
Rodebay, Greenland. 1974
Youth reading comics in the Jakobshavn District.
Unpublished
© NGS

86. Volkmar Kurt Wentzel
Angola. 1959
Mwila girl.
Unpublished
© NGS

87. Steve McCurry
Near Timbuktu, Mali. 1986
Tuareg girl in her tent during the heat of the day.
Unpublished
© Steve McCurry

88. Yva Momatiuk/John Eastcott
Chochotowska, Poland. 1980
Late for Church
Unpublished
© Yva Momatiuk/John Eastcott

89. Robert Caputo
Kenya. 1985
Cheetah and Cub
With her cub atop an old termite mound, a cheetah surveys the surrounding terrain for prey. She lost all her other cubs to illness or predation.
Unpublished
© Robert Caputo

90. Jonathan Blair
Zululand, South Africa. 1977
Baby Nile crocodile.
Unpublished
© Jonathan Blair

91. David Doubilet
Red Sea, Sinai, Israel (Egypt). 1979
Purple fridmani fish and sea fan fish.
Unpublished
© David Doubilet

92. Paul Chesley
San Juan Mountains, Colorado. 1979
Reflection in Rio Grande headwaters.
Unpublished
© Paul Chesley

93. Paul Chesley
Yellowstone National Park, Wyoming. 1979
Grand Prismatic Thermal Spring.
Published, *High Country Trail: The Continental Divide*, 1981
© Paul Chesley

94. Jon Schneeberger with Ted Johnson, electrical engineer, and Anthony Peritore, photographic engineer
John F. Kennedy Space Center, Florida. 1981
Ascent of the space shuttle recorded by a remote camera behind Launch Pad 39A, which was triggered by sound calibrated to engine levels.
Unpublished
© NGS

95. Jon Schneeberger with Ted Johnson, electrical engineer, and Anthony Peritore, photographic engineer
John F. Kennedy Space Center, Florida. 1981
Space shuttle lifting off with 6.5 million pounds of thrust.
Triptych
Unpublished
© NGS

96. Harold E. Edgerton
Cambridge, Massachusetts. 1959
Bullet Through Balloons
Three consecutive balloons burst by a .22 caliber bullet.
Published October 1987, "Doc Edgerton — The Man Who Made Time Stand Still"
© Harold E. Edgerton

97. Photographer unknown
Fort Sill, Oklahoma. 1918
Hydrogen balloon exploding at Post Field.
Published May 1919, "Helium, the New Balloon Gas"
Division of Military Aeronautics

98. Photographer unknown
Kagoshima, Japan. 1914
Sakurajima erupting.
Published October 1923, "The Empire of the Risen Sun"
Collection National Geographic Society

99. Fred A. Wardenburg
Belgian Congo (Zaire). n.d.
Published February 1960, "My Life with Africa's Little People," received 1952
© NGS

100. R. Senz & Company, Bangkok
Siam (Thailand). 1911
Gamblers.
Unpublished
Collection National Geographic Society

101. Jack Hillers
New Mexico. c. 1875
The Jemez Ruins
Unpublished
Collection National Geographic Society

102. Jack Hillers
New Mexico. c. 1875
Pueblo de Taos (North)
Unpublished
Collection National Geographic Society

103. Hiram Bingham
Machu Picchu, Peru. c. 1912
San Miguel Bridge just below Machu Picchu.
Unpublished
© NGS

104. Hiram Bingham
Patallacta, Peru. c. 1912
Unpublished
© NGS

105. Lowell Georgia
Chesapeake Bay. 1979
Capsized sailboat.
Published October 1980, "My Chesapeake — Queen of Bays"
© NGS

106. Nathan Benn
Salisbury Beach, Massachusetts. 1978
Summer cottages on the Atlantic shore.
Unpublished
© Nathan Benn

107. Photographer unknown
Long Island, New York. 1932
Published November 1932, "Observing a Total Eclipse of the Sun"
Collection National Geographic Society

108. Jacob Gayer
Fort Valley, Georgia. 1935
Autochrome
Unpublished
© NGS

109. Volkmar Kurt Wentzel
Kentucky. 1940
Unpublished
© NGS

110. George R. King
Zuider Zee, Netherlands. n.d.
Fisherman and his family on the island of Marken.
Hand-colored platinotype
Published November 1914, "Young Russia"
Collection National Geographic Society

111. Photographer unknown
Algeria. n.d.
Hand-colored silver gelatin print
Published March 1917, "16 Pages in Four Colors"
Collection National Geographic Society

112. Robert Reid
Banffshire, Scotland. 1928
Fisher Girls
Unpublished
© NGS

113. Tom Nebbia
Cuautla, Mexico. 1977
Remaining members of Emiliano Zapata's revolutionary forces.

Published May 1978, "Mexico: A Very Beautiful Challenge"
© NGS

114. James L. Stanfield
New Orleans, Louisiana. 1970
Published February 1971, "New Orleans and Her River"
© NGS

115. Justin Locke
New Orleans, Louisiana. 1952
Morning Call coffee shop at French Market.
Unpublished
© NGS

116. Maynard Owen Williams
Semakh, Palestine (the Golan). 1927
Unpublished
© NGS

117. Tom Nebbia
Los Angeles, California. 1984
Dogs trained to watch television for motion picture work.
Unpublished
© Tom Nebbia

118. Volkmar Kurt Wentzel
India. 1948
Unpublished
© NGS

119. Frans Lanting
Madagascar. 1986
Market, Camp Robin
Similar photograph published February 1987, "Madagascar: A World Apart"
© Frans Lanting

120. William Albert Allard
Paris, France. 1986
Unpublished
© William Albert Allard

121. Luis Marden
Panama. 1941
Unpublished
© NGS

122. Luis Marden
Panama. 1941
Unpublished
© NGS

123. Emory Kristof
Ocean City, Maryland. 1975
Unpublished
© NGS

124. Eliza R. Scidmore
Japan. n.d.
Hand-colored silver gelatin print
Published July 1914, "Young Japan"
Collection National Geographic Society

125. Eliza R. Scidmore
Japan. n.d.
The Prize Chrysanthemums
Diptych
Hand-colored silver gelatin print
Unpublished, received 1918
Collection National Geographic Society

126. Eliza R. Scidmore
Japan. n.d.
Hand-colored silver gelatin print
Published July 1914, "Young Japan"
Collection National Geographic Society

127. Eliza R. Scidmore
Japan. n.d.
Triptych
Hand-colored silver gelatin print
Unpublished, received 1918
Collection National Geographic Society

128. Gustav Heurlin
Sweden. c. 1920
Four images
Unpublished
© NGS

129. Harry F. Blanchard
United States. c. 1915
Published August 1923, "Our Heritage of the Fresh Waters"
Collection National Geographic Society

130. B. Anthony Stewart
England. 1948
Unpublished
© NGS

131. Nathan Benn
Middlebury, Vermont. 1973
Farm woman at the door of the communal Lorien Farm.
Unpublished
© Nathan Benn

132. J. Baylor Roberts
Wakulla Springs, Florida. n.d.
Published January 1944, "Gulf Coast Towns Get Into the Fight"
© NGS

133. Luis Marden
El Salvador. 1944
Unpublished
© NGS

134. Carole Devillers
Haiti. 1985
Published March 1985, "Haiti's Voodoo Pilgrimages"
© Carole Devillers

135. Stephanie Maze
Rio de Janeiro, Brazil. 1985
Carnival Dancer
Unpublished
© Stephanie Maze

136. David Alan Harvey
Dallas, Texas. 1984
Published September 1984, "Dallas!"
© NGS

137. Nathan Benn
Palm Beach, Florida. 1981
Costume ball at the Breakers Hotel.
Unpublished
© Nathan Benn

138. Edwin L. Wisherd
San Juan, Puerto Rico. c. 1935
La Fortaleza, where Puerto Rico's governors have maintained their homes and offices for four centuries.
Published December 1939, "Puerto Rico Polychromes"
© NGS

139. Farrell Grehan
Stavoren, Netherlands. 1985
Summer boating enthusiasts.
Unpublished
© Farrell Grehan

140. Gail Mooney
Montreal, Quebec, Canada. 1983
Mural near Rue St. Denis.
Unpublished
© Gail Mooney

141. Bruce Dale
Mera, Romania. 1969
Youth in dining room.
Unpublished
© NGS

142. Luis Marden
Costa Rica. c. 1945
Published October 1946, "Land of the Painted Oxcarts"
© NGS

143. Stephen R. Brown
Nantucket, Massachusetts. 1985
Unpublished
© Stephen R. Brown

144. Paul Almasy
Madagascar. 1938
Published June 1942, "Madagascar: Mystery Island"
© Paul Almasy

145. Jodi Cobb
London, England. 1984
On the shores of the Serpentine in Hyde Park.
Unpublished
© NGS

146. Steven C. Wilson
Matagorda, Texas. 1979
Texas horned lizard on the runway of Matagorda's defunct airfield.
Published February 1981, "Where Oil and Wildlife Mix"
© Steven C. Wilson/Entheos

147. O. F. Cook
Peru. c. 1916
Tree tomato, *Cyphomandra*.
Published May 1916, "Staircase Farms of the Ancients"
Collection National Geographic Society

148. Frans Lanting
Madagascar. 1986
Parsons Chameleon
Similar photograph published February 1987, "Madagascar: A World Apart"
© Frans Lanting

149. James P. Blair
Cape Cod, Massachusetts. 1972
Herring gulls on the Chatham's Fish House weather vane.
Published July 1975, "Cape Cod's Circle of Seasons"
© NGS

150. Steven C. Wilson
Texas. 1979
Mated pair of reddish egrets in an aerial altercation.
Published February 1981, "Where Oil and Wildlife Mix"
© Steven C. Wilson/Entheos

151. Lynwood M. Chace
Swansea, Massachusetts. c. 1930
Star-nosed mole, with outsize claws and 22 nose tentacles.
Published, *Wild Animals Book*, 1960
© L. M. Chace/National Audubon Society

152. William L. Finley and H. T. Bohlman
California. 1905
Young turkey vulture.
Published August 1923, "Hunting Birds with a Camera"
Collection National Geographic Society

153. David Fleay
New South Wales, Australia. 1950
Male brown snakes fighting during mating season near the
Lachlan-Murrumbidgee confluence.
Unpublished
© David Fleay

154. William Albert Allard
Peru. 1981
Fishmarket
Unpublished
© William Albert Allard

155. O. L. Mazzatenta
Madrid, Spain. 1985
Window display in the 260-year-old Casa Botin restaurant —
a favorite of American writer Ernest Hemingway —
announcing the house specialty, roast suckling pig.
Published February 1986, "Madrid: The Change in Spain"
© NGS

156. Cary Wolinsky
Near St. Agatha, Maine. 1978
Multipurpose barn on a small dairy farm.
Published September 1980, "Madawaska: Down East with a
French Accent"
© NGS

157. Herbert G. Ponting
Antarctica. 1910
Ponies of the Scott South Polar Expedition on the *Terra Nova*.
Unpublished
© NGS

158. Peter Magubane
South Africa. 1985
Traditional thatched and painted Ndebele architecture is now
rare. Danisile Ndimande, one of her people's finest artists,
painted her home freehand without sketches or plans.
Published February 1986, "South Africa's Ndebele People"
© NGS

159. William Belknap, Jr.
Las Vegas, Nevada. c. 1948
Contestant in the Helldorado Rodeo.
Published December 1948, "Mapping Our Changing
Southwest"
© William Belknap, Jr.

160. Mitsuaki Iwago
Serengeti National Park, Tanzania. 1985
Zebras seeking safety in a herd of migrating wildebeests.
Published May 1986, "The Serengeti: A Portfolio"
© Mitsuaki Iwago

161. Mitsuaki Iwago
Serengeti National Park, Tanzania. 1985
Some of the Park's 1.5 million wildebeests migrate across a
river. Hundreds drown in such crossings, especially calves.
Published May 1986, "The Serengeti: A Portfolio"
© Mitsuaki Iwago

162. Ric Ergenbright
Monument Valley, Utah/Arizona border. 1985
View from Hunt's Mesa.
Published Spring 1987, *National Geographic Traveler*
© Ric Ergenbright

163. Frederick William Wallace
Grand Banks, Atlantic Ocean. n.d.
Flying Sets
Published July 1921, "Life on the Grand Banks"
Collection National Geographic Society

164. Bill Curtsinger
Deception Island, Antarctica. 1979
Weddell Seal on Volcanic Beach
Unpublished
© Bill Curtsinger

165. Flip Nicklin
California. 1980
Sleeping California shark.
Published August 1981, "Sharks: Magnificent and
Misunderstood"
© NGS

166. Cary Wolinsky
Varanasi, India. 1973
Water buffalo in the Ganges River.
Unpublished
© Cary Wolinsky

167. Joe Scherschel
Andalusia, Spain. 1972
A female partridge decorates a Benaojan street, living like a
pet until the fall hunting season when she will be used to lure
courting males from cover.
Published June 1975, "Andalusia, the Spirit of Spain"
© NGS

168. James L. Stanfield
Goma Sushitsa, Bulgaria. 1978
Grieving Mother #4
Peasant woman from Pirin Mountains mourning the murder
of her youngest son shortly after he left the village to make
his mark in the country's capital.
Unpublished
© NGS

169. Jodi Cobb
Helsinki, Finland. 1980
Renowned actress Ella Eronen posing in front of a portrait
her husband painted of her as Mame, her most famous role.
Unpublished
© NGS

170. Paul Zahl
Brazil. c. 1958
Published May 1959, "Giant Insects of the Amazon"
© NGS

171. Sam Abell
London, England. 1980
Mallow plant in bloom, seen at sunset through the greenhouse's glass at Chelsea Physic Garden.
Unpublished
© Sam Abell

172. Rear Admiral Donald B. MacMillan
Etah, Greenland. n.d.
Bouquet picked in July.
Unpublished, received 1919
Collection National Geographic Society

173. Cary Wolinsky
Ulyanovsk, Soviet Union. 1983
Impatiens and an African violet pressing against a cold window for light as winter begins.
Unpublished
© Cary Wolinsky

174. Colonel E. J. Parker
France. 1918
Published April 1920, "The Salvation Army"
Collection National Geographic Society

175. Photographer unknown
Russia (Soviet Union). n.d.
Unpublished, received 1913
Collection National Geographic Society

176. Photographer unknown
Oman. 1917
Published November 1919, "The Rise of the New Arab Nation"
Collection National Geographic Society

177. Joseph F. Rock
China. 1928
Autochrome
Published October 1935, "Demon-Possessed Tibetans and Their Incredible Feats"
© NGS

178. Joseph F. Rock
Choni, China. 1925
This Tibetan *drokwa* (nomad) woman of the grasslands northwest of Choni wears her hair braided into 108 pigtails and gathered in a red leather pouch decorated with silver disks.
Unpublished
© NGS

179. Joseph K. Dixon
North America. c. 1913
Mrs. Sadie Boyd and infant photographed on the third Rodman Wanamaker Historical Expedition to study the North American Indian.
Unpublished
Collection National Geographic Society

180. Ernest B. Schoedsack
Turkey. 1925
Women of Konia.

Published August 1925, "From England to India by Automobile"
Collection National Geographic Society

181. Joseph F. Rock
Choni, China. 1925
The lama caretaker poses in one of the six buildings which housed the printing blocks of the Kanjur and Tanjur, the Tibetan Buddhist bible and its commentary. The entire collection of wooden blocks was destroyed by fire in 1928 when Moslems attacked Choni and its lamasery in retaliation for the killing of the wives of a Moslem general by the Choni prince.
Unpublished
© NGS

182. Jacob Gayer
Rio de Janeiro, Brazil. 1930
Votive offerings hang in the Igreja da Penha (Church of the Rock), a popular shrine in the outskirts of the capital. These objects indicate the nature of the supplicants' misfortunes and are symbolic of answers to prayer.
Unpublished
© NGS

183. Cary Wolinsky
Wookey Hole, Somerset, England. 1978
Heads of state and other famous and infamous wax figures from Madame Tussaud's Exhibition, in storage near Wells.
Similar photograph published October 1979, "Two Englands"
© Cary Wolinsky

184. Lennart Larsen
Denmark. 1952
Tollund Man
Well-preserved head of a peat-bog man.
Published March 1954, "Lifelike Man Preserved 2,000 Years in Peat"
© Lennart Larsen Fot/Danish Information Office

185. P. V. Glob
Denmark. 1952
Grauballe Man
The body of a man preserved in the Grauballe Bog for 2,000 years was discovered in Middle Jutland in 1952. The man, around thirty at his death, was found naked with his throat cut. His right hand, fingerprinted by the police, made as clear an impression as that of a live person.
Published March 1954, "Lifelike Man Preserved 2,000 Years in Peat"
© P. V. Glob

186. Jonathan Blair
Palermo, Sicily, Italy. 1974
350-year-old catacombs of Capuchin Convent.
Published March 1976, "Sicily, Where All the Songs are Sad"
© NGS

187. Hugo Brehme
Mexico. c. 1915
Unpublished
Collection National Geographic Society

188. Hugo Brehme
Mexico. c. 1915
Unpublished
Collection National Geographic Society

189. Luis Marden
Chichicastenango, Guatemala. 1936
Traveling barber setting up shop in an alcove of Santo Tomas on market day.
Unpublished
© NGS

190. Admiral Robert E. Peary
Greenland. 1892
"Stars and Stripes" at Navy Cliff, July 4.
Unpublished
Collection National Geographic Society

191. Joseph K. Dixon
North America. c. 1913
Child with puppy photographed on the third Rodman Wanamaker Historical Expedition to study the North American Indian.
Unpublished
Collection National Geographic Society

192. Edward S. Curtis
Montana. 1908
Two Whistles — Apsaroke
Photogravure
Unpublished
Collection National Geographic Society

193. Edward S. Curtis
Montana. 1908
Lone Flag — Atsina
Photogravure
Unpublished
Collection National Geographic Society

194. Edward S. Curtis
Montana. 1908
Lone Tree — Apsaroke
Photogravure
Unpublished
Collection National Geographic Society

195. Edward S. Curtis
Arizona. 1907
Tonovige — Havasupai
Photogravure
Unpublished
Collection National Geographic Society

196. Roland W. Reed
North America. 1907
The First Sail
Unpublished
Collection National Geographic Society

197. Thomas J. Abercrombie
Easter Island, Pacific Ocean. 1961
Published January 1962, "Easter Island and Its Mysterious Monuments"
© NGS

198. Jim Brandenburg
Namibia. 1981
Oryx tracks decorating the world's tallest sand dunes (1,200 feet) behind strolling flamingos.
Unpublished
© Jim Brandenburg

199. Wolfgang Kaehler
Bransfield Strait. 1985
Chin-strap penguins resting between feeding forays, near the Antarctic Peninsula.
Published, *Our Awesome Earth: Its Mysteries and Its Splendors*, 1986
© Wolfgang Kaehler

200. Alan Root
Mzima Springs, Kenya. 1971
Hippopotamus prowling an underwater tunnel formed by vegetation.
Published September 1971, "Mzima, Kenya's Spring of Life"
© NGS

201. David Doubilet
Red Sea, Sinai, Israel (Egypt). 1981
Face of a 5-foot, 400-pound bump head wrasse.
Unpublished
© David Doubilet

202. Eugene A. Cernan
Moon. 1972
Published September 1973, "Exploring Taurus-Littrow: Photographs by the Crew of Apollo 17"
Eugene A. Cernan/NASA

203. Vittorio Sella
Ruwenzori, Uganda. 1906
Unpublished
Collection National Geographic Society

204. Vittorio Sella
Ruwenzori, Uganda. 1906
Heath forest in the lower Bujuku Valley.
Unpublished
Collection National Geographic Society

205. Merlin Minshall
Nürnberg, Germany (West Germany). c. 1936
Graf Zeppelin soaring over Nürnberg as Nazis salute Reichsführer Hitler.
Published May 1937, "By Sail Across Europe"
© Merlin Minshall

206. Photographer unknown
Frankfurt, Germany (West Germany). n.d.
Published June 1936, "Cologne, Key City of the Rhineland"
European Picture Service

207. Nicholas John Caire
Australia. n.d.
Unpublished, received 1917
Collection National Geographic Society

208. Steve Wall
California. 1982
River otter on the bank of the Smith River in northern California.
Published, *America's Wild and Scenic Rivers*, 1983
© NGS

209. Rear Admiral Donald B. MacMillan
Etah, Greenland. n.d.
An Arctic Summer
Salmon trout from Alida Lake.
Unpublished, received 1919
Collection National Geographic Society

210. Hiram Bingham
Copacavana, Peru. c. 1912
Unpublished
Collection National Geographic Society

211. Hiram Bingham
Tiahuanaco, Peru. c. 1912
Unpublished
Collection National Geographic Society

212. Luis Marden
Antigua, Guatemala. 1936
Architectural detail of cathedral ruins.
Unpublished
© NGS

213. Steve McCurry
Rajasthan, India. 1983
Winds searing the arid plains before the rainy season as
women seek shelter from a dust storm.
Unpublished
© Steve McCurry

214. Joseph K. Dixon
Arizona. c. 1913
Havasupai mother and child photographed on the third
Rodman Wanamaker Historical Expedition to study the
North American Indian.
Unpublished
Collection National Geographic Society

215. Helen Marian Place Moser
Aden (Yemen). c. 1909
Somali mother and child.
Published June 1917, "Madonnas of Many Lands"
Collection National Geographic Society

216. James P. Blair
Haiti. 1987
The young mother has brought her baby to a rural clinic to be
examined. She has syphilis and fears that she has transmitted
the disease to her child.
Published November 1987, "Haiti — Against All Odds"
© NGS

217. Stephanie Maze
Rio de Janeiro, Brazil. 1985
Carnival Preparation
Unpublished
© Stephanie Maze

218. Steve McCurry
Tiguent, Mauritania. 1986
A married couple sit on their bed while other members of this
extended family prepare tea in the afternoon heat. Eight
people share this one-room house.
Unpublished
© Steve McCurry

219. Jodi Cobb
Suwannee, Florida. 1976
John L. Colson, Sr. — Crabber, Sturgeon Fisher, Turtle Trapper,
and Bulkhead Builder
Published July 1977, "The Suwannee"
© NGS

220. William Albert Allard
Arizona. 1970
Henry Gray, rancher

Published May 1971, "Two Wheels Along the Mexican
Border"
© NGS

221. Craig Aurness
Britt, Iowa. 1980
Annual National Hobo Convention.
Published May 1981, "Iowa, America's Middle Earth"
© NGS

222. Photographer unknown
Denver, Colorado. n.d.
Published October 1923, "The Automobile Industry"
Denver Tourist Office

223. Chris Johns
Vancouver, British Columbia, Canada. 1984
A do-it-yourself drive-in brings better television reception for
John Adams of Dunster and his mother, Josie.
Published July 1986, "The Untamed Fraser River"
© NGS

224. John Patric
Budapest, Hungary. n.d.
Published January 1938, "Magyar Mirth and Melancholy"
© NGS

225. Cotton R. Coulson
East Berlin. 1981
Three Penny Opera
Unpublished
© Cotton R. Coulson

226. Harry A. McBride
Warsaw, Poland. 1921
The Immigration Problem: One Million Visas
Unpublished
Collection National Geographic Society

227. Edmond Sacre
Ghent, Belgium. n.d.
Beguines of Ghent
Published May 1925, "Through the Back Doors of Belgium"
Collection National Geographic Society

228. Photographer unknown
Morristown, New Jersey. n.d.
The Morning Crank
Ambulance drivers at a training camp cranking Ford
automobiles.
Published December 1917, "Training the New Armies of
Liberty"
Press Illustrating Service, Inc.

229. Frederick R. Wulsin
Choni, China. 1923
Kitchen of a rich Tibetan.
Published September 1925, "Experiences of a Lone
Geographer"
Collection National Geographic Society

230. Annie Griffiths Belt
Bodie, California. 1983
Place setting in the home of a former madam in a ghost town
preserved as the Bodie Historical Park.
Published, America's Hidden Corners, 1983
© NGS

231. Clifton Adams
Corsica, France. c. 1921

Published September 1923, "The Coasts of Corsica"
© NGS

232. Robert Reid
Argyll, Scotland. 1927
Interior of ferry house at Inverawe estate.
Unpublished
© NGS

233. Sam Abell
Hagi, Japan. 1980
Looking out a window of the Tomoe Inn.
Published June 1984, "Hagi: Where Japan's Revolution Began"
© NGS

234. Hans Hildenbrand
Italy. 1927
Autochrome
Published April 1928, "Man and Nature Paint Italian Scenes in Prodigal Colors"
© NGS

235. William Thompson
Alaska. 1983
"Air-to-air" shot over Mendenhall Glacier.
Unpublished
© William Thompson

236. Wilbur E. Garrett
Mekong River, Cambodia (Kampuchea). 1968
Buddhist monks in a window of Bayon, the central temple of Angkor Thom.
Published December 1968, "The Mekong, River of Terror and Hope"
© NGS

237. Gordon Gahan
Dusky Sound, New Zealand. 1970
Published September 1971, "Captain Cook: The Man Who Mapped the Pacific"
© NGS

238. Cotton R. Coulson
Ireland. 1980
Ponies for Sale
Unpublished
© Cotton R. Coulson

239. James A. Sugar
Ireland. 1968
Published September 1969, "The Friendly Irish"
© NGS

240. Adam Woolfitt
Faeroe Islands, North Atlantic Ocean. 1968
Aftermath of a whale hunt.
Published September 1970, "The Faeroes, Isles of Maybe"
© NGS

241. James Nachtwey
Krukira, Nicaragua. 1985
Wake for a Miskito Indian man in a small village on the Atlantic coast.
Unpublished
© James Nachtwey/Magnum Photos

242. Robert Madden
Chichicastenango, Guatemala. 1976

Man praying in front of a shrine outside an earthquake-demolished church.
Unpublished
© NGS

243. James P. Blair
Capetown, South Africa. 1976
Dunele Kewana, in Groote Schuur Hospital, stabbed in the shoulders, head, and chest, during a fight in Cape Flats, the "coloured" ghetto.
Unpublished
© NGS

244. Farrell Grehan
Nigeria. 1973
Youth dying of starvation in a Red Cross Camp.
Unpublished
© Farrell Grehan

245. Robert Caputo
Uganda. 1987
Wrapped in bark cloth, the traditional Baganda shroud, the body of AIDS victim Josephine Nagingo lies in her parents' house near the town of Kyotera, in the Rakai District. Josephine's mother mourns nearby.
Unpublished
© Robert Caputo

246. Wilbur E. Garrett
Kampuchea. 1981
Published May 1982, "Kampuchea Wakens from a Nightmare"
© NGS

247. James Nachtwey
Nicaragua. 1985
Published December 1985, "Nicaragua: Nation in Conflict"
© NGS

248. Albert Couturiaux
Belgian Congo (Zaire). 1920s
Published November 1937, "Keeping House on the Congo"
© NGS

249. Father F. J. Kirschbaum
New Guinea. c. 1928
Forced and sometimes fatal initiation ceremony.
Published September 1929, "Into Primeval Papua by Seaplane"
Collection National Geographic Society

250. Dickey Chapelle
South Vietnam. 1964
Published February 1966, "What Was a Woman Doing There?" (Memorial Tribute)
© NGS

251. Jodi Cobb
Lake Thun, Switzerland. 1986
Swimming platform in Alpine morning fog.
Unpublished
© NGS

252. Photographer unknown
Bikini Atoll, Marshall Islands, Pacific Ocean. 1946
Atomic bomb test.
Unpublished
Joint Army-Navy Task Force One

253. Photographer unknown
 Bikini Atoll, Marshall Islands, Pacific Ocean. 1946
 Atomic bomb test.
 Unpublished
 Joint Army-Navy Task Force One
254. Photographer unknown
 Bikini Atoll, Marshall Islands, Pacific Ocean. 1946
 Atomic bomb test.
 Unpublished
 Joint Army-Navy Task Force One
255. David Doubilet
 Marsa Mukabela, Sinai Coast, Israel (Egypt). 1982
 Undersea Desert
 Unpublished
 © David Doubilet
256. Vittorio Sella
 Ruwenzori, Uganda. 1906
 Lobelia deckenii in flower, Bujuku Valley.
 Unpublished
 Collection National Geographic Society
257. Vittorio Sella
 Ruwenzori, Uganda. 1906
 Lobelia deckenii in flower, Bujuku Valley.
 Unpublished
 Collection National Geographic Society
258. Nicholas Morant
 Lake Louise, Alberta, Canada. 1946
 Published June 1947, "On the Ridgepole of the Rockies"
 © NGS
259. Wilbur E. Garrett
 Canada. 1969
 Published October 1970, "Canada's Heartland, the Prairie
 Provinces"
 © NGS
260. George Shiras III
 Sandy Lake, Newfoundland, Canada. n.d.
 Canoeist ready to pursue swimming caribou in migration.
 Published June 1908, "One Season's Game-Bag with the
 Camera"
 © NGS
261. Clifton Adams
 Washington, D.C. 1924
 Sky-writer signing off at sunset above Bolling Field.
 Unpublished
 © NGS
262. Homer E. Hoopes
 Arizona. 1902
 Hopi Tribe.
 Diptych
 Unpublished
 Collection National Geographic Society
263. Luis Marden
 Guatemala City, Guatemala. 1936
 Cantina called "The Sad Leavetaking," on the corner
 opposite the cemetery.
 Unpublished
 © NGS
264. Edwin L. Wisherd
 New Orleans, Louisiana. 1929

Entrance to the Little Theater in the French Quarter.
 Autochrome
 Published April 1930, "Color Camera Records of New
 Orleans"
 © NGS
265. Clifton Adams
 Washington, D.C. 1930
 Agfacolor
 Unpublished
 © NGS
266. Hugo Brehme
 Candelaria, Mexico. c. 1915
 Unpublished
 Collection National Geographic Society
267. Hugo Brehme
 Mexico. c. 1915
 Published February 1917, "16 Pages of Photogravure"
 Collection National Geographic Society
268. Tamotsu Enami
 Japan. 1920
 Peasants Coming Home From Their Work
 Unpublished
 Collection National Geographic Society
269. W. Robert Moore
 Jamaica. 1947
 Unpublished
 © NGS
270. David Alan Harvey
 Malaysia. 1977
 Chinese traveling theater actor backstage.
 Unpublished
 © David Alan Harvey
271. David Burnett
 Kingston, Jamaica. 1981
 Published January 1985, "Jamaica: Hard Times, High Hopes"
 © NGS
272. Lehnert & Landrock
 Tunis, Tunisia. n.d.
 Published December 1911, "The Sacred City of the Sands"
 Collection National Geographic Society
273. Ernest B. Schoedsack
 Siam (Thailand). 1927
 Unpublished
 Collection National Geographic Society
274. Melville Chater
 Durban, South Africa. 1930
 Autochrome
 Unpublished
 © NGS
275. Wiele & Klein
 India. n.d.
 Published December 1913, "Religious Penances and
 Punishments Self-Inflicted by the Holy Men of India"
 Collection National Geographic Society
276. Lynn Acutt
 Durban, South Africa. n.d.
 Published April 1931, "Under the South African Union"
 Collection National Geographic Society

277. Joseph F. Rock
China. 1928
Three prisoners who committed a double murder are kept in a black stone dungeon where they sit day and night with huge boards around their necks.
Unpublished
© NGS

278. Mitsuaki Iwago
Serengeti National Park, Tanzania. 1985
Feeble wildebeest downed by a lion on the parched savanna.
Unpublished
© Mitsuaki Iwago

279. William Albert Allard
Peru. 1981
Slaughterhouse
Unpublished
© William Albert Allard

280. William Albert Allard
Peru. 1981
Slaughterhouse
Unpublished
© William Albert Allard

281. Robert F. Sisson
Washington, D.C. 1978
Swarm of two-millimeter long ants devouring a dogday cicada.
Unpublished
© NGS

282. Paul Zahl
Location unknown. 1974
Guppies.
Unpublished
© NGS

283. Martin Rogers
Portsall, Brittany, France. 1978
History's largest oil spill tainted more than a hundred miles of a coastline known for its vigorous fishing industry and rustic charm. The bow of the *Cadiz* rears from the sea some two miles off Portsall.
Published July 1978, "Black Day for Brittany"
© NGS

284. José Azel
Burbank, California. 1985
Perpetual Green
Woodlawn Cemetery.
Unpublished
© José Azel/Contact Press Images

285. George F. Mobley
Helsinki, Finland. 1967
May Day snow squall buffeting merrymakers at Kaivopuisto Park.
Published May 1968, "Finland: Plucky Neighbor of Soviet Russia"
© NGS

286. Bruce Dale
Bahamas. 1981
Published September 1982, "Boom Times and Buccaneering: The Bahamas"
© NGS

287. Douglas Miller
Ephrata, Washington. 1980
Three hours after the eruption, clouds of ash menace this town 144 miles northeast of Mount St. Helens.
Published, *Exploring Our Living Planet*, 1983
© Douglas Miller/West Stock

288. Bradford Washburn
Chitina Glacier, Alaska. 1938
Unpublished
© Bradford Washburn

289. Stephen McAlko
Near Blythe, California. 1932
"…the curious thing about them was this: So huge were they in outline and so shallow in indentation that they were virtually invisible to anyone standing only a few yards away. Nor were there any hills near enough to afford a comprehensive view…"
Published September 1952, "Giant Effigies of the Southwest"
U.S. Air Force

THE PHOTOGRAPHERS

The Pictures of the Year competition has been held annually since 1957 and is sponsored jointly by
the National Press Photographers Association and the University of Missouri School of Journalism.
The biographies were compiled and written by Frances Fralin.

Sam Abell was born February 19, 1945, in Sylvania, Ohio. He became a National Geographic intern in 1967 and has been a contract photographer since 1971. Assignments for more than a dozen *Geographic* articles have led him around the world. His photographs illustrate the Society books *Pacific Crest Trail* (1975), *Still Waters, White Waters* (1978), plus chapters in others, as well as *C. M. Russell's West* (1987), published by Thomasson-Grant of Charlottesville, Virginia. Abell, who lives in Crozet, Virginia, has had one-man exhibitions in Toronto, Boston, Milwaukee, and Atlanta.

Thomas J. Abercrombie was born August 13, 1930, in Stillwater, Minnesota. Since 1956 he has been a National Geographic staff writer and photographer; for the past fifteen years he has specialized in the Islamic world. Abercrombie was named Newspaper Photographer of the Year in 1954 and Magazine Photographer of the Year in 1959 in the Pictures of the Year competition, and received the 1972 Overseas Press Club Award for best photographic reporting. He lives in Shady Side, Maryland.

Lincesal Robert Leslie (Lynn) Acutt was born in Durban, South Africa, in 1896. Acutt operated a car dealership and wrote and illustrated a weekly column about new cars and scenic routes for the *Natal Mercury.* Eventually he became a press photographer for the newspaper. In 1929 he opened a studio and camera shop; later he became involved in filmmaking. During World War II, Acutt was a South African Army photographer. At his death in 1964, Acutt left historically important photographs documenting the city to the Durban Museum and a collection of southern African artifacts to Durban's William Campbell Museum.

Clifton Royal Adams was born in 1890. As a National Geographic staff photographer from 1920 until 1934, he traveled throughout the United States, Central America, and Europe, contributing thirty color portfolios and many black-and-white illustrations to the *Geographic.* Adams died of a brain tumor in 1934 after becoming ill while on assignment to photograph the California giant Sequoia forest.

William Albert Allard was born September 30, 1937, in Minneapolis, Minnesota. He has been affiliated with National Geographic since 1964 — as an intern and on staff for three years, then alternately as a freelance and contract photographer since 1967 — concentrating on human interest stories. His photographs illustrate the Society book *American Cowboy in Life and Legend* (1972) and have appeared in major American and European magazines. Allard's book *Vanishing Breed* was published by New York Graphic Society Books in 1982. It received several awards, including the American Society of Magazine Photographers Award for Outstanding Achievement. His photographs have been included in exhibitions at the Metropolitan Museum of Art, the George Eastman House in Rochester, New York, the Library of Congress, and the Oklahoma Arts Institute in Oklahoma City, among others. He has had one-man exhibitions at galleries in Alexandria and Norfolk, Virginia, and at the Daytona Beach Community College, Florida. Allard lives in Batesville, Virginia.

Paul Almasy was born May 29, 1906, in Budapest, Hungary. As a young man, he studied political science at the Universities of Vienna and Heidelberg before emigrating to France, where he became a freelance journalist traveling in Europe and North Africa. After World War II, he also worked for UNESCO in Paris and the World Health Organization in Geneva and Washington, D.C. In 1978 he received the Master of Photography Award from the Council of Professional Photographers of Europe. Almasy teaches photojournalism at the Sorbonne and the High School for Journalism in Paris and sits on the board of directors of several prestigious photographic organizations including the Musée Français de Photographie in Bievres. He has had one-man exhibitions in Rome, Budapest, Oslo, London, Milan, Paris, and other European cities, and his work is in several important museum collections. Almasy resides in Thoerie, France.

James L. Amos was born January 25, 1929, in Kalamazoo, Michigan. After attending the University of Idaho and Rochester Institute of Technology, he was an Eastman Kodak technical sales represen-

tative for sixteen years. He joined the National Geographic staff in 1969. Although his photography for the *Geographic* has concentrated on regional America, he has also worked on historical and industrial subjects. His photographs illustrate the Society books *Hawaii* (1970) and *America's Inland Waterways* (1973). In 1970 and 1971 he was named Magazine Photographer of the Year in the Pictures of the Year competition. Amos lives in Centreville, Maryland.

Craig Aurness was born November 20, 1946, in Los Angeles, California. He became a freelance photographer for National Geographic in 1977, specializing in nature subjects of the American West. Twenty-five agencies around the world distribute his photographs, and his work has appeared in *Fortune, Geo, Newsweek, Time,* and many other magazines. His books include: *Iowa, the American Heartland; The West; Colorado; Los Angeles/Hollywood;* and *California, the Golden State.* Aurness, a major owner of West Light, a large stock-photography agency, was cited in the Pictures of the Year competition in 1979. He lives in West Los Angeles.

José Azel was born August 18, 1953, in Havana, Cuba. A frequent contributor to National Geographic Society books, Azel has also had his work published in *Sports Illustrated, Smithsonian, Time, Life, Geo,* and the *London Sunday Times.* From 1977 to 1982 he was a staff member of the *Miami Herald.* Azel won the World Press Olympic Award in 1984 and has received several citations in the Pictures of the Year competition. His work was included in "Contact Press Images — 10 Years of Photojournalism" at the International Center of Photography, New York, in 1987. Azel lives in Lovell, Maine.

Henri Béchard (dates unknown) was active as a photographer during the 1870s and '80s. His photographs, later published in *L'Egypte et la Nubie* (1888), won a gold medal at the Universal Exposition of 1878 in Paris. In 1972 a number of them were republished in *Up the Nile, A Photographic Excursion: Egypt 1839-1898.*

William Belknap, Jr. was born June 30, 1920, at Oscawana-on-Hudson, New York. He began running the Colorado River rapids in the 1950s and made early historic trips through the Grand Canyon, including the only successful jet boat run against the rapids in 1960. *National Geographic* published four articles written and photographed by him and three others illustrated with his photographs from 1957 to 1966. As a friend of regional historian Otis "Dock" Marston, he also became knowledgeable about Colorado River history. With his son Buzz and daughter Loie, Belknap wrote four guidebooks on the Colorado River system. Belknap's river touring agency, Fastwater Expeditions, operated on the Green, San Juan, and Dolores Rivers. He died in 1986.

Annie Griffiths Belt was born February 27, 1953, in Minneapolis, Minnesota. She has been a freelance photographer for National Geographic since 1978. Prior to her affiliation with the Society, she was a staff photographer for the *Minnesota Daily* and the *Worthington Daily Globe.* Belt has been a contributing photographer for *Smithsonian* and has been published in *Forbes, Geo, Newsweek,* and other magazines. Her work was included in the National Organization of Women 1986 exhibition "Women in Photography," and she has received numerous Pictures of the Year competition awards. Belt lives in Silver Spring, Maryland.

Nathan Benn was born June 12, 1950, in Miami, Florida. He joined National Geographic as an intern in 1972 and has been under contract for most of the time since then. Assignments have taken him throughout the United States, Europe, the Middle East, Africa, and Asia. His work has been published in *Geo, Merian, Connoisseur,* and *Ambiente.* In 1985 Thomasson-Grant of Charlottesville, Virginia, published a book of his photographs, *A Voyage on the Mississippi River.* Benn, who has received numerous White House News Photographers Association and Pictures of the Year competition awards, lives in Washington, D.C.

Mehmet Biber was born May 26, 1931, in Eskicuma, a Turkish community in Bulgaria. His family moved to Turkey when he was three. After finishing Technic Art School in Bursa, he began a career in photojournalism. In 1962 Biber came to the United States on assignment and stayed to cover the United Nations as a freelance photographer. His work for *National Geographic* has concentrated on Eastern Europe and the Middle East. *Time, Geo, Bunte, Stern, Al Saisal* (Saudi Arabia), and *Hurriyet* (Istanbul) have also published Biber's photographs. He has won numerous Turkish Press Association and Syndication awards and received two Kodak awards for work included in "The World and Its People" exhibition at the 1964 New York World's Fair. His photographs have also been shown in the World Press Photo exhibition "Eye Witness" at the International Center of Photography in 1987. Biber lives in Annandale, Virginia.

Hiram Bingham was born November 19, 1875, in Honolulu, Hawaii. He received degrees from Yale and Harvard Universities and the University of California. In 1911 Bingham directed the Yale Peruvian expedition that discovered the ruins of Machu Picchu. He did further research in Peru under the auspices of Yale and the National Geographic Society. Among the many books he wrote is *Lost City of the Incas.* He received the Society's Jane M. Smith Award in 1917. An explorer, scholar, writer, aviator, teacher, and businessman, Bingham also served as governor of Connecticut and U.S. senator from Connecticut. He died in 1956 in Washington, D.C.

James P. Blair was born April 14, 1931, in Philadelphia, Pennsylvania. He worked as a television film photographer and reporter for WIIC-NBC in Pittsburgh, Pennsylvania, and as a Time-Life stringer before becoming a National Geographic staff photographer in 1962. His pictures have illustrated more than forty *Geographic* articles concentrating on environmental issues, science, and social change. He was the principal photographer for the Society books *As We Live and Breathe* (1971) and *Our Threatened Inheritance* (1984) and has contributed to several others. Blair has received numerous White House News Photographers Association and Picture of the Year competition awards, and in 1977 he won the Overseas Press Club "Best Photographic Reporting from Abroad" award for his South African coverage. He had a one-man exhibition at the Carnegie Museum, Pittsburgh, in 1962 and was included in the "Harry Callahan & His Students" exhibition at Georgia State University in 1983. Blair lives in Washington, D.C.

Jonathan Blair was born January 25, 1941, in Bryn Mawr, Pennsylvania. He began at National Geographic as a summer intern, had his first freelance assignment in 1965, and has been under contract most of the time since then. His photographs have illustrated

twenty-eight articles and have been included in many Society books and filmstrips. Blair lives in Wilmington, Delaware.

Harry F. Blanchard (dates unknown) was living in South Glens Falls, New York, when he submitted several groups of photographs to the National Geographic Society between 1916 and 1920. About a dozen of his pictures, mostly of children, were published in the *Geographic.*

H. T. Bohlman (dates unknown) was a colleague of naturalist William L. Finley. Striving to show with the camera what Audubon had shown with his brush, they worked together for twenty years to assemble a portfolio of artistic and informative photographs of American birds. An August 1923 *National Geographic* article, written by Finley and illustrated by him, Bohlman, and Irene Finley, featured the results of their collaboration.

Jim Brandenburg was born November 23, 1945, in Luverne, Minnesota. Before becoming a National Geographic contract photographer in 1978, specializing in natural history, Brandenburg worked for the *Worthington Daily Globe* in Minnesota. The U.S. Postal Service commissioned him to design and photograph a set of ten wildlife stamps issued in 1981. In addition to being named Magazine Photographer of the Year in the 1981 and 1983 Pictures of the Year competitions, he has had work exhibited at the Tweed Gallery in Duluth, Minnesota. Brandenburg lives in Minneapolis.

Hugo Brehme was born in Germany in 1882. At an early age, he became an accomplished photographer and traveled in Africa and Central America before settling in Mexico. Around 1910 he opened a photographic studio in Mexico City, and in 1923 Brehme published a selection of his photographs in a book titled *Mexico Pintoresco*, also published in English and German. He was a disciple of Guillermo Kahlo (father of painter Frida Kahlo) and strongly influenced Manuel Alvarez Bravo. Brehme died in 1954.

David L. Brill was born July 2, 1949, in Cedar Grove, Wisconsin. He became a National Geographic intern in 1970 and has been a freelance photographer for the Society since then, specializing in anthropological assignments. His photographs have appeared in many *Geographic* articles, Society books, and filmstrips. He formerly worked for *The Paper*, Oshkosh, Wisconsin, and was named National College Photographer of the Year in 1970. Brill lives in Fairburn, Georgia.

Horace Bristol was born November 16, 1908, in Whittier, California. He attended the University of Redlands and Stanford University. He used his first camera, which he bought while studying at the Technische Hochschule in Munich, to photograph architectural subjects in France, Germany, and Spain. From 1933 to 1937 he lived in San Francisco, and worked with Ansel Adams, Imogen Cunningham, Dorothea Lange, and Edward Weston during the establishment of Group F64. He did fashion photography for the *San Francisco Call-Bulletin*, food photography for *Sunset*, and varied assignments for *Time* and *Fortune* before joining the staff of *Life* in 1937 to cover the western United States. During World War II, Bristol was one of five photographers originally chosen by Edward Steichen for his special U.S. Naval Photographic Unit. After the war, *Fortune* sent Bristol on a two-year assignment to the Far East; he stayed for

twenty-five years, freelancing for major U.S. and European magazines. Bristol lives in Ojai, California.

Stephen R. Brown was born December 26, 1947, in Brooklyn, New York. He has been associated with National Geographic as a freelance photographer since 1976. On the staff of *U.S. News and World Report* during the early 1980s, he has also worked for *Discover, Life, Newsweek, Smithsonian*, and *Time*. Photographs from his coverage of the 1982 siege of Beirut were chosen for the Corcoran Gallery of Art exhibition, "The Indelible Image: Photographs of War, 1846 to the Present" (1986), which traveled to New York City and Houston, Texas. Brown lives in Washington, D.C.

David Burnett was born September 7, 1946, in Salt Lake City, Utah. As a freelance photographer and founding member of Contact Press Images, he has worked extensively in France, Korea, and Brazil and covered areas of turmoil from Vietnam to the Middle East. Burnett took photographs in Jamaica for a *National Geographic* story published in January 1985. In 1980 he received the Photographer of the Year award in the Pictures of the Year competition and the Press Photo of the Year award from World Press Photo; in 1986 the American Society of Magazine Photographers gave him the Philippe Halsman Award for Photojournalism. Burnett divides his time between Arlington, Virginia, and New York City.

Nicholas John Caire was born February 28, 1837, in Guernsey, Channel Islands. He moved to Australia with his family about 1860. Taught by Townsend Duryea, an American-born photographer, Caire began his photographic career using the wet-plate method, but eventually discarded this difficult technique for the newer dryplate process. In the 1870s he established photography studios in Melbourne and Victoria. Although many of his photographs portrayed pioneer life or aboriginal people, he specialized in the Australian landscape. Caire's work is in the permanent collections of the National Gallery of Victoria and the Royal Melbourne Institute of Technology. He died in 1918.

Robert Caputo was born January 15, 1949, in Camp Lejeune, North Carolina. Crossing Zaire's rainforest after college, he and friends rescued a baby chimpanzee. Caputo's desire to return the chimp to the wild led him to Jane Goodall's chimpanzee study area in Tanzania, where Baron Hugo van Lawick taught him to shoot wildlife documentaries. After earning a degree from New York University Film School, Caputo returned to Africa to photograph and write children's books and became a stringer for *Time* in Nairobi. Since 1980, when he began freelancing for the National Geographic as photographer and writer, his work has focused on Africa. His photographs have appeared in *Life, Natural History*, and *Geo* magazines, and received awards in the Pictures of the Year competition in 1981 and 1986. Caputo lives in Washington, D.C.

Eugene A. Cernan was born March 14, 1934, in Chicago, Illinois. Cernan served twenty years as a naval aviator, including thirteen as an astronaut with the National Aeronautics and Space Administration (NASA) space program. As the pilot on Gemini IX and a crew member of Apollo X, he walked in space and ventured to the moon. As Commander of Apollo XVII, he was the most recent man to leave his footprints on the moon's surface. From 1973 through 1975, Captain Cernan served as senior United States negotiator for the

joint Apollo/Soyuz project with the Soviet Union. He has received many honors and awards, including four honorary doctoral degrees. Cernan is chairman and president of Cernan Group, Inc. and the Cernan Corporation, space-related technology and marketing consulting firms based in Houston, Texas, where he resides.

Lynwood M. Chace was born in Swansea, Massachusetts, in 1901. One of America's foremost nature photographers, he produced educational movies for *Encyclopaedia Britannica*. His photographs of birds, insects, mammals, and reptiles in their natural surroundings have been published in leading national magazines, including thirteen issues of *National Geographic* from 1929 through 1956. His photographs illustrate the book *Look at Life!* published by Alfred A. Knopf in 1940. Chace lives in New Bedford, Massachusetts.

Dickey Chapelle was born Georgette Meyer in Milwaukee, Wisconsin, in 1918. A daring pilot and parachutist, she deplored war, yet became a famous war photographer and correspondent. She first learned news photography techniques from Anthony Chapelle, whom she married in 1940. When he joined the armed services, she became a professional photojournalist, and covered the Pacific throughout World War II. In the 1950s, *National Geographic* published two articles written and illustrated by Tony and Dickey Chapelle. She continued to report on the world's troubled regions, including Korea, Hungary, Cuba, the Dominican Republic, Algeria, Lebanon, Kashmir, Laos, and Vietnam. Her 1962 article, "Helicopter War in South Vietnam," was one of *Geographic's* first on-the-spot accounts of war. Chapelle's autobiography, *What's a Woman Doing Here? A Reporter's Report on Herself*, was published by Morrow, New York, in 1962. She died November 4, 1965, after being wounded by a Vietcong land mine.

Melville Chater was born in Florida in 1878. He wrote short fiction for New York magazines, was field correspondent for *Red Cross Magazine* (1917-1919) in France, Italy, Turkey, and Asia Minor, and was publicist for Near East Relief in Asia Minor, Syria, and Palestine (1920-1922). In 1922 he began covering the United States, Asia, Europe, and southern Africa for National Geographic and lectured widely on his travels. Chater wrote four books: *Little Love Stories of Manhattan* (1906), *The Eternal Rose* (1910), *The Bubble Ballads* (1914), and *Two Canoe Gypsies* (1932). He died in 1936.

Paul Chesley was born September 10, 1946, in Red Wing, Minnesota. Beginning his freelance work for National Geographic in 1976, he has generally concentrated on Asia and the western United States. His photographs illustrate the Society's book *Along the Continental Divide* (1981) and chapters in others on the wonders of nature. Chesley has had one-man exhibitions at the Colorado Fine Arts Center, Colorado Springs (1974), Nishi Ginza Galleries, Tokyo (1975), Nikon House, New York City (1976), and the Honolulu Academy of Arts (1977). His photographs have appeared in *Fortune*, *Geo*, and *Stern* magazines. Chesley lives in Aspen, Colorado.

Fred Payne Clatworthy was born August 30, 1875, in Dayton, Ohio. His career began in Chicago; he specialized in natural color landscape photography and drew large audiences to screenings of his work on the western United States and foreign countries. In addition to supplying illustrations to *National Geographic*, his work was published in *World's Work*, *Outlook*, and other publications. He

was a member of the Denver Art Association, the Pictorial Photographers of America, and the Colorado Mountain Club, among many associations. He had a summer home in Estes Park. Colorado, where he served as mayor in 1919, and spent his winters in Palm Springs, California. He died in 1953.

Jodi Cobb, born in Auburn, Alabama, grew up in Iran and lived in several other countries before receiving undergraduate and graduate degrees from the University of Missouri School of Journalism. Once a staff photographer for the Wilmington, Delaware, *News-Journal* and the *Denver Post*, she also freelanced for *Time*, *People*, and the *New York Times*. In 1973 she was included in the "Images of Concern" exhibition at the International Center of Photography in New York City. Cobb had her first National Geographic assignment in 1975; as a staff photographer since 1977, she has focused on the Middle East and its people. Work on eleven *Geographic* articles and five Society books has also taken her to China, Finland, Switzerland, England, the Caribbean, and Kenya. Cobb received the White House News Photographers Association Photographer of the Year Award (the first woman to do so) and a World Press Award in 1985, and has won numerous Pictures of the Year competition awards. She lives in Washington, D.C.

Dean Conger was born August 26, 1927, in Casper, Wyoming. After nine years with the *Denver Post*, he joined the National Geographic as a staff photographer in 1959. A broad range of assignments have taken him all over Europe and Asia, as well as the United States, where for a time he specialized in coverage of the space program. He has made more than thirty trips to the Soviet Union, photographing for the *Geographic* and the Society book *Journey Across Russia* (1977) for which he received a World Understanding Award and a citation of excellence from the Overseas Press Club. Conger currently directs Geographic's Multi-Image, Audiovisual Services Division. Named Newspaper Photographer of the Year three times during the 1950s and Magazine Photographer of the Year in 1962 in the Pictures of the Year competition, Conger received the National Press Photographers Association Joseph A. Sprague Memorial Award for a lifetime of outstanding work in photojournalism in 1987. He has been honored as a distinguished alumnus by both Casper College, Wyoming, and the University of Wyoming. Conger lives in Bethesda, Maryland.

Orator Fuller Cook was born May 28, 1867, in Clyde, New York. He moved to Washington in 1898 to work for the U.S. Department of Agriculture, eventually becoming chief botanist for the Bureau of Plant Industry. A prolific writer on botany, archeology, heredity, and evolution, Cook traveled the tropical world — South America, Africa, and Asia — studying rubber and cotton plants. He received the National Geographic Society Jane M. Smith Award in 1919 for his studies of Machu Picchu. Cook died in 1949.

Cotton R. Coulson was born May 16, 1952, in Cambridge, Massachusetts. A National Geographic freelance photographer beginning in 1974 and on contract from 1979 through 1985, Coulson traveled across the United States, the West Indies, and Europe. His work has illustrated a dozen *Geographic* articles and appears in Society books and filmstrips. He has received awards from the White House News Photographers Association and in the Pictures of the Year competition. Coulson lives in Potomac, Maryland.

Gervais Courtellemont was born in Avon, France, in 1863. A writer, explorer, and photographer, he published an Algerian review called *L'Algerie Artistique et Pittoresque*. Between 1924 and 1932, *National Geographic* published twenty-four autochrome photographic essays by Courtellemont recording Spain, Portugal, France, the Holy Land, and several northern African and Asian countries. He was a member of the Société Française de la Photographie. Courtellemont died in 1931.

Albert Couturiaux (dates unknown) sent a group of photographs to the National Geographic Society in 1926. Two were published in a November 1937 *Geographic* article on the Congo.

Willard R. Culver was born in Ellendale, Delaware, in 1898, and began his career at the *Baltimore News* and the *Baltimore Post*. A member of the National Geographic staff from 1934 to 1958, he was a pioneer in color photography. He was known as an innovator in industrial photography, particularly in the use of synchronized flash to light large, indoor areas. Culver was also the first underwater photographer to work from a diving chamber called an "aquascope." His photographs illustrate over forty articles or essays in *National Geographic*. Culver died in 1986.

Edward Sheriff Curtis was born near Whitewater, Wisconsin, in 1868. In 1887 his family moved to Puget Sound. His photography career grew out of a boyhood hobby and flourished on his fashionable portraiture and romantic views of Pacific Northwest scenery. Curtis is now remembered for his monumental thirty-year documentation of the American Indian. Beginning in 1900, he visited more than eighty tribes west of the Mississippi and took over 40,000 photographs. The result was *The North American Indian*, twenty volumes of text with 1,500 bound plates and twenty portfolios of unbound gravure plates. His portrayal eliminated all signs of contact with white culture and attempted to record the Indians' innate dignity and close relationship with nature. Curtis died in 1952.

Bill Curtsinger was born January 23, 1946, in Philadelphia, Pennsylvania. He had his first freelance assignment for National Geographic in 1971 and has been on contract since 1979, concentrating on underwater, natural history, and archeological assignments. His work appears in many *Geographic* articles and several Society books. Curtsinger's photographs illustrate two other books, *Wake of the Whale*, written by Kenneth Brower and published by Friends of the Earth, Washington, in 1979, and *The Pine Barrens*, written by John McPhee and published by Farrar-Straus, New York, in 1981. He had a one-man exhibition, "Antarctica" at the Portland Performing Arts Center in 1984 and another at Westbrook College Gallery of Photography in 1985. He lives in Portland, Maine.

Bruce Dale was born October 10, 1938, in Tiffin, Ohio. While still in high school, he had numerous pictures published in Cleveland papers. He worked for the *Toledo Blade* from 1957 to 1964. Since joining the National Geographic staff in 1964, he has had assignments in over fifty countries. His photographs illustrate thirty-three articles in *National Geographic*, including a story he also wrote on U.S. Highway 1. He has received numerous awards from the White House News Photographers Association and in the Pictures of the Year competition, where he was named Magazine Photographer of the Year in 1967 and 1974. Dale lives in Arlington, Virginia.

Carole Devillers was born July 7, 1948, in Luitre, France. She has worked in West Africa (Sahel), French Guiana, and Haiti as a freelance photographer for the National Geographic Society. Also a freelancer for the Associated Press, she has exhibited her photographs in Port-au-Prince and founded a nonprofit organization, "Patch" (Photography in Aid to Children of Haiti). Devillers has lived in the United States, Burkina Faso, Ivory Coast, and French Guiana, and now makes her home in Haiti.

Joseph Kossuth Dixon, a clergyman and doctor of law, was born in Hemlock Lake, New York, in 1856. He served as leader of three expeditions to the West financed by Rodman Wanamaker, heir to the Philadelphia department store dynasty, between 1908 and 1913. Photographs taken on these expeditions were used to publicize Indian history in order to strengthen a campaign to make them citizens. In 1908 the first expedition went to the Little Bighorn Valley in Montana to film a movie version of "The Song of Hiawatha" with Indians playing the roles. In 1909 the second expedition returned for what was expected to be the last great Indian Council. Portraits were made of chiefs from nearly every reservation, as well as scenes of camp life and mock battles. The Wanamaker expeditions produced 11,000 negatives on glass plates and nitrate film and fifty miles of motion picture film. In 1913 Dixon published a book of photographs, *The Vanishing Race*. He died in Philadelphia in 1926.

David Doubilet was born November 28, 1946, in New York City. He began snorkeling at the age of eight in the Atlantic Ocean off New Jersey. By the age of thirteen, he was taking black-and-white pictures above and below the sea with his first camera. He majored in film and journalism at the Boston University School of Public Communications. First published in *National Geographic* in 1972, Doubilet went on contract in 1977 and has produced over twenty stories for the *Geographic*. His warm-water work has taken him through the South Pacific and Indian Oceans and the Caribbean. The Red Sea, his favorite "underwater studio," has provided six *Geographic* articles. Cold-water work has led him to England's coast, Scotland's Loch Ness, the Galapagos Islands, Japan, and Canada's northwest Pacific. He has also worked extensively off the Atlantic and Pacific shores of the United States. Doubilet has received numerous awards, including several in the Pictures of the Year competition. He and his wife Anne, also a photographer and diver, have worked together on nearly all of the Geographic stories. They live in New York City.

Dick Durrance II was born December 4, 1942, in Seattle, Washington. A National Geographic intern in 1965 and staff photographer from 1969 through 1976, Durrance has illustrated eleven *Geographic* stories and portions of several Society books on the American scenic landscape. He was named Photographer of the Year in 1971 by the White House News Photographers Association and Advertising Photographer of the Year in 1987 by the American Society of Magazine Photographers. His photographs have been shown at the Addison Gallery of American Art, Andover, Massachusetts. Durrance lives in Rockport, Maine.

Harold Eugene Edgerton was born April 6, 1903, in Fremont, Nebraska. He received his master's and doctoral degrees in science from the Massachusetts Institute of Technology in Cambridge, Massachusetts. In 1928 he began teaching at MIT, where he developed

stroboscopic high-speed motion and still-photography equipment; he retired in 1968 as Institute professor emeritus. Edgerton has received many awards for innovative contributions to photography, including the Franklin Institute's Potts Medal, the National Geographic Society's La Gorce Medal, and the German Society for Photography's Cultural Prize. His work has been exhibited widely and is in many museum collections, including that of the Corcoran Gallery of Art. In 1986 he was inducted into the National Inventors Hall of Fame. A monograph, *Stopping Time: The Photographs of Harold Edgerton*, by Estelle Jussim and Gus Kayafas, was published in 1987 by Harry N. Abrams, New York. Edgerton lives in Cambridge.

Tamotsu Enami (dates unknown) owned a commercial photography studio in Yokohama during the 1920s and '30s. His father was an assistant to Kazuma Ogawa, a famous Japanese photographer of the late 19th century. Enami is known to have submitted pictures to several international photo salons held in the United States. His name appears in the Asahi Photographic Annual and the Japan Photography Yearbook of 1930 and 1931. Enami survived World War II, although his studio was destroyed in the bombing of Yokohama. He continued to work, producing glass-plate film for lack of materials and selling his tinted photographs to foreigners. Nothing else is known of his postwar activities.

Eric C. (Ric) Ergenbright was born June 6, 1944, in Burbank, California. As a freelance travel photographer, he has contributed work to *National Geographic Traveler* and other Society publications. His photographs have appeared in *Adventure Travel, Darkroom Techniques, Travel/Holiday, Travel & Leisure, The World & I, Nation's Business, Financial Planning*, and many other magazines. He lives in Bend, Oregon.

David Falconer was born March 29, 1932, in Vancouver, British Columbia. Now a United States citizen, he is a freelance photographer who concentrates on the Pacific Northwest. His work has been published in many National Geographic Society books, magazines, and filmstrips. He has also photographed for *Time, Sunset, People, Boys Life*, the *Oregonian*, the *Dallas Morning News, USA Today*, and the *New York Times*. The National Press Photographers Association and the Society of American Travel Writers have honored him with awards. His photographs have been included in exhibitions in Russia as well as the United States. Falconer lives in Portland, Oregon.

William Lovell Finley was born August 9, 1876, in Santa Clara, California. With H. T. Bohlman, he spent twenty years assembling a portfolio of art-quality bird photographs highlighted in a 1923 *National Geographic* article. A naturalist who lectured for the National Association of Audubon Societies from 1906 to 1925, he served as Oregon's Game Warden, State Biologist, and a member of the State Game Commission. He was also a member of the Advisory Board for the U.S. Department of Agriculture Migratory Bird Treaty Act and the Advisory Council on Outdoor Recreation. Finley was active with many wildlife associations and was honorary president of the Oregon Audubon Society. He wrote several books and scientific papers on birds and other wildlife and produced Finley Nature Films. He died in 1953.

David Fleay, an Australian zoologist, was born in 1907. He graduated from Melbourne University in 1931 and was designer and curator of the Australian Section of the Melbourne Zoo from 1934 to 1937. Fleay has written several books on Australian wildlife: *We Breed the Platypus* (1944), *Gliders of the Gum Trees* (1947), *Talking of Animals* (1956), *Living with Animals* (1960), *Nightwatchmen of Bush and Plain* (1968), *Paradoxical Platypus* (1980), and *Looking at Animals* (1981). He has been director of Research Reserve, West Burleigh, Queensland, since 1962 and resides at Fauna Centre, Burleigh Heads, Queensland.

Gordon W. Gahan was born November 5, 1945, in New York City. A National Geographic freelance photographer from 1968 to 1972, Gahan then joined the staff for ten years. His photographs illustrate fifteen diverse *Geographic* articles, as well as the Society's book *Voyages to Paradise: Exploring in the Wake of Captain Cook* (1981). Before his years with National Geographic, Gahan served as bureau manager for United Press International in Minneapolis and as a U.S. Army photographer for *Army Digest* in Vietnam. His work at Dak To and Khe Sanh won him two bronze stars and a Purple Heart. Gahan moved to New York City in 1982 to form an advertising photography business. In 1984 he was killed in a helicopter crash while taking aerial photographs of sailboats in the Virgin Islands.

Wilbur E. Garrett was born September 4, 1930, in Kansas City, Missouri. He graduated from the University of Missouri with a degree in journalism. He joined the National Geographic staff in 1954 and became the *Geographic's* seventh editor in 1980. In addition to the thirty-three magazine articles and several chapters for Society books that he has photographed and/or written, he coproduced the National Geographic television special "Alaska!," conceived and edited *Atlas of North America* (1985), and edited *Historical Atlas of the United States* (October 1988). He also serves on the National Geographic Society Board of Trustees. Garrett's photography and writing awards include the Newhouse Citation (Syracuse University, 1963), the Honor Award for Distinguished Service in Journalism (University of Missouri, 1978), the Overseas Press Club award for outstanding photography, and many White House News Photographers Association and Pictures of the Year competition awards, including Magazine Photographer of the Year in 1968. In 1982 Garrett received the Leadership Medal of the United Nations Environment Programme, and the University of Miami conferred on him an honorary doctor of letters degree in 1985. He lives in Great Falls, Virginia.

Jacob Gayer, born in Akron, Ohio, in 1884, graduated from the University of Heidelberg in Germany. He was a National Geographic staff writer and photographer from 1921 to 1931. Assignments took him from the Arctic through North and South America, and he had twelve *Geographic* stories or color portfolios to his credit. Gayer was the official chronicler on Commander Donald B. MacMillan's Arctic exploration of 1925, bringing back some of the first color photographs ever made that far north. After leaving the National Geographic Society, he worked for the government. He died in 1969.

Lowell Georgia was born March 19, 1933, in Green Bay, Wisconsin. A National Geographic freelance photographer since 1965 (on staff 1967-68), his assignments have focused on North American people

and their environments. In addition to twenty-three *Geographic* articles, his photographs illustrate two Society books — *Into the Wilderness* (1978) and *Playful Dolphins* (1977) — and chapters in many others. He previously was associated with the *Denver Post*. In 1963 he was named Photographer of the Year in the Pictures of the Year competition. Georgia lives in Arvada, Colorado.

P. V. (Peter Vilhelm) Glob was born in Denmark in 1911. He studied archeology at Copenhagen University and worked on the staff of the Danish National Museum from 1934 to 1949. In 1949 he was appointed to the newly created Chair of Scandinavian Archeology and European Prehistory at Århus University and became director of the Prehistoric Museum in Århus. In 1960 he was named state antiquary of Denmark and director of the National Museum. Glob led Danish archeological expeditions to Kuwait, Bahrain, Qatar, and Abu Dhabi between 1952 and 1966 and published articles on his findings. *The Bog People* (1969), a study of ancient bodies found in Danish peat bogs, is one of his best-known books. Glob died in 1985.

Farrell Grehan was born September 19, 1926, in New York City. For thirteen years he worked as a contract photographer for *Life* until its demise as a weekly in 1972. He then began freelancing for National Geographic, and his photographs illustrate a number of magazine articles and two Society books: *John Muir's Wild America* (1976) and *Ancient Egypt* (1978). He has also published work in *Connoisseur*, *Travel & Leisure*, *Smithsonian*, *The World & I*, and numerous foreign magazines. Two shows organized by the Museum of Modern Art, New York, "Always the Young Strangers" (1954) and "Family of Man" (1955), included his work, which also hung in a 1984 exhibition of National Geographic freelance photography in Tokyo, Japan. Grehan lives in New York City.

Gilbert Hovey Grosvenor was born October 28, 1875, in Istanbul, Turkey, the son of a history professor from the United States. At the urging of Alexander Graham Bell, he became the fledgling National Geographic Society's first full-time employee in 1899. The Society, with only 1,000 members at the turn of the century, was built by Grosvenor into the world's largest nonprofit scientific and educational organization. Dr. Grosvenor popularized geography by bringing the world's wonders to homes and classrooms in vivid words, photographs, and illustrations. Geographically oriented photographs were scarce when he began his editorship, so he bought a camera and embarked on six decades of picture-taking. Grosvenor was a gifted geographer, educator, writer, and administrator; press historians agree that he was an exceptionally talented editor. He served the Society, as editor or chairman of its Board of Trustees, until his death in 1966.

Earle Harrison was born in Maryland c. 1882. He lived in Knoxville, Tennessee, where he had an art and commercial photography shop on Gay Street. Between 1915 and 1918, the National Geographic Society purchased photographs he had taken in Algeria, Jamaica, Egypt, and other locations. He died in 1920.

David Alan Harvey was born June 5, 1944, in San Francisco, California. After graduate school in art and journalism, he spent three years working for the *Topeka Capital-Journal* and Richmond Newspapers, Inc. A Virginia Museum of Fine Arts Photography Fellowship changed the focus of his work from black-and-white newspaper to color magazine photography. Harvey began working for National Geographic as a contract photographer in 1974. A staff member from 1978 to 1986, he is presently on contract again. His photographs have illustrated nearly twenty articles in the *Geographic* and the Society books *The Mysterious Maya* (1977), and *America's Atlantic Isles* (1982). He was named Magazine Photographer of the Year in the Pictures of the Year competition in 1978. His work has been included in exhibitions at the Virginia Museum of Fine Arts in Richmond, the Museum of Modern Art in New York City, and the Corcoran Gallery of Art. Harvey lives in Washington, D.C.

Gustav Heurlin was born April 5, 1862, in Wirestad Parish, Kronoberg County, Sweden. He moved to the United States in 1908, where he allegedly owned a hotel, and returned to Sweden four years later. Originally an amateur photographer, he had become the Swedish court photographer by 1934. Between 1919 and 1931, the National Geographic purchased his autochromes and black-and-white photographs of Scandinavian and Baltic countries. Heurlin died in 1939.

Hans Hildenbrand was born Jakob Hildenbrand March 4, 1870, in Boll in what is now Baden-Wurttemberg, Germany. At a young age he liked to draw and paint with watercolors. Noticed by a photographer from Pforzheim who invited him to become his apprentice, Hildenbrand worked in Pforzheim until he was 19, when he moved to Stuttgart and opened his own studio. He became court photographer for the royal family of King Wilhelm of Wurttemberg. At the height of his popularity between 1900 and 1914, he traveled to the Near East, the Balkans, and North Africa, making color photographs which were reproduced in books and articles. He was known for his beautiful, glass-plate autochromes of landscapes, women, and rare plants and animals, but he lost his personal collection when his studio was destroyed in the 1944 bombing of Stuttgart. However, the National Geographic Society archives contain over 700 Hildenbrand autochromes purchased prior to the war. He died at the age of eighty-six.

John (Jack) K. Hillers was born in Hannover, Germany, in 1843. He came to the United States at the age of nine. At the beginning of the Civil War, he enlisted in the Naval Brigade, later transferring to the Army. In 1870 he met John Wesley Powell in San Francisco and joined Powell's first Colorado River expedition the next year. On Powell's second expedition Hillers became the chief photographer. From 1881 until 1900, Hillers headed the U.S. Geological Survey. He died in 1925 and is buried near Powell in Arlington National Cemetery.

Homer E. Hoopes was born in Pennsylvania in 1848. He was an amateur photographer who gave his profession as "capitalist." He accompanied his friend Adam Clark Vroman, a photographer and Pasadena bookstore owner who made frequent trips to the Southwest, on his 1902 expedition to photograph the Hopi Indians in Arizona. In 1910 twenty-eight Hoopes photographs were submitted to *National Geographic* for an article on the Hopi Indian Snake Dance.

Mitsuaki Iwago, born November 27, 1950, in Tokyo, Japan, has been a professional photographer since college. He has made award-winning wildlife and nature photographs in more than sev-

enty countries. *National Geographic* featured a portfolio of his photographs of animals in Tanzania's Serengeti National Park in the May 1986 issue. His book *Serengeti, Natural Order on the African Plain* was published by Chronicle Books, San Francisco, California, in 1987. Among the many honors he has received is the 1987 Society of Publication Designers Award of Distinctive Merit. Iwago, whose work is exhibited widely, lives in Tokyo.

Chris Johns was born April 15, 1951, in Medford, Oregon. A staff photographer for the *Topeka Capital-Journal* from 1975 to 1980, he then spent three years on the *Seattle Times* staff. He began freelancing for the National Geographic in 1983 and has been on contract since 1985. His work for the Society reflects his interest in western North America. In 1979 he was named Newspaper Photographer of the Year in the Pictures of the Year competition. Johns lives in Seattle, Washington.

Wolfgang Kaehler was born December 14, 1952, in Oldenburg, Schleswig-Holstein, West Germany. Since 1976 he has been a freelance photographer for magazines and publishing companies, including *National Geographic*, *Travel & Leisure*, and Time-Life. Kaehler specializes in photographing natural history, traditional architecture, and local culture. He has traveled to more than one hundred countries and has visited Antarctica fifteen times. Kaehler lives in Bellevue, Washington.

George R. King (dates unknown) lived at one time in Los Angeles before moving to the area now known as Allston-Brighton, a borough of Boston, Massachusetts, in 1914. He had a photo shop at 144 Congress Street in 1916 and at 367 Boylston Street in 1918. From 1919 to 1924, he was secretary of the International Products Corporation in Boston. The Boston Public Library owns a large number of his photographs taken in California, Arizona, New Mexico, and New York. He also traveled extensively through Europe and Asia.

Father Franz Josef Kirschbaum (dates unknown), a German priest, lived in Madang, the chief town in northeast New Guinea. In 1928 he joined E. W. Brandes for the latter part of an expedition in New Guinea sponsored by the U.S. Department of Agriculture.

Franklin Price Knott was born in Santa Barbara, California, in 1854. He was widely known for his miniatures and autochromes which appeared in travel magazines. In 1927 he returned from a 40,000-mile tour through the Orient as an explorer for the National Geographic Society, bringing back several hundred natural color photographs of scenes and people never before captured on film. He was the first to photograph the brilliant royal court of Kashmir in color and also recorded rare scenes in Japan, China, and the island of Bali. Knott died in 1930.

Emory Kristof was born November 19, 1942, in Laurel, Maryland. He interned at National Geographic before joining the staff in 1964. Many of his assignments have focused on energy and computers. Kristof has made many innovations in photographic equipment used in undersea scientific exploration. He has received numerous awards from the White House News Photographers Association and in the Pictures of the Year competition. In 1986 he was honored with the American Society of Magazine Photographers Award for Innovations in Photography. Kristof lives in Arlington, Virginia.

Frans Marten Lanting was born July 13, 1951, in Rotterdam, Holland. A freelance photographer with the National Geographic since 1985, he has contributed illustrations for several *Geographic* articles and Society books. His photographs have received numerous awards and have been exhibited at Fotokina in Cologne, West Germany, Minolta House in London, the American Museum of Natural History in New York, and the California Academy of Sciences in San Francisco. Lanting lives in Santa Cruz, California.

Lennart Larsen was born July 15, 1924, in Copenhagen, Denmark. He trained at Middleboe, a leading center for photographic publication techniques. Since 1945 he has worked principally for the National Museum in Copenhagen, although he also completes assignments for other institutions' art, historical, and architectural publications. In 1956 Larsen received a grant to study at the Metropolitan Museum in New York City and at Kodak Laboratories in Rochester, New York. He was chosen to make an official portrait of Her Majesty Queen Margrethe II commemorating her fortieth birthday in 1980. Larsen lives in Copenhagen.

Lehnert & Landrock was a company based in Cairo, Egypt, which published travel guides in multiple languages around the turn of the century.

Justin Locke was born August 2, 1920, in California. After serving as attache to the U.S. Embassy in Spain during World War II, he moved to Washington, D.C. In 1947 the Smithsonian exhibited his photographs, mostly of Spain. As a result of this and work done in Mexico, he was hired as a staff photographer by National Geographic. His five-year association with the Society included assignments in the Pyrenees, Basque Provinces, Paris, Puerto Rico, and Mexico, as well as several national parks in the United States, which provided illustrations for nineteen *Geographic* articles, one of which he wrote. In 1948 Locke moved to Taos and in 1952 to Mexico, where he turned to watercolor painting. He later returned to Taos and worked in acrylics and experimental photography. In 1973 he had an exhibition at the former Dennis Hopper Gallery of Taos. A number of his photographs were included in "The New Mexico Portfolio" exhibition at the Colorado Photographic Art Center in Denver. Locke died in 1979.

Donald Baxter MacMillan was born November 10, 1874, in Provincetown, Massachusetts. He spent his life making treks to the far north, beginning with Robert E. Peary's 1908-09 North Pole expedition. As one of Peary's assistants, MacMillan led a support team that carried supplies by dogsled from the expedition's ship, the *Roosevelt*. MacMillan received the National Geographic Society's Hubbard Medal in 1953 "for outstanding Arctic exploration from 1908 to 1952." His achievements also led Congress to advance MacMillan to the rank of rear admiral in 1954. That same year, at the age of eighty, MacMillan made his thirtieth and last trip north with a crew of college students. He died in 1970.

Robert W. Madden was born March 17, 1939, in Freeport, Illinois. He came to National Geographic as an intern in 1967 and continued

with the Society on a freelance basis until he became a staff member in 1973. Assignments have taken him to Antarctica, Asia, Hawaii, Australia, Europe, and throughout North and South America. His photographs illustrate nineteen *Geographic* stories. Named Magazine Photographer of the Year in the 1971 and 1976 Pictures of the Year competitions, he also received the Robert Capa Gold Medal and shared the Overseas Press Club award for Best Photographic Reporting from Abroad in 1976. His work was featured in an exhibition at the Citicorp Center in New York in 1984. He is currently senior assistant editor for layout at the National Geographic. Madden lives in Annapolis, Maryland.

Peter Magubane was born in 1932 in Vrededorp, Johannesburg, South Africa. For thirty years his photographs of white oppression and black resistance have helped awaken the world's conscience, sparking widespread political repercussions. In 1969 and 1970 Magubane spent 586 days in solitary confinement. Between 1970 and 1975 the South African government banned him and in 1976 detained him for 120 days with other black newsmen covering school uprisings. Magubane has worked for *Drum* magazine and the *Rand Daily Mail*, and now works for *Time*. He has published six books; *Black As I Am* received the Janusz Korczak Award, and the American Library Association Roundtable gave *The Black Child* the Coretta Scott King Award. Magubane's photojournalism has brought him over fifteen awards, including South Africa's highly coveted Stellenbosch Farmers Winery Award for Enterprising Journalism (1976), the Overseas Press Club of America Robert Capa Gold Medal (1985), and Germany's prestigious Dr. Erich Salomon Prize (1986). Exhibitions of his work have traveled throughout South Africa, and to Japan, England, Sweden, Germany, Brazil, the Netherlands, and other countries. Magubane lives in New York when not on assignment in South Africa.

Luis Marden was born in Chelsea, Massachusetts, in 1913. He was a National Geographic staff member from 1934 to 1976, pioneering both 35mm color and underwater photography. Marden contributed fifty-eight articles to the *Geographic* as writer or photographer or both, including stories on the recovery of Mayan artifacts from a sacrificial well in Yucatan (1936), a voyage aboard Jacques-Yves Cousteau's *Calypso* (1955), and his discovery of William Bligh's *Bounty* off Pitcairn Island (1957). A diver, sailor, and airplane pilot, Marden has also filmed eleven documentary films for the Society's lecture series. Although retired, he still writes articles for the *Geographic*. He lives in McLean, Virginia.

Charles Martin was born July 26, 1877. He was an Army sergeant on the staff of Dean C. Worcester, Secretary of the Interior of the Philippine Islands, in 1912 when he took the photographs that appeared in the 1913 *National Geographic* article "Head Hunters of Northern Luzon." In 1915 the Society hired him to supervise the magazine's new darkrooms and photographic laboratory. As laboratory chief, Martin set the standards of excellence that have continued in the Society's photographic operations. Collaborating with Goucher College ichthyologist Dr. W. H. Longley, Martin made the world's first underwater color photographs using the autochrome process in 1926 off the Dry Tortugas, Florida. Under his direction, the National Geographic experimented with several other color photographic processes during the early 1930s, including Finlay and

Dufay. Martin also continued to photograph, exploring Puerto Rico, California, Tibet, the Atlantic Seaboard, and the District of Columbia. His photographs illustrate thirteen *Geographic* articles. Martin died in 1977.

Stephanie Maze was born July 2, 1949, in New York City. She worked on the staff of the *San Francisco Chronicle* from 1973 to 1979. As a freelance photographer for the National Geographic, she has covered Hispanic subjects. *Geo, Newsweek, Time, Air and Space*, and *Smithsonian* magazines, as well as the *Washington Post*, have published her pictures. She has won many newspaper and magazine awards, and her photographs have been exhibited in San Francisco and Portugal; a Brazilian exhibition is planned for 1988-89. Maze lives in Washington, D.C.

O. Louis Mazzatenta was born December 5, 1938, in Ashtabula, Ohio. From 1959 to 1962 Mazzatenta worked for newspapers in Indiana, Ohio, and Minnesota. Since joining the National Geographic staff in 1963, he has worked as a photographer, writer, illustrations editor, and chief of the magazine's Photo Layout Department. Currently he is senior assistant editor in charge of scheduling. He has received various White House News Photographers Association awards during his career. Mazzatenta lives in Annandale, Virginia.

Stephen McAlko (dates unknown) was a sergeant in the United States Army Air Force at March Field, California. Sometime in the late 1930s or early '40s he took an aerial photograph of the giant effigies near Blythe, California. General Henry H. Arnold, then commander of March Field, brought the effigies to the attention of General George C. Marshall, who wrote the introduction to an article on giant effigies of the Southwest in the September 1952 *Geographic*.

Harry A. McBride was born in Pontiac, Michigan, in 1888. He entered the Foreign Service in 1915 after three years in newspaper and advertising work. His twenty-four year career with the United States government took him throughout Europe and to Africa. He wrote and illustrated several articles for *National Geographic*. In 1939 McBride resigned as assistant secretary of state to become administrator of the National Gallery of Art in Washington, D.C., where he remained, with an interruption during World War II, until he retired in 1953. Colonel McBride was awarded the Legion of Merit for his wartime service. He died in 1961.

Steve McCurry was born April 23, 1950, in Darby, Pennsylvania. A freelance photographer for National Geographic beginning in 1980 and a contract photographer since 1985, he has concentrated on southern Asia and the Islamic world. McCurry, an associate member of Magnum Photos, Inc., has freelanced for the *New York Times* and the *Christian Science Monitor*. He received the Overseas Press Club Robert Capa Gold Medal in 1980, was named Magazine Photographer of the Year in the Pictures of the Year competition in 1984, and won the Olivier Rebbot Memorial Award for Best Photographic Reporting from Abroad from the Overseas Press Club in 1986, as well as several first-place awards from World Press Photo. A book of his photographs, *The Imperial Way: By Rail from Peshawar to Chittagong*, was published by Hamish Hamilton, London, in 1985,

and a book titled *Monsoon*, written and photographed by McCurry, will be published by Thames and Hudson, London, in the fall of 1988. McCurry lives in New York City.

Roland McKee (dates unknown) was an agronomist with the U.S. Department of Agriculture during the 1920s and '30s.

Donald McLeish was born in London, England, in 1879. Between 1915 and World War II, he supplied the National Geographic Society with large numbers of photographs taken in Europe, North Africa, and the Middle East. He was also a war photographer for the British Army and contributed as a freelance photographer to various international publications. McLeish died in 1950.

Douglas Miller was born July 16, 1948, in Denver, Colorado. He has been a freelance photographer for the past ten years. In addition to work published by the National Geographic Society, he has had photographs in *Stern, Geo, Northwest Edition,* and *Natura-Italy.* His pictures of the 1980 eruption of Mount St. Helens, possible only because he lived so close by, are part of a permanent exhibit at the Oregon Museum of Science and Industry. Miller lives and has a studio in Ephrata, Washington.

Merlin Minshall, born in 1906, studied modern history at Oxford and architecture at the University of London. After working as an architect, he sailed across Europe through inland waterways in an antique Dutch boat and reported on his three-year cruise in *National Geographic.* During World War II, he served as an agent with British Naval Intelligence. An account of these eventful years is described in his book *Guilt-Edged,* published by Bachman & Turner, London, in 1975. In addition to his other ventures, he worked at various times as a restaurant critic, motor car racer, and professional photographer. Minshall died in 1987.

George F. Mobley was born February 4, 1935, in San Bernardino, California. Since joining the National Geographic staff in 1961, his photographic assignments have taken him throughout Asia, Europe, and the Americas. In addition to *Geographic* articles, his photographs illustrate three Society books — *Alaska* (1969), *Alaska: High Roads to Adventure* (1976), *The Great Southwest* (1980) — and are included in several others. Before he came to National Geographic, Mobley freelanced for various regional magazines and midwestern newspapers. Since 1960 he has received numerous White House News Photographers Association and Pictures of the Year competition awards. Mobley resides in Woodstock, Virginia.

Yva Momatiuk, born in Warsaw, Poland, and **John Eastcott,** born in Lower Hutt, New Zealand, are a husband-and-wife freelance team that has written and photographed for the National Geographic Society since 1976. Their stories have documented isolated or changing cultures in remote locations. They received four Pictures of the Year competition awards in 1986 and their work has been shown at Idaho State University, Pocatello. Momatiuk and Eastcott live in Hurley, New York.

Gail Mooney was born July 21, 1951, in Chicago, Illinois. Freelance photographic assignments for *National Geographic Traveler* have sent her throughout North America. She has also been published in magazines including *Communication Arts, Cuisine, Geo, Money, New York Magazine, Popular Photography, The Saturday Evening Post, Smithsonian,* and *Travel & Leisure.* Mooney has received the Leica Medal of Excellence, eleven awards from Communication Arts, and two from the Society of Publication Design. She lives in North Plainfield, New Jersey.

W. Robert Moore was born August 15, 1899, on a farm in Butler Township, Michigan. He worked for the *Detroit Free Press* and the *Detroit News* before joining the National Geographic staff in 1931 as a writer and photographer. A pioneer in natural color photography, he was chief of the Foreign Editorial Staff from 1953 to 1964 and retired in 1967. During his career with the Society, he traveled more than one million miles in pursuit of stories — through Africa, Asia, Russia, North and South America — and photographed and/or wrote nearly ninety magazine pieces. Moore died in 1968.

Nicholas Morant was born in 1910 on a fruit farm in Kamloops, British Columbia. Until his retirement in 1982, he was probably Canada's most widely published photographer. He spent over half a century traveling as special photographer for CP Limited, the holding company for Canadian Pacific Rail, CP Air, CP Steamships, and other divisions. During World War II, Morant went on leave from CP Limited to serve at the Canadian Office of Public Information. In 1945 he was assigned to cover the United Nations Founding Conference in San Francisco. He has been a consultant on movies shot by various major studios on or around Canadian Pacific Rail tracks. Morant lives in Banff, Alberta, Canada.

Helen Marian Place Moser was born c. 1867. Moser met her husband Charles Kroth Moser when he studied music with her in Riverside, California; thirteen years later they were married. She accompanied him to Washington when he became an editorial writer for the *Washington Post.* After Charles Moser joined the Foreign Service in 1909, Helen took photographs at several foreign posts, including Aden on the Arabian Peninsula; Colombo, Ceylon; and Harbin, Manchuria. After her divorce in the early 1920s, Helen Moser taught music in Baltimore. She died c. 1952.

James Nachtwey was born March 14, 1948, in Syracuse, New York. Associated with Magnum Photos, Inc., he is a contract photographer for *Time* and has worked in Nicaragua and Guatemala as a freelance photographer for *National Geographic.* Nachtwey concentrates on the action and aftermath of war; he has worked in Central America, the Middle East, and Asia. His awards include the Robert Capa Gold Medal from the Overseas Press Club in 1983, 1984, and 1986; Magazine Photographer of the Year in the Pictures of the Year competition in 1983 and 1986; and a World Press Photo award in 1984. Nachtwey's work was included in the Corcoran Gallery of Art exhibition, "The Indelible Image: Photographs of War, 1846 to the Present" (1986), which traveled to New York City and Houston, Texas. He resides in New York City.

Thomas Nebbia was born November 12, 1929, in Rochester, New York. He worked for the *State-Record* in Columbia, South Carolina before joining the National Geographic as a staff photographer from 1958 to 1966 and a contract photographer from 1973 to 1978. Nebbia has received awards from *U.S. Camera, Popular Photography,*

and in the Pictures of the Year competition. The Asheville Art Museum, North Carolina, the California Museum of Science and Industry, Los Angeles, and the Columbia Art Museum, South Carolina have exhibited his photographs. Nebbia lives in Horse Shoe, North Carolina.

Flip Nicklin was born September 18, 1948, in San Diego, California. A freelance photographer, Nicklin has shot a number of National Geographic assignments on whales and other sea animals. His photographs appear in major publications in Japan, Germany, France, Italy, and elsewhere around the world. Nicklin lives in San Diego.

Edward Justus Parker was born August 2, 1869, in Elgin, Illinois. Commissioned an officer in the Salvation Army at the age of sixteen, he served until his retirement in 1943. He is best known for his work as the Eastern Men's Social Service Secretary (1908-1927), the National War Secretary (1918), and the National Chief Secretary (1930-1943). His lectures, held coast to coast, were illustrated with his own photographs. During World War I, Colonel Parker was commissioned by the U.S. government to photograph at the front, where he took more than one thousand photographs and thousands of feet of film. He was one of the founders of the USO. Parker died in 1961.

Winfield Parks was born April 24, 1932, in West Barrington, Rhode Island. He began his career with the *Providence Journal-Bulletin* where he worked for eleven years interrupted by a two-year stint as a Navy photographer in Korea. He joined the National Geographic staff in 1961, and traveled through forty countries in Europe, Asia, the Middle East, and North and South America. Parks, often a prize winner, had photographs published in *Life, Look, Time, Fortune, The Saturday Evening Post,* and other national magazines. He died of a heart attack in 1977 at his home in Washington, D.C.

John Patric was born May 22, 1902, in Snohomish, Washington. At age fourteen, his services refused by the Navy as the United States entered World War I, he quit school, built a makeshift truck, and collected scrap iron for the war effort. Over the next twenty years he worked for several newspapers, returned to high school and graduated as valedictorian, and attended, by one count, seven different colleges, though he never received a degree. Between 1936 and 1940, *National Geographic* published six articles that he wrote and partially illustrated about his travels through Japan, Italy, Czechoslovakia, Hungary, and the mid-Atlantic region of the United States. His writing was also published in *Reader's Digest* and other magazines, and in three books — *Repairmen Will Get You If You Don't Watch Out* (1942), *Why Japan Was Strong* (1943), and *Yankee Hobo in the Orient* (1945). In 1957 he returned to his hometown, where he spent most of the rest of his life. Enraged at what he perceived to be corrupt local politics, he began publishing a vituperative weekly newspaper from his house, and also became a perennial candidate for local and state offices. He died in 1985, leaving behind an unfinished novel.

Robert Edwin Peary was born May 6, 1856, in Cresson, Pennsylvania. He grew up in Maine, where he graduated from Bowdoin College. He joined the U.S. Navy in 1881 as a civil engineer and was sent to Nicaragua to survey possible Atlantic-Pacific canal routes. In 1891 the Academy of Natural Sciences in Philadelphia and the American Geographical Society appointed Peary to lead an expedition to the Arctic. He led seven more; on the last, on April 6, 1909, he reached the North Pole (a claim now under dispute). Peary was the recipient of many medals, including the National Geographic Society's Special Gold Medal (1909). In 1911, the U.S. Congress made Peary a rear admiral in recognition of his discovery of the North Pole. Beginning in 1889, thirty-seven articles by or about Peary appeared in *National Geographic.* He retired after his epic journey to the Pole and died in 1920 in Washington, D.C.

Luigi Pellerano (dates unknown), an Italian colonel living in Rome, provided National Geographic with many photographs taken around the Mediterranean in the 1920s. Between 1925 and 1937, eight color portfolios of his work appeared in the magazine. The Society's archives contain a large number of his glass-plate autochromes and black-and-white photographs.

Herbert G. Ponting was born March 21, 1870, in Salisbury, England. Around 1893 he emigrated to the United States where he worked for several newspapers. He covered the Russo-Japanese War of 1904-1905. In 1900 Ponting was awarded a first prize for telephotography by the Royal Geographical Society for Antarctic exploration, and the same year he exhibited with Kodak at the World's Fair in St. Louis. Known for inventing the "kinatome," a portable projector, Ponting made the first movies of Antarctica on the British Antarctic Expedition of 1910-1913 under Captain Robert F. Scott. His photographs appeared in *Ladies Weekly, Harpers Weekly,* and many other magazines, and his work is in the collection of the British Museum. Ponting died in 1935.

Louie Psihoyos was born April 15, 1957, in Dubuque, Iowa. He was a National Geographic intern in 1980 and a contract photographer in 1982. He has illustrated *National Geographic* stories on trash, energy, smell, sleep, the Underground Railroad, and other subjects. He has also worked for *Life, Geo, Stern,* and *Newsweek* magazines and the *Los Angeles Times* newspaper. Psihoyos lives in New York City.

Steve Raymer was born November 25, 1945, in Beloit, Wisconsin. He graduated from the University of Wisconsin with a master's degree in journalism in 1971. Prior to joining the National Geographic staff in 1972, he worked for the *Wisconsin State Journal* in Madison. National Geographic assignments have taken him to more than sixty-five countries; he has concentrated on problems of developing countries. He was named Magazine Photographer of the Year in the Pictures of the Year competition in 1975, received the Overseas Press Club Special Citation for Excellence in 1981, and was a John S. Knight Fellow at Stanford University from 1984 to 1985. He has had four one-man exhibitions sponsored by the U.S. Information Agency and one by the International Committee of the Red Cross. He resides in Washington, D.C.

Roland W. Reed was born in 1864 in Fox River Valley, Wisconsin. Heading west in 1890, he began his career making Indian sketches along the Great Northern Railroad. Dissatisfied with his art, he joined Daniel Dutro's photography studio in Havre, Montana, taking Indian portraits which were sold to the railroad news department for publicity material used to attract passengers. After leaving Dutro

to join the Associated Press news service in Seattle, he finally settled in Bemidji, Minnesota, in 1900, where he used his studio-portrait photography to finance field trips among local Chippewa (Ojibway) Indians. By 1907 he spent all his time making a photographic record of Indian life. In 1915 he and writer James Willard Schultz collaborated on an illustrated book, *Blackfeet Tales of Glacier National Park.* Although the Blackfeet had never lived in the park, a group of them worked with Schultz and Reed to recreate romanticized stories there. Reed viewed his painstaking work on North American Indians as an art form and would only grant publication rights to the National Geographic Society. He died in 1934.

Robert Reid was born in Wishaw, Scotland, in 1868. He joined his father's photography business and attained recognition for his landscape and animal images. Before his death in 1948, Reid spent twenty years of retirement handcoloring prints. The National Geographic Society purchased a large number of his black-and-white photographs.

Joseph Baylor Roberts was born March 29, 1902, in Washington, D.C. A U.S. Marine Corps photographer after World War I, he joined the old *Washington Times* as its only staff photographer in 1922, and was chief photographer and picture editor for the *Times* until he joined the National Geographic staff in 1936. Assignments took him to Mexico, the Middle East, Africa, the Far East, Europe, Australia, Canada, and various locations in the United States. Roberts also filmed the first submerged voyage around the world aboard the USS *Triton.* Between 1950 and 1963, the White House News Photographers Association awarded him first prize for his color work six times. In 1962 his photograph of a Belgian ship in heavy seas, now in the Metropolitan Museum of Art's permanent collection, won second prize in the Pictures of the Year competition. Roberts retired in 1967 as assistant director of Photography. He resides in Annapolis, Maryland.

Joseph Francis Charles Rock was born in Vienna, Austria, in 1884. A brilliant, introverted, sickly child, he taught himself to speak Chinese by the time he was thirteen. With almost no academic or professional training, he went on to become a linguist, artist, photographer, botanist, and agronomist. Despite his poor health, he traveled all his life, passing through southern Europe, North Africa, Havana, Mexico, and New York. In Waco, Texas, he briefly attended Baylor, his first and only college; in Honolulu, he became a professor at the University of Hawaii. Appointed an agricultural explorer by the U.S. Department of Agriculture, he then spent twenty-seven years in the mountains of China and Tibet, and became an international authority on the region. He also headed expeditions for Harvard University and the National Geographic Society, during which he collected 60,000 exotic plant species, 1,600 birds, and 60 mammals. *National Geographic* featured several accounts of his work. He died in 1962 in Hawaii.

Martin Rogers was born November 22, 1949, in Wilson, North Carolina. His photographic career started at the *Raleigh News and Observer.* In 1969 he became a National Geographic intern and was alternately a freelance and contract photographer for the Society until 1982. He moved to New York City and worked for numerous advertising firms, corporations, and government agencies. His photographs have appeared in *Life, Time, Newsweek, Fortune, Smithso-*

nian, Stern, the *New York Times, Business Week, Sports Illustrated, Geo, Ladies Home Journal, House & Garden,* and other magazines and newspapers. Rogers has received awards from the Overseas Press Club, the White House News Photographers Association, the New York Art Directors Club, the Chicago Art Directors Club, and was named Southern Photographer of the Year in 1972 by the National Press Photographers Association. He lives in Washington, D.C.

Alan Root, born in London in 1938, emigrated to Kenya with his family after World War II. A self-taught naturalist, he is one of the world's great wildlife cameramen. He and his wife Joan, born in Kenya, generally work in Africa, although they have also filmed in Australia and New Guinea. Among their films are *Castles in the Clay* (which won a Peabody Award), *The Great Migration: The Year of the Wildebeest,* and *The Enchanted Islands.* They live in Kenya.

Edmond Sacre was born in Ghent, Belgium, in 1851. His photographs of Belgium were purchased by journalist Melville Chater (see Chater entry) for use in *National Geographic.* Sacre died in 1921.

Joseph J. Scherschel was born December 18, 1920, in Chicago, Illinois. After four years in the Navy and a stint at the *Milwaukee Journal,* he traveled the world as a *Life* Magazine staff photographer from 1947 to 1962. Scherschel joined the National Geographic as a staff photographer in 1963 and became assistant director of Photography in 1972. That same year he won the Grand Award in the White House News Photographers Association annual photo contest, one of many honors he has received. Scherschel, who retired in 1985, resides in Flint Hill, Virginia.

Jon Schneeberger was born January 11, 1938, in New York City. As illustrations editor for *National Geographic* since 1966, he has edited over two hundred stories, most of them on space, science, and primitive peoples. He has guided the Geographic's photographic coverage of the space program for the last twenty years and is a leading journalist in the fields of space and satellite imagery. The images for the *National Geographic Atlas of North America, Space Age Portrait of a Continent* were generated from satellite data through his expertise. Schneeberger lives in Arlington, Virginia.

Ernest Beaumont Schoedsack was born June 8, 1893, in Council Bluffs, Iowa. He began his film career as a cameraman for Mack Sennett at Keystone studios in 1914. A combat cameraman for the Signal Corps during World War I, he stayed overseas after the Armistice to make newsreels. In 1920 he embarked on several joint projects with Merian C. Cooper, codirecting two documentaries in the Near and Far East, followed by feature films with exotic or mysterious backgrounds, such as the atmospheric thriller *The Most Dangerous Game/The Hounds of Zaroff* (1932). Their most famous collaboration was *King Kong* (1933), the fantasy-horror classic. Two *National Geographic* articles written by Cooper were illustrated by Schoedsack, whose pictures were included in other stories as well. During World War II, while serving as an Air Force officer helping to develop new weapons, Schoedsack lost his eyesight in an accident. He died in 1979.

Eliza Ruhamah Scidmore was born in Wisconsin in 1856. She began her career as a newspaper correspondent in Washington, D.C., covering the capital's social scene. She soon turned to travel

writing, and beginning in the 1880s, she lived for long periods of time in southern and eastern Asia. The theme of intercultural cooperation permeated her work; she particularly encouraged understanding between the United States and Japan, where her brother served as consul general in Yokohama. She was decorated by the Japanese emperor for her sympathetic reporting on Japan's treatment of prisoners during the Russo-Japanese War. One of the first to advocate planting Japanese cherry trees in Washington, Scidmore also wrote several books on Japan and the Far East and a travel guide to Alaska and North America's northwest coast. She wrote for many popular journals but had a special affiliation with the National Geographic Society. Not only did she contribute articles and photographs to the *Geographic,* she was its corresponding secretary and the first woman to serve on its Board of Managers. Scidmore spent the last five years of her life promoting the League of Nations. She died in 1928.

Pascal Sebah and Joaillier (dates unknown) were photographers active in Turkey c. 1860s to 1880s. Sebah, who was Turkish, was most noted for his views of Constantinople, where he had a studio. He also photographed monuments and the interiors of mosques and made studies of native people and their costumes.

Vittorio Sella was born in Biella, Italy, c. 1859. At the age of twenty-one, he decided to make a career combining alpinism and photography. The next year he made an unprecedented crossing of the Matterhorn in winter. No one before Sella had taken photographs of the high Alps from equal altitudes. Sella photographed the Italian Alps, the Caucasus Mountains, Africa's Ruwenzori Mountains, Alaska's Mount St. Elias, and the Himalayas. In 1909 Sella retired, spending his time disseminating prints and converting his home in Biella into a gallery setting. As his fame grew, organizations such as the National Geographic and Royal Geographical Societies bought large sets of his prints. Ansel Adams was strongly influenced by his work. Sella died in 1943.

R. Senz & Company, Bangkok (history unknown).

George Shiras III was born January 1, 1859, in Allegheny, Pennsylvania. Shiras received degrees from Cornell and Yale Universities and Trinity College, was a lawyer and biologist, and served in the United States Congress from 1903 to 1905. He promoted legislation to protect wild animals and birds and wrote bills that put migratory fish and birds under federal control. Noted as an amateur photographer of wild animals, he invented methods for taking their pictures at night by magnesium powder flashlight. His photographs won a gold medal at the Paris Exposition in 1900 and grand prize at the St. Louis World's Fair in 1904. In 1908 he became a trustee of the National Geographic Society and in 1930 turned over to the Society his collection of negatives made from 1889 to 1930. His two-volume *Hunting Wild Life with Camera and Flashlight* was published in 1935. Shiras died in 1942.

Robert F. Sisson was born May 30, 1923, in Glen Ridge, New Jersey. He has been a National Geographic staff photographer since 1942. His work has illustrated nearly seventy natural history stories for the magazine, many of which he wrote. Sisson is particularly well-known for his photographs of nature's miniature worlds. He has received many honors and awards for his work, including a first

prize from the White House News Photographers Association, the Natural Science Award from the Canadian government, and election to the New York Academy of Sciences. His work has been exhibited at the Washington Press Club, the Berkshire Museum, Massachusetts, and the Brooks Institute of Photography, Santa Barbara, California. Sisson lives in Washington, D.C.

James Lee Stanfield was born September 21, 1937, in Milwaukee, Wisconsin. Stanfield was a staff photographer with the *Milwaukee Journal* for five years and worked for Black Star for one year before becoming a freelance photographer for the National Geographic in 1965. He joined the Society's staff in 1967. His photographs illustrate forty-six *Geographic* articles, as well as a Society book, *The Mighty Mississippi* (1971), and several children's books. Since 1962 Stanfield has won over forty major awards; most recently he was named photographer of the year by the White House News Photographers Association in 1977, 1982, and 1988, and Magazine Photographer of the Year in the Pictures of the Year competition in 1985. Stanfield lives in Arlington, Virginia.

B. Anthony Stewart was born in Lynch Station, Virginia, in 1904. He joined the staff of National Geographic in 1927, spending forty-two years with the Society before retiring in 1969 as assistant director of Photography. During his career, he pioneered 35mm and color photography. He traveled widely and won recognition for his portrayal of foreign lands and peoples. His awards from the White House News Photographers Association and the National Press Photographers Association were numerous, including Pictures of the Year competition awards in 1963 and 1967. When Stewart died in 1977, he had contributed more pictures to the *Geographic* than any other photographer.

James A. Sugar was born February 8, 1946, in Baltimore, Maryland. He began his career with the National Geographic Society as a summer intern in 1967, continued as a freelancer, and has been a contract photographer since 1979, specializing in aviation, science, and technology. His photographs illustrate seventeen magazine articles, three of which he wrote, and the Society books *Railroads: The Great American Adventure* (1977) and *America's Sunset Coast* (1978). Sugar was named Magazine Photographer of the Year in the Pictures of the Year competition in 1978, and in 1980 he won the top photographic award from the Aviation Sports Writers Association. The same year he had a one-man exhibition at Nikon Gallery, New York City. Sugar lives in Mill Valley, California.

George Tairraz was born May 16, 1868, into a family of photographers in Chamonix, France. Tairraz and his partner and successor Savioz were noted for their portrayal of the Alps. Tairraz died in 1924. In 1963 two of his photographs were given to the National Geographic Society by Enterprises Andre Borie, a Paris based company then engaged in constructing the Mont Blanc Tunnel. These were for an article — never published — on the tunnel.

William Thompson was born on a ranch in Fresno, California. Once an oil painter, he owned a climbing school and guide service in Grand Teton National Park for fifteen years, taught as a college professor, and worked as a communications consultant. At the age of thirty-eight, Thompson became a photographer, and his first assignment was with National Geographic. He continues to practice

photojournalism and commercial photography. His work has been in a number of juried international competitions, and is included in major art collections, particularly his "Landscapes of a Western Mind" series. He lives in Seattle, Washington.

Tomasz Tomaszewski was born May 6, 1953, in Warsaw, Poland. After his studies at Warsaw University and Warsaw Technical University, he became staff photographer for a succession of Polish weeklies and a contributor to *Solidarity* weekly. In 1978 he joined the Union of Polish Art Photographers and was elected deputy chairman in 1985. He is a member of the French photo agency, Agence Ana. His photography, closely intertwined with Poland's cultural and political scene, has been exhibited in two one-man shows and included in a number of group exhibitions in Poland, as well as at the Museum of Modern Art, Paris, the International Center of Photography, New York, and the Museum of the Diaspora, Tel Aviv. A number of Polish photographic awards have been given him, including the Underground Solidarity Award for Culture, 1985, and the Wyspialiski National Award for Young Artists, 1986. His photographs have illustrated *Geographic* articles on Polish Jews and the United States, several Polish and West German books, and have also been published in *Stern* (West Germany), *La Croix, Geo, Paris Match* and *La Vie* (France), *Weltwoche* (Switzerland), and *Famiglia Christiana* (Italy). His most recent book is *Remnants, The Last Jews of Poland,* Friendly Press, New York (1986). Tomaszewski lives in Warsaw.

Baron Wilhelm von Gloeden was born September 16, 1856, near Wismar, in what is now East Germany. Seeking a warmer climate because of poor health, he settled in Taormina, Sicily. A cousin in Naples taught him photographic technique, and von Gloeden turned to photography as a career when his family allowance was severed in 1889. His principal subjects were the young men of Taormina. Von Gloeden's generous disposition and the ample royalties he paid his models tempered villagers' attitudes toward his open homosexuality. The Baron became a magnet for prominent fin de siècle figures, who avidly collected his nudes. In 1911 and 1916, the Geographic published some of his photographs, received from Rear Admiral Colby Chester. Von Gloeden died in 1931. Pancrazio Bucini, a friend and model, became responsible for the Baron's estimated three thousand glass-plate negatives. In 1936 a fascist raiding party impounded his negatives, destroying or damaging more than half of them. A subsequent trial acquitted the estate of pornography charges, but the glass plates were not returned until after World War II, when only a few hundred remained intact. Significant collections of prints, such as those owned by the National Geographic Society, periodically surface.

Steve Wall was born June 28, 1946, in Shelby, North Carolina. He began his career in Chattanooga as a newspaper photographer for the *News-Free Press* and the *Chattanooga Times.* From 1969 through 1978, he worked for United Press International and Black Star, covering stories in more than thirty countries. A National Geographic freelance photographer since 1978, he has concentrated on social and environmental issues. Wall received the Douglas Tomlinson Award for Significant Achievement in Feature Writing and News and Feature Photography from the All-Church Press in 1975. His photographs have been exhibited in North Carolina, Georgia, and Mississippi. Wall lives in Charlotte, North Carolina.

Frederick William Wallace was born in Glasgow, Scotland, in 1887, and emigrated to Canada as a young boy. He became a novelist, historian, editor, commercial fisheries authority, and founder of the trade publication *Canadian Fisherman.* In 1921 *National Geographic* published "Life on the Grand Banks," an article he wrote and photographed. In 1926 Herbert Hoover, then Secretary of Commerce, appointed Wallace to the Advisory Board of the U.S. Bureau of Fisheries. Founder and first president of the Canadian Fisheries Association, Wallace also compiled standard reference works for shipbuilding in the Maritime Provinces. His novels *Blue Water* and *Captain Salvation* were made into motion pictures. Wallace died in 1958.

Frederic A. Wardenburg was born in Atchison, Kansas, in 1881. An electrical engineer, he joined the Du Pont Company in 1907. He retired in 1946 as general manager of the Ammonia Department, but retained his position on the Du Pont Board of Directors until his death in 1966. Active as a civic leader, sportsman, fisherman, painter, photographer, and world traveler, Wardenburg made safaris to Africa in 1947-48, 1949-50, and 1952-53.

Bradford Washburn was born June 7, 1910, in Cambridge, Massachusetts. A cartographer, explorer, mountain climber, teacher, and one-time director of the Boston Museum of Science, Washburn won renown for his aerial photographs of mountains, which have helped mountaineers plan their routes. Cartographers have used his data in preparing maps of Mount Everest, Mount McKinley, and the Grand Canyon. Washburn has contributed articles to numerous publications, including *Life, Look,* and *National Geographic.* He joined the Explorers Club in 1931, the Royal Geographical Society in 1936, became a member of the American Association for the Advancement of Science in 1960, has been an Honorary Fellow of the American Geographical Society since 1961 and joined the National Advisory Board of the World Center for Exploration in 1969. Washburn lives and continues his work in Belmont, Massachusetts.

Volkmar Kurt Wentzel, born February 8, 1915, in Dresden, Germany, became a U.S. citizen in 1932. He attended the Corcoran School of Art in Washington, D.C. In 1937 he joined the National Geographic staff, where he spent his career, except for four years as an aerial photographic officer during World War II. He became one of the Society's most traveled senior photographer-writers. A two-year photo-survey of India ranks high among his many assignments. On expeditions to Nepal, Mozambique, and French Equatorial Africa (where he was the guest of Albert Schweitzer) he was both motion picture and still photographer. Decorated for his articles and photographs by the governments of Austria and Portugal, Wentzel has had numerous exhibitions and won many awards. At the National Geographic, he initiated programs to preserve and use the Society's irreplaceable collection of historic photographs. Retired in 1985, Wentzel remains active with projects and spends his time between Washington, D.C., and his farm in West Virginia.

Wiele & Klein was a photographic studio in Madras, India, in the early part of the twentieth century. In the 1930s it became Klein & Peyerl.

Maynard Owen Williams, born September 12, 1888, in Montour Falls, New York, grew up in Kalamazoo, Michigan. After receiving

degrees simultaneously from Kalamazoo College and the University of Chicago, he spent a few years teaching at what later became the American University in Beirut, then worked as a Baptist missionary teacher in Hangchow, China. He joined the National Geographic staff in 1919 after spending some years with the *Kalamazoo Gazette* and the *Christian Herald.* During his career with the Society, Williams photographed and wrote about many areas of the world including Greece, the Middle East, China, Czechoslovakia, Afghanistan, Sinai, the Netherlands, and the East Indies, contributing over ninety magazine articles. He participated in the opening of King Tutankhamen's tomb in Egypt in 1923, National Geographic's MacMillan Arctic Expedition in 1925, and the French Citroen-Haardt Expedition crossing Asia by motor car in 1931-1932. Williams spent thirty-four years with *National Geographic,* many of them as the chief foreign editor. He died in 1963.

Steven C. Wilson was born July 22, 1931, in Ames, Iowa. He is a freelance photographer whose work for *National Geographic* and numerous Society books since 1981 has focused on the natural landscape and environmental issues in North America. His awards include the New York Art Director's Silver Award in its sixty-first annual exhibition in 1982. His work has been exhibited at the American Museum of Natural History, the Smithsonian Institution, and other locations. A founder and director of Entheos Mountain Agriculture, a tree conservation group, Wilson lives in Seabeck, Washington.

Edwin L. Wisherd was born September 9, 1900, in Hagerstown, Maryland. He came to National Geographic as a nineteen-year-old assistant to the one-man photographic staff. He became one of the magazine's earliest staff photographers and took *Geographic*'s first natural color plates exposed in the field. After he became chief of the photographic lab in 1936, Wisherd was instrumental in equipping photographers with the novel 35mm cameras and color film, a step that made *National Geographic* famous for dramatic, fast-action shots in lifelike color. His methods for making large dye-transfer prints for exhibitions were later adapted by printers producing color plates for the *Geographic.* He received awards and commendations from the American Society of Magazine Photographers, the National Press Photographers Association, and numerous other professional groups. Retiring after fifty years with the Geographic, Wisherd continued to serve as a consultant until he died in 1970.

Cary Sol Wolinsky was born October 14, 1947, in Pittsburgh, Pennsylvania. After working for the *Boston Globe,* he became a National Geographic freelance photographer in 1972 and a contract photographer with the Society in 1980. His assignments have taken him around the world and especially to Asia. Wolinsky's work is represented by the Pucker Safrai Gallery in Boston, Massachusetts. He lives in Norwell, Massachusetts.

Adam Pearce Woolfitt was born October 10, 1938, in London, England. He has been a freelance photographer for National Geographic since 1966, concentrating on people and places in Europe and the United States. Woolfitt also has contributed work to *Travel & Leisure, U.S. News and World Report, Geo,* and *Country Life* magazines. He lives in London.

Frederick R. Wulsin was born in 1891. After graduating from Harvard in 1913, he spent two years in East Africa and Madagascar gathering material for Harvard's Museum of Comparative Zoology. In 1923 the National Geographic Society sponsored Wulsin's expedition to China's northwest borders to study animal and plant species and to compile records of China's people and landscape. He collected thousands of zoological and botanical specimens and returned with 2,000 photographic negatives. Wulsin completed his doctorate in anthropology in 1929 and taught at Boston University and Tufts. During World War II, he worked with the Quartermaster General's office researching human survival under extreme climatic conditions. Wulsin died in 1961.

Paul A. Zahl was born March 20, 1910, in Bensenville, Illinois. He received master's and doctoral degrees in experimental biology from Harvard. In 1937 he and a colleague established the Haskins Laboratories in New York, a research clinic for biochemistry, biophysics, and medical physiology. As staff physiologist and later associate director, he published some sixty scientific papers, trekked to tropical outposts around the world, and wrote several books. During World War II, he played a leading role in the Office of Scientific Research and Development, which mobilized science to aid the war effort. A member of the National Geographic staff from 1958 to 1975, Zahl took part in expeditions to Australia, the Caribbean, South America, Asia, and Africa. He sought out the habitats of unusual life-forms such as the world's largest ant in the Amazon or the biggest flower blossom in Malaysia. Zahl photographed and wrote forty-nine articles and photographed five others for the *Geographic,* was the Society's senior natural scientist, and served on the Committee for Research and Exploration. After retiring in 1975, Zahl continued to act as a consultant for National Geographic until his death in 1985.

AFTERWORD AND ACKNOWLEDGMENTS

ODYSSEY marks the first exploration in the name of art of the vast photographic archives of the National Geographic Society. Never before has National Geographic been approached like any other historic photographic treasury. The effort has required the cooperation of many and the prolonged involvement of four individuals: Frances Fralin, Assistant Curator of Photography, Corcoran Gallery of Art; Dena Andre, Exhibition Coordinator, Corcoran Gallery of Art; Declan Haun, Photography Editor, National Geographic Society; and myself. Kathy Moran, Picture Editor, Communications, National Geographic Society, has worked with us throughout our selection.

The project began in the spring of 1986 with a series of informal meetings among Frances Fralin; Declan Haun; Wilbur E. Garrett, Editor of *National Geographic*; Rich Clarkson, then Director of Photography at the National Geographic Society; and me. In 1988 the National Geographic Society would turn one hundred. As the centennial year approached, we thought it was time for a fresh look at the photographic legacy that ten decades of global picture assignments, collecting, and systematic filing had amassed. The Corcoran Gallery of Art had established itself as the primary photographic showplace in Washington, D.C., concentrating on American art, and we were about the same age as the National Geographic Society. These two venerable Washington, D.C. institutions ought, we agreed, to join forces by producing an important exhibition of photographs spanning the century, memorializing a rich era of exploration by the camera.

Together the National Geographic's President, Gilbert M. Grosvenor, and the Corcoran's Board of Trustees proposed to organize an exhibition to open in the centennial year. Bill Garrett took on a specially nurturing role in the endeavor; without his close involvement the project would have been impossible. The Corcoran committed the summer months of 1988 for the exhibition, and, through the involvement of Cornell Capa, Director of the International Center of Photography, a fall showing was booked in New York. We were joined by the Eastman Kodak Company, whose head of the Professional Division, Ray De Moulin, made an early decision to sponsor both the Corcoran's organizational costs and the international museum tour. Eastman Kodak, whose history has been so closely intertwined with the National Geographic Society's photographic evolution, has become a full partner in the entire development of the exhibition and book.

Sorting through the seemingly bottomless photographic archives housed at the National Geographic's two main facilities, its headquarters in downtown Washington, D.C., and the Membership Center Building's storage facility in Gaithersburg, Maryland, was itself challenging. We organized our initial research in several stages. Five of us divided the territory, working in teams. Frances Fralin, Declan Haun, and I were joined by Dena Andre, who has coordinated the entire undertaking and participated in every aspect of its production, and Kathy Moran, who searched primarily through material from the unpublished file selects in the National Geographic Illustrations Library.

Declan Haun coordinated another aspect of the task by soliciting from National Geographic staff, contract, and freelance photographers work they particularly wanted us to consider. Frances, Dena, Declan, Kathy, and I spent many days at the Gaithersburg facility, where published photographs (prints, glass plates, albums of contact sheets, negatives) predating 1970, as well as unpublished autochromes and black-and-white images, are kept. We looked through the exhaustive film and slide files at the Wash-

COLOR SEPARATIONS AND OFFSET LITHOGRAPHY
GARDNER LITHOGRAPH, BUENA PARK, CALIFORNIA
ON 100 LB. VINTAGE GLOSS BOOK

TYPOGRAPHY IN MERIDIEN AND TIMES ROMAN
THE TYPEWORKS, BALTIMORE

SMYTH-SEWN BINDING
ROSWELL BOOKBINDING, PHOENIX, ARIZONA

DESIGN
CASTRO/HOLLOWPRESS, BALTIMORE

PUBLISHED
THOMASSON-GRANT
CHARLOTTESVILLE, VIRGINIA
AND
THE CORCORAN GALLERY OF ART
WASHINGTON, D.C.
JUNE 1988

ington, D.C. Society library, we looked at every issue of the *National Geographic* and every Society book, we looked at all the work submitted by living photographers. We spent days viewing slides on a table-top slide enlarger. Images we liked as 35mm slides were printed at the Geographic lab into 5" × 7" color prints; black-and-white images were xeroxed. We pinned them up on walls to rearrange and stare at and rotate again. Some images stayed for weeks before banishment, some for months, some in the end were rescued from retirement — a few stayed untouched on the wall from beginning to end. Finally, we came to a consensus for our selection.

The book, designed and sequenced by Alex and Caroline Castro, has been the result of an extraordinarily devoted effort. In the end, it may well be Alex and Carrie's imprint that most distinguishes what we see here. The photographers' biographies were painstakingly assembled, researched, and written by Frances Fralin.

Mark Power, a Washington, D.C. photographer and writer, when asked gave perfect guidance on my text. The text was skillfully edited by Carolyn M. Clark. I also wish to acknowledge Priit Vesilind, senior writer at *National Geographic*, whose unpublished manuscript on the history of color photography at the National Geographic Society has helped me more than any single source.

With the exception of vintage material, the black-and-white exhibition prints were made by Palm Press of Littleton, Massachusetts, and the dye transfers were printed by the Visual Project Center in Pepperell, Massachusetts. All exhibition printing has been overseen by Gus Kayafas and Dale Parker. John Marcy and Mark Germann of Palm Press printed the black and whites; Dale Parker, Dan Spikol, Richard Steigler, William Wells MacFeeley, Kathy Wootton, Stanley Walton, Pam Furciniti, and Peter Goldberg of the Visual Project Center made the dye transfers.

While photo researching, we received the able assistance of the National Geographic Illustrations Library staff: Eudora L. (Dori) Babyak, William C. Bonner, Flora D. Davis, Robert A. Henry, Michael R. Ratcliffe, Beth Richardson, and Scott Sroka.

From Photographic Services we wish to thank Carl M. Shrader, David H. Chisman, William S. Petrini, Denise L. Shaffer, and Alfred M. Yee.

Special credit goes to Lee Smith, Research Correspondence, National Geographic Society, who against all odds tracked down information on some of the more obscure photographers. Also assisting in biographical or copyright research were Rebecca Fralin and Sheila Haggerty of the Corcoran Gallery and Joseph M. Blanton, Jr., Carolyn F. Clewell, Jeanne Peters, and Eugenia M. Ryan from National Geographic.

For legal advice and assistance we are indebted to Nicholas Ward, Esq., Corcoran Gallery Counsel; and to Suzanne K. Dupré, Corporate Counsel, and Nora Hohenlohe, Assistant Corporate Counsel, National Geographic Society.

For sharing her expertise on nineteenth-century photographic prints we thank Constance McCabe, Conservator; and for giving us research assistance, particularly with the autochromes, we thank Robin Siegel, Conservator, National Geographic Society.

For coordinating this project with the magazine and its itinerant photographers, thanks are due to three senior assistant editors at *National Geographic*: Tom Kennedy, Robert W. Madden, and W. Allan Royce. Thanks also go to Anne D. Kobor, Brooke Kane, John Morris, Jennie Mosley, and Benita Swash of National Geographic for their varied assistance.

From the Corcoran Gallery we are grateful for the support of Edward J. Nygren, Executive Director, and the indispensable help of my assistant, Nancy Huvendick, and Mary O'Neill, Secretary to the Curatorial Department.

Finally, our true appreciation is extended to Robert Gilka, Luis Marden, and Volkmar Wentzel, some of *National Geographic*'s lifeblood, for sharing with us their recollections and candid opinions, and thus giving us invaluable perspectives on the Society's history and nature.

Jane Livingston